MW01069602

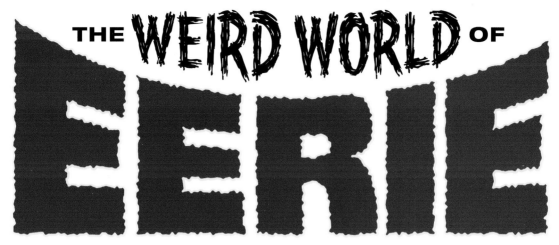

THE WEIRD WORLD OF EERIE PUBLICATIONS

Comic Gore That Warped Millions of Young Minds!

by Mike Howlett

Introduction by Stephen R. Bissett

Feral House

www.FeralHouse.com

Feral House
1240 W. Sims Way Suite 124
Port Townsend Wa 98368

Design by Sean Tejaratchi

Printed in China through Four Colour Print Group

EERIE
CONTENTS

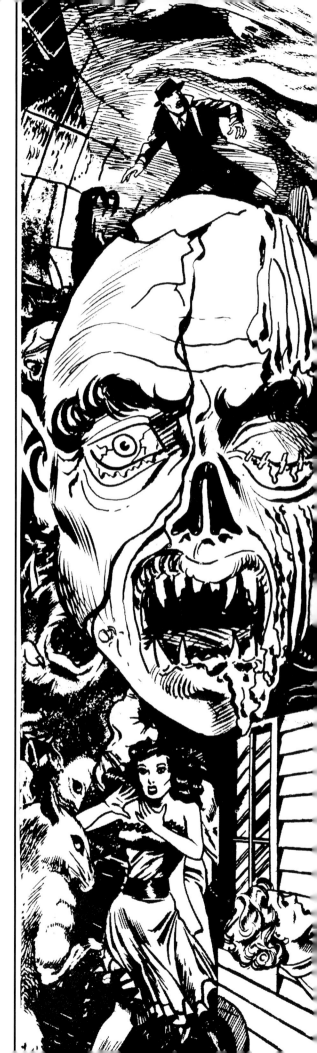

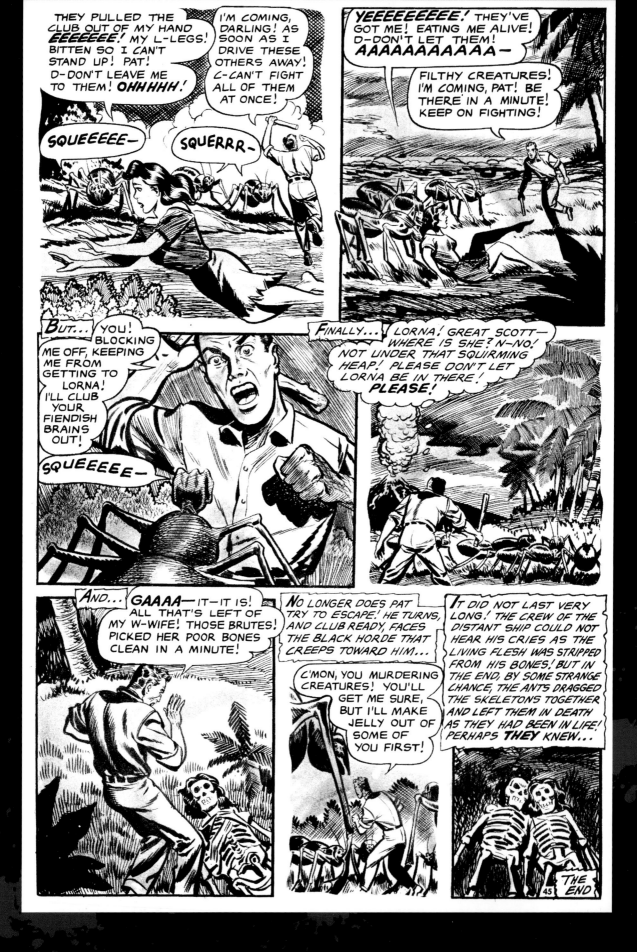

MINUTES LATER, IN A BEDROOM FILLED ONLY WITH THE SOUNDS OF ONE WHO IS ASLEEP...

WEIRD SHIT
A CONTAGIOUS CONFESSIONAL
Introduction by Stephen R. Bissette

I ADMIT IT: *I am cursed.*

I have been cursed since childhood.

If you know what's good for you, *you'll stop reading right now*. You'll stop reading this, and you won't read another page of this book.

In fact, if you really care for your soul and well-being, *you'll destroy this book right now*.

You see, I bought the first issue of Myron Fass' *Weird* off the newsstand back in 1965.

Forgive me, please. What did I know? What *could* I have known? I was only 10 years old (I wouldn't turn 11 until 1966), and it was a tough decision to make—but in the end, I bought that damned, cursed magazine and *brought it home*.

I brought it home and I brought it into the room I shared with my older brother Rick and I *let it infect me*.

Little did I know at the time that it was a disease, a malignancy, and that I was cursed.

Little did I know that buying *Weird*'s first issue meant I would forever haunt the newsstands searching for another issue, and another, and *another*, and then the other Eerie Publications horror comics magazines.

Little did I know that I'd be irrevocably infected by something so truly insidious,

"The Skin Rippers," Martha Barnes' redraw of the Ajax favorite "Black Death"

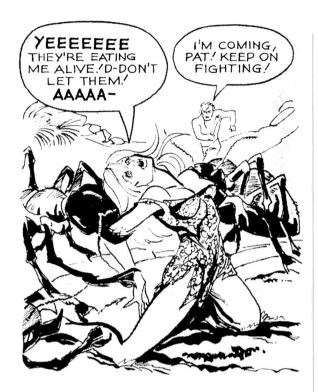

mind-rotting and strangely non-contagious (anyone I ever showed these zines to simply waved them off, asking what I saw in them anyway).

Would I have still plunked down my 35 cents if I'd known what I was in for?

You bet your ass I would have.

Mind you, when I bought that first issue, I didn't know it was the first issue. Buying *Weird* #1 would have been a no-brainer, even in those pre-collector days. I bought any and all monster magazines' debut issues, if only to see what they might turn into. But the first issue of *Weird*, just like *Eerie*'s exquisite first issue, *wasn't a number one*. *Eerie*'s first issue—the first I saw and bought, the first listed in the back issue pages where you could mail-order what you'd missed—was *Eerie* #2, and that was a unsolved mystery that prompted sleepless nights for years.

I didn't lose any sleep over *Weird*'s first issue. The contents page said it was "Vol. 1, No. 10," and all I could wonder was how much worse the earlier nine issues could have possibly been. I did wonder, later, how did I miss nine issues of something like this? But that didn't bother me; I figured if #10 looked as cheesy as it did, the earlier issues must have been so bad that Vincent's Pharmacy just wouldn't allow them on the newsstand.

So, you see, I was there from the beginning, though at the time it was just another odd eruption on the racks in Vincent's Pharmacy in downtown Waterbury, Vermont. *Weird* Vol. 1, No. 10 blighted the racks during a season of many such eruptions: the monster magazines had been coming thick and fast since 1964, and it was tough to hold onto my pennies long enough to afford yet another magazine, particularly one my mother and father might consider suspect.

And this particular monster magazine was *mighty* suspect, especially to a discerning customer like yours truly.

And that was what made it so—needed.

It really looked like it sucked, and sucked in a *bad* way, like something I *shouldn't* take home with me, like a strange cocoon or a waterbug in a jar, a white pouch of spider eggs or a wasp's nest or a bare forked branch wrapped with tent caterpillar webbing (of course, I had brought all of those home at one time or another).

There were a lot of things that defined *Weird* as a "suck" horror comic magazine, especially when compared to the clearly superior *Creepy* and *Eerie*.

First of all, there was that absolutely crappy cover, painted (well, drawn and *partially* painted) by God-knows-who (or, to be more accurate, Myron-Fass-knows-who). It had none of the evocative conviction or power of the Frazetta *Creepy* and *Eerie* covers, which completely seduced the eye. It looked rough, rushed, unfinished.

Even at age 10, I didn't think magazines could or would look like this. How could it have even reached the newsstand, much less cost money, looking like *this*?

Whoever did the *Weird* #10 cover either didn't have time or didn't care to finish the illustration. It showed a crudely watercolored outsized Frankenstein's Monster staggering up a line drawing of a city street and sidewalk. The background, such as it was, was splashed with an amorphous blue and purple mess of color. The hapless citizens—stumbling in the street behind the monster, screaming in the foreground, and even the poor sap plunging to certain damage and/or death from the monster's open hand—had been sketched in and inked, but they weren't even rendered or colored. Well, OK, the one screaming guy in the foreground had a smear of darker blue/violet watercolor splobbed onto him. I remember thinking, "well, at least they stayed inside the lines," like it was a page from one of my younger sister's coloring books.

Furthermore, there was an undefined splash of white (with yellow/tan lines on one side) erupting from the top of the monster's left leg. Was it a shell detonating on the monster's hip, fired from an off-panel cannon? A splash of water? His hip bursting with lightning-like energy? I was too young to have thought of this bizarre jizz-like explosion as representing the monster's semen or ejaculate—that guesswork came (pun intended) later in life, when I stumbled on the issue amid my stash of better monster magazines.

On the other hand, *the cover got me to buy the magazine* (and as I tell my students at the Center for Cartoon Studies, that is ultimately the purpose of any comic book, magazine or book cover).

In 1966, 35 cents was a fair amount of swag for a kid to drop for such an ugly item—I could have gotten *three* color comic books and a candy bar at the same price. But I'd never seen anything like this magazine. You could see the pencil lines under the watercolor and ink lines—you could see how the cover had been drawn, even if it hadn't been properly completed. There were drawing secrets here. This was a curious goldmine for an aspiring young cartoonist, requiring further scrutiny than I could possibly get away with in front of the magazine rack at Vincent's Pharmacy— and then there was all that festered inside.

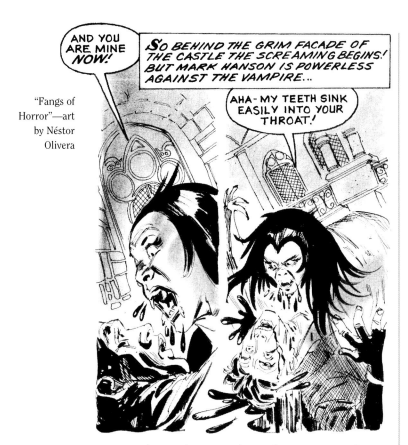

"Fangs of Horror"—art by Néstor Olivera

In short, this was the *ugliest* comic I'd ever seen. I had never even *imagined* as repellent a comic as this.

And it wasn't just the art—the stories themselves looked dangerous. I didn't have time to read them right then and there, but their panel-to-bloody-panel narratives were demanding my full attention, ripe with the promise of the forbidden. These stories weren't like the ones in *Creepy* and *Eerie*—these were the most unsettling, hideous things I'd ever seen.

These were like the dead cow carcass we'd found the summer before, or the roadkill we'd come across during the springs and summer months, and have to poke at with sticks.

Not only that, but the ink came off on your fingers, like the nasty tabloid *National Enquirer* newspapers I would find at my aunts' and uncles' houses. Damn, those were ugly things, those early 1960s issues of the *Enquirer* and its imitators: burnt corpses, decapitated car crash victims, dead people and mashed skulls and bullet-riddled criminals on the covers, worse photos inside.

Weird was like those—it even *felt* dirty. I would literally have to wash my hands after reading this comic! This was as close to "toxic" as any comic book I'd ever seen, and its arsenic allure was strangely irresistible.

Sick as it sounds, it was love at first sight.

The stories weren't that toxic, as it turned out. I read them without a single nightmare rippling through my sleep. Even flipping through the magazine today, I can see why they didn't really get to me—vampires, witches, flying decapitated heads and hoo-hah like that didn't really register with me, not then and not now.

There was just one story in *Weird* #10 that I enjoyed and even copied panels from. It was the wacko mummy story "The Terror of Akbar." My later studious reading of any horror fiction I could lay my hands on proved this was pretty derivative stuff: short stories about mummy curses—and, yes, mummy eyes were so popular, there was even a silent movie about mummy's eyes, *Die Augen der Mumie Ma* (1918), directed by none other than Ernst Lubitsch and starring Pola Negri and Emil Jannings (!). At age 10, however, this

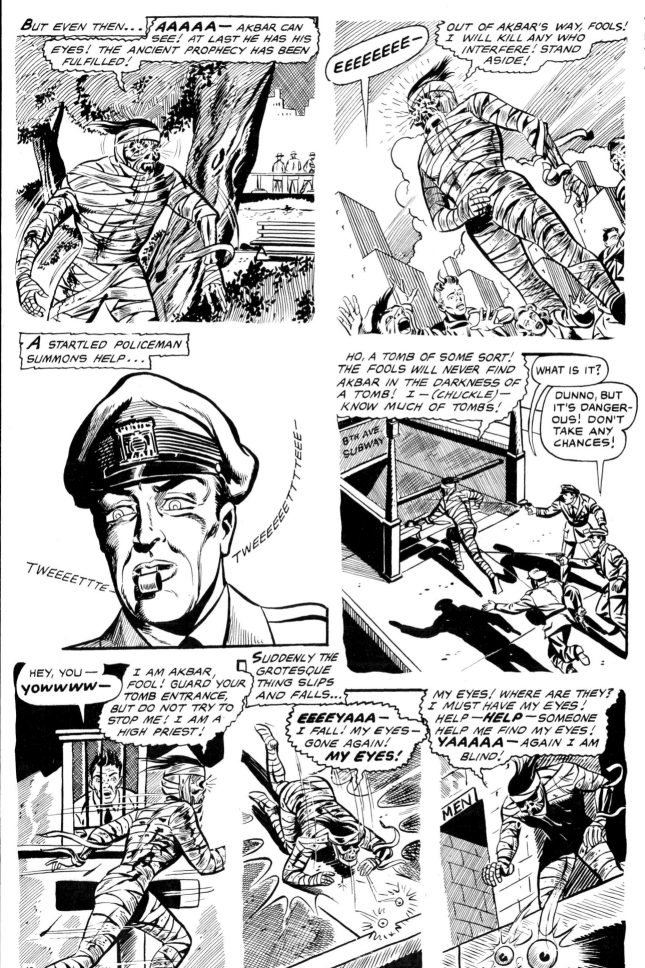

"The Headless
Ones"—art
by Enrique
Cristóbal

was all new to me. It was bleakly funny how the mummy's disembodied eyes moved on their own, how the eyeless mummy (splotches of black ink dripping from his jaws and hollow sockets) went stalking his eyes, and how— once he got 'em back in his skull—he stupidly fell on a subway platform (which he mistook for a tomb) and sent his orbs rolling onto the tracks, where he was crushed by an oncoming train. This was dumb, dumb, dumb stuff. Still, I loved the story; as an adult, I gleefully reprinted a few choice panels in *Taboo 1*.

It was the *next* couple of issues of *Weird* that started to get to me. With the exception of the messy lead pen, ink and wash story about Frankenstein's Monster in *Weird* #10 (the only new material in the issue, as it turns out, credited to "Elwood & Burgos," as in associate editor Roger Elwood and editor Carl Burgos)

and the inside-front-cover single-pagers (most likely by the same writer/artist team), most of the stories had the same relentlessly bleak tenor, tone and look.

• • •

I had no idea I was in fact enjoying my first exposure to pre-code horror comics material from the early 1950s. *Weird* and its successors—more about those in a few paragraphs—were composed primarily of reprinted, ink-splattered output from Jerry Iger Studios originally published between 1950 to 1954 in Ajax-Farrell comics *Fantastic Fears, Voodoo, Haunted Thrills* and *Strange Fantasy*.

Like all kids who read comics, I had no idea at the time where this stuff came from. I hadn't a clue who or what was behind *Weird*—I only knew that I was cursed, and doomed to stupidly buy and read *Weird* as long as it existed.

I've since learned how this all fits together, and you're about to read the inside scoop (Mike Howlett will walk you through the whole checkered story—unless you took my advice right from the beginning and *stopped reading* this and better yet *destroyed this accursed tome! But you haven't, have you? Have you??? You fool! FOOL!!!!*).

I have also since tracked down and compiled a modest collection of those pre-

code Ajax-Farrell titles. It turned out that Eerie Publications was helmed by magazine mogul Myron Fass, who himself drew plenty of pre-code stories and covers, and Robert W. Farrell, another veteran of the pre-code and post-code comics industry.

Robert W. Farrell's career arc began with the birth of the pamphlet-format four-color comic books in the 1930s, as a writer for Iger Studios, a partner with comics publisher Victor Fox, and a full-fledged publisher (Superior, Farrell, Four Star, Ajax, etc.). Myron Fass labored among the freelance comic book artist pool from 1948 until 1955, grinding out readable but unexceptional covers and stories in all genres: Westerns, romance, jungle, espionage, action, crime and horror comics. I've stumbled onto Fass' signature in comics from a plethora of publishers, primarily among the likes of Toby, Gleason and Trojan, but occasionally popping up in Atlas (later better known as Marvel Comics); he was at best a journeyman, at worst a hack.

I've never read an account of how Fass and Farrell met; it's likely that Fass at some point worked for Farrell during his freelancing as a cartoonist. Suffice to say that sometime after 1955 Fass made the leap into editing, packaging and eventually publishing his own magazines, beginning with the *MAD* imitation *Lunatickle* (published by Whitestone Publishing) and saucy sex rags like *Foto-Rama*. Somewhere before the '60s, Fass and Farrell

joined forces; by then, Fass had already packaged and published the cheesy faux-monster magazines *Shock Tales* (1959). Only after I was working professionally in the comics industry myself did I hear or read anything about Fass. I was later told by one of the artists who contributed to Fass' *Heavy Metal* knockoff *Gasm* that Fass ruled over his Manhattan office bullpen with a loaded .44 Magnum jammed into his pants. Before the end of the 1990s, the most comprehensive article I'd ever found about Fass was "I, Myron" by Mark Jacobson in *The Village Voice* (October 23, 1978), which confirmed the Magnum reign of terror and revealed much about Fass' empire, sadly without discussing at all the infamous horror comics Fass continued to publish.

However they came together, however it all happened, it's obvious Farrell and Fass reveled in the horror comics, and always sought a way to bring their small ocean of horrors back to market. While most publishers fled the genre after the imposition of the Comics Code Authority at the end of 1954, Farrell and Fass soldiered on, with Farrell reprinting heavily censored Code-approved versions of his horror story backlog in 1957–58 as *Strange, Dark Shadows, Strange Journey* and *Midnight*. Those are barely readable; once packager Russ Jones, editor Archie Goodwin and publisher Jim Warren showed the way anew with the successful launch of *Creepy* and *Eerie,* Fass

BUT SUDDENLY, THE FIRST RAY OF DAWNING SUNLIGHT STREAKS INTO THE DANK MAUSOLEUM AND THE DECAYING CORPSES SINK INTO THEIR COFFINS...

"Tombstone for a Ghoul"—art by Antonio Reynoso

and Farrell repackaged uncensored, sloppily-toned and gored-up versions of the venerable Iger Studios file material for *Weird*.

The times had changed. Instead of toning down the art, Farrell, Fass, Myron's brother Irving Fass (art director) and editor Carl Burgos (creator of Atlas/Marvel's original Golden Age *Human Torch*, among other chestnuts) spiked the horror quotient by slashing white-out drool and thick, black ink blots of gore onto stats of the pre-code art, making it more tactile and grotesque than it had been in its original four-color form. Farrell listed his own name as publisher on the contents page bylines of the earliest issues of *Weird*, but he soon moved on.

I should also mention Myron Fass and Carl Burgos also collaborated in 1965–66 on their own original four-color comics. Under the company name of M.F. Enterprises (the same imprint behind Fass' crap 1959 monster magazine *Shock Tales*, among others), Fass, Burgos and writer Roger Elwood packaged and published six ill-fated issues of their own take on *Captain Marvel* (1966–67). In their incarnation, Captain Marvel was a superhero whose rather ghoulish power was the ability to make his head and limbs separate from his torso and fly to their target ("Split!"); it was arguably the strangest and least appealing of all 1960s superheroes in a crowded field jam-packed with unappealing contenders. Fass also published a short-lived *Archie* teen comic book knockoff by vet cartoonist Bob Powell entitled *Henry Brewster* (also published under the suggestive title *Jumbo Size Henry*). I'd read the first issue of the Elwood/Burgos *Captain Marvel* at my Duxbury classmate Jeff Parker's house, but had no desire to seek it out for myself. Once was enough.

Obviously, most American kids felt the same way.

All Fass' four-color comics folded—only the black-and-white horror Eerie Publications horror comics zines thrived and survived.

It had to have been the curse that kept them going, and kept idiots like me buying and reading them…

• • •

Crude as almost all these Eerie Publications stories were and remain, in their blunt, thuddingly literal cruelty there was an aesthetic perfectly attuned to the times. Though these were stories essentially a decade old, they were perfectly timed for rebirth: we were ready for them in the 1960s. After all, our President had been assassinated, and then his alleged assassin was assassinated right before our eyes, on television (and if we missed it, that video was played and replayed until we would never, ever forget it). We were living in a cruel new decade of civil rights protests and violence, the escalation of the Vietnam War and rumblings from a new youth movement that seemed positively tribal in nature.

How did that spill into our homes? It was on the TV news every night. We couldn't escape it.

It also changed everything in the pop culture. If you were a kid, the first rumbles were the gory full-color *Mars Attacks* and *Civil War* bubblegum cards. If you were a kid like me, you also had convinced your parents it was OK to stay up late at night to watch 1930s and 1940s horror movies on television, and you kept your eye on the newspaper ads for a whole new breed of horror movie. Only a couple of years before the debut of *Weird*, low-budget horrors like Joseph Green's risible *The Brain That Wouldn't Die*, James Landis' harrowing *The Sadist* and the collaboration of skin producer David Friedman and Florida

huckster Herschell Gordon Lewis on *Blood Feast* heralded a new era in horror. The first of a rough new breed were upon us, sans a handy label to aid in either their marketing or banishment. Like Fass and Farrell, cheapjack filmmakers like Green, Landis, Friedman and Lewis were at heart hucksters hoping to turn a quick buck, pulling out the stops to show mayhem on the big screen that was a new and novel extreme in 1962–63. It worked, and the bloodgates were open, never to be closed.

For the most part, kids were initially sheltered from such cinematic atrocities, though I vividly recall the ads in the newspaper for all these films and the ache to see what I was not permitted to. The first of this forbidden breed I would get to see with my own eyes was *2000 Maniacs*, and it fried me. I had accidentally been exposed to *2000 Maniacs* at a drive-in during a family out-of-state trip the same

"A Shape of Evil"—art by Cirilo Muñoz

year *Weird* hit the newsstands, a traumatic experience that marked me as deeply as did the 1966 issues of *Weird*. Next up was *The Brain That Wouldn't Die*, dumped into syndication by American-International Pictures in a movie package our local Channel 22 would play and replay on Saturday afternoons, with the gore AIP had cut for its theatrical release in 1962 inexplicably restored. *The Brain That Wouldn't Die* absolutely anticipated *Weird* and the entire Eerie Publications aesthetic: it was even a refugee of the 1950s itself, having been made in 1959 and shelved, unreleased, until AIP finally picked it up and trimmed it a bit for wide drive-in, nabe (neighborhood theater) and grindhouse play in 1962.

I wouldn't catch up with *Blood Feast* (at a Manhattan midnight movie revival) until the end of the 1970s or *The Sadist* until the 1980s, but I have since found newspaper photos of a town parade in downtown Brattleboro, Vermont, in which a local beauty waves from the top of a flower-covered vehicle, the Paramount Theater marquee visible behind her promoting the double-feature of *The Sadist* and *Tower of London*. Much as parents, theater owners and even good ol' Forrest J. Ackerman in the letters pages of *Famous Monsters of Filmland* did their best to spare us or steer us away from these horrors, we still encountered them.

The curse was manifesting, reaching critical mass, and there was no escape.

"No escape" was the operative term: there was no escape from the bloody images *2000 Maniacs* burned into my brainpan, no escape from the addictive reruns of *The Brain That Wouldn't Die*, and I have to say the grisliest fare in *Weird* similarly branded me, too.

• • •

If I had to cite just one Eerie Publication story that forever marked me, it would be "Black Death" in *Weird* #12 (October 1966). I had no idea it was a reprint when I read it at the tender age of 11, nor would have that mattered a whit: it was one of the bleakest horror stories I'd ever read up to that point in my life, and it troubled me for days.

"Love, they say is like dying a little! So if two lovers must die, what better way than to die together, hand in hand?" So begins the tale of a shipwrecked honeymooning couple, stranded on a remote isle. Its beaches sport odd cone-shaped sand formations, the surrounding sand peppered with unidentifiable claw prints. By page three, the cause of the claw tracks and denizens of the sand cones are revealed: they are ravenous lion-sized ants, and the couple is on the menu. They fight valiantly, but they are eventually overwhelmed: she is dragged away and picked clean to the bone, while he beats as many of the insects to death as he can before he, too, is reduced to a skeleton. "But in the end, by some strange chance, the ants

dragged the skeletons together and left them in death as they had been in life! Perhaps they knew…"

I kept revisiting the story, trying to sort out why it was so disturbing, why it struck such a deep nerve. It was badly written and the art was competent at best (the mewling ants were ungainly lumps with minuscule heads and what appeared to be broken sticks for legs), but every time I reread it, my unease only mounted. It didn't matter that these people were good people who loved one another: there was no escape, no exit, no salvation or redemption. They fought hard; utterly devoted to one another to the bitter end, but *the ants got 'em.* They died horribly, eaten alive, leaving the ants to feed another day—and the last shot of their skeletons side by side (hers, of course, still sporting her complete head of hair) only made things worse, as if the ants knew they were young and virile and in love and fucking ate 'em anyways. I loved it, though I knew I shouldn't.

OK, it's lame stuff. But I tell you, this stupid little comic story affected me. It still bothers me when I just think about it.

That entire issue of *Weird* was an ungainly gem, from the carnivorous flower story that opened the issue ("The Blood Blossom") to the concluding pair of ghost stories, one featuring a headless walking corpse ("Nightmare") and the other a *Gaslight*-like tale of a husband driving his wife insane only to be haunted

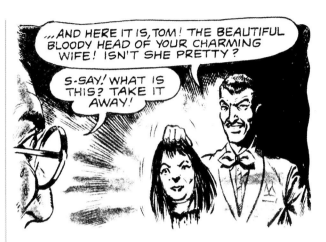

It's a "Bloody Head," with art by Oscar Stepancich

by her vengeful spectre ("Rest in Peril"). The scaly, drooling demon of "Fanged Terror" was pretty cool, and the "Swamp Haunt" story was cool.

But best of all was "Heads of Horror," wherein a physicist avenges himself on his adulterous wife and her lover by *shrinking their heads* while they still live, turning them into freakish beings. On the final page, the pea-headed couple turned the tables, tying the scientist up in his lab and shrinking *his* head before seeing through an improvised suicide pact ("Goodbye! We're going to kill ourselves! I advise you do the same!"); by the time the cops arrive, he's a gibbering idiot, consigned in the final page to a freak-show cage.

⬤　⬤　⬤

None of these were *good* horror comics stories, but they sure were nasty, nihilistic, sexist, misanthropic and to the point. This was bare-boned exploitation in its rawest form, recycling past atrocities without a hint of remorse.

"House of
Blood"—art
by Rubèn
Marchionne

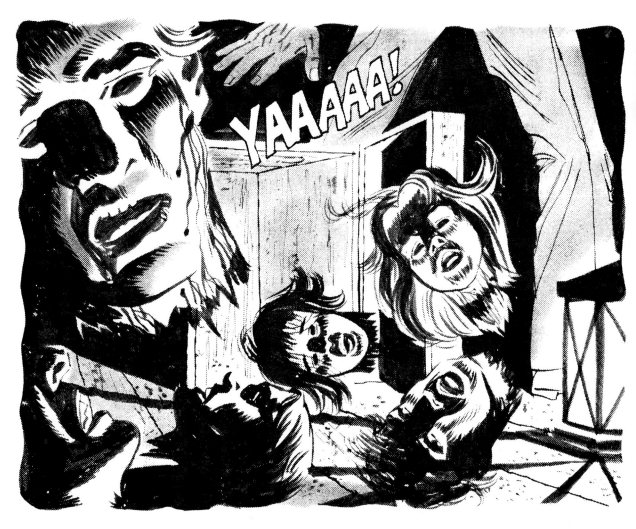

These were also precursors to the modern horror movies and literature to come. The first time I felt in a movie theater the way I had in my bedroom when I first read "Black Death" was when I saw *Night of the Living Dead* on the big screen.

There was no escape. No exit.

And knowing the young couple in the truck really loved each other only made it worse, as if the zombies knew they were young and virile and in love and they fucking ate 'em anyways.

Just like those goddamned ants.

Now, I'm not saying *Weird* was as good as *Night of the Living Dead*—if anything, *Weird* was closest to the lurid, sexist bargain-basement lunacy of *The Brain That Wouldn't Die*—but I am saying *Weird* and its clammy "the world's gone to shit" brand of horror was one of the few pop harbingers of what was just around the corner. Myron Fass and his shoddily printed pre-code reprints groomed and prepared cursed readers like me for where George Romero took us all in 1968 and after.

The curse reached critical mass, and the entire world looked at times like those smeary black-and-gray panels and pages.

• • •

I've held on to the first eight issues of *Weird* over the years, though I'm not sure why. I would occasionally purge my collection of entire runs of the Eerie Publications titles, but I kept those first *Weird* issues through thick and thin. The magazine never got any better, just more repugnant as Fass, Burgos and Fass kept cranking it out on a roughly bimonthly schedule.

The covers became loopier and gorier, looking more and more like carny freak show posters or hand-painted African movie posters for grindhouse shockers that never existed. They mashed monsters together into nonsensical tableaux of werewolves staking vampires (Vol. 2, No. 3, June 1967) and fishmen and hunchbacks tearing clothing off screaming women while badly-foreshortened male vampires hovered overhead (Vol. 2, No. 6, April 1968).

Weird lasted until 1980, as best I can tell (I never saw a new issue after that year). *Weird* had been published for 15 years, and throughout that run it never let up: it was shamelessly, unapologetically dismal and despairing to its final issue.

Some sources claim there was an earlier Eerie Publications experiment with reprinting pre-code horror comics in black-and-white magazine form. The one-shot *Tales of Terror* #1 was cover-dated Summer 1964; according to our steadfast Virgil in this tour of Fass' Inferno, Mike Howlett, that one-shot wasn't published by Fass at all; it was a Charlton

"Terror Tunnel"—art by Domingo Mandrafina

one-shot. In hindsight, it's likely there was *something* being put together by Fass and Farrell in the summer/fall of 1965 that they intended to publish as *Eerie* #1. That pending title had prompted publisher James Warren and editor Archie Goodwin to package and print overnight a few hundred copies of an ashcan-format *Eerie* #1 to secure the title as their own. It was a scam on Warren's part—they had only placed copies in select Manhattan news and magazine vendors to sway the decisive meeting with a key distributor in their favor—but it worked. Warren couldn't prevent Fass and Farrell from naming their imprint Eerie Publications, though.

What I believe now, though there's no way to confirm it, is that what was published as *Weird* Vol. 1 No. 10 was Fass' and Farrell's intended *Eerie* magazine. That might even explain the unfinished cover painting, rushed through production in a race to beat their competitor to the pitch. It doesn't matter—we'll never really know, will we?

"WE FOUGHT BACK THE WEIRD MONSTERS THAT INFESTED THE JANGLED WILDS...

Once *Weird* hit the stands and was apparently a success (obviously, I couldn't have been the only infected individual), Fass and Farrell kept grinding out the same hash under other titles. The plethora of Eerie Publications companion titles were, if anything, even grottier fare: *Witches' Tales, Tales of Voodoo, Tales from the Tomb, Terror Tales, Tales from the Crypt* (yep, they were that shameless; William Gaines clamped down on that too-close-for-comfort titular rip-off), the 1977 giant special *Classic Horror Tales* and the abysmal science-fiction/horror hybrids *Strange Galaxy* and *Weird Worlds*. If anything, the covers only got wilder, woollier and more outlandishly insane. Vampires eating werewolves while ghouls ripped bloody eyes out of screaming Mimis were *de rigueur*;

the intrusion of science-fiction imagery into the Gothic grand guignol tableaux had begun way back in 1966 (with *Weird* Vol. 2, No. 1, December 1966, featuring a ray gun being held to the head of a bloodied robot in the foreground while an amphibian man carried an unconscious belle in the background), but was in complete overdrive in the 1970s. My all-time favorite remains the cover to *Weird Worlds* Vol. 2, No. 2 (April 1971), in which what appears to be a multi-limbed super-jumbo primate screaming in the void of space is either trying to hold together an exploding planet, or is actually pulling apart or (more likely) humping the planet, causing it to erupt with its super-Kong orgasm. Like I say, it's hard to tell what might really be going on. But man oh man, *what a cover*.

New artwork began to surface amid the blotchy reprint pages around 1970, though they weren't a noticeable improvement, it must be said. I've traced many to being redrawn pre-code comics scripts, for that matter: Fass was still essentially recycling old material. Eventually, the market was exhausted, and Eerie Publications ceased to exist.

After Eerie Publications vanished from the stands, Modern Day Periodicals continued packaging similar material as *Weird Vampire Tales* and *Terrors of Dracula*. New titles, but it was the same old shit. Only the publishing firm's name had changed, and maybe the street address.

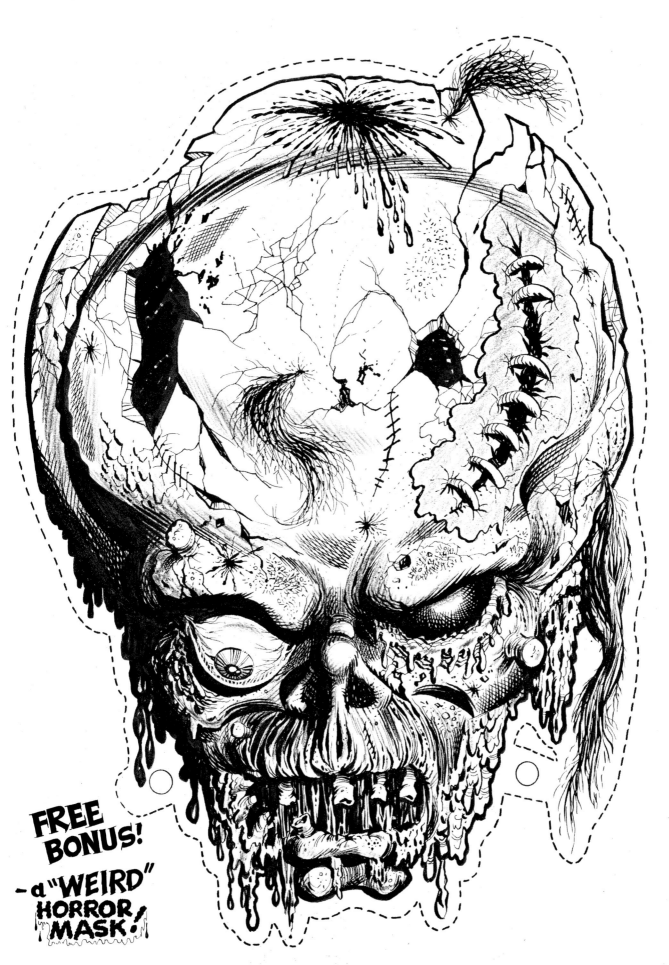

FREE
BONUS!
-a "WEIRD"
HORROR
MASK!

... CUT ALONG DOTTED LINES, PUNCH THRU HOLES and ATTACH ELASTIC!

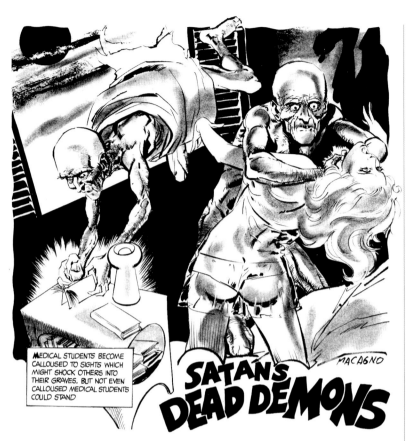

MEDICAL STUDENTS BECOME CALLOUSED TO SIGHTS WHICH MIGHT SHOCK OTHERS INTO THEIR GRAVES, BUT NOT EVEN CALLOUSED MEDICAL STUDENTS COULD STAND

SATANS DEAD DEMONS

"Satan's Dead Demons"—art by Alberto Macagno

I bought the last issue I ever saw from the Eerie Publications horror stable in a little country store in Saxton's River, Vermont. I couldn't help myself—I was *still* cursed.

I was with a couple of my friends, and one of them said, "Why are you buying that weird shit?"

"Ya, those zines always did suck," my other pal said.

"I don't know, I just love 'em," I said, and I meant it.

I *still* don't know.

I *do* love 'em.

That's the curse.

• • •

For decades, Eerie Publications were easily found at flea markets and occasionally at comic conventions for bargain-basement blowout prices. Nobody gave a royal rat's ass about them; they were the lowest of the low.

By the 1990s, the once-mighty and unstoppable Myron Fass publishing empire was dwindling, and I lost track of all this weird shit. I stopped seeing Fass' wonky UFO magazines on the stands and racks, though I was told he was still at it, publishing gun magazines and the like.

Then I saw one of my favorite DVD packagers, Something Weird Video, include random galleries of old Eerie cover art as bonus items on their DVDs. Something was shifting in the pop firmament, something was changing. Magazine and fanzine articles began to appear on both sides of the Atlantic, trying to make sense of the Eerie Publications legacy. Somebody was starting to pay attention to *Weird* and its abominable kith and kin, *because*, not in spite, of their gory excesses, rank depravity and splattery kitsch madness.

I read somewhere that Myron Fass had passed away (indeed, he had, on September 14th, 2006, at the age of 80).

I'd outlived both Fass and *Weird*.

I was at last free, *free* from the curse!

Or so I thought.

Then I met Mike Howlett in 2008.

Then I was asked to write this introduction.

I pulled my old collection out of the boxes, and gingerly looked at those unbelievably cheesy cover paintings.

I began re-reading "Black Death"…

. . .

Heaven help you if you've read this far. *I warned you!*

I told you to stop reading right from the beginning—to destroy this viral contagion, this curse between two covers, but no, you dolt, you swine, you dumb-as-a-bag-of-hammers shit-for-brains, you ignored my advice and kept on reading, didn't you? Didn't you??? I warned you, and you didn't listen!!!!

Because, see, when Mike Howlett first mentioned to me he was doing this book, I realized something that was both terrifying and a great relief:

Maybe the curse had always been a contagion; maybe I just lived amid circles of people who had a natural immunity to the contagion (they call it "good taste").

Or maybe the curse is that we who are cursed are doomed to *spread* the curse.

Maybe the curse we are afflicted with spreads in a unique way.

Rather than just *showing* people Eerie Publications, which they could easily dismiss or ignore or shun (as others have all my life thus far), maybe those of us who are cursed have to *write about them.*

We have to make them sound alluring and interesting, perhaps even valuable or culturally important.

Convinced Mike was onto something, I agreed to write this introduction—and now *you are cursed,* and Mike and I are *free! Free of the curse!! Because now it is yours!!!*

Believe me when I tell you that once you lay eyes on the contents of this book, you, too, will be marked for life.

There's no washing the ink from your fingers.

There's no un-branding your brain.

You are cursed, I tell you, *cursed!!!!!!*

—Stephen R. Bissette,
 Mountains of Madness, VT

A text illustration from "Space Rot"—art by Ezra Jackson

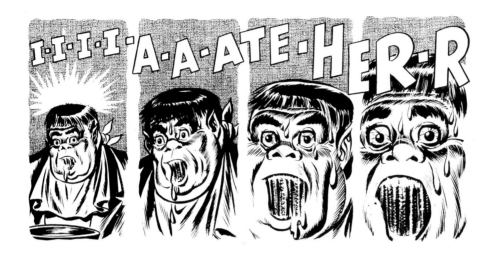

MY TAKE ON EERIE PUBS

Foreword by Mike Howlett

I HAVE TO BE completely honest here…

As a kid in the early 1970s, Eerie Publications weren't exactly my first choice for horror comic entertainment. I did buy them on occasion, but often as a last resort. I had my priorities; I was a bit of a snob.

Warren and Skywald magazines topped my shopping list. No big surprise there. DC's four-color "mystery" comics were also a weekly staple. After that, I'd turn to Marvel's horror reprint titles or Charlton's ghost comics, both of which glutted the comic rack. If there was

nothing else and I still hadn't scratched my itch, I'd grab an Eerie Pub.

Truthfully, I sometimes couldn't tell if I'd purchased something new or not. Eerie's habit of recycling stories and cobbling together previously used cover art confused my already addled pre-teen brain. Once in hand, however, the Pubs always delivered the gory goods, even if they did sometimes seem a bit familiar.

Sadly, my most vivid childhood memory of an Eerie Publications magazine was trading

Opposite: My favorite Eerie Pubs cover—***Weird V3 #2*** (May 1969), art by Chic Stone.

Above: "Yeech"—art by Carl Burgos

THE WITCHES COVEN

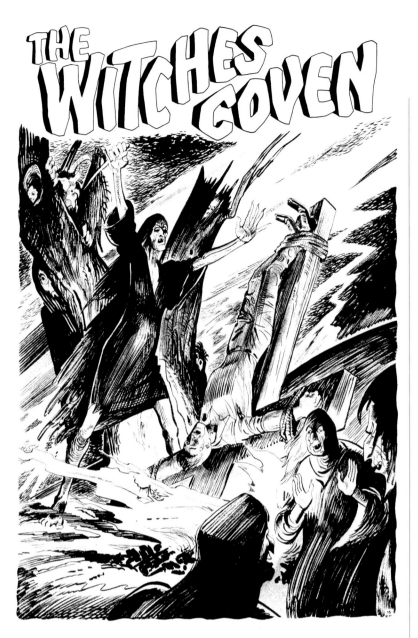

Above: The disturbing splash from Larry Woromay's "The Witches' Coven"

Right: "The Hungry Ghoul"—art by Dick Ayers

forever under-appreciated art started to speak to me. An obsession was born.

I had completed my Warren and Skywald runs and had just a few dozen Eerie Pubs lying around when I saw Chic Stone's cover for the May 1969 *Weird* for the first time. How this cover managed to evade me until the '80s is a mystery, but when I saw it, I became a changed person and I had to have them all. Of course, I didn't realize what I was getting myself into.

One never really knows just how many Eerie Pubs were published. I like to think that I have them all, and have for many years, but I wouldn't be the least bit surprised to see something heretofore unknown pop up someday. In their heyday, Eerie Pubs were misdated, misnumbered, issues were skipped and titles were dropped, all without

an issue of *Horror Tales* to my friend Charlie Mondrick for the drag picture sleeve 7" of the Rolling Stones' "Have You Seen Your Mother, Baby, Standing in the Shadow?"—a trade I would still make today. I have no idea what happened to that record over the years.

It wasn't until "adulthood" (in age, if not maturity level) that I began to really appreciate the Eerie Pubs books for what they were. Cheap knock-offs? You bet, but the audacity of the mags themselves, the astounding colors and garish action of the covers, the guerrilla publishing style and the

explanation. This line of comics has been the collector's worst nightmare for as long as there have been Eerie Pubs collectors.

Of course, nothing can be said about Eerie Publications without uttering the word plagiarism. That last sentence, however, will be the only time you'll see that word in this book. Borrowed, swiped, copied, influenced by, inspired by… yes, it's all true. The practice of reusing existing material may be a little underhanded, sure, but since nobody realized that 98% of the stories were ripped from 1950s horror comics until 30 years after the fact, I'd say that no one was hurt by the practice.

I doubt there's ever been a more maligned group of comics. Printed on the cheapest possible paper with less than household names providing most of the artwork, people have been slamming these fine publications pretty hard over the years. Only now, in the twenty-first century, are the Eerie Pubs books being recognized by normal folks as worthy comics to collect. Eerie Publisher Myron Fass himself called his magazines "masterpieces on cheap paper."

Look, I'm not an idiot. I realize that Bill Alexander is no Frank Frazetta and Oscar Fraga is no Berni Wrightson. Warren and Skywald magazines are timeless; their artwork is as valid today as it was in the '70s. Eerie Pubs, on the other hand, are now being appreciated (in "mainstream" circles at least) as nostalgic and kitschy, a product of their time; a throwback

"Horror Club"—art by Oscar Fraga

to something that could never fly today. They were (and are) down and dirty like 42nd Street in the '70s: dirty and dangerous.

I enjoy them for what they are: fun, cheap, gratuitous and entertaining. Some of my favorite films could be called the same thing: *Tombs of the Blind Dead* (1971), *The Gore-Gore Girls* (1972), *Werewolf vs. the Vampire Woman* (1972), Hammer horrors, Santo flicks, and countless Italian zombie movies. I defy anyone to watch the finale of the Paul Naschy flick *Hunchback of the Morgue* (1973) and tell me that the battle between the hunchback and the primordial creature in an underground laboratory, with Rosanna Yanni laying prone in the foreground, doesn't look like an Eerie Pubs cover come to life. I like gore, sleaze, horror and lowbrow entertainment, and I'm not afraid to admit it. It all makes me the repulsive creature that I am.

This goes out to all of my fellow repulsive creatures. ✳

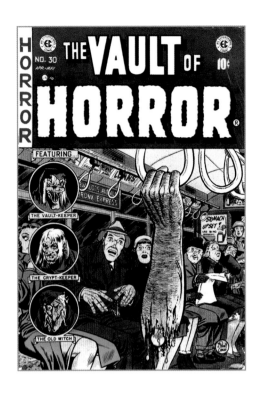

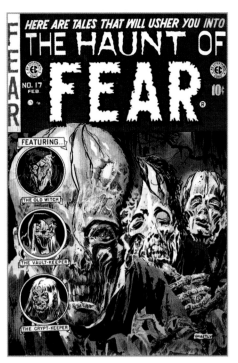

Chapter 1

PREHISTORY IN A NUTSHELL

Opposite and this page: To this day, EC's horror comics are the standards by which all others are judged.

Opposite:
Tales from the Crypt #24 (June/July 1951) Cover art by Al Feldstein

Above left:
The Vault of Horror #30 (April/May 1953) Cover art by Johnny Craig

Above right:
The Haunt of Fear #17 (Jan/Feb 1953) Cover art by "Ghastly" Graham Ingels

HORROR COMICS DIED in 1954.

Early in that year, one could choose from over 50 different horror-themed comic books on the newsstand. They were extremely popular. The success of William M. Gaines' EC comics, who published such legendary titles as *Tales From the Crypt* and *Vault of Horror*, popularized the horror genre, and dozens of other publishers jumped on the bandwagon, eager for a piece of the putrid pie. Horror

was the comic craze of the early 1950s and newsstands swelled with product. Some of these comics were good, some were lousy, some were mild, and some were wickedly violent. Either way, when the witch hunt started, they all had to go.

Spearheaded by Dr. Frederick Wertham and his book *Seduction of the Innocent*, the war against comic books was on. Wertham's book professed that comic books, specifically

Top:
Seduction of the Innocent
(Rinehart and Co., 1954)

Bottom left:
Chamber of Chills #23
(Harvey, May 1954) Cover art by Lee Elias

Bottom right:
Mysterious Adventures #13
(Story, April 1953)

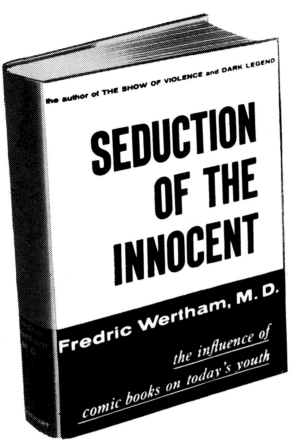

those in the horror and crime genres, were the leading cause of juvenile delinquency. This idea was nothing new. For over a decade, the comics medium had been accused of influencing bad behavior and teaching low morals, but with an outspoken psychiatrist in the spotlight, armed with "proof" of comics' ill effects on kids, an investigation seemed to be in order.

Senate Subcommittee to Investigate Juvenile Delinquency began hearings in April 1954 to determine if, in fact, comic books were detrimental to children. The hearings got a lot of press, both in print and on television. A relatively new but influential news medium,

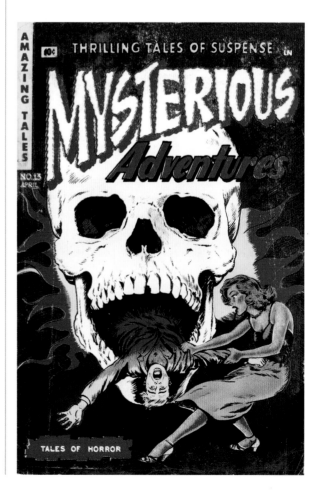

TV sets brought the drama right into family living rooms. William Gaines became the industry's whipping boy, as he was the only publisher who took the stand during the hearings, the lone voice in favor of freedom of the press. Certainly he had the most to lose; EC was the most successful horror comic publisher and their books were the industry standard.

The fact that the investigation proved nothing mattered little. The frenzy whipped up by Wertham and the hearings resulted in boycotts and book burnings. Unopened bundles of horror comics were being returned from the distributors to the publishers. The hearings

Top: William M. Gaines testifying at the Kefauver hearings, April 22, 1954

Bottom left: *Out of the Shadows* #11 (Standard, Jan. 1954) Cover art by Ross Andru

Bottom right: *Web of Mystery* #17 (Ace, Feb. 1953) Cover art by Lou Cameron

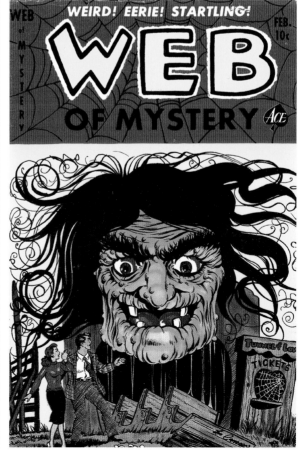

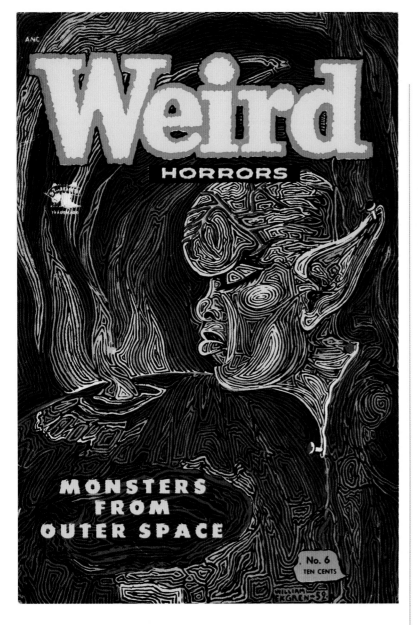

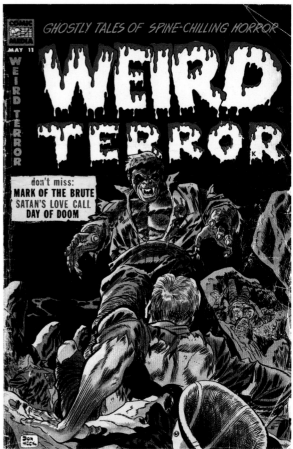

Left: ***Weird Horrors*** (St. John, Feb. 1953) Cover art by William Ekgren

Right: ***Weird Terror*** #8 (Comic Media, Nov. 1953) Cover art by Don Heck

provided no evidence of comics' unsavory influence, but the message was loud and clear: comic publishers had to clean up their books.

Gaines was bruised, but not beaten. He rallied his fellow publishers together to come up with a remedy that would be fair and acceptable for the publishers and the public. They formed the Comics Magazine Association of America (CMAA) in hopes of battling censorship and shining up the comic industry's tarnished image.

Or so Gaines had thought.

The group's first motion was to ban the

words "Horror," "Terror," "Crime" and even "Weird" from comics. This wasn't exactly the solution Gaines had been looking for. Disgusted, he left his own meeting and didn't join the association.

The CMAA adopted a code of comic book ethics, one that made a real horror comic impossible to exist. Horror, bloodshed, depravity, sadism, torture, cannibalism, vampires, zombies, werewolves, ghouls… in other words, the good stuff… were all prohibited. If a book didn't conform to the code, the comic wouldn't receive the all-important seal of approval. Without the CMAA stamp, news dealers wouldn't display the book.

Gaines' hands were tied. Ostracized by his

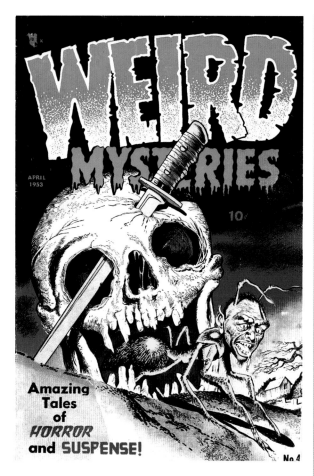

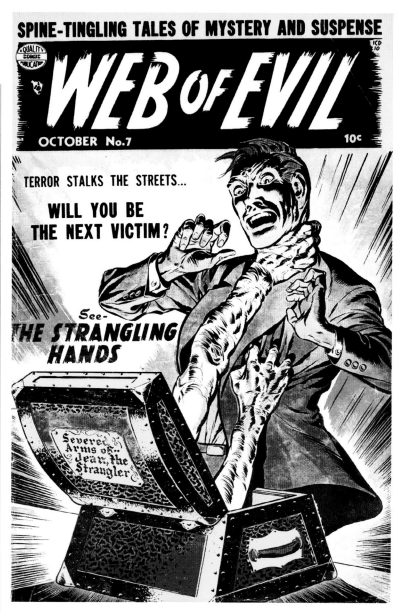

spineless peers, who were seemingly trying to weed out the stiff completion that his books presented, Gaines gave in. EC abandoned their horror titles. In fact, everybody did.

Horror comics had died.

Post-Code

The end of horror comics came with a whimper, a painful, gurgling death rattle. The last few months of the pre-code era showed a definite softening of the material, and in early 1955, the last of the horror comics had fizzled out. With the strict code in place,

family-friendly fantasy fare could be found, but nothing bloodthirsty or even remotely scary was being published. Many comic book companies simply closed their doors.

William Gaines eventually joined the CMAA in order to get his new books approved and stamped. EC attempted to launch a handful of non-horror titles, but all were short-lived. Gaines decided to quit the comic business and concentrate on his one remaining lucrative title, *MAD*, which had been changed to a black-and-white slick magazine, thus bypassing the code.

Left: *Weird Mysteries* #4 (Gillmor- April 1953) Cover art by Bernard Bailey

Right: *Web of Evil* #7 (Quality- Oct. 1953) Cover art by Jack Cole

5

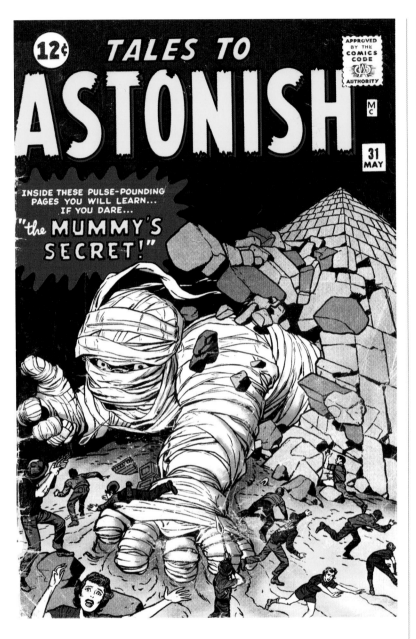

THE DAY THE SEASONS CHANGED

Gaines did make one last attempt at horror and crime books, EC's former bread and butter, with their Picto-Fiction line in 1956. The comics were published in magazine format, like *MAD* (which continued to be successful and code-free), but the scars from the furor of 1954 were still fresh in the minds of news dealers, and the books never really got a fair shake.

Some remaining publishers, like Atlas (soon to be Marvel) and Charlton, continued their "horror" titles, but with watered-down, less risky (or risqué) stories. In place of horror was "mystery" and "suspense," which was neither very mysterious nor suspenseful, and far from horrifying. The code had castrated

the medium and it looked like the cut was going to be non-reversible.

Later in the 1950s, Atlas was specializing in big monsters from space with goofy names and stories of anti-monster heroism that were fun and satisfied some of the appetite for weirdness, but it just wasn't the real thing. The Silver Age of comics had begun in 1956, and superheroes saved the day for the industry, but...

Horror comics remained dead.

New Hope for the Wretched

In 1957, while genre comics were busy being tepid, chill seekers had a lot to smile about at the movies. American International Pictures were bringing kids back into the theaters with teenage monsters, saucer people and all sorts of gruesome creatures great and small. Meanwhile, Universal Movies brought their old horror movies to television in the wildly popular Shock Theater package. Frankenstein, Dracula, wolfmen and zombies were invading people's homes through their TV screens. Horror-starved people were eating it up.

The stars must have been aligned, because right around the same time, sci-fi super-fan Forrest Ackerman was in France, buying a few copies of a film discussion magazine

called *Studio 57*. It was a special all-horror issue, crammed with photos of movie monsters. Back home in the USA, he showed his purchase to James Warren, a magazine publisher who was looking for something new. Warren was impressed with what he saw. Monsters were back in the public eye and the time was right for his new creation: a full-on monster magazine. Ackerman was brought on to write and edit the project. His humongous collection of film photos would be put to good use to illustrate his pun-filled prose.

Warren released *Famous Monsters of Filmland* into the world in 1957 and it was an instant success. Planned as a one-shot, Warren realized that he had a monster on his hands and convinced Ackerman to dig deeper into his collection and stay on board as *FM*'s

Opposite: Interesting, yes... but scary? Definitely not!

Opposite top left: ***Tales to Astonish*** #31 (Atlas, May 1962) Cover art by Jack Kirby and our boy Dick Ayers

Opposite top right: ***Alarming Adventures*** #3 (Harvey, Feb. 1963) Cover art by John Severin

Opposite bottom left: The dreaded Comics Code seal of approval!

This page: The first issue of Warren's ***Famous Monsters of Filmland*** (Feb. 1958)

CREEPY

No. 1 35¢

COMICS TO GIVE YOU THE CREEPS!
COLLECTOR'S EDITION

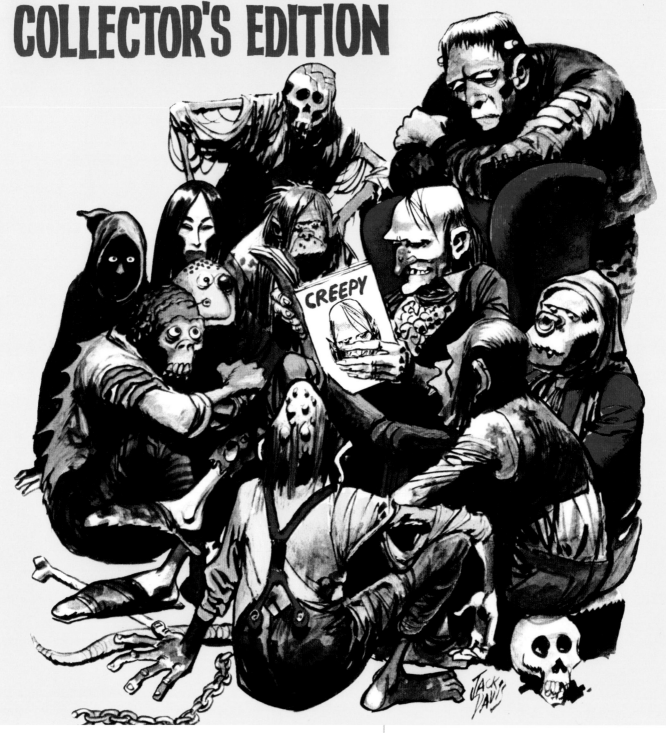

editor. Finally, weirdos and monster lovers had a magazine to call their own. Like EC comics had before it, the success of *FM* spawned many imitations and competitors. It was once again acceptable (and profitable) to jump aboard the monster bandwagon.

Among the throngs of *FM* imitators was Warren's own mag *Monster World*, *FM*'s companion title. Starting in November 1964, the first three issues had something special on display: black-and-white horror comics. The stories were adaptations of Universal and Hammer horror films, with artwork by EC alums Wally Wood and Joe Orlando. Though rather tame, scare fans were once again reading code-free horror comics. Warren was only getting warmed up.

How about an all-illustrated horror magazine? It had been tried before on a small scale with *Weird Mysteries* (Pastime, March/April 1959) and *Eerie Tales* (Hastings Associates, Nov. 1959), but both of those efforts had failed to make an impact. Warren's timing was better. Comics had become very popular again and his company was better equipped to make a successful horror comic.

Creepy was born in 1964. The first issue, cover dated January 1965, was the best thing to happen for horror comic fans since the dreaded code had stolen our fun a decade earlier. *Creepy* featured EC-style stories, Uncle Creepy, a wisecrackin' host in the style of EC's fun storytellers (The Crypt Keeper, The Vault

Keeper and The Old Witch) and, best of all, new exciting artwork, much of it from EC's roster of greats. Jack Davis, Wally Wood, Frank Frazetta, Reed Crandall, Al Williamson and other legendary comic artists contributed to early issues. Warren had secured the cream of the crop. Being a magazine, *Creepy* was also code-free, so werewolves, zombies, vampires, all forbidden fruit to the CMAA, were once again stomping through the pages of a comic book, all in beautiful black and white. This was what horror fans had been waiting for and *Creepy* was a runaway hit.

Horror comics had finally risen from the grave. ✳

Opposite:
Creepy #1 (Warren Publishing, 1964) Cover art by Jack Davis

This page: The hits just kept on comin' with *Creepy* #2 (Warren, 1964) Cover art by Frank Frazetta

THE SINCEREST FORM OF FLATTERY

WHEN ALL is said and done, Myron Fass stands as one of the most successful independent publishers in history. His ability to spot a trend and capitalize on it quickly and inexpensively made him a rich man. The road to Eerie Publications is paved with Fass' smarts, tenacity, and never letting morals get in the way of a good publication.

Fass came from very humble beginnings.

Born in Brooklyn on March 29th in 1926, his neighborhood was a crowded melting pot, and his father, an immigrant orthodox Jew, toiled as a sewer worker to feed his three sons. Myron honed his drawing ability throughout his younger years and put it to use during World War II, doing cartoons and PR work. After the war, he stepped into the world of comic books, and a career in pulp was born.

Opposite: Swiped or not, this is a pretty cool cover. ***Beware #6*** (Trojan, Nov. 1953)

This page: Mr. Myron Fass

11

The Iger Studio

The Iger Studio was an art studio formed in the '30s to provide stories for the burgeoning comic book industry. An astounding collection of comic artists got their start with this studio.

In 1936, a young cartoonist/writer by the name of Samuel Maxwell Iger (better known as Jerry) got a job from John Henle, who was interested in putting out a new cartoon magazine. Iger named it *Wow! What a Magazine* and produced the project himself. The workload proved to be a bit too much for one man, and Iger placed a want ad for other cartoonists to assist. William Eisner was one of the applicants and he was quickly hired. A kid named Bob Kane also came on board. Of course, Kane went on to superstardom a few years later as co-creator of Batman. That was the kind of young art talent that was seeking employment in 1936. By the end of the year, the Iger Studio was in good shape, stocked with quality illustrators.

In 1937, Jerry Iger made Will Eisner his partner in order to keep him around during a setback in production. *Wow! What a Magazine* had run its course, so the studio looked elsewhere to interest publishers in their product. They sold strips to newspapers and scored big when the pulp publisher Fiction House wanted to enter the comic book field. Iger created his most enduring character for Fiction House: Sheena, Queen of the Jungle.

With the success of National's Action Comics and their new character Superman in 1938, the comic book industry started growing by leaps and bounds, and doing so faster than a speeding bullet. The Iger Studio was now employing artists such as Jack Kirby, Bernard Bailey and future EC superstar Reed Crandall. Even Eisner's departure in 1939 (to work on his new creation The Spirit and become an industry icon) didn't stall the studio's progress. Fox and Quality Comics were also utilizing the Iger Studio's services, and Iger added more talented draftsmen. Successful new action characters were always being created at the Shop.

The early '40s brought in future EC regular Jack Kamen, as

In the early and mid-1940s, comic books were a new, exciting, and lucrative medium. As interest in comics grew and more publishers hopped onto the bandwagon, the need for creators also grew. Fass found work among a stable of artists in the Iger Shop, a collective that produced stories for many of the new outfits that had joined the growing comic book industry. Fass was just one of many talented artists who produced work for Iger; his co-workers would later read like a who's who of comic art legends.

Fass left the studio in the early 1950s to work on his own. The assembly line style at the Iger Shop must have proved too stifling for Myron, who was born to be noticed. He found work at Avon in 1950, illustrating a story for their one-shot *Atomic Spy Cases* and romance comics, all with equal aplomb, but his real strength would be rearing its horrid head in 1952.

In the previous year, when EC Comics had reinvented the horror genre, which had been all but nonexistent, they put gruesome horror on the map. As always, the competing publishers unleashed rival product to cash in on the craze, but EC stood strong against the wannabe usurpers, producing a stellar line of unequaled horror comics. Their formula was simple: they wrote intelligent scripts and used the best artists. EC's success did not go unnoticed by Myron Fass.

Fass had proven his worth to Toby's head

honchos and was handed the keys to their new horror title *Tales of Horror.* Providing covers and interior stories, he was showing signs of being very comfortable with the genre. Fass was definitely interested in horror; that's where EC was making a real impact on the market, and that was a smart lead to follow in 1952. *Tales of Horror* #2 (Sept. 1952) sports a fine Fass cover which previews the lead-off story, his 10-page masterpiece "The Thing in the Pool," which dishes up a terrified beauty, a beaked tentacle monster and a hero that strips down to his tighty whities!

Concurrently, Fass began some of his highest-profile comic artwork with Atlas

well as Al Feldstein, Bill Gaines' future partner in crime at EC. (Feldstein wrote many of the groundbreaking EC stories and edited much of that company's output.) Matt Baker, Maurice Whitman, and Bob Powell, plus future Eerie Pubs big names Myron Fass and Ezra Jackson, excellent artists one and all, worked in the Iger Shop. The comic book industry stayed busy even during the turbulence of World War II. When an artist was drafted, a new one was brought in.

The art produced by the shop was very good, even when it was produced by an assembly line. Sometimes, many different artists would work on the same story, just to meet deadlines. Because of this, the art from the Iger Studio has a distinct style and a certain feel to it. While some artists' work stands out (Kamen and Baker come to mind), much of the artwork can only be described as "Iger Shop." Clean, crisp lines, neat panels and concise storytelling are the earmarks of Iger Shop artwork.

Robert Farrell, who wrote for the Studio in the late '30s, was always keen to use Iger Shop stories in his comics. An associate at Fox, Superior, and the main man at Ajax, Farrell used the Iger Shop up until the very end, and even a bit beyond.

Jerry Iger closed up the shop in 1955, after the Comics Code came into effect. There wasn't as much demand for comic book art after that, however the studio's work continued to pop up from time to time. Iger later returned to his artwork, mostly in the advertising field and as a teacher. He passed away in 1990.

THE THING IN THE POOL

DO YOU LIKE TO SWIM? IS IT YOUR IDEA OF HEAVEN ON EARTH TO TAKE A LEISURELY DIP IN A POOL? WELL, DON'T! OR, LIKE ANN AND GEORGE WINSOR, YOU MIGHT FIND YOURSELF ENSNARLED IN THE WRIGGLING, CHOKING TENTACLES OF...'THE THING IN THE POOL'!

Myron Fass

Carl Burgos. Starting in 1951 drawing crime and sports comics, Fass illustrated over two dozen stories for Atlas, and most of them were horror.

Adventures Into Weird Worlds, Uncanny Tales, Mystic, Astonishing… Myron Fass produced artwork for all of these successful Atlas horror titles. The more work he got in the genre, the more comfortable he became and his art took on a more horrific and crazy tone. As he would do throughout his life, Myron Fass cast an eye toward what the competition was doing right and he learned from them.

It's well known among artists, art historians and just us plain ol' comic fans that good ideas get borrowed from time to time. Most comic book artists keep a "swipe file," clippings of people or fashions, cars, animals… whatever figure or thing a story might call for. Some would clip pictures from current magazines to keep their art on top of the latest trends. Some would save pictures of people in different stages of movement, having the reference on hand should it be needed. Some artists just looked to other comic books to see what had effectively been done before.

A half of a century after the fact, it's easy to say that comic art swipery was a nefarious deed in the early 1950s, but it's really not too different from saving clippings from a Montgomery Ward catalog. Those catalog models, however, never brandished axes or had fangs. I'm sure that when a comic artist

Previous page: Even Fass's romance stories had a touch of the bizarre. From "Beanpole," ***Dr. Anthony King, Hollywood Love Doctor*** #2 (Toby, 1952)

This page: *"The Thing in the Pool"* ***Tales of Horror*** #2 (Toby, Sept. 1952)

Publications. Atlas was a well-established company, first known as Timely in the '30s and '40s. They're still going strong today, known since 1961 as Marvel Comics. Atlas was arguably EC's closest competition in the field, publishing over a dozen different horror titles in the early '50s, many under editor Stan Lee's supervision. Fass' work was appearing side by side with some of the greats like Bill Everett, Joe Maneely, Joe Sinnott and his future cohort,

saw a drawing in an EC (or any other comic) that moved him in some way, and borrowed it, being busted for it three decades later was the furthest thing from their mind. I make no moral judgments; I just look at the art.

Myron Fass was not one to pass up on a good idea. His opening panel to "The Executioner" in *Uncanny Tales* #9 (June 1953) was clearly lifted from Jack Davis' cover to *Tales From the Crypt* #31 (EC Aug.-Sept. 1952), right down to the skull on the axe blade. Davis' illustration was a fine one and it helped tell the tale for Fass, so why the hell not borrow it?! Fass was fond of using images from EC, and was also very capable of emulating some of the EC artists' styles, employing a Wally Wood, Johnny Craig, or Jack Davis style where needed, or even a gray-toned, Al Williamson-esque style in "Death Of An Army" (*Adventures Into Weird Worlds* #20, July 1953). As Peter Normanton says in his article on Fass' pre-code horror art in his excellent fanzine *From the Tomb* (#11), "Myron, to his credit, only swiped from the best."

1953 and 1954 were the boom years for horror comics, and publishers filled the stands with more and more horrible comics. Trojan, for whom Fass had already done some crime work, stepped up the horror content of their title *Beware* and Myron was their choice to make it fly. The November 1953 issue (#6) featured not only his most blatant swipe on the

Left:
Crime Smashers #15
(Trojan, Mar. 1953)

Right: "The Executioner,"
Uncanny Tales #9 (Atlas, June 1953)
© 2010 Marvel Characters. Used by permission.

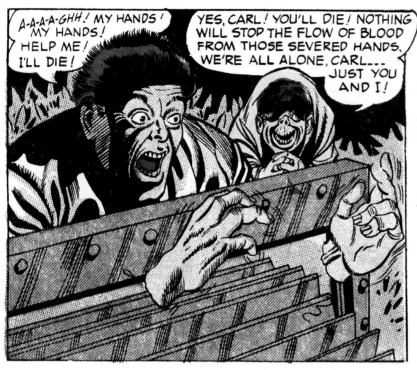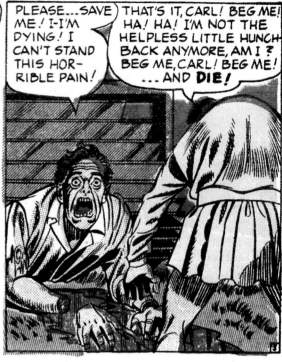

cover, but arguably his most gruesome story. The cover displayed two easy-to-spot lifts: a zombie breaking out of the cement from Jack Davis' splash panel to "Graft In Concrete," from EC's *Vault of Horror* #26 (July 1952), and the screaming female from the cover of *Adventures Into Darkness* #10 (Standard, July 1953). This female figure would pop up again over the years.

Fass' inside story, the lead-off tale "The Thing From Beyond," has it all: dismemberment, cruelty, disfigurement and murder—a treasure trove of pre-code nastiness. Fass had started signing his name in a style more befitting a horror artist, this time with "Mad art by Myron Fass."

Perhaps taking a cue from Graham Ingels, EC's preeminent horror artist who simply signed his strips "Ghastly," Fass became "Insane" or "Nuts Myron Fass" and his work was more than living up to those monikers. In *Crime*

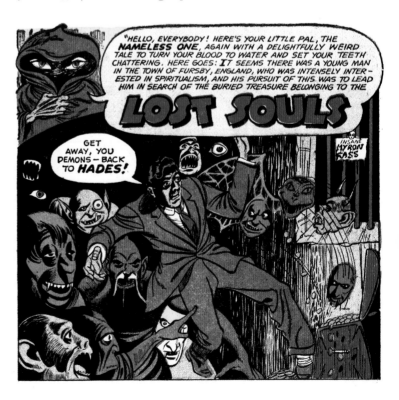

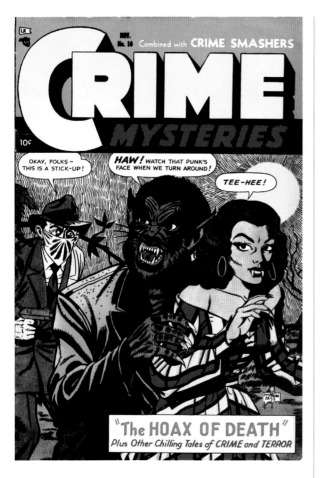

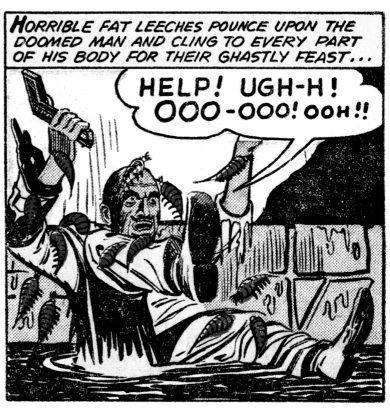

Mysteries #13 (Ribage/Trojan, May 1954), he went so far as to sign the story "Suicide Ship" with "Yes I am mad Myron Fass."

In *Beware* #7 (Trojan, Jan. 1954), Fass' story "The Life of Riley" has more dismemberment but adds a helping of cannibalism to the stew, making this one, curiously signed "Myron Fass… Good by" [sic], one of Fass' more stomach-churning pre-code entries. More interesting still is Fass' cover to *Beware* #11 (Sept. 1954), where he draws himself as a comic book artist tortured by his own creations. He screams to the demons, "I only drew you from my imagination"—true as far as I can tell, although horrific clippings can be seen taped to a bulletin board in front of the drawing table. Like I said, it was common to keep references on hand. This cover wouldn't be Fass' only self-portrait to see print.

As 1954 was coming to an ugly close, Fass did some more covers and stories for *Beware*,

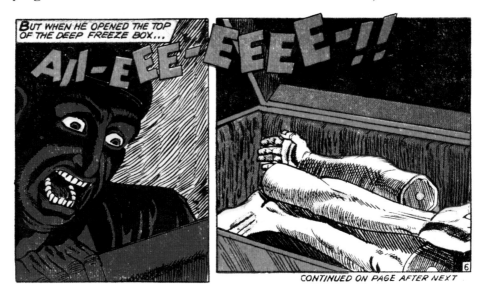

CONTINUED ON PAGE AFTER NEXT

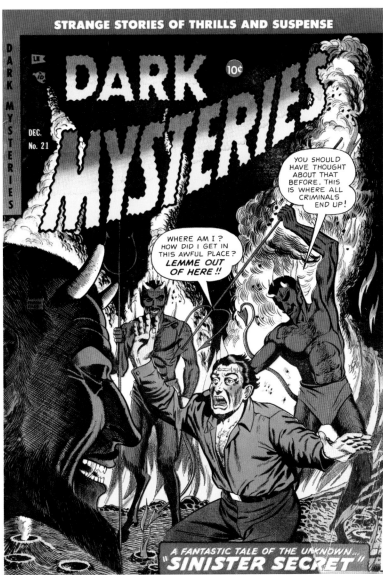

continued to keep Toby's *Tales of Horror* going, and drew the occasional Atlas story, but with the fetid air rising from the Subcommittee meetings, the imminent comics code and that damn *Seduction Of The Innocent* book, even the Insane One had to lighten up. His last few pre-code pieces were sanitized and safe, like everybody else's had become at the time. A very good thing was definitely coming to an end.

Once the code was in effect, Fass closed out the last couple of issues of *Beware*, then moved over to Lev Gleason's publishing house, where he drew a few covers and stories for the kiddie comic *Adventures in Wonderland* before working on the last half dozen of issues for the long-running *Black Diamond Western*.

He even managed to put a self-portrait into the lower right hand of the cover for *Black Diamond* #58 (Oct.-Nov. 1955), an issue in which he drew three stories.

The newly safe and saccharine comic field was not where a big personality like Myron Fass belonged. It was time to find a new direction. ☀

Opposite:
Beware #11 (Trojan, Sept. 1954) Fass' self-portrait of a horror artist's worst nightmare.

This page left:
Adventures in Wonderland #4 (Lev Gleason, Oct. 1955) This is Insane Myron Fass!?

This page right:
One of Fass' last horror covers.
Dark Mysteries #21 (Story, Dec. 1954)

LUNATICKLE

LUNATIC'S HOME COMPANION

No. 1 25¢

FUNNY FOTOS

Chapter 3

MASTERPIECES ON CHEAP PAPER

LIKE MANY artists after the collapse of the comic medium, Myron Fass was in a period of change. Once again, he looked in the direction of Bill Gaines and EC, whose comic *MAD* had changed to a code-free magazine format and continued its bestselling ways. Inspired by *MAD*'s format, possibilities and sales potential, Fass set to work on his own code-free humor magazine.

Lunatickle #1, released by Whitestone Publishing, hit the newsstands with a February 1956 date. It was one of the earliest of *MAD*'s many imitators that would pop up over the next few decades. Fass later told Marc Jacobson

in the *Village Voice* that *Lunatickle* "sold a million first issue, was dead by the third." Dead indeed; the third issue never even made it to the presses. The two existing issues, however, have a lot of interesting pieces, decent humor and some superb artwork.

Many excellent artists joined Fass for his magazine maiden voyage, including household comic book names like Joe Kubert, Russ Heath, and Lee Elias. Fass himself contributed, with some of his finest work appearing in #1, including some very fetching female forms, not exactly his forte during the horror years. Of most interest, however, is his

Opposite:
Lunatickle #1
(Whitestone,
Feb. 1956)
Myron Fass
takes charge.

This page:
Fass' self
portrait from
the contents
page of
Lunatickle #1

THE BIRTH OF THE LOONY BIRD

In the editor's desk drawer, an outlandish egg begins to shake . . . rattle . . . and roll. . . ! Suddenly, with a thunderous roar, the shell crumbles. . .

. . . and a squawking, demoniac bird emerges! He was chosen as Lunatickle's mascot . . . for the intelligent gaze shining out of his dotted eyes. . .

. . . and his great flight instinct! His ability to zoom fantastic heights of *two big inches* into the air, and come down to perfect three-point landings.

He was chosen for his talented mimicry and stupendous sense of showmanship. "I'm little Caesar, see! Ya wanna make somethin' outta it. . . ?"

Loony doesn't stop with impersonations . . . he's also Loony the Shakespearean scholar! "I'm little Caesar, see! Wanna make somethin' outta it?"

His repertoire also includes graceful acrobatics and modern dances, so thrilling to behold and nearly excelling his conquest of flight. . . !

Because of his intellect and wisdom; his cautious investment of money; Loony is able to bring you the finest talent available from the insane asylums.

Watch for Loony, on the covers of the future Lunatickles! He's your only insurance against copycats, imitators and mainly, inferior competitors!

Loony must forcibly leave you now! But, don't worry! He'll figure a way to elude his keepers—Loony's also an escape artist and magician!

Nanu: "Opps! You've caught me a little off base, boys, but come on in! Have a nice tasty stick of Sneers Bubble Gum! You don't mind if I keep dressing?" Preacher: "Duh. . . Duh. . . Duh. . . Duh. . . Ulp, Nanu! But I never chew nuthin' but Beachy!"

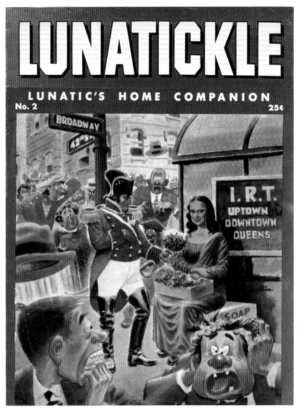

one-page story "The Birth of the Loony Bird," which reveals the origins of *Lunatickle*'s mascot, an emotionally challenged avian. One panel warns of buying inferior imitators' magazines and the titles in the drawing are all riffs on *MAD*... Med, Mid, Sad, etc, and even has *MAD* #11 (EC, May 1954) pictured with "Mud" pasted over the real logo, with Basil Wolverton's cover art intact!

With *Lunatickle* #2, Myron Fass handed the editorial reins over to pulp writer and artist Joe Archibald, but the contents remain pretty much the same. Bob Powell came aboard with some typically excellent artwork. The real standout in this issue is a 10-page "exposé" entitled "The Horrible Comic Story Behind the Horror Story Comic Books," written by Jack Mendelsohn and illustrated by Lee Elias.

Opposite:
The birth of the loony bird—Fass' troubled avian warns against "cheep" imitations.

This page left:
Serving up the sex appeal, Fass style

This page right:
Lunatickle #2 (Whitestone, April 1956)

23

The first issue hits the newsstands and amazed citizens get their first glimpse at its lurid, shocking, reeking pages. Being normal human beings, they are knocked off their pins. They can't BE-LIEVE it, won't believe it! They stare, goggle-eyed! Enraptured!

But as we said, they are normal human beings, so they rush the stand and buy it like crazy! Before you can do a take, the whole supply of Grisly's new comic is sold out! . . . The news spreads far!

The success of Sam Grisly's Horrow Comics is firmly established, and George Frankenstein and his staff are over-joyed. Sam begins making more trips to the bank than Liberace. Money pours in as the gore runs out.

Other comic book publishers grumble over Grisly's success, and declare that such a book will have a bad affect on the youth of America. . . . They also grumble because they want some of the profits. They begin to grumble even more , . . and MORE!

But mostly they grumble because they didn't think of it first! Soon their own presses are humming with other startling variations on the horror theme. They work day and night to out-horror Sam Grisly's comic book and send the kiddies off their little rockers, the hoot-owls out of their trees. Br-r-r-r! Glop!

Almost overnight, the stands are glutted with hair-raising horror books, as the publishers convert even long-established titles to fit the new trend towards bloodshed, gore, and dismembered bodies. Timid souls gagged! . . . Legitimate monsters picketed!

It tells the story of ECCH Publications, its publisher Samuel Grisly and the rise and fall of horror comics prior to the Comics Code. Yes, Sam Grisly looks a bit like Bill Gaines and do I really have to explain what ECCH Pubs are supposed to be? The strip is pretty funny and the bit about ECCH's rival publishers glutting the newsstands with copycat material is more than just a little bit ironic, especially in hindsight.

While *Lunatickle* proved to be a short-lived venture, its publication fanned the flames of Myron Fass' newfound interest in magazines. He took his knowledge and some tricks of the trade from Whitestone and, under the aegis of True Problems Publications, put together his next magazine, *Ogle*. The first issue (March 1956) is part cheesecake and part *MAD*

magazine, with sexy girls and twisted humor. Inspired by Whitestone's humor magazines *Cockeyed* and *Cuckoo*, *Ogle*'s stock in trade was photo manipulation and cut-and-paste, well before the age of Photoshop.

The first issue, with a two-headed Jayne Mansfield (who was a friend of Myron's) on the cover, has a flat-chested Jane Russell and a pictorial with Myron Fass' floating head peeping at Chita Rivera. The X-Acto knives were working overtime. Besides these (and more) photo pieces, the magazine was supplemented with cartoons and some risqué fiction. Most interesting of all is the back cover: an unflattering caricature of Fass, "Our Editor"—fat, unshaven and

Opposite: "The Horrible Comic Story Behind the Horror Story Comic Books" by Jack Mendelsohn and Lee Elias.

This page left: Fass' friend Jayne Mansfield graces *Ogle* V1 #1 (Mar 1956)

This page right: Myron Fass takes a ride in his underwear on the cover of *Ogle* V1 #2 (July 1957, still published by "True Problems Publications")

This page: Pictures from the article "Our Editor at Work"… Fass ogles Chita Rivera in the first issue of **Ogle**, much to her dismay.

wearing a wifebeater, but with an angelic halo above his head.

Presumably started before *Ogle* (hence that magazine's publishing name), *True Problems* V1 #1 hit the street with a June 1956 cover date. Taking a cue from EC's newly minted Picto-Fiction line (*Shock Illustrated*, *Crime Illustrated*, *Terror Illustrated* and most notably, *Confessions Illustrated*), *True Problems* featured adult-themed text stories, illustrated with panels of excellent pen, ink and wash drawings. A.C. Hollingsworth, a pre-code horror veteran, handled the art on one story and it appears that Myron Fass himself (who was also the editor) provided the illos for

OUR EDITOR suitable for framing

Top left: Portrait of an Editor—the back cover of *Ogle*'s debut issue. The artist's signature says "Perfect"

Top right: ***True Problems*** V1 #1 (June 1956) Cover art by Leon Baker

Bottom: Fass looking rather dapper in his photo on the contents page of ***True Problems***

the first story "I Hated My In-Laws." The cover announced that these sordid tales of real-life drama were "New! Told in Illustories." Despite the novel idea, EC's Picto-Fiction line was a failure, so it comes as no surprise that Myron Fass' Picto-clone also failed to find an audience. Only one issue was published.

Over the next few years, Fass was also editing *Foto-Rama*, an established, digest-sized magazine featuring pinup girls and sometimes gritty, always exploitable news stories. It was published from the same editorial address as *Ogle* and *True Problems* (225 Varrick Street, New York) and its business manager was one William Harris, a man who

would be a large part of Myron's future. "Full of panties [and] crotch shots," Fass reflected nostalgically to Marc Jacobson in 1978. Pictures of posing pulchritude and stories of scandalous sensationalism would be this title's stock in trade for many years to come. If sleaze was going to sell, then that's exactly what Fass was going to put on the plate. He

VOL. 1 NO. 1 JUNE 1956

| MYRON FASS | PAT KAHN | HARRY MATETSKY | FRANCES RUBIN |
| Editor | Assoc. Editor | Art Director | Production |

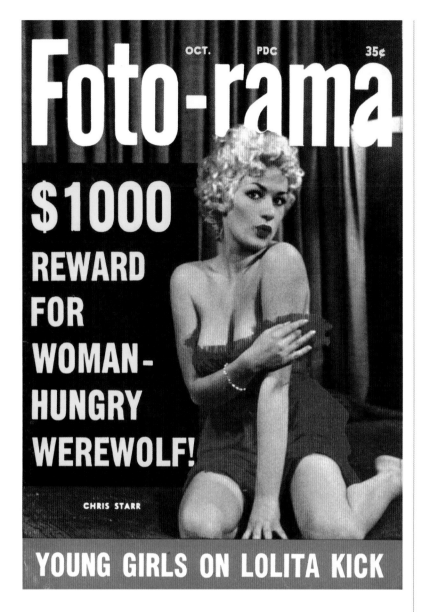

Foto-rama

OCT. PDC 35¢

$1000
REWARD
FOR
WOMAN-
HUNGRY
WEREWOLF!

CHRIS STARR

YOUNG GIRLS ON LOLITA KICK

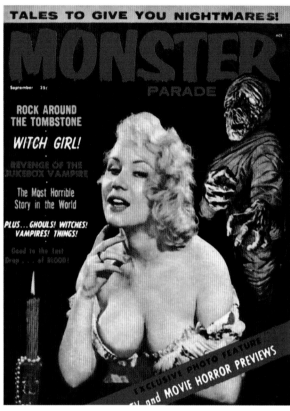

TALES TO GIVE YOU NIGHTMARES!

MONSTER
PARADE

ROCK AROUND
THE TOMBSTONE

WITCH GIRL!

REVENGE OF THE
JUKEBOX VAMPIRE

The Most Horrible
Story in the World

PLUS... GHOULS! WITCHES!
VAMPIRES! THINGS!

Good to the Last
Drop ... of BLOOD!

EXCLUSIVE PHOTO FEATURE
TV and MOVIE HORROR PREVIEWS

Left:
Foto-rama
V6 #8
(Oct. 1959)

Right:
***Monster
Parade*** V2 #6
[#1] (Magnum,
Sept. 1958)
Just because…

often dished up weird features on monsters and horror films in *Foto-Rama*, proving that he was a fan of the genre.

Fass' next voyage into the stormy sea of publishing was in 1958, with two issues' worth of "Factual Stories of the Impossible" in *True or False*. This full-sized magazine featured the sensational stories of *Foto-Rama* without the scantily clad vixens. Spies, UFOs, miracles, insane adventures and H-Bomb babies… nothing was too bizarre for these two mags.

They were the first to be published by Modern Day Periodicals (at 342 Madison Avenue in New York). In what would soon be typical Fass fashion, the cover of the premier issue (V1 #1, April 1958) presents us with a bloody bear attack, with the blood of the victim clearly drawn in with red pen. Blatantly lying, the blurb across the bottom edge proclaims "This cover is an actual unretouched photograph!" Though it lasted only two issues, *True or False* was the precursor to a genre of magazines that would be very successful for Myron Fass throughout his career.

When James Warren unleashed *Famous Monsters of Filmland* (*FM*) into the world in 1957 and monsters were back in vogue, Myron Fass wasn't the only entrepreneur taking notice. Magsyn Publications struck early in

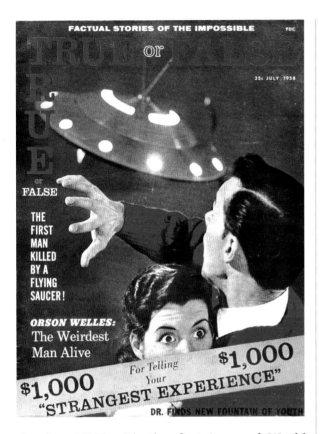

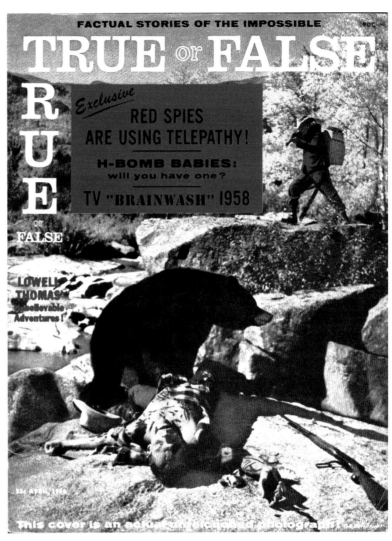

October 1958 with the first issue of *World Famous Creatures* and Magnum countered with the unforgettable *Monster Parade* #1 in Sept. 1958. While Magsyn's debut was more of a direct *FM* rip, *Monster Parade*'s contents were slightly more adult in content, with short fiction dominating the page count. This approach appealed to Fass' sense of sleaze, apparently, and his re-entry into the horror field came in 1959.

With a January 1959 cover date, *Shock Tales* sullied the magazine racks in the winter of 1958. Published by Myron's own M.F. Publications, this mag was meant to thrill and titillate and maybe, just maybe, make you sick. It's mostly illustrated with "special photography" by Don Snyder—photos of half-dressed models in peril, being threatened

by monsters, and covered with blood. It's probable that many of the menacing monsters and the voluptuous victims were portrayed by M.F. employees.

Other than a two-page article on the makeup for the film *The Black Sleep*, there's no *FM*-style features in *Shock Tales*. Photos from Hammer's *Horror of Dracula* (1958) illustrate one non-fiction piece about protecting oneself from vampires, and there are a couple of nice illustrations elsewhere, which might be the work of Bob Powell. The inside front cover has a letter to the readers

Left: ***True or False***, published by Fass under the Modern Day Periodicals banner.

Right: ***True or False*** V1 #1 (April 1958) and (Left) V1 #2 (July 1958). The very last Eerie Publications, over two decades later, would also be published under the Modern Day imprint.

I watched helplessly as the werewolf tore clothes from her bleeding body.

The Rapist Werewolf

Strong stuff for 1959, this snippet of prose from "The Rapist Werewolf" in SHOCK TALES #1 is a gruesome foreshadowing for the bloodletting and horror that would stain the pages of the Eerie Pubs a decade later. The story is attributed to Geoffrey Dickens, no doubt a distant relation to Charles. I resisted the urge to edit the piece.

"His naked torso had been shredded into a bloody jelly. From it the white rib bones protruded brokenly like white bars of a cage that had been spread to permit the escape of the tortured soul within. The slashes on his face and limb were deep, ugly, as though they might have been inflicted by a native's machete of the type used for hacking sugar cane. But I knew the autopsy would reveal no clean blade cuts, only jagged tears made by the claws and fangs of the inhuman murderer. And there were the other unmistakable signs- the partially devoured bowels and the missing genitals.

Then a bloody bubble grew on those torn lips and burst. He was still alive."

from Fass, daring us to read the "strong, well muscled and full blooded" horror stories and even has a faux Fass signature. The stories have all received the "Shock Award for Horror." This is the only issue of *Shock Tales* to be produced, but it's a doozy and it's a highly sought-after item by collectors of weird magazines. Horror-wise, Fass was off to an auspicious start.

Early 1959 brought the comic world two of the rarest and least seen horror books ever published. They were black-and-white, code-free horror comics that were published a full five years before Jim Warren unleashed *Creepy*, which is often lauded as the first comic of its kind. These magazines have been shrouded in mystery ever since they hit the streets that year and differing opinions have

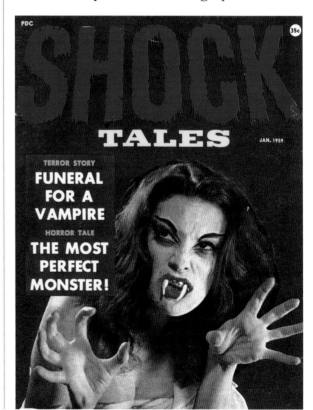

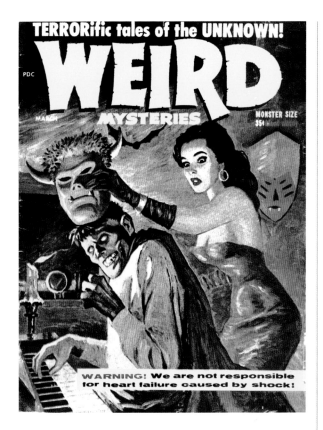

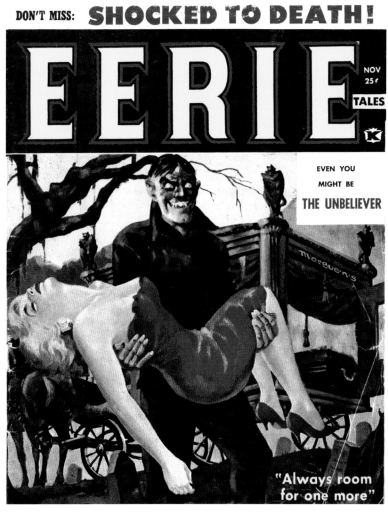

been formed about their origins. Of course, it's all speculation.

The magazines in question are *Weird Mysteries* Vol. 1 #1, dated March-April 1959, and *Eerie Tales* Vol. 1 #1, dated November of the same year. *Weird Mysteries* was published by Pastimes Publications of Holyoke, Massachusetts, while *Eerie Tales* was produced by Hastings Associates in New York. Both of these magazines were definitely put together by the same crew; both utilized many of the same artists and both featured a bona fide horror host named Morgue'n, a wisecrackin' storyteller with a penchant for puns. No real credits were given; *Eerie Tales* claimed to be edited by Basil Darkerton with help from associate Vanessa Vampira.

In the fanzine *Alter Ego* (TwoMorrows),

Michael T. Gilbert used two issues (#31–Dec. 2003 and #32–Jan. 2004) worth of his column space to analyze these two mystery mags. In his overview, he identifies many of the artists and looked into just who it was that might have put these two magazines out. Comic historian Mike Feldman offers up the name Robert Sproul, who was concurrently starting up the *MAD* clone *Cracked*, and his argument is sound. I would also like to speculate on the possibility that our boy Myron Fass might have been involved in some way. Certainly Carl Burgos was.

Opposite: ***Shock Tales*** V1 #1 (Jan. 1959) Myron Fass' return to straight horror

This page left: ***Weird Mysteries*** #1 (Pastime, Mar. Apr. 1959) art by George Tuska

This page right: ***Eerie Tales*** V1 #1 (Hastings Associates, Nov. 1959) art possibly by Bob Powell

WELCOME, DEAR FIENDS--I AM MORGUE'N, YOUR MONSTER OF CEREMOANIES!

As you can see, I am currently entertaining some shocking friends, each and every one of them a live wire. Ah, yes— — there's good noose — — because there's gunna be a hot time in the cold parlor tonight. So hang around. Badder yet, pull up a slightly chilled marble slab, but don't come too near to the electrodes or you'll make an ash of yourself. — —While we're waiting for the boys to warm things up, I'll spin a few yarns for you. Nothing too trivial of corpse, because we mustn't spoil your appetite for the Hungarian Ghoulish we plan to serve later.

And—please forgive me for not rising for I'm beheaded in the other direction and I want to live it down a little.—So, may I offer a toast—which is slightly burned—and which is—ME!

This page: Morgue'n, your Monster of Ceremoanies in **Weird Mysteries** and **Eerie Tales**. Art by Carl Burgos.

First, and most importantly, most of the stories that were presented in both of these magazines were borrowed from pre-code horror stories, most notably from EC. Of course, a decade later, Eerie Pubs would be practicing that same nefarious deed (though they'd steer clear of EC stories). Some of the strips were written by melding two pre-code stories together, some were flat-out steals. There was very little original storytelling going on in these two publications. Most of the stories identified in the two mags were originally written by Carl Wessler so it is probable that he was involved, handling his own rewrites.

Secondly, there is evidence of hasty pasteups, and the scent of mucilage and X-acto knives hangs heavily over these comics. One story is stretched out from five pages to six and there are plenty of instances of bizarrely placed text and titles.

Sketchy production values aside, these mags are packed to the gills with tremendous art. A bevy of pre-code artists turned up to fill these books with top-notch horror art. Among the luminaries were EC's Angelo Torres, Al Williamson, and Joe Orlando, plus Paul Reinman, George Tuska and two future Eerie Publications players, Bob Powell and Pubs main man Carl Burgos, who created the host Morgue'n and surely edited the mags as well. These artists had obviously been missing the horror genre and they delivered some outstanding graphics.

The address inside *Weird Mysteries*, Holyoke, Mass, was a fairly common mailing location at the time, and had cheap printing facilities (Holyoke Magazine Press); dozens of crime pulps sported the same "publishing" address. *Weird Mysteries* was distributed by PCD, the same distributor as *Shock Tales*, while *Eerie Tales* was distributed by Kable, who would handle *Ogle* a few months later.

Proof? No, but it's a possibility that Myron Fass had his thumb in the pie of the first code-free horror comics. At any rate, Carl Burgos was definitely all over these magazines and many of the ideas presented

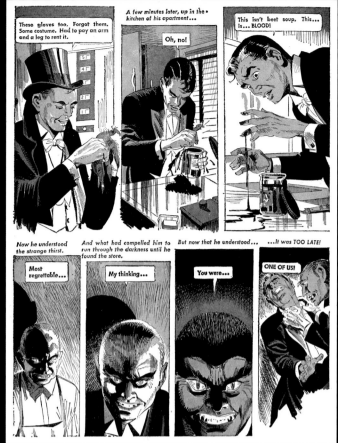

Recycled Soup

Appearing in Toby's *Tales of Horror* #6 (August 1953), the story "Special on Beet Soup" (with art by Mel Keefer) was a neat little horror tale with a fun twist ending. Apparently I'm not the only one to ever think that.

The weird and mysterious *Weird Mysteries* #1 updated the story in beautiful black and white as "Strange Thirst" in 1959, drawn by Atlas star Paul Reinman. This placed the Toby tale in heady company alongside rips of strips from EC and Atlas.

The Eerie Pubs went right back to the soupy source with a redraw by Fernand called "Horror with Fangs," which made its first Pubs appearance in late 1974.

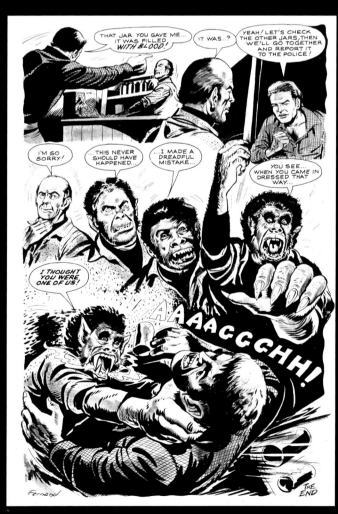

SUSPENSE

Don't Miss—
9:30 APPOINTMENT
FOR **MR. HYDE**

PDC SEPT. 35¢

BIG, EXCITING CONTEST!
CAN YOU SPEND A NIGHT IN A... *HAUNTED HOUSE?*

Opposite: **Suspense** V1 #4 (Sept. 1959) Brother Irving
joins the gang as the cover ghoul

Above: Myron, just hangin' around, in a picture from **Suspense** #4

in them were again used years later in his Eerie Publications mags.

Fass finished out the decade with another photo-illustrated horror fiction mag entitled *Suspense* (September 1959). Although it's numbered Volume 1 #4, this is the only issue that saw print. Even though it's published by Suspense Publications Inc. (at the Madison Avenue address) and no Fasses are named on the contents page, it's clearly the work of the M.F. Publications crew, right down to a shot of a Myron ghoul menacing a model on page 28 and the cover brute being portrayed by his brother Irving.

With the '60s on their way, Fass was stepping up to become a real player in the publishing game. ✳

Fuel For the Fire

In late 1958 and early 1959, Carl Burgos was editing the *MAD* knockoff *Zany* for Candor Publishing. The first issue of *Zany* shares a publishing address (218 W. 48th, New York) with Major Magazines, who had just started up *Cracked*. In the three subsequent issues, the address changes to the Holyoke, MA location while the executive offices remain at West 48th Street.

In the horror comic *Gore Shriek* #5 (Fantaco, 1988), editor Archie Goodwin reminisces about his days with Warren Publishing. When discussing the birth of *Eerie*, sister publication to *Creepy*, he mentions the magazine *Eerie Tales* (as "Eerie") and how the rights to the name had lapsed, making the title fair game for Warren. Of course, Myron Fass was another interested party, planning to publish his own *EERIE*. Did Fass think he had first dibs on the name because of his involvement in Eerie Tales? The battle between Warren and Fass is examined in Chapter 5.

Weird Mysteries and *Eerie Tales* are most likely both edited by Burgos. He created and drew Morgue'n, the host, he illustrated the text pieces and the layout of WM looks very similar to his work in Zany. The *Eerie Tales* contents page is pure Burgos, with puns and hyperbole. A fair guess would be that he put both mags together but, with bad sales and no backing, the second issue of *WM* was aborted. Looking for backing to get out what was already put together, Burgos might have come into contact with Fass.

Like trying to find "Paul is dead" clues on Beatles albums, one can find many things to support any given theory. The credits in both *Eerie Tales* and Fass' *Shock Tales* have a male editor (Basil Darkerton/Fass), a female associate (Vanessa Vampira/Pat Kahn), an art/photography credit and a production credit.

Weird Mysteries is numbered only #1, whereas *Eerie Tales* is Vol. 1 #1; Fass was fond of volume numbers.

Could the two horror comics be the numerical link between *Shock Tales* V1 #1 and *Suspense* V1 #4? Obsessive and unhinged minds need to know!

THRILLER

FEB. 35c

SHOCKER:
THE VAMPIRE
WAS A SUCKER!

HER
BLOOD
RAN
HOT!

THE GIRL AND THE MONSTER!

PRE-PUB-ESSENCE

MYRON FASS went roaring into the '60s with magazines on the mind. *Ogle* continued its run, with humor, sexy gals and fiction. Never one to waste, Fass peppered *Ogle* with some of the leftover staged horror shots from *Shock Tales*, this time with humorous captions. His caricature from the debut issue also continued to get a lot of play.

The *Shock Tales* and *Suspense* approach was back again in early 1962 with a three-issue run of *Thriller* under Fass' Tempest Publications imprint. *Thriller* was again full of titillating terror tales and staged horror shots of pulchritudinous peril. Fass himself was the cover ghoul on issue #1, and his brother Irving, the art director, donned the makeup for a few more sinister appearances as well. *Shock Tales'* cover vampirette got another shot at the big time with the cover of *Thriller* #2, using a great picture taken four years earlier at the same photo session. Most of the features in *Thriller* were reprinted from the two 1959 magazines.

Fass had taken over the publishing reins of

Opposite: ***Thriller*** V1 #1 (Feb. 1962) Myron Fass puts himself on another cover

This page: The crew as seen in ***Thriller*** V1 #2; Myron Fass, Irving Fass and maybe Mel Lenny

Left:
Thriller V1 #3
(July 1962) Can
you stand the
unbridled horror
of "Werewolves
are Furry"?!

Right:
Thriller V1 #2
(May 1962)

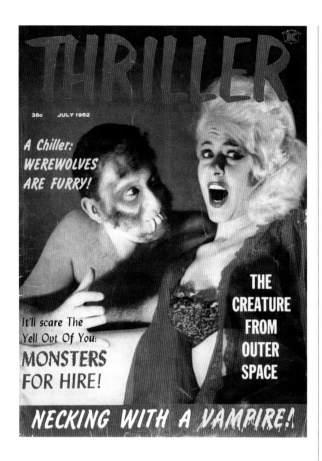

Foto-Rama in 1960 and is listed as the owner of Arena Publishing in the February 1960 issue's statement of ownership. He continued to produce this and *Photo Life*, another fine pinup-and-scandal digest, occasionally using pseudonyms like Norym Shaf and Ron Mass. He also still provided spot illustrations and cartoons on occasion. Not surprisingly, the staged monster shots were used again in these magazines. Waste not, want not.

The early '60s were a whirlwind of activity for Myron Fass. He'd become adept at churning out magazines quickly, effectively, and profitably. With backing from William Harris (of the Harris Press family, a printing press that revolutionized the industry and is still in use), he stepped up his production by

leaps and bounds. Harris had been impressed with Fass' work over at Arena Publishing and both he and his newly graduated son Stanley would act as Myron's business manager on various magazines.

The John F. Kennedy assassination was a tragic event that proved to be a big seller for them. Under their own Country Wide Publications, they rushed out a few one-shot pulps commemorating the president and his family. These memorial mags were huge sellers and would bankroll upcoming projects. More one-shots and new titles were quick to follow. A plethora of TV and movie gossip rags featured the widowed first lady on the cover, cashing in on the tragedy in Camelot and her struggle for happiness in the years after.

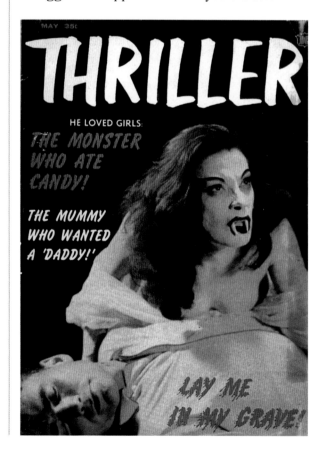

In 1964, when the Dave Clark Five ousted the Beatles from the number one spot on the British music charts, there were rumblings about the DC5 taking over the pop world and replacing the Fab Four at the top of the heap. That was good enough for Fass to rush out two *Dave Clark vs. the Beatles* magazines, exploiting the vicious battle between the two bands, whether one really existed or not. Screaming headlines and hyperbole grabbed the reader's attention and that's what counted. Fass had discovered a formula and would make it work for decades to come.

1964 also saw the introduction of *Quick*, a magazine full of pinups and manly sensationalism, topics that had proved successful before. *Pic* was added to the stable of sexy digest-sized magazines. This year

was also the beginning of Country Wide's long-running tabloid newspaper *National Mirror*, which was more of the same, with shocking headlines, unbelievable stories and sleazy pictures. One of its writers in 1968, Al Goldstein (who admits to having made up his stories on the spot), would go on to infamy as the publisher of the sex paper *Screw*.

Perhaps the company's most important introduction in 1964 was the debut issue of *Jaguar* (Dec. 1964) under its own imprint. It was Fass' knockoff of the incredibly popular girly mag *Playboy*. Its format was a carbon copy of its inspiration—articles for men, cartoons, fiction and topless females, including a centerfold. The first issue of *Jaguar* gave the reader a bonus (I said BONUS!) with two cuties on the centerfold. Fass' audacity flared

Left:
Dave Clark 5
vs. the Beatles!
Who will win?
Popular Annual
V1 #1 (Sept 1964)

Right:
Quick V1 #2
(April 1965)
The poor dear…
her eyes are
crossed!

39

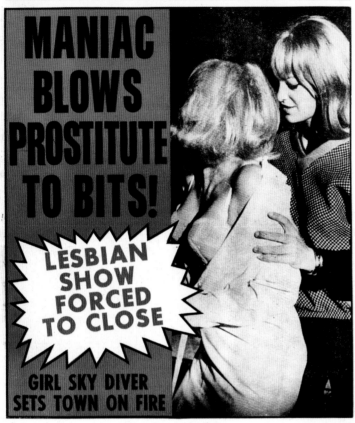

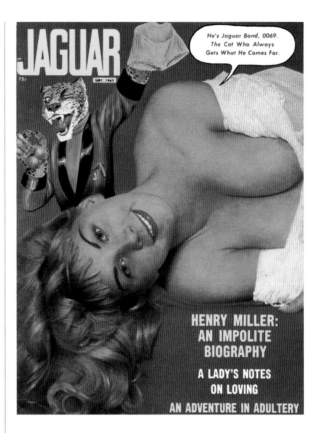

Playboy Party Jokes Page's femlin. Powell's Jaguar Bond character also appeared on the covers, interacting with the models.

1965 was a real boom year for the growing Fass empire, now condensed to Countrywide. With a few successes under his belt, and a solid foundation, thanks to Harris, Fass started up many new magazine ventures, often utilizing the same staff. A pair of *16 Magazine*-inspired teen mags, *Teen Circle* and *Teen Trends*, hit the stands in late 1965, with much of the same crew as their girly mags: Irving Fass as art director, Alex Sanchez and Perry Raso as art assistants and the ever-present Mel Lenny as an advertising representative. Irving and Mel Lenny (sometimes as Melvin Lenowitz) had been on the team for years already, and would stick around to the bitter end. His comrades

Left:
National Mirror V3 #7 (Aug. 9th, 1966)

Right:
Bob Powell's Jaguar Bond has a successful panty raid on the cover of ***Jaguar*** V1 #5 (Sept. 1965)

up once again on the back cover of this debut issue, with a *"Jaguar* vs. *Playboy"* challenge, which would be settled in the next issue. *Jaguar* V1 #2 (Feb. 1965) makes no mention of it whatsoever.

Jaguar V1 #3 (April 1965) is of interest to Eerie Pubs fans, as it's the first issue to carry artwork by Bob Powell. Along with some lovely full-page painted cartoons, he contributes a four-page "Jaguar Bond" comic strip, *Jaguar*'s answer to "Little Annie Fannie" from *Playboy*, with a James Bond-esque, big, horny cat scoring with the chicks and saving the world. One of the females our fearless feline frolics with looks suspiciously like the

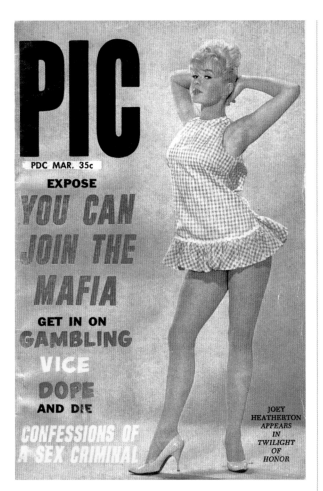

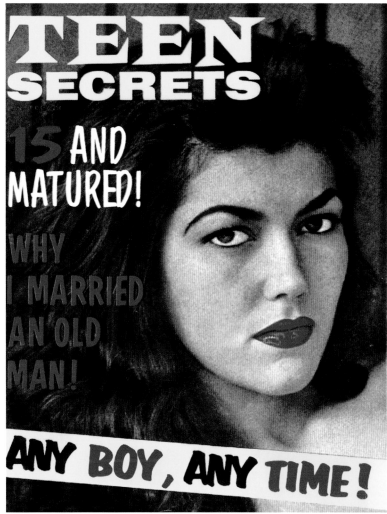

in part to Marvel Comics' reinvention of the superhero genre with the very successful pair *Fantastic Four* and *Amazing Spider-Man*. The time was ripe to launch a few new projects.

When James Warren had breathed life back into real horror comics in 1964 with the successful publication of *Creepy*, Myron Fass was among the first to take notice. Being the fast mover that he was, not to mention an obvious fan of the genre, Myron quickly set the wheels into motion.

How about a non-code black-and-white horror comic magazine called EERIE? ☀

would come into work Monday morning and encounter a floor littered with tiny red plastic things; Fass, a gun enthusiast, would take target practice with his pellet gun in the office over weekends. It helped him to think.

TV and movie magazines, scandal rags, teen magazines, girly mags… anything that would turn a profit was considered, and brought to fruition. Other publishers had tested the market with various magazine genres and the good folks at Countrywide, under their many different imprint names, were quick to pounce on a successful idea. Comic books, Myron Fass' first success, were again extremely popular in the mid-'60s, due

Left : Everybody's father's favorite hottie, Joey Heatherton on the cover of *Pic* Vol. 1 #2 (Mar. 1964)

Right : *Teen Secrets* Vol. 1 #7 (Jan. 1960) Fass' wholesome teen mag complete with ads for handguns and "French lift" bras!

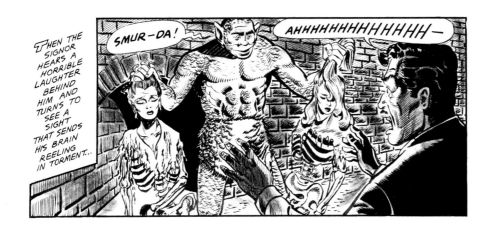

Chapter 5

BRING ON THE PUBS

JAMES WARREN had been considering producing another horror comic as early as *Creepy* #2 (April 1965). Returns had been good and it looked like the market would support a companion magazine. The name EERIE had been chosen and before long the spinoff was being advertised in the December 1965 issues of *Creepy* (#6) and *Famous Monsters of Filmland* as something for the fans to watch for.

Myron Fass, along with his business partner, Stanley R. Harris, son of Countrywide's benefactor, and their publishing partner for this venture, Robert W. Farrell, were thinking the same thing: a horror comic called EERIE. If it was in fact Fass (or Farrell?) that had put

out *Eerie Tales* six years prior, that would have been reason enough to make him think that they should get first crack at the name. At any rate, word got around that they harbored a similar idea to Warren's. Fass would be running reprints provided by Farrell's huge inventory of his pre-code horror stories, so production costs would be low; the artwork was all ready to go, having been drawn over a decade earlier. The all-new contents of Warren's proposed EERIE #1 were not yet finished. There was a definite difference of opinion about who was going to get to use the name.

Both sides were being distributed by the Publishers Distributing Corporation. Fass had been pushing more product and as a result was

Opposite: The beginning of an Eerie Era—***Weird*** V1 #10 (Jan. 1966), cover art by Burgos

This page: From the Ajax/Farrell masterpiece "Fiends from the Crypt"

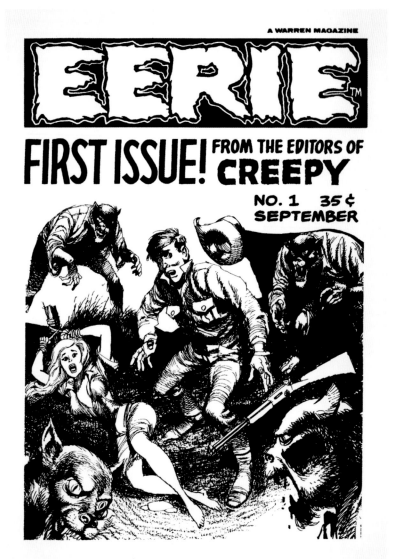

A WARREN MAGAZINE

EERIE ™

FIRST ISSUE! FROM THE EDITORS OF CREEPY

NO. 1 35¢
SEPTEMBER

Eerie #1, Warren's overnight sensation (Warren Publications, 1965)

horror stories, putting their existing EERIE logo across the top of the cover. They used stories and artwork that were already in the office, intended for the next issue of *Creepy* as well as some reprint material. As legend has it, couriers were standing by as they printed up 200 copies overnight and rushed them to newsstands in four different states, as well as to the U.S. Copyright Office in Washington.

On the way into the meeting the next morning, Warren got the newsstand outside of the distributor's building to display a few copies for sale. He walked into the meeting, handed a few copies to Fass, one to the distributor and mentioned that the book was already on sale, including at the stand right outside. Warren's tireless work had paid off and Myron Fass had to acquiesce; the name EERIE was awarded to Warren. Fass would settle for *Weird* (which incidentally was half of the name of that other unsuccessful mag of 1959, *Weird Mysteries*). In what was surely an act of spite, Eerie Publications was the name chosen for the new publishing imprint.

Fass had his usual assemblage of staff for this new venture, though there were some notable additions. Robert Farrell was listed as the publisher, and the artwork from his vaults provided most of the content for *Weird*'s premier issue. Farrell had published his own magazines in the late '50s and early '60s, and had resurfaced in 1965, putting out reprints of his humor mag *Panic*. The resurrected

probably seen as a better client, so it looked as though Warren was going to be shit out of luck; the distributors called the shots. A meeting was set up between PDC, Countrywide, and Warren to settle the argument. Essentially, whoever produced the first issue got to keep the name EERIE. Warren had to come up with a plan overnight.

Warren locked himself, editor Archie Goodwin and letterer Gaspar Saladino into the Warren offices and cobbled together a small, digest-sized "ashcan" issue of three

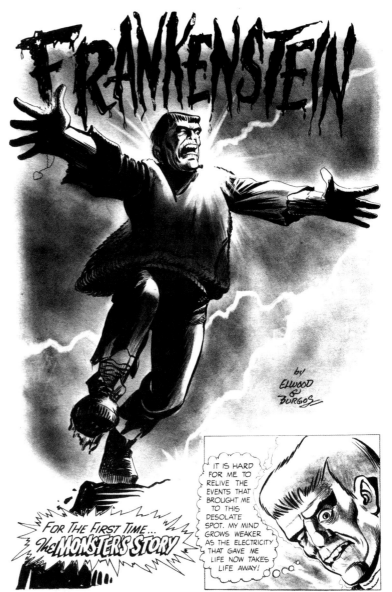

Panic was staffed by the Countrywide stable and being edited by veteran Carl Burgos, one of the artists featured among the humor reprints. The new horror comic would be published from Farrell's address.

Burgos was on board as *Weird*'s editor, and also provided the artwork for the title's first story, an eight-page retelling of "Frankenstein." Roger Elwood, that story's author, was listed as the magazine's associate editor. Familiar names, including brother Irving, rounded out the credits. Burgos and Elwood were concurrently creating the unforgettable new *Captain Marvel* comic for Fass. (See Appendix 1: What's In a Name? The Sordid History of Captain Marvel)

It looks like Warren wasn't the only one rushing to meet the deadline to capture the name "Eerie." *Weird*'s debut (numbered V1 #10, Jan. 1966) features a cover that appears to be unfinished. The cover art, attributed to

Left:
Carl Burgos in the early '50s (photo courtesy of Susan Burgos)

Right: Splash panel for Elwood and Burgos's "Frankenstein" in ***Weird*** V1 #10 (Jan. 1966), the only writing credit that would ever appear in an Eerie Publication

'NEW' THAT DARE PROBE UNKNOWN HORRORS!....

This page left: Close-up of the blacked-out "magazines" in the first issue of *Weird*

This page right: Morris, as seen in *Panic* V2 #11 (Feb. 1966)

HELLO, OUT THERE, ALL YOU GORGEOUS GHOULS! I'M MORRIS, THE CARETAKER OF WEIRD THAT BEASTLY BUNDLE OF BLOODY HORRORS CONCOCTED TO SCARE YOU OUT OF A YEAR'S GROWTH! MY WORLD IS A GHOSTLY ONE OF VAMPIRES, WEREWOLVES ZOMBIES AND OTHER ASSORTED MONSTERS! I DUG THEM UP (PIECE BY PIECE) FROM LOTS OF EERIE PLACES

Burgos, clearly shows unerased pencil lines, loosely inked over and highlighted with watercolor paints—definitely a rush job. Still, the big, blood-red splash-glob of text on the left side of the cover, soon to be an Eerie Pubs trademark, was very eye-catching, as was the yellow and purple logo. The headlines screamed of great things inside, and they even had the balls to say "featuring the most FAMOUS MONSTERS in the world."

The frontispiece for this first issue is where we meet Morris the Caretaker, *Weird*'s unofficial horror host, as drawn by Burgos. Tall and skinny, like *Creepy*'s namesake Uncle, this is his only appearance in the issue. More interesting is what he's hawking. This is a full-page ad for Eerie Pubs magazines that never came to fruition. A banner across the bottom of the page says "SUSPENSE and SHOCK" (incidentally, two titles used by Fass in the '50s), "new magazines that dare probe unknown horrors… on sale soon at your newsstand"… except that the word "magazines," though still readable, has been blacked out. This house ad is the only advertisement in the issue.

The contents page, with another fine Burgos illustration, started the Eerie ball rolling with a short, lively synopsis for each story. As sensational as headlines from a scandal mag, these blurbs were sometimes inaccurate, but always dramatic and fun. They too would become an Eerie Pubs tradition.

Alongside Burgos and Elwood's "Franken-stein" story, the first *Weird* reprinted seven pre-code horror stories that originated in Farrell's Ajax-Farrell comics. Drawn in the early '50s by the Iger Shop, they all had a similar, static style of artwork, slightly dated by the mid-'60s, but still crazy and exciting. In some panels, a few extra drops of blood were added to the original art to make it a bit more

gruesome. The last story not only went on to the inside back cover, but on to the back cover itself. This was another Eerie Pubs trademark in the making.

While the proposed "Shock" and "Suspense" titles that Morris was so keen to tell us about never materialized, *Weird* was raring to roll on. The only thing Eerie Publications needed to produce more issues would be covers, as they had hundreds of old Ajax-Farrell stories to reprint. Golden Age comic icon Bob Powell had been part of the gang for a while, doing cartoons and the Jaguar Bond strip for *Jaguar*, and was also writing and drawing the *Henry Brewster* comic for Fass. (See Appendix 2: Henry Brewster) A pre-code horror master, Powell was no stranger to the genre. Though paintings weren't what he was known for, Powell did paint a few covers, and with very good results. His cover of *Weird* V1 #12 (Oct. 1966) is one of the best remembered images from the whole Eerie Pubs line and was reprinted twice with very few changes. If I were calling the shots back then, I'd have had Powell's Franken-babe supplant Morris as the mouthpiece of *Weird*.

Morris the Caretaker appeared over the next few issues, though he remained nameless. He introduced single-page collages of strange beliefs, ghoulish facts and superstitions, adding the mandatory puns and quips. The charcoal-and-ink art style of these fillers reminds one of the Ripley's "Believe It Or Not" strips, which

Numbering

For reasons unknown, the Countrywide gang rarely began the numbering of their publications with #1. Perhaps they were thinking like Standard Comics did back in the pre-code '50s. Standard started the numbering of their comics with #5 to make it appear as if the comic was a tried and true title, well established with five issues. That way, it would have appeared more worthy of shelf space to a merchant stocking an overloaded comic book rack.

At any rate, Fass' '60s publications often started with Volume 1 Number 10. Eerie Pubs' *Weird* and *Tales From the Crypt* did this, as did the first issue of the Western mag *Great West* (April 1967) and both of the Countrywide true crime magazines premier issues, *Crime Does Not Pay* (Jan. Feb. 1968) and *Crime and Punishment* (Dec. 1968). The first *Tales of Voodoo* (Nov. 1968) continued the *Crypt* numbering with Volume 1 #11. Subsequent horror titles would start their numbering with Volume 1 #6 or #7. Oddly enough, Fass' girly mags of the same period, *Jaguar* and its companion magazines *Duke* and *Poorboy*, did not follow this stratagem; they started with Volume 1 #1. Go figger...

It's all just part of the charm, and frustration, of collecting Eerie Pubs.

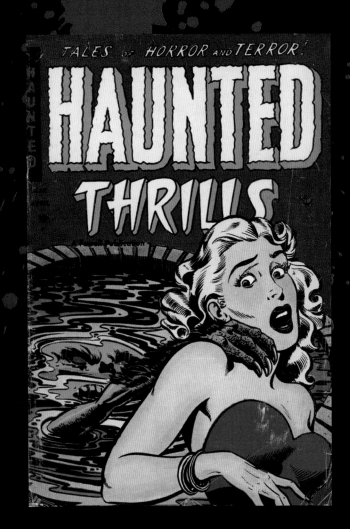

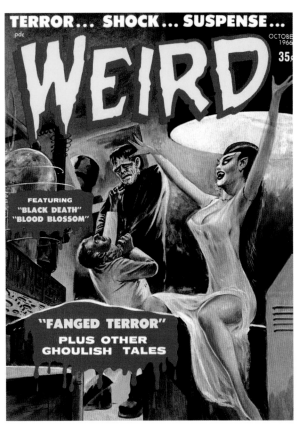

Powell's delightful Franken-babe cover from
Weird Vol. 1 #12 (Oct. 1966)

Ajax-Farrell Publishing

In the early 1950s, when every comic book publisher was dabbling in the horror genre, Ajax-Farrell, under the aliases of Farrell Comics, Four Star Publications, and Excellent Publications, among others, produced some of the weirdest and most memorable horror comics of them all. Headed up by Robert W. Farrell, the company put out a comparatively large number of pre-code horror comics. War, romance, funny animals and adventure were also represented in their output.

Ajax-Farrell's four horror comic book titles were *Voodoo*, *Haunted Thrills*, *Strange Fantasy*, and *Fantastic Fears* (which became *Fantastic Comics* with its tenth issue). Most of the artwork in these titles was produced by the Iger Shop and their house style creates a nice continuity, making the Ajax horror titles instantly recognizable and interchangeable. *Voodoo* had a bit of a jungle

was the intention. These pages were always drawn by Burgos and always appeared on the frontispiece. The remaining content for the next few issues was made up entirely of Ajax-Farrell pre-code reprints.

The formula was pretty well set: Burgos picked a new cover, lined up a few reprints, drew in a little extra blood and shadows, and sent it off. The mags remained free of advertisements, except for an ad for a "Batman Projector" in the fourth and fifth issues. DC's popular characters decorated the ad and orders could be sent to Countrywide's home office. Like Warren, Eerie Pubs was charging 35 cents for their mags, but spending next to

nothing to produce them, using ultra-cheap, pulpy paper and reprinted material. The only new expense was a cover, and that cost was probably kept fairly low as well.

At the end of 1966, in between V2 #1 (Dec. 1966) and V2 #2 (April 1967), Robert Farrell's name had disappeared from the credits page and the Eerie Publishing address in the indicia moved from Farrell's offices (315 W. 70th St., NY) to Countrywide's well-established address of 150 Fifth Avenue in New York, which they had called home since 1964. Farrell's time with the Pubs ended as he moved on and into the newspaper business. The contents of *Weird* remained the same, however, each issue brimming with touched up Ajax pre-code reprints. The April 1967 issue replaced the above-logo headline "Terror… Shock… Suspense…" with "Told in New Chilling Picto-Fiction" (harkening back to *True Problems'* claim, "New—Told in Illustories"). That headline would remain for the next 10 years.

Mel Lenny's name started to appear as publisher in mid-1967 and remained in the credits for about a year. Like Fass' brother Irving, Lenny had been a satellite circling Planet Myron for years already and was happy to lend his name to the credits page. Despite calling itself a bimonthly in the indicia, only three issues of *Weird* came out that year. Things were, however, well on their way to becoming the Pubs of the future. Sadly, Bob Powell passed away in January of 1967, ending the

theme going on in the early issues, but overall, Ajax horror stories were solid shockers. The Iger shop specialized in "good girl art," so there are lots of perky breasts and long, slender, panel-busting legs on display. The stories can be surreal, scary, humorous, gratuitous (though not overtly gory), sexy and just plain weird. (See Iger Studio sidebar in Chapter 2)

Reprints from Farrell's own *Ellery Queen* (published by Superior in the late '40s) turned up regularly in early Ajax issues. Often with horrific content, the stories played fairly well, with Ellery Queen's name being changed to Chick Ayers or Marty Curan. Farrell also acquired Iger-produced strips from Victor Fox, a former associate of his, whose company had gone under. The usual Iger Shop artwork of these stories fit in nicely with the new work that would appear in the same issue.

Fantastic Fears #5 (Jan.-Feb. 1954) contained one of the first

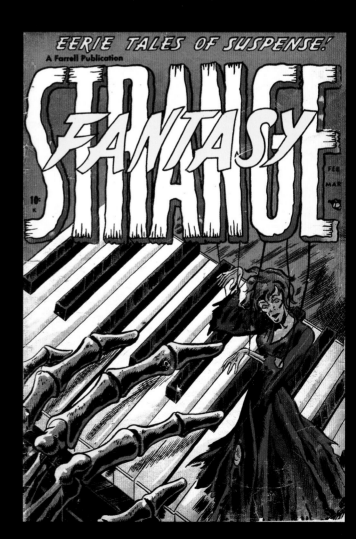

published stories drawn by future comic book icon Steve Ditko, who became a very big deal in the '60s as the co-creator (with Stan Lee) of Marvel's Amazing Spider-Man. This issue is hard to find due to the heavy demand by Ditko collectors. This story, "Stretching Things," was reprinted many times by Eerie Pubs.

Another artist that can be found in Ajax-Farrell horror comics is the great Matt Baker. Unequaled in good girl art, Baker was the main man in the '40s on the Fox comic books *Phantom Lady* and *Jo-Jo*, and is thought to have collaborated with Jack Kamen on the art for *Rulah—Jungle Goddess*. An Iger Shop artist, Baker also illustrated numerous romance comics, displaying his aptitude at portraying the female form. His work from Seven Seas Comics and other jungle-themed strips ended up in early issues of Ajax-Farrell horror comics, albeit with slight name changes (Rulah became Pulah or Kolah, "South Sea Girl" Alani became El'nee, etc.) and,

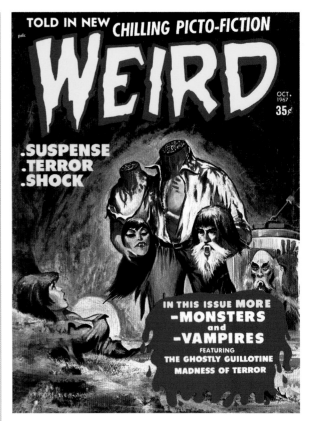

Burgos doubles your pleasure- *Weird* V2 #4 (Oct. 1967)

possibility of more of his paintings. This forced Burgos to step up his own cover production. His cover for *Weird* October 1967 (V2 #4) is the first of many decapitation covers, and it's a twofer! This was mere foreshadowing of what was in store over the next few years.

Along with a bit of extra blood, gray wash was added to the original Ajax artwork, creating shadows and texture. This was a way of making the art look a little more modern, more like Warren's comics. Lines were darkened and heavy black inks were used in abundance. As the issues progressed, the blood flowed more freely. What was once a mere trickle was steadily becoming streams and geysers. Eerie Pubs were finding their niche.

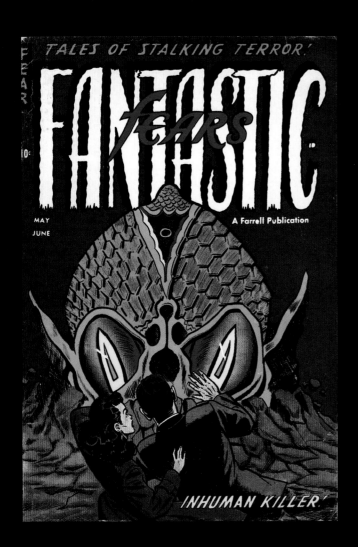

Weird V3 #1 (Jan. 1968) Burgos art

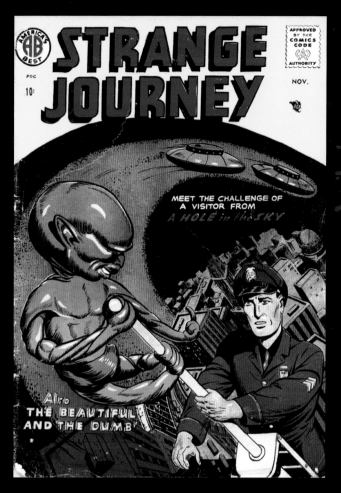

After a four-month space, *Weird* rang in 1968 with Volume 3 #1 (Jan. 1968), with a solid Burgos effort for the cover; he was redefining the look of the title. Now, the female victim wasn't only restrained, she was bound and bloodied, with white bone peeking through torn flesh. The art touchups on the reprint stories became more elaborate, with fangs elongated, breasts enlarged and new figures added to splash panels. In many cases, Burgos would draw a whole new splash to pump up the horror for the jaded late-'60s gorehounds.

With *Weird*'s April 1968 issue, numbering reverted back to Volume 2, for no apparent reason. They may have originally wanted to start a new volume with each year, like they

regrettably, slight art changes. These revised versions were the ones printed by Eerie Pubs.

After the doom and gloom of the CCA, Ajax-Farrell contented themselves with romance comics, safe hero reprints and kiddie books. In 1957, when the industry had rebounded slightly, the company geared up to introduce a slew of new titles. Among the new Western, war and humor comics, Ajax re-entered the fantasy field with a quartet of books, probably inspired by the success that Atlas Comics had maintained with their large line of genre titles. *Strange*, *Midnight*, *Strange Journey* and *Dark Shadows* all hit the stands this year. The most noteworthy thing about these code-approved comics is the sad (albeit interesting) way that the stories were put together.

No strangers to cutting and pasting or retouching artwork, Ajax-Farrell's art department took existing pre-code horror stories, excised or redrew panels that might have been deemed too

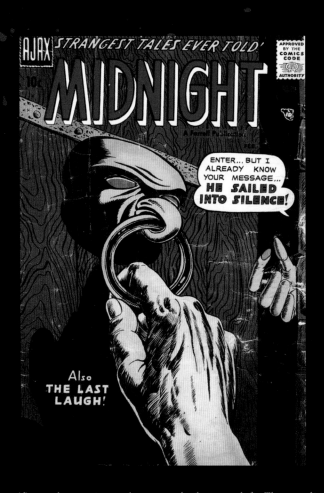

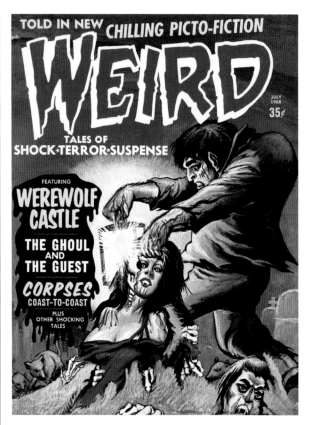

Above: **Weird** V2 #8 (July 1968), Burgos art

Opposite: **Weird** V2 #3 (June 1967), art probably by Powell

horrific, and rewrote stories around what was left. The result was usually an incoherent mess. Ajax stories, in their original form, were pretty weird and surreal to begin with; the castrated versions had no chance of ever making sense. Sadly, it appears that the original art was altered to create these new stories, as I've never seen any artwork collected or offered of the pre-code Ajax versions. It's these re-cobbled atrocities that were reprinted in the Eerie Pubs. Humorously, when some of these sanitized stories saw print in the Pubs, they were gored back up to make them more horrific again. A vicious circle!

At the end of 1958, the Ajax-Farrell line of comics ended. Robert W. Farrell, like Myron Fass, went into the magazine field, most notably with the humor mag *Panic,* and, of course, future collaborations with the Fass gang. He was also a determined newspaper writer and publisher in the '60s and '70s. He published a tabloid newspaper in New York, *The Daily Mirror,* to go head to head with the *Daily News,* but it lasted just over a year.

would eventually do with all of their titles, but as 1967 saw only the three issues of *Weird* produced, there was plenty more Volume 2 to be had. Perhaps they just wanted to frustrate the hell out of future collectors. It worked. The April 1968 issue was numbered V2 #6, with the January 1968 issue, though numbered V3 #1, took the place of V2 #5. Confused yet? I am. There is much more confusion to come, as the next issue of *Weird* in July would be Volume 2 #8. Perhaps the maiden voyage of their next horror comic, also dated July 1968, was intended for V2 #7.

Numbering anomalies and a sporadic publishing schedule aside, sales were looking

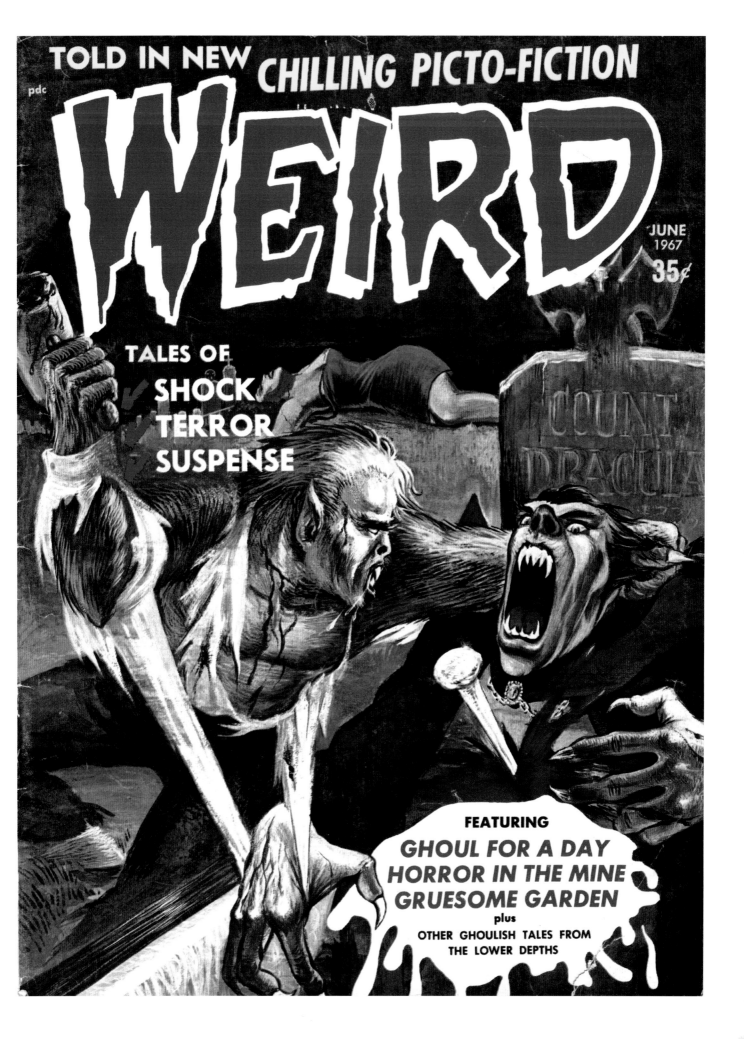

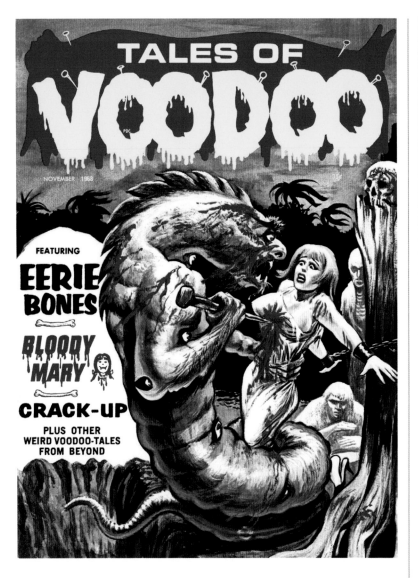

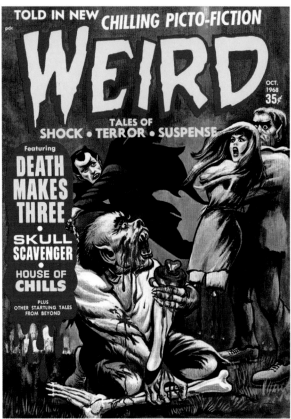

Left: The first issue of *Tales of Voodoo* V1 #11 (Nov. 1968) Burgos art

Right: *Weird* V2 #9 (Oct. 1968) Burgos art

good enough for Eerie Pubs to develop another title. In a move that proves that Fass and Burgos had gonads the size of boulders, they named their second magazine *Tales From the Crypt*. The first and only issue was cover dated July 1968 and, like *Weird*'s debut issue, was numbered V1 #10. The look and layout of the magazine was identical to any given issue of *Weird*: a Burgos cover, a new Morris frontispiece, and retouched Ajax reprints. Exactly why EC's flagship pre-code horror title was chosen as the handle of the

new Eerie Pubs magazine is anyone's guess, but since Bill Gaines still owned the rights to the name, it's easy to see why *Tales From the Crypt* lasted only one issue.

Weird returned in October of 1968 with Volume 2 #9 with the most stomach-churning cover yet. This time, the female victim is being restrained by a monster while she screams, watching another beast eat her severed legs! Burgos' painting features three monsters, one victim, protruding bones and gore galore. This would be the last issue with Mel Lenny's name in it.

The next month, Eerie Publications made good on their effort to introduce a sister title for *Weird*. *Tales of Voodoo* V1 #11 (Nov. 1968) not only picked up *Tales From the Crypt*'s

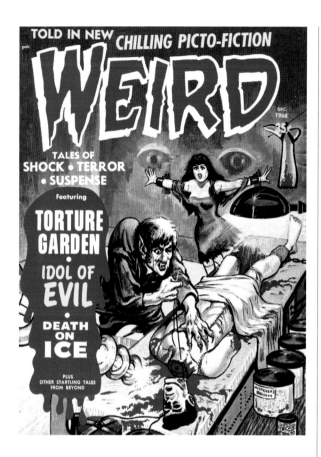

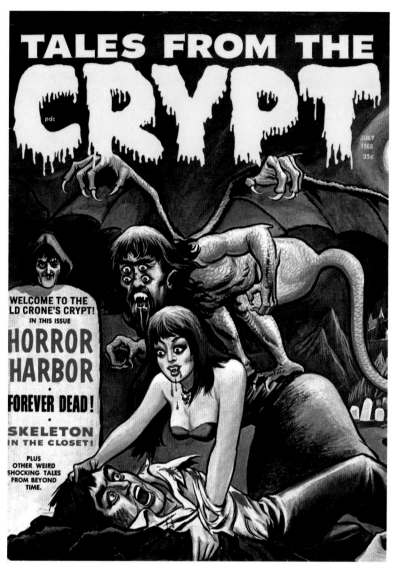

numbering, but borrowed their title logo as well: block letters above a dripping, bloody font. The only difference was the addition of voodoo pins jutting from the masthead. Again, the contents were interchangeable with any issue of *Weird*, except that a ghoulish voodoo lady (with voodoo doll in hand) was drawn into some of the stories' splash panels. Like the past few issues of *Weird*, *Tales of Voodoo*'s inside front cover had a house ad promoting *Great West*, another M.F. Publications magazine edited by Burgos. Featuring photos, drawings and stories that "brings the lusty West to life," some of the covers of *Great West* were pretty gory themselves.

1968 closed with a bang. *Weird* V2 #10 (Dec. 1968) had a disgusting gorefest of a cover

again, courtesy of Burgos, and with a companion mag also on the stands, Eerie Publications were poised to make some big noise in 1969. Burgos and Fass were gearing up for the big time, to provide the horror consumer a real alternative to Warren's two code-free horror comic magazines. It wasn't going to cost them an arm and a leg either, although many arms and many legs would be severed between the covers of their comics. ☀

Left:
Weird
V2 #10
(Dec. 1968)
Burgos art

Right:
Attention Bill Gaines! I smell a lawsuit! ***Tales from the Crypt*** V1 #10 (July 1968) Burgos art

Carl Burgos amended the Ajax art to make it more suitable for readers of the 1960s. More than just adding blood, he would often redraw entire panels.

Top left: from *Haunted Thrills* #8 (April 1954)

Bottom left: Burgos's amusing revision.

Top right: The original Ajax version from *Haunted Thrills* #14 (Mar. April 1954)

Middle right: Ajax's cleaned-up version from *Strange Journey* #1 (Sept. 1957)

Bottom right: Burgos takes it all the way back (and then some!) for the Eerie Pubs

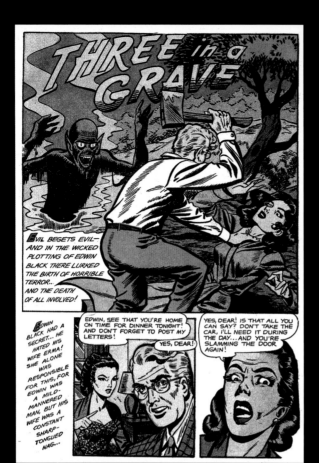

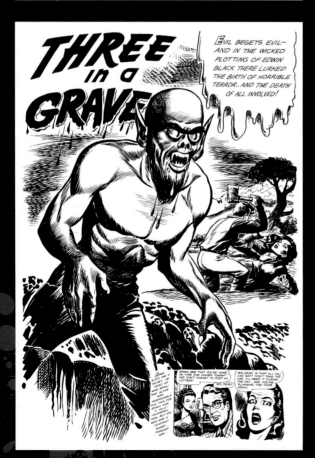

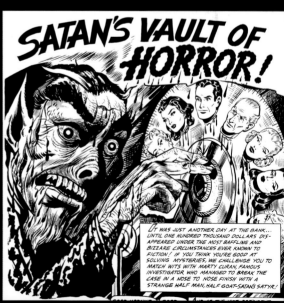

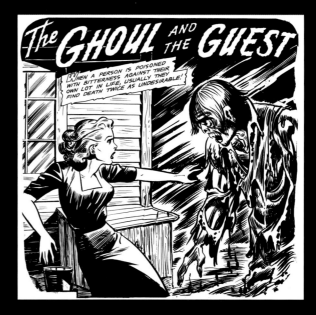

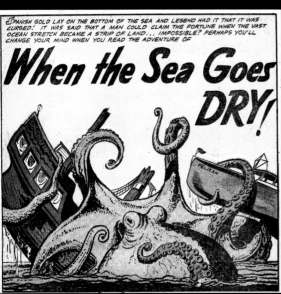

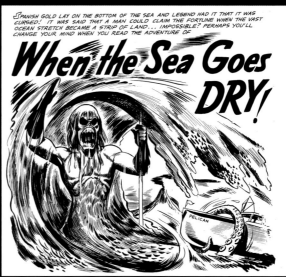

Top: The original from *Fantastic* #10 (Nov/Dec 1954) and the Pubs version

Middle: From Ajax's first issue of *Strange Fantasy* #1 (Aug. 1952) and Burgos's update.

Bottom: A cleaned-up, post-code splash from *Strange Journey* #1 (Sept. 1957) and Burgos's downright bizarre revamp.

TERROR TALES

PDC

May 1969
35¢

FEATURING:

MEET ME
IN THE
TOMB
•
THE SHELF
OF
SKULLS

DEATH
CLAWS

**PLUS OTHER
SUSPENSE-PACKED
STORIES THAT SHOCK**

...SINKING IN WHAT SEEMED TO BE A STICKY, RED POOL OF BLOOD...

Chapter 6

FLOODING THE MARKET (WITH BLOOD)

THE YEAR 1969 was a pivotal one for black-and-white horror comics. Eerie Pubs were ready to inundate the newsstands with gory product and Warren had begun teasing their readers, hinting about an addition to their own horror comic family.

Publisher Stanley Morse, who put out some of the grislier EC clone comics in the pre-code era, entered the field of horror magazines in May. His idea was inspired by Eerie Pubs:

reprint old '50s horror comics in black and white with new (or reprinted) covers. Stanley Publications culled stories from Morse's pre-code comics like *Mister Mystery* and *Weird Mysteries*, which were usually gorier than Eerie's Ajax reprints, though except for one nice Basil Wolverton story (which was reprinted sans the last page), the artwork was comparatively weak. The eventual move to all-ACG reprints, which were tepid at best,

Opposite: Chic Stone's unforget- table cover to *Terror Tales* V1 #8 (May 1969)

This page: Chic Stone again, from the classic "Blood Bath"

59

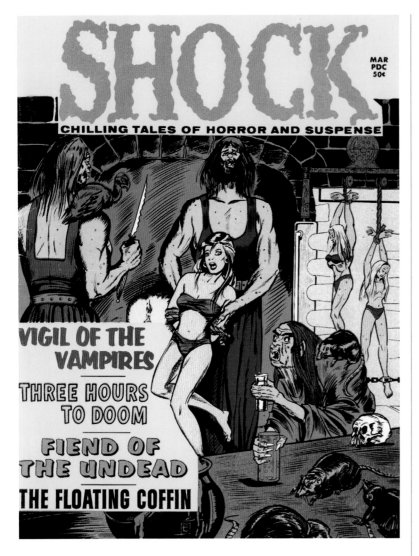

Stanley Morse's sub-Pub horror; **Shock** V3 #1 (Mar. 1971) art by Frank Carin

would make Stanley's comic magazines even less exciting.

Stanley's first entry into the illustrated horror sweepstakes was *Shock* Vol. 1 #1 (May 1969), followed by the first issue of *Chilling Tales of Horror* (Vol. 1 #1) in June. The formula was similar to the Pubs and, like Eerie's Ajax reprints, most readers at that time had missed these stories back in the day. Magazine racks were definitely becoming more interesting in 1969.

Eerie Publications started the year with new issues of their two titles in February. *Tales*

of Voodoo V2 #1 (Feb. 1969) was Carl Burgos' final all-new cover for the time being. His hands were becoming very full with the day-to-day tasks of putting these books together, and the workload would be even heavier in the months to come. One thing that lightened his load was finding new cover artists. *Weird* V3 #1 (Feb. 1969... this is the second issue with that number... remember the January '68 issue?) was the first of a handful of memorable covers by Chic Stone. Another former Iger Shop artist, Stone had earned a reputation as one of the industry's finest inkers. He had become a comic book star by inking Jack Kirby's pencils for many Marvel Comics titles, including the bestselling *Fantastic Four*. Letting Chic Stone loose to produce horror comics on his own was a stroke of genius (or luck) for Fass and Burgos. His addition was a fortunate one and his contribution was immense.

If two titles were good then three would be great, and the first issue of *Terror Tales* (V1 #7) arrived a month later, cover dated March 1969. Again, this debut issue was interchangeable with everything that Eerie had previously published, but the company had become very visible on the newsstands with this triumvirate of terror. House ads began appearing in the front of Pubs mags, offering subscriptions and an enticing potluck special... four Pubs for a buck!

With this increase in production, more help would be needed. Burgos' solution

was to bring aboard another experienced artist to tighten things up. The man for the job was Ezra Jackson, another former Iger Shopper and artist with years of experience. An exceptional inker, he stepped into the role of art editor with *Tales of Voodoo* V2 #2 (May 1969) and stayed in that position through 1974. Much of the look of the upcoming Eerie Publications revolution was Jackson's doing, and another major contributor was just around the corner.

Chic Stone's covers were wild, gory and completely over the top. His human corn-on-the-cob cover for *Terror Tales* V1 #8 (May 1969) is one of the most notorious of all Eerie Publications covers. His stomach-churning scenarios were the stuff of nightmares, but with production being tripled in 1969, more help was needed to keep the blood a-flowin'. The artist they needed was already in their midst... Bill Alexander.

Alexander, a fetish artist for Irving Klaw in the '50s, had been working on Fass' nudie magazines since mid-1968. He'd provided excellent charcoal story illustrations and took over the comic strips in *Jaguar* and *Duke* after Bob Powell's death. His transition from sexy humor to grisly horror looked like a comfortable one (though he continued the Countrywide softcore gig through 1972). His vibrant, colorful gouache paintings always jumped right off of the covers. Despite being very gruesome and packed with bondage and

torture (hey, the man had made a living as a fetish artist!), a good dose of humor was also evident in his paintings. When one thinks of a typical Eerie Pubs cover, one thinks of Alexander's multi-monster, action-packed, bloody, sexy, over-the-top paintings. For my money, Bill Alexander's artwork defined the look of the Eerie Publications horror comics.

Alexander's first Eerie Pubs cover was also the first issue of the fourth horror title, the generically titled *Horror Tales* (Vol. 1 #7, June 1969). His crowded devil/guillotine scene is filled with severed heads

Four Pubs for a buck! The house ad that ran as soon as there were three titles in the Pubs stable

The Bloody Stream

This story has the distinction of being the only straight-up pre-code horror story reprinted in the Pubs that did *not* come from the Ajax/Farrell inventory. Originally titled "The One that Got Away," it was first seen in *Weird Mysteries* #8 (Gillmor—Jan. 1954). Just how the story found its way into the pulpy pages of the Pubs is anyone's guess, but it appeared twice: in *Horror Tales* V1 #9 (Nov. 1969) and in *Weird* V5 #2 (Apr. 1971).

The story had been printed under its original title a mere five months before its first Pubs appearance in *Chilling Tales of Horror* Vol. 1 #1 (June 1969) by Stanley Publications, a competing outfit that also relied on reprints. Stanley owned the story. It is fun to think that Fass and Burgos, pissed off by the competition, just ripped the story from the Stanley mag and gave it a new title.

The artwork is by Tony Mortellaro, a frequent contributor to the Gillmor pre-code horror comics who went on to work for Atlas/Marvel.

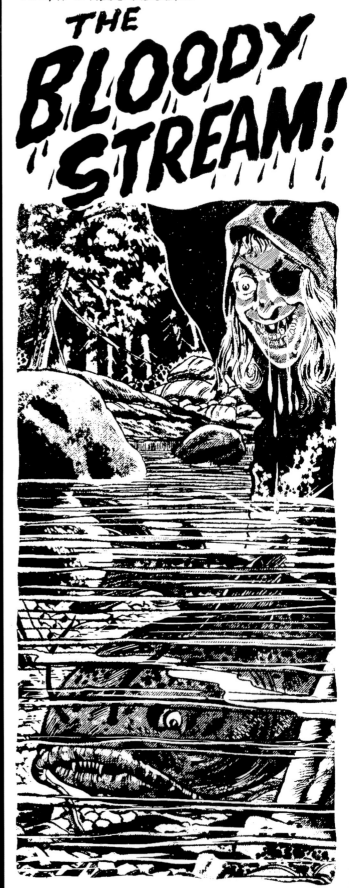

and loathsome creatures and it's considered by some to be a classic horror cover. Despite another exciting new cover artist in the stable, the contents of the issue were again the same as every other Eerie Pub. There was never a story inside to match the cover art on any Eerie mag (except, arguably, the very first issue of *Weird*)… that just wasn't the way Fass and Burgos had it planned.

Was their lease up or was the ever-expanding Countrywide empire growing so fast that they needed new digs? Offices were again moving, this time just a few blocks away to Park Avenue. To keep a presence on the newsstand during this transition, the Eerie crew clobbered the market with a ton of new product, including two more new titles. There

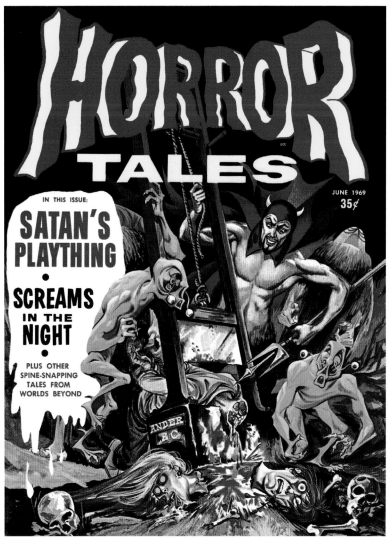

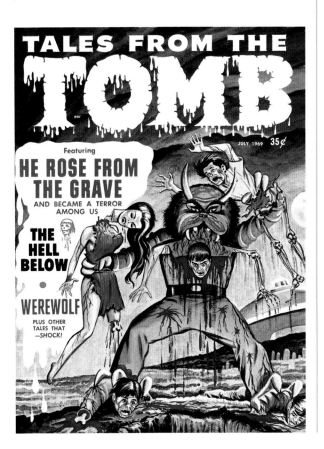

were five Eerie Pubs with a cover date of July 1969, including the first issues of both *Tales From the Tomb* (V1 #6) and *Witches' Tales* V1 #7 (please note the plural possessive). These two debut issues were Chic Stone's last new covers and they're gore-filled delights. Needless to say, the contents of all of these magazines were Ajax reprints once again.

Ezra Jackson had proved to be a master at gore. He was fond of completely redrawing panels to make them gorier. A favorite effect was to have a victim's cheek ripped away, exposing a line of teeth inside, or flesh ripped away exposing the bone underneath. If there was not enough room on the original Ajax

Top: ***Horror Tales*** V1 #7 (June 1969) Bill Alexander's first of many Eerie Pubs covers

Left: Chic Stone strikes again with ***Tales from the Tomb*** V1 #6 (July 1969)

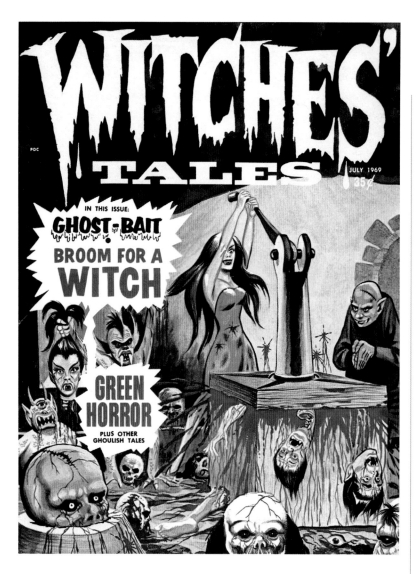

Top left:
Witches' Tales
V1 #7 (July 1969)
Chic Stone's final
Pubs cover

Top right: Even
the great Rulah,
Jungle Goddess
wasn't safe from
Ezra Jackson's
cheek-rippin'
carnage!

Bottom:
Jackson even
makes the walk-
ing cactus story
"Green Horror"
(***Fantastic Fears***
#8, July/Aug.
1954) into a
gorefest!

art to rip away some flesh, new panels were created and pasted on top. Often the gore was excessive and meaningless to the storyline but that's what we all love about this company, isn't it?

While Eerie Pubs had a lot of visibility on the newsstands during the summer of 1969, they were still missing one thing—new stories. Fass and Burgos realized that they could only go so far with the dated Ajax reprints, even if they were gored up, shaded and presented with colorful new covers. New stories would have to be created. Warren was having great success with their two horror titles and a third, *Vampirella*, had just made its debut. These magazines all had new stories and art, and the horror fans were eating it up. The

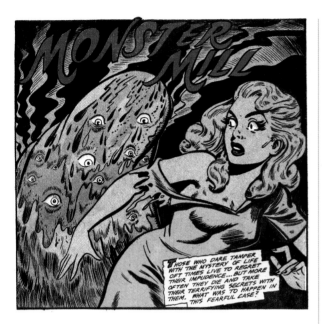

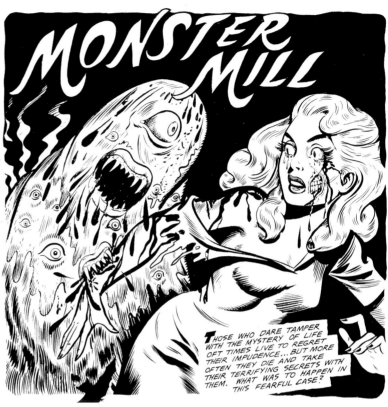

Warren letter columns were peppered with missives from readers slamming the Pubs for their inferior product. There were enough reprints for the magazines to coast on for a while longer, but once they were settled into their new offices, Eerie Publications would have to compete with some new material.

Chic Stone, who was a creative writer as well as an artist, contributed a few of his own stories to Eerie Pubs, which he wrote and illustrated. The first to see print was "The Thing (In the Cellar)," a quick four-pager that broke the golden rule (one with which I never agreed) by killing a child. He adapted this from a one-page strip that he'd written back in 1962 for his own publishing effort *Boy*

Ezra Jackson never met an Ajax comic panel that he couldn't turn into a blood-thirsty master-piece. Please note the prevalence of ripped cheeks.

Top: "Monster Mill" from *Haunted Thrills* #6 (Feb. 1953) and Jackson's updating

Bottom: "My Dear Friend" (*Dark Shadows* #1, Oct. 1957) was a code-safe, sanitized version of "Death Do Us Part" from *Haunted Thrills* #13… Ezra shows us what he thought of the Comics Code

A good example of Eerie Pubs' rock-bottom production values: the paste-up on the hand's stump is clearly visible.

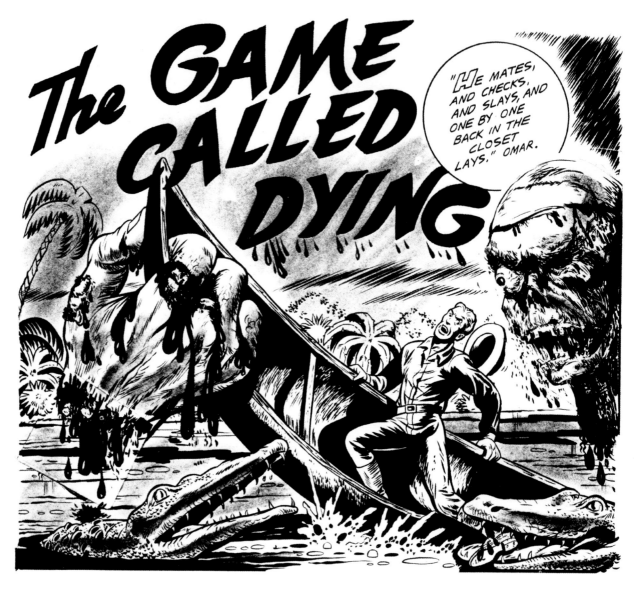

Illustrated #1 (June 1962). (See the original in Appendix 4- The Thing in the Cellar) He also produced the ultimate cautionary drug tale with "Blood Bath," possibly the goriest comic story of all time and thus a favorite of many fans. Its message is simple: if you do LSD, the chances of mutilating everyone around you in a crazed fit of violence are at least doubled.

Unlike Chic Stone, not every artist has the ability to write as well as draw, so the question of scripts for the family of Eerie Publications magazines posed some problems. There were

six titles to provide material for, and artists would be much easier to find than writers. Those two mysterious black-and-white comic mags in 1959 had solved the same problem by reworking comic stories from the pre-code era. By 1969, it had been a full 10 years since the failed experiment of *Weird Mysteries* and *Eerie Tales*. Surely the old pre-code stories were even further from the public's collective memory by the late '60s. There was a vast source for material that had worked before, and it might just fly this time around.

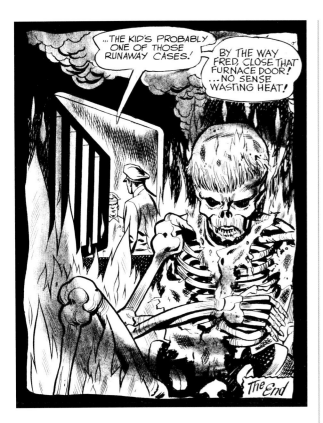

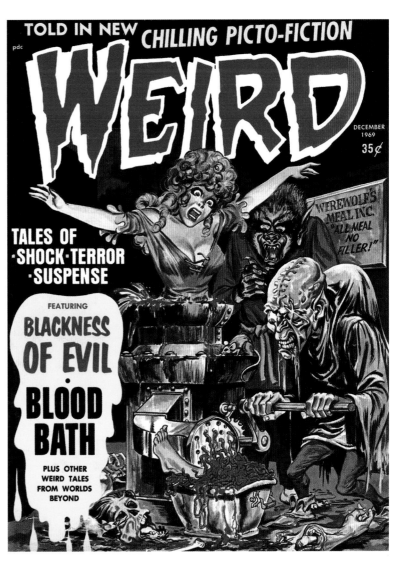

The formula was simple. Pick a story from a pre-code horror comic and photocopy it. Get the copy to an artist with instructions to redraw the art, making it gorier and more horrific. Some artists ran with that concept and reinterpreted the art and panel layout, often improving on the storytelling of the original. Others simply took the easy route and redrew the same thing, panel for panel. The artists were told to ignore the story's title (a new title would be concocted by the Eerie crew), but use the same text and dialogue balloons as the copies that were provided.

Sarah Burgos told Jim Amash in an interview printed in *Alter Ego* #49 (TwoMorrows—June 2005) that her father Carl had thrown out his comic book collection in 1966, feeling that the industry had been unfair

to him in the past (and present). This makes me wonder if the comics used for stories in the Pubs were from this collection, given to Fass before the sloughing, or from Fass' own collection, which may well have been a pretty extensive one. Fass was, after all, an obvious fan of the genre, and had used a few panels here and there for swipes back in the early '50s. I believe the latter to be the case. At any rate, a few rules had to be observed.

While horror had ended as a comic book genre, not every publisher ceased to exist

Left: Barbequed brat, Chic Stone style! The dénouement of "The Thing (in the Cellar)"

Right: *Weird* V3 #5 (Dec. 1969); the issue where stories with new artwork started to appear.

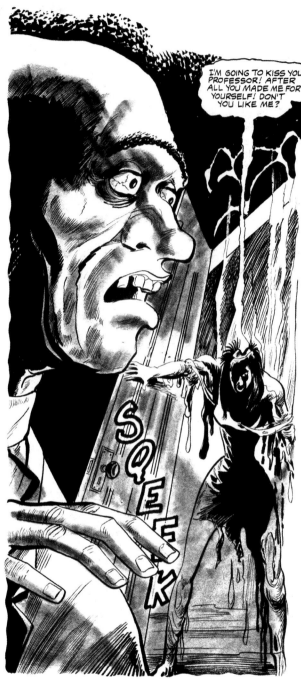

after the Comics Code went into effect back in 1954. Many, like Atlas/Marvel, D.C, and EC carried on and eventually thrived. Thus, these three companies' pre-code output was off limits. Burgos needed stories, not lawsuits. There was plenty of usable material to use from other (presumably) defunct publishers of pre-code horror.

Carl Burgos was an editor that knew what his readers would like. Many of the

stories used were pruned of excess wordage, getting the tale told with less o' that needless readin' stuff. Some of the companies that the stories were pilfered from, such as Ace, were exceedingly verbose (i.e., boring), and serious editing was in order. Depending on the original story, whole paragraphs were eviscerated,

sometimes there was merely a name change and often, nothing was changed at all except for the story title. According to Dick Ayers, it was Burgos who came up with the new titles.

The December 1969 issues of both *Weird* (V3 #5, with Alexander's incredible meat grinder cover) and *Witches' Tales* (V1 #9) were the first to feature extensive new material, with only a handful of reprints mixed in. Larry Woromay, a mainstay of Atlas' '50s horror comics, was well represented in these two magazines, as was Argentine comics veteran Oscar Fraga. Woromay, in particular, really understood what was required of him by Burgos and went the extra mile on his stories. His Eerie Pubs work is rife with action, mood and gore, the way a good horror tale should be.

Across town, Robert Sproul, publisher of *Cracked*, a very successful *MAD* imitator, stepped into the black-and-white horror magazine ring with the first issue of *Web of Horror* (Dec. 1969). Financially disappointing, but adored by horror fans, this three-issue run featured spectacular work by up and coming artists like Bernie Wrightson, Mike Kaluta and Ralph Reese, and gorgeous painted covers by Jeff Jones and Wrightson. A top-notch effort all around, with a superb mix of veteran talent and future stars, excellent original stories and art, and even a cute spider-host named Webster, *Web of Horror* had it all, but it didn't sell. So it didn't last. A ready-to-go fourth issue never made it to press.

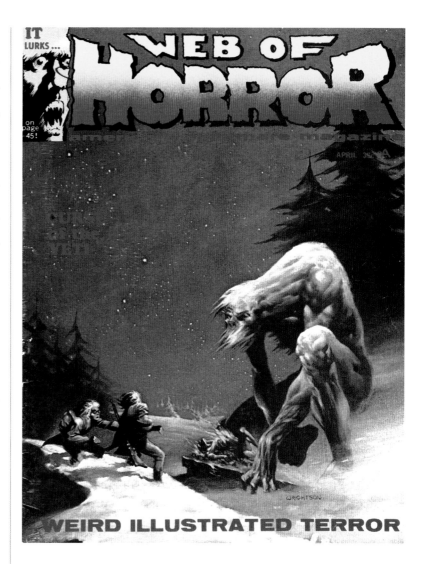

Web of Horror #3 (Major, Apr. 1970) art by Berni Wrightson

Into The '70s in a Blaze Of Gory

Meanwhile, as the '60s were rolling over into the '70s, Eerie Publications was a horror-comic-producing juggernaut. With six titles going full tilt, they finally established a publishing schedule of three titles a month, a schedule that they would more or less maintain for the next few years.

Bill Alexander worked overtime, painting 30 of the 37 covers used by Eerie Publications

Burgos Art?

Other than "Frankenstein" in the first issue of *Weird*, Carl Burgos illustrated five tales for Eerie Publications. In many cases, his artwork is like a carbon copy of the original stories ("Yeech!" being the worst offender, looking so much like "A Matter of Taste" from Harvey's *Witches' Tales* #19 that it practically looks like a reprint).

The ink work on these comics is pure Burgos and many of the (non-copied) figures are definitely his. But some of the details, particularly the women's eyes, look less like the Burgos style that I'm accustomed to. That's not to say that a veteran artist can't mix things up, though.

Speculation is fun, however, so what if it's Myron Fass' pencils that Burgos was going over? I doubt that it is but it's not out of the realm of possibility. "House of Shock" (which only appeared in *Tales of Voodoo* V3 #1, Jan. 1970) is surely the work of Burgos, but isn't that one pose on the last page pretty much the same one that Fass swiped way back in 1953 for the cover of *Beware* #6?

The mind boggles.

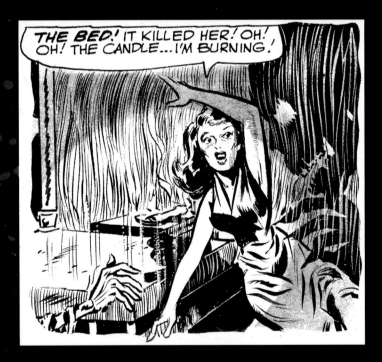

Definitely Burgos art... but that pose... hmmm... from *"House of Shock"*

with 1970 cover dates. More artists came on board to illustrate the stories, including Walter Casadei, an Italian expatriate working from Argentina and Antonio Reynoso, another veteran Argentine cartoonist. Carl Burgos and Ezra Jackson also pitched in with a handful of stories. The biggest addition, however, was Dick Ayers. A comic book pro from way back to the pre-code days, Ayers was a well-respected, dependable and talented artist who more than delivered the Eerie goods.

Like Larry Woromay, Dick Ayers understood what "Carl and Myron" were asking for and gave it to them in spades. They wanted gore? They got it! Ripped-off limbs, lolling tongues, gouts of blood and oh my... those popping eyes! Ayers' trademark was the eye-poppin'. Sockets just couldn't contain 'em! Not content to merely copy what was given to him to work from, Ayers would reconstruct

the story to squeeze the most excitement from it, and dish out the gore like a maniac. He told me that he would do the voice balloons and text first, to get the feel for the story, and then tell it his own way from the script on the blank pages. He rarely (though sometimes) referred to the original art for ideas. Dick Ayers' are probably the most fondly remembered stories in all of the Eerie Pubs mags.

Carl Burgos, despite being the man calling the shots, does a surprisingly unoriginal job on his own handful of stories. Many of his panels seem to be almost traced from the pre-code originals, with extra blood and spittle added here and there. His females also have more ooomph, but frankly, he seems to have rushed his stories out with little effort, changing panels and layouts infrequently. Still, some of the stories are fun and when you don't compare them to the art from the original stories, Burgos' bold inks look pretty nice.

Ezra Jackson fared much better, although he had a much smaller output. He used the pre-code stories as springboards, and took the stories off into different directions. His story "The Witch and the Werewolf" uses many panel swipes and the gimmick of no dialog from the story "Sshhh" from *Weird Mysteries* #7 (Gilmore—Oct. 1953), but changes that story's silly ending to something far more gruesome. He even closes the story with a rare bit of Eerie Pubs continuity, by basing his witch in the story on Bill Alexander's *Witches'*

Tales cover girl. It should be mentioned that Ezra Jackson was quite adept at poppin' eyeballs himself.

Despite the influx of new artwork, the Eerie Pubs line of magazines was still not exempt from reprints. The oft-used Ajax stories still made up the majority of any given issue's content. By mid-1970, many magazines would lead off with the potent one-two punch of Ayers and Woromay, who were

Opposite:
A panel from Casadei's "The Vampire-Ghouls"

This page:
Dick Ayers puts the splash into splash panel!

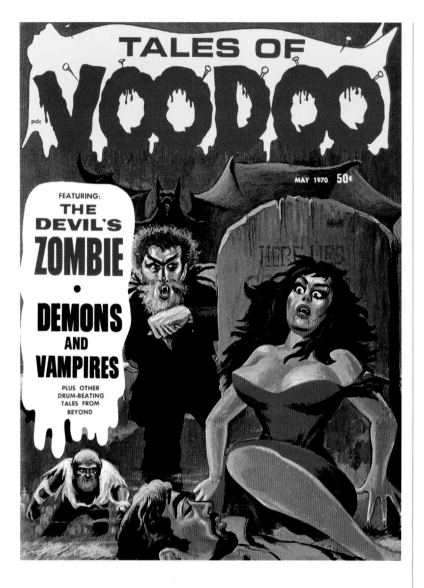

This page: Recycled and repainted; the cobbling begins. **Weird** V3 #1 (Jan. 1968)

Opposite: **Terror Tales** V2 #3 (May 1970) Alexander art

really in your face with the gory goods, but follow those two with more Ajax reprints. It wasn't long before the earliest stories by Stone, Woromay and Fraga were in the reprint rotation as well. The reprinted stories, where they were once just gray-toned for shadowing, were being slathered heavily with grays, with just a spotlight of untouched area around the main action of a panel. It made it a real bitch to admire the artwork.

The most distressing shortcut, however, was the idea to recycle covers. The May 1970

cover to *Tales of Voodoo* (V3 #3) shows Burgos taking the artwork from *Weird* V3 #1 (Jan. 1968) and painting new details and characters into the scene. The impact of the original is lost, as the victim's wounds are gone, as are the ropes that bound her. This is the first of many instances of reusing and retouching previously published covers, and the practice continues to puzzle fans over 30 years later.

Coincidentally (or not), right around the same time as Burgos' watered-down rendering of the *Weird* cover, Alexander's covers also became less violent. His excellent sense of humor was frequently on display, with humorous signs and sometimes goofy-looking ghouls breaking the tension, but he had also begun showing robotic gears and wires instead of the guts and gore that previously leaked from severed limbs and sockets. One wonders if Countrywide's distributor (PDC) was having a tough time placing the overtly gory covers on America's newsstands.

Another artist from Argentina started providing stories for Burgos by midyear. Cirilo Muñoz was a comic veteran in his homeland, but this was his (as well as most of his fellow countrymen's) first foray into the wilds of the U.S. comic scene. His fine lines and dramatic cross-hatching are very well suited to black-and-white horror and his first few stories are knockouts. His artwork is always a joy to admire, but he often "Burgosed" it and didn't stray far from the original layouts. Muñoz

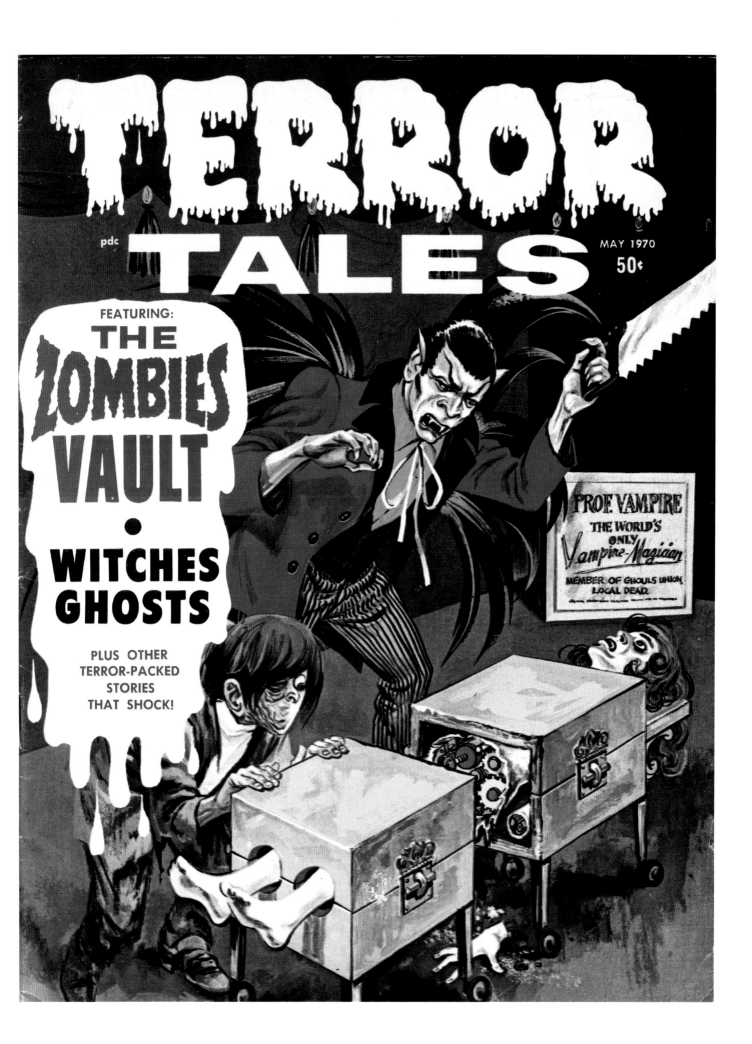

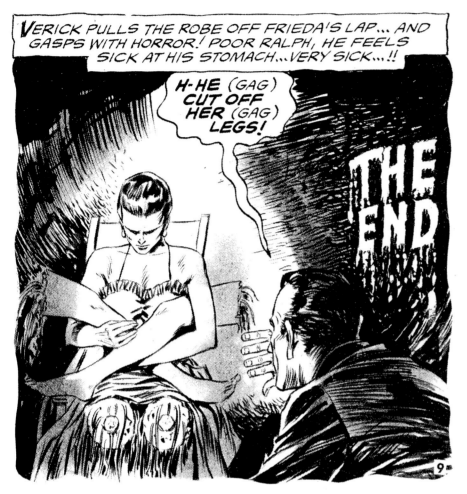

different genres. There are questions about whether he had any actual rights to reprint them but, legal or not, those books came out.

The Skywald line provided real competition for everyone involved. They used a handful of Waldman's reprints for some of the interiors, but they had planned to go all-original after a short while. Early issues scored high marks with some nice Boris Vallejo covers and inside art by Atlas/Marvel stars like Bill Everett, Mike Esposito and Paul Reinman. Skywald mags had a nice slick look, were well put together, and would only get better over the next few years.

Top left: The shock ending from Cirilo Muñoz's "The Bloody Ax"

Bottom right: Skywald steps up the plate with *Psycho* #1 (Jan. 1971) art by Brendan Lynch

also painted the cover for *Horror Tales* V2 #5 (Sept. 1970), his only Eerie Pubs cover.

One more new player was suiting up to test the waters of monochrome comic mayhem. Sol Brodsky, an Atlas/Marvel artist and production man throughout much of the '50s and '60s (and first editor of *Cracked* magazine), had teamed up with Israel Waldman to form Skywald Publications. Waldman was the man behind I.W. Enterprises (later known as Super Comics), who reprinted pre-code stories into new titles in the late '50s and early '60s. He had acquired the printing plates from various companies earlier in the decade and churned out comic titles in many

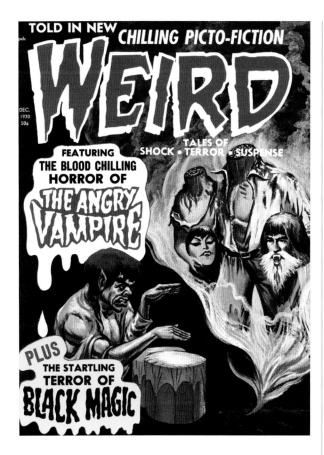

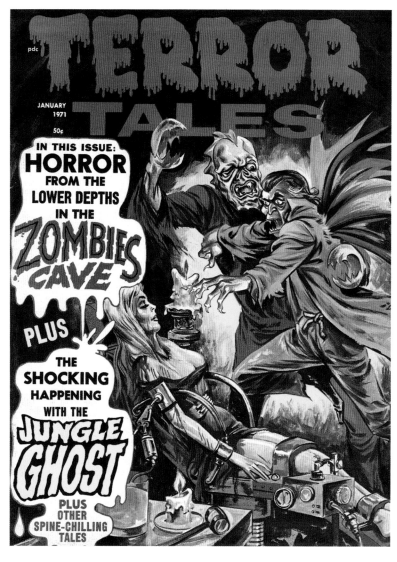

Though the titles were still virtually interchangeable, the Eerie Publications magazines were obviously working and the shocking sextet was selling well enough to justify their existence. The prolific Alexander may have become a bit overextended as the year neared the end, and those consumer-befuddling cobble covers started popping up more often. Images from covers past were cut up and pasted together with others, creating (not entirely successful) new covers. Only the most striking and memorable images were used, often to the detriment of the product. I, for one, was thoroughly perplexed back in the day, knowing I'd seen these images before, and thinking I must already have that issue. The oft-recycled Ajax stories inside didn't help matters any.

The last all-new Bill Alexander cover (before a brief respite) was for *Terror Tales* V3 #1 (Jan. 1971), and it's a stunner. Superb colors, mood and action, he really nailed it on this one. Unfortunately, it would be the only all-new cover from him with a 1971 cover date. He would take up residence for the time being at Star Distributors, a porno paperback publisher, providing jaw-dropping covers and sketches for their... ahem... specialty books. ✳

Left: ***Weird*** V4 #6 (Dec. 1970) Cut and paste and repaint by Burgos

Right: Bill Alexander's excellent cover for ***Terror Tales*** V3 #1 (Jan. 1971)

THE TARGET... KYBLOS, THE PLANET OF WALKING DEAD! WHERE THE SPIRIT OF LIVING BEINGS LEFT PAIN-RACKED BODIES AND MOVED INTO MORE COMFORTABLE SHELLS...

Chapter 7

CUTTING CORNERS AND PASTING THEM

ALWAYS with an eye for bargains, Myron Fass would purchase suitable artwork from various sources that could be used for his many publications. After nearly two years of publishing six horror comic titles, and having had to resort to cut-and-paste cobbles and redraws, it was time to dip into that stash of art that he had been acquiring over the years.

Among Fass' art acquisitions were dozens of paintings with a science fiction theme, good solid artwork that would look great on U.S. newsstands. These covers, along with new interior stories lifted from pre-code

sci-fi comics like *Strange Worlds* and *Weird Tales of the Future,* would usher the Pubs into 1971, known to many (me, anyway) as the year of Eerie Sci-Fi. The irony here is that Fass was a leader, an innovator! This was six years before the sci-fi craze arrived in a big way with George Lucas' ridiculously successful film *Star Wars.* Once that film became a hit, outer space stories became the order of the day, but Fass was, unfortunately, a few years ahead of the rest of the world with this one.

Two new titles were lined up to show off these dazzling covers: *Strange Galaxy* and

Opposite: You are entering the realm of Eerie Science Fiction! *Weird Worlds* V1#10 (Dec. 1970) art by Johnny Bruck

This page top: from Walter Casadei's "Space Spirits"

This page left: The Countrywide logo started to appear on the Eerie Pubs in 1971.

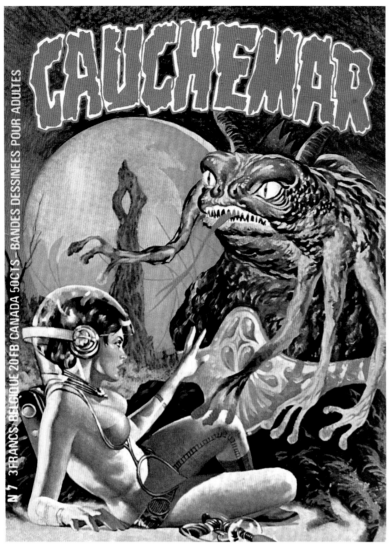

Top left: Fernando Fernandez's cover of **Terror Tales** V4 #2 (Mar. 1972) before Burgos painted a new demon onto it. The intact painting is from the cover of **Cauchemar** #7 (Editions de poche, 1972), the French version of Skywald's **Nightmare**.

Top right: One of Antonio Reynoso's superb sci-fi stories

Bottom left: **If** V19 #5 (Galaxy Publishing, May 1969)

Weird Worlds were born. *Weird Worlds* V1 #10 appeared first, in December 1970. The interior artwork was mostly science fiction-themed, and was, in fact, the first magazine put out by Eerie Pubs to feature all-new inside art. With the exception of the first issue of *Strange Galaxy* (V1 #8, Feb. 1971), all of the subsequent sci-fi issues were interspersed with the familiar Ajax reprints. For the first half of 1971, all of the horror titles boasted science fiction covers as well. Dozens of Eerie Pubs reached the stands with these atypical (for them) covers. The inside art was still showcasing the talents of Ayers, Fraga, Reynoso (who really excelled at sci-fi), and Muñoz, with a few reprints mixed in for good measure. Oswal, a respected Argentine artist, embellished the Pubs with some outstanding sci-fi entries.

So, where did all of these dazzling science fiction covers come from? It came from Myron

Top:
Preliminary
character
sketches
for Oswal's
"The Metal
Replacements."
Courtesy of
the artist.

Bottom left:
Sometimes,
Burgos had a
little fun by
rewriting
text from the
'50s comics.
"Sabotage on
Space Station 1,"
Strange Worlds
#7 (Avon, May
1952)

Bottom right:
"Terror on
Station One" art
by Cirilo Muñoz

Fass' knack of finding good art at a low price.

The paintings that adorn most of the Eerie sci-fi era covers were done by Johnny Bruck. Bruck did over 1800 cover paintings for the German *Perry Rhodan* pulps that were serialized from the early '60s through the '80s. These Rhodan paintings were reprinted for the Eerie Pubs sci-fi covers.

Starting in 1961, Perry Rhodan stories came out weekly in Germany, in short (roughly 60- to 80-page) installments, printed on cheap paper, but featuring full-color, original cover art. Planned as a short series, the Perry Rhodan stories were very well received, so

79

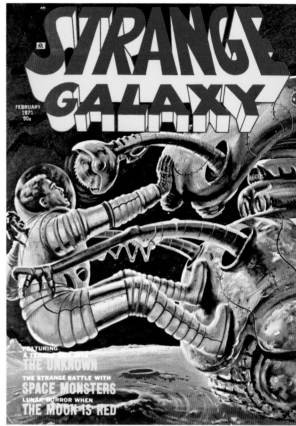

the stories continued… and continued… and continued! Many different authors handled Perry's exploits over the years, and the series thrived, adapting to the decades in which it appeared. Forrest Ackerman, of *Famous Monsters* fame, had some stories translated for English-speaking consumption, a movie was made, and Perry Rhodan became one of the most popular science fiction characters of all time. All the while, Johnny Bruck was PR's premier cover artist.

Fass and Burgos weren't the only ones taking advantage of the Rhodan paintings. Popular Library used Bruck's covers for some of their paperback reprints of *Captain Future* in 1969. Ultimate Publishing and Galaxy Publishing both used some PR paintings on

the covers of their sci-fi digests in late 1969 and early 1970. In some cases, a cover used by these publishers would later turn up as a Pubs cover as well. Ultimate and Galaxy got their Bruck art from the Three Lions Picture Agency. Three Lions, Inc. had been around since the '40s, supplying photographs for books and periodicals on an international level and, in the '60s, added illustration to their inventory. This was probably also Fass' source.

Eerie Publications' first use of Bruck's Perry Rhodan art goes way back to the fourth issue of *Weird* (December 1966). This suggests that Fass had an avenue to get art from his source over a period of time. While this cover was first published in Germany for PR #131 in February 1964, many of the subsequent

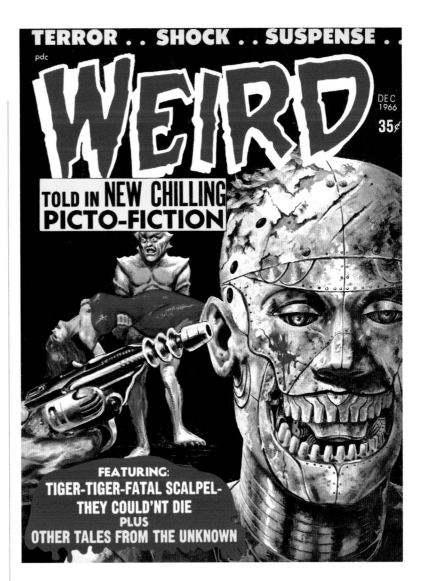

Bruck covers used by Eerie in 1971 weren't yet painted in late 1966. The *Weird* 12/66 cover depicts Bruck's robot with a gun to its head, with a new Burgos monster and fainting female added to the background. This is the only time that one of Bruck's paintings was appended by the Pubs, though his work would be cut up and pasted onto some of the later cobbled covers.

Of course, the artwork used by Eerie Pubs featured Perry Rhodan characters and plot devices that were unfamiliar with American readers (the four-armed Icho Tolot appeared on three Eerie Pubs covers himself) and had nothing to do with that issue's contents, but then none of their covers ever did. Most horror fans in the U.S. had no idea who those characters were, but the artwork was sure compelling. (For a listing of the Perry Rhodan pulps from which the Pub covers came, see Appendix 5—*Perry Rhodan* Covers)

This influx of all things spacey was not to last, however.

Back in the '50s, EC's Bill Gaines said that science fiction was a difficult genre for comic books. He published his own titles, *Weird Science* and *Weird Fantasy,* despite losing money, just because he loved sci-fi. History has shown that science fiction comics often die on the vine. Whether or not it was market indifference that caused the demise of the Eerie science fiction era is hard to say. Personally, I think Fass and Burgos ran out

of the Bruck art, so they moved on without blinking an eye.

As the era of Eerie sci-fi came and went, subtle changes were occurring inside the horror magazines. More Argentine artists were finding work for Burgos, including Oscar Novelle, Hernan Torre Repiso and Rubèn Marchionne. Antonio Reynoso's art had become a Pubs fixture, leading off many issues. His dark, ink-heavy brush strokes, when on, were evocative and moody, setting the right twilight tone for the rest of the mag. Oscar Fraga, Walter Casadei and Cirilo Muñoz continued to contribute prolifically, though sometimes with less success than in their

The earliest Pubs appearance of Bruck's artwork—***Weird*** V2 #1 (Dec. 1966)

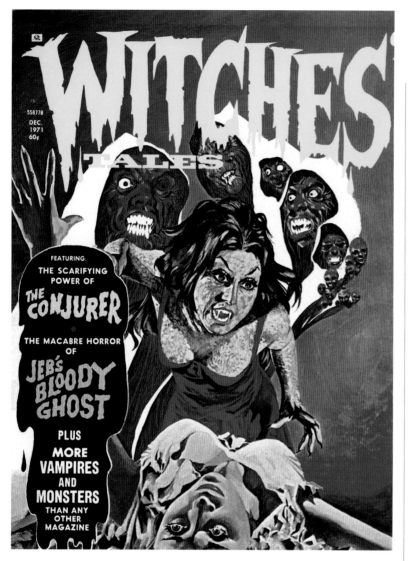

Top: Saldaña (a.k.a. Fernando Fernández) delivers an iconic image for **Witches' Tales** V3 #6 (Dec. 1971)

Bottom: **Tales from the Tomb** V3 #3 (June 1971) art by soon-to-be Warren superstar Enrich.

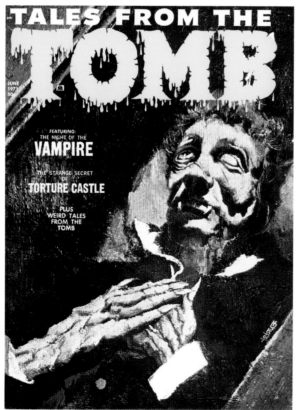

82

earlier stories. (For a condensed history of comics in Argentina, see **Appendix 6—Please Draw for Me, Argentina**.)

Sadly, the proliferation of artwork from South America made less room for Dick Ayers, whose last new work appeared in *Terror Tales* V3 #4 (July 1971—"The Tomb") and Larry Woromay. By late 1971, Ayers had become noticeably absent, and Woromay would only contribute a couple of new stories over the next year. Though there would soon be no more new material from this dynamic duo, their gory stories would live on in a zombie-like reprint afterlife.

Besides Johnny Bruck's Perry Rhodan covers, there were plenty of other new (to the company) pieces of art popping up everywhere. Fass and Burgos brought in a gorgeous, colorful batch of paintings from Spanish artists. A far cry from Alexander's fun, action-packed madness, these somber yet still horrifying pieces had more of a Warren look to them than the usual Eerie Pubs cover.

Ironically, Eerie Publications beat their rivals to the punch by publishing a cover by Enrique Torres (Enrich) a few months before Warren first published his work on *Eerie* #35 (Sept. 1971). *Tales From the Tomb* V3 #3 (June 1971) and *Tales of Voodoo* V4 #4 (July 1971) feature portraits derived from the horror films *Horror of Dracula* (Hammer, 1958) and *The Mummy* (Universal, 1932) respectively. These paintings, done by a younger Enrich, first

saw print in Spain as the covers to Géminis Publishing's *Narraciones de Terror* pulp mags in 1968. Enrich would go on to be the premier cover artist for Warren's *Vampirella* within a few years. Here, his technique isn't as accomplished as his Warren work would be, but the black backgrounds and muted colors are still very effective.

Other fine paintings were used in the post sci-fi era, including some by Fernando Fernandez, a prolific, successful and incredibly talented artist who would also lend his talents to Warren's *Vampirella* magazine in the near future. His work was done specifically for the Pubs, though it was done pseudonymously as "Saldaña." A female friend of his was the model for many of his Pubs covers. A real downer, however, was the continued practice of reusing old cover images.

With the return to full-fledged horror, Burgos again resorted to cobbling together previously used artwork to create new covers. Sometimes, he would just zoom in on one part of the cover, stick in another figure, and cut and paste. The worst example with a 1971 cover date may well be September's *Tales of Voodoo* (V4 #5) which takes Bill Alexander's fine cover from *Horror Tales* V1 #8 (Aug. 1969) and essentially puts the ripped-up gal back together, and covers up bloody bits with a zoom and an incomprehensible picture pasted in from the February cover of *Tales From the Tomb* (V3 #1)... an image from

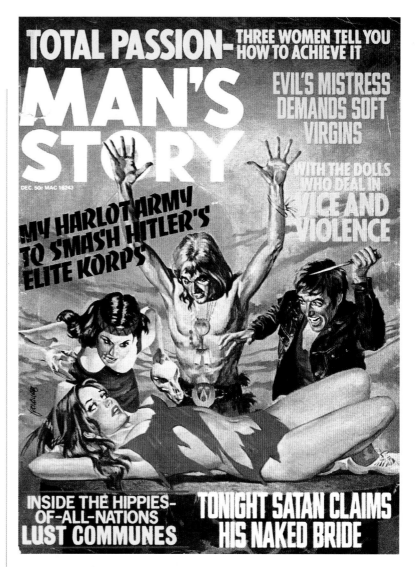

Top:
A familiar pose from Fernandez's favorite model, as seen on ***Man's Story*** V12 #6 (Em Tee Pubs, Dec. 1971)

Bottom: Karloff makes the cover of ***Tales of Voodoo*** V4 #4 (July 1971) art by Enrich

Right:
Text illo by
Ezra Jackson;
from the story
"The Vampires"

Bottom:
Horror Tales
V1 #8
(Aug. 1969)
Alexander art

earlier that same year! Burgos also painted over Alexander's original ghoul's face. Innovative, it ain't.

Worse still was the decision to run text stories in their comic books. Back in the pre-code days, comic books had to have at least two pages of text to qualify for 2nd Class mailing, which offered a less expensive postal rate. Text stories were a necessary evil. The decision to run a text story (or two!?!) in a black-and-white horror comic magazine had no other purpose than to inexpensively fill pages. The only good thing that I can say about this idea is that it gave Ezra Jackson a chance to do some nice illustrations to accompany the stories, which were sometimes yarns that had appeared 40 years (or more) prior in *Weird Tales*, *Strange*

Tales and other pulp magazines. These text stories, some as long as eight or 10 pages, printed alongside the same old overused Ajax reprints, make some of these late 1971 issues pretty tedious reading. (For all of the dirt on the text stories and a checklist, see Appendix 7— Taking up Space.)

Meanwhile, the folks at Skywald were putting up some good numbers with their all-original horror magazines. They had partially gone the "continuing character" route, with monsters like Frankenstein and the Heap returning month after month for further horrible adventures. Skywald's *Nightmare* and *Psycho* always had excellent covers and interior art, including new work from erstwhile Eerie gang member Chic Stone.

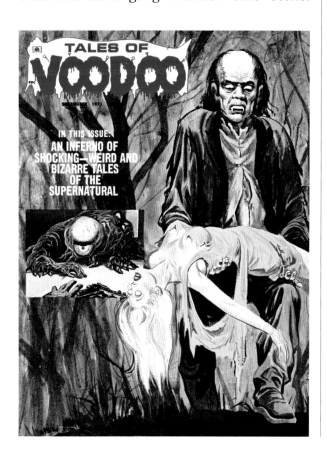

Bottom: The incomprehensible taming of the **Horror Tales** cover, from **Tales of Voodoo** V4 #5 (Sept. 1971)

Left: Another text illustration by Ezra Jackson, from "The Vampires"

Crime Does Not Pay V3 #2 (June 1970) Alexander art

consisting of nothing but reprints with poorly drawn new covers (and a few nice, reprinted pre-code ones). Morse had stolen a little bit of the market from Warren and Countrywide, but with the addition of Skywald's product, there was just no point anymore. Again, some of Morse's reprints (of pre-code Gilmore stories) that he ran in his magazines were on the stands concurrently with Eerie Pubs' redraws of the same stories.

Even Warren had been treading on thin ice in the early '70s, resorting to reprinting stories from earlier, better issues, but they shook things up and came roaring back with a new group of excellent artists and stories. This jump start may be due in part to the competition that Skywald had started to provide. If there was still a keen sense of déjà vu for the horror fans shopping at the drugstore magazine rack in 1972, it was probably Burgos' cobble-and-repaint covers that were to blame.

In the first half of 1972, over a dozen covers appeared from Eerie Pubs with parts that had been used before. Some amount of credit should be given to Burgos, I guess, for doing some original art on the new covers, but their origins are obvious. One wonders if the new creatures were sometimes painted right on top of the original painting to create those "new" covers. Most forgivable is the repainted cover for *Terror Tales* V4 #4 (June 1972) which took one of Alexander's dynamic *Crime Does Not Pay* covers and painted monsters

Stone's Skywald stuff was nice, but it's not the cornucopia of carnage that his Pubs work was. Skywald also put out a comic-sized four-color comic book in 1971, *The Heap* (Sept. 1971) that, ironically, padded out its pages with a few reprints from Waldman's stash, pre-code stories that were also being redrawn by Eerie Pubs right around the same time.

Mid-1971 marked the end of Stanley Morse's line of horror comics. In two years, he had published four titles, *Chilling Tales of Horror, Shock, Ghoul Tales* and *Stark Terror,*

over the people, keeping the pose and action the same. Many horror fans may have missed the original cover (*Crime Does Not Pay* V3 #2, June 1970), so I'll let that one slide.

Burgos also contributed some excellent illustrations for those damn dispensable text stories that just kept on coming. Some of his illustrations were full-pagers and it makes one wonder why he didn't just do a few more and establish a pinup section instead of going with the text stories (that had tiny typeface that was difficult to read, anyway). Ezra Jackson did some knockout text illustrations as well. Personally, I've never EVER slogged though any of the turgid text tales over the years, but I love to admire the pen-and-ink work of Burgos and Jackson. Even Edgar Allen Poe's "Ms. Found In A Bottle" in *Tales of Voodoo* V5 #4 (June 1972), as great as it is, doesn't do it for me here. I want comics in my comic books.

Eerie Pubs' issue numbering and publishing schedule went askew early in 1972, but it more or less righted itself by year's end. Very little else changed for a time in Eerie Pubs-land. A

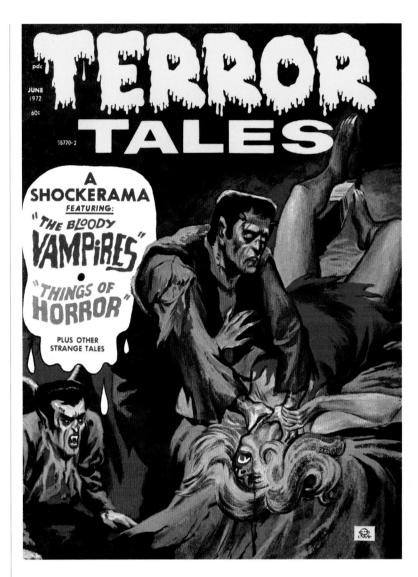

few titles juggled their contents page layouts, but most things remained static. Some issues were dire, displaying cobbled covers on the outside and a text story or two alongside the well-worn reprints on the inside. The Morris pages even returned to take up space in some issues. Hell, the Ajax reprints were still being used; some had been in rotation since 1966. I guess if I had to say something positive about it, at least readers in 1972 still got to see Matt Baker's luscious artwork.

A few bright spots were poking through,

Top: Burgos re-imagines Alexander's crime cover as a horror piece, *Terror Tales* V4 #4 (June 1972)

Bottom: A typically nice text illustration by Carl Burgos, for "The Mummy"

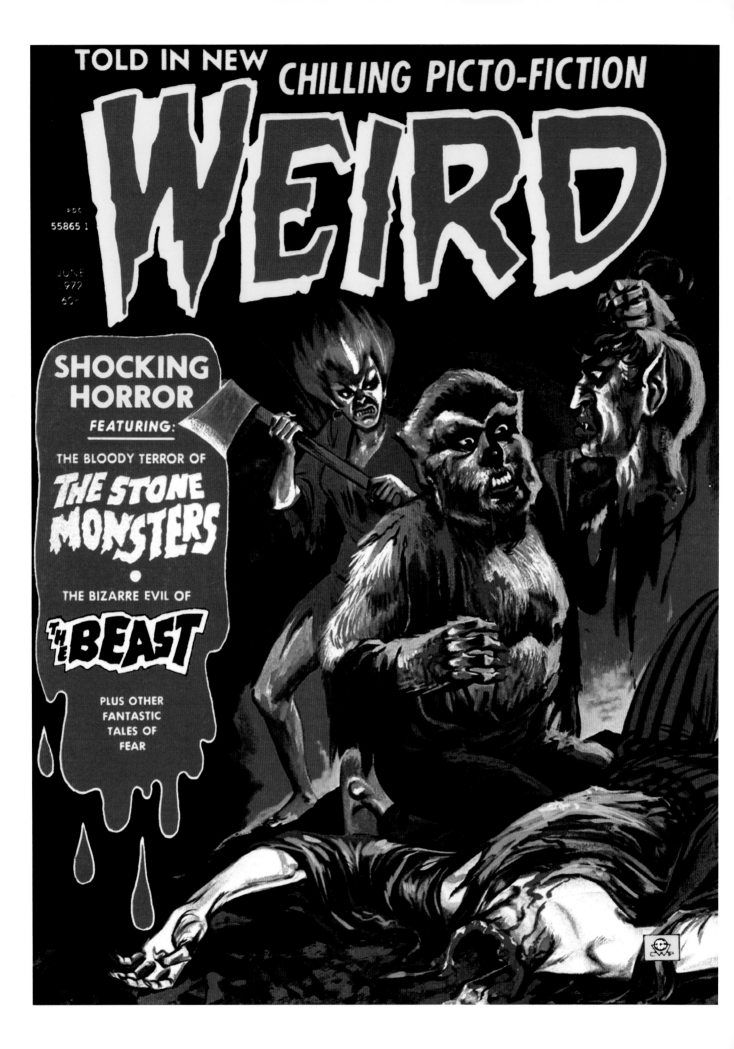

however. A trio of artists, again, all from Argentina, started contributing some excellent stories to the Pubs. Rubèn Marchionne, Alberto Macagno and Domingo Mandrafina all had distinct art styles that were exciting and accomplished, bringing a much-needed kick in the ass to an issue that might not feature anything else worth admiring. They were all young and had a lot to prove, and it shows in their work. The three of them also brought

a little more sex appeal to the art. Whereas Ayers and Woromay were all about the gore and Reynoso was more about the mood, "Las tres M" (as their studio in Argentina was known) could also draw a fine female figure, and horny guys have always appreciated that. A nipple or two was known to peek out from time to time in their stories, a rarity in the Pubs (though not in Warren's books).

Besides a nipple shot and couple of belated Woromay stories, his last for the company, the most exciting event during this time period was the return of Bill Alexander. His cover to *Weird* V6 #4 (June 1972) was vintage Alexander:

Opposite: Bill Alexander's welcome return to Eerie Pubs, **Weird** V6 #4 (June 1972)

This page: Las Tres M, high points during a low time

Top left: Alberto Macagno's "The Swamp Devils"

Top right: Ruben Marchionne's "The Monster"

Bottom: Domingo Mandrafina's "The Devil's Witch"

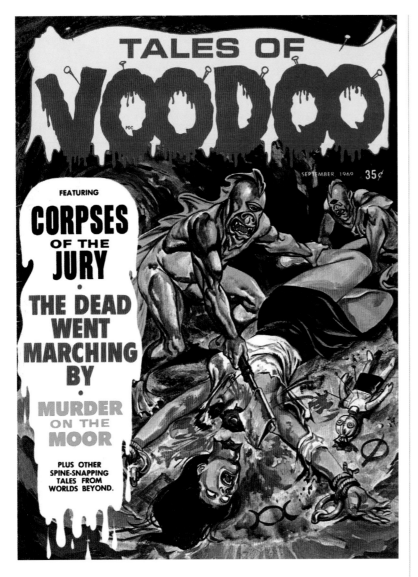

Alexander's mind bending cover to *Tales of Voodoo* V2 #4 (Sept. 1969)

background. New lows were hit with the most hideous censoring of any Eerie Pubs cover on *Terror Tales* V4 #6 (Oct. 1972). Bill Alexander's revolting decap cover from *Tales of Voodoo* V2 #4 (Sept. 1969, back when hard-gore was still encouraged) was disturbing, visceral and brilliant. Burgos' sanitizing of that cover breaks my heart. Not only is the head attached and the axe-wielding ghoul repainted to look like a green teddy bear, the otherwise untouched background Cyclops was given a second eye. What the fuck was that all about?

Alan Crouse, the proud owner of an original Bill Alexander cover painting (*Horror Tales* V5 #1, Feb. 1973) explains that the extra monster that was pasted onto the art was actually clipped from a printed cover. The green-faced guy, originally seen on *Tales From the Tomb* V3 #6 (Dec. 1971), was simply cut from the cover of the magazine, pasted onto Alexander's new art, and with some added blood, Burgos had his multi-monster artwork ready to go.

Finally, at the end of 1972, the Ajax stories started to thin out. The early 1973 issues would have one or two, then none. They were laid to rest at last. The text stories also were disappearing and by early 1973 only making the occasional guest appearance. Taking their place were reprints of the earlier Eerie Pubs-commissioned stories. Most issues had one or two old stories drawn by Ayers, Stone or Woromay reprinted amongst the new art, keeping the gore level artificially

frenetic, colorful and completely implausible. He painted 11 of the last 20 covers with a 1972 date, and more than a dozen in 1973. It was damn good to see his stuff again. By this time, he was no longer contributing to Fass' girly magazines, but he was keeping extremely busy as a cover artist over at Star Distribution.

Despite Alexander's return, the cobble covers continued. That damnable cover of *Tales of Voodoo* V4 #5 (Sept. 1971) got new life on the December 1972 issue of *Weird* (V6 #7), just sticking the main image onto a new

high. These reprinted stories were sometimes slightly retitled, as if that would disguise their replication. Artist signatures were often removed or changed; Oswal's name was even changed to Oswald for some repeat printings. The new stories, now done exclusively by Argentine artists, were not as blood-soaked and nasty as what had come before. Despite continuing to mine the Harvey horror titles for gold, the pre-code comic stories that delivered the gruesome goods were running out.

Instead of the horrific stories copied from Gilmore, Trojan and Story, Burgos was forced to dip into Prize's *Black Magic* pre-code comics for stories. A Joe Simon and Jack Kirby production, the title usually featured an S & K story backed up by a few lukewarm horror tales. Only once was one of the leadoff S & K stories adapted, but the backups were used frequently. One wonders if Burgos avoided those stories out of respect for the duo, or because he knew that DC was planning a revival of the title *Black Magic* which would reprint those particular pre-code stories.

American Comics Group (ACG) had never been used before for source material, but one issue snuck into the world of Eerie Pubs. *Adventures Into the Unknown* #26 (Dec. 1951) was pilfered for three of its stories. This seems to be the only time that an ACG comic was copied for stories. ACG had gone belly-up in 1967, so it was fair game, but they wrote notoriously dull horror stories; it's surprising

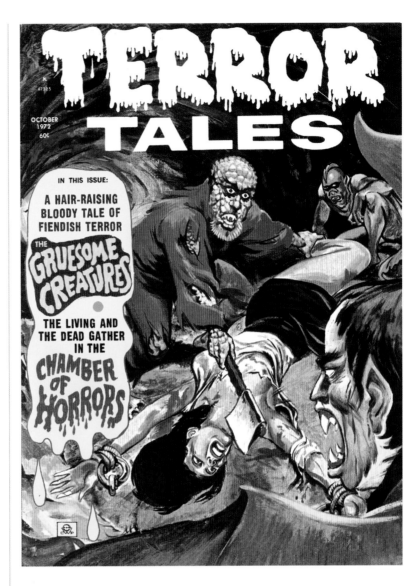

that Burgos deemed their work worthy of appropriating.

Morris's age-old *Weird Facts* pages hadn't resurfaced for a year or so, but Ezra Jackson delivered some one-pagers culled from Harvey's comics. Jackson also had been back to the drawing board and did a couple of full stories, his first since 1970. His tale "The Demon Is a Hag" in *Witches' Tales* V5 #3 (May 1973) is a joy to behold, full of haggard witch panels that display Jackson's usual excellent brush strokes and attention to detail. Another

This page: Burgos repaints and destroys a classic cover on ***Terror Tales*** V4 #6 (Oct. 1972)

Next page: Oscar Novelle's first cover for Eerie, ***Witches' Tales*** V5 #4 (July 1973)

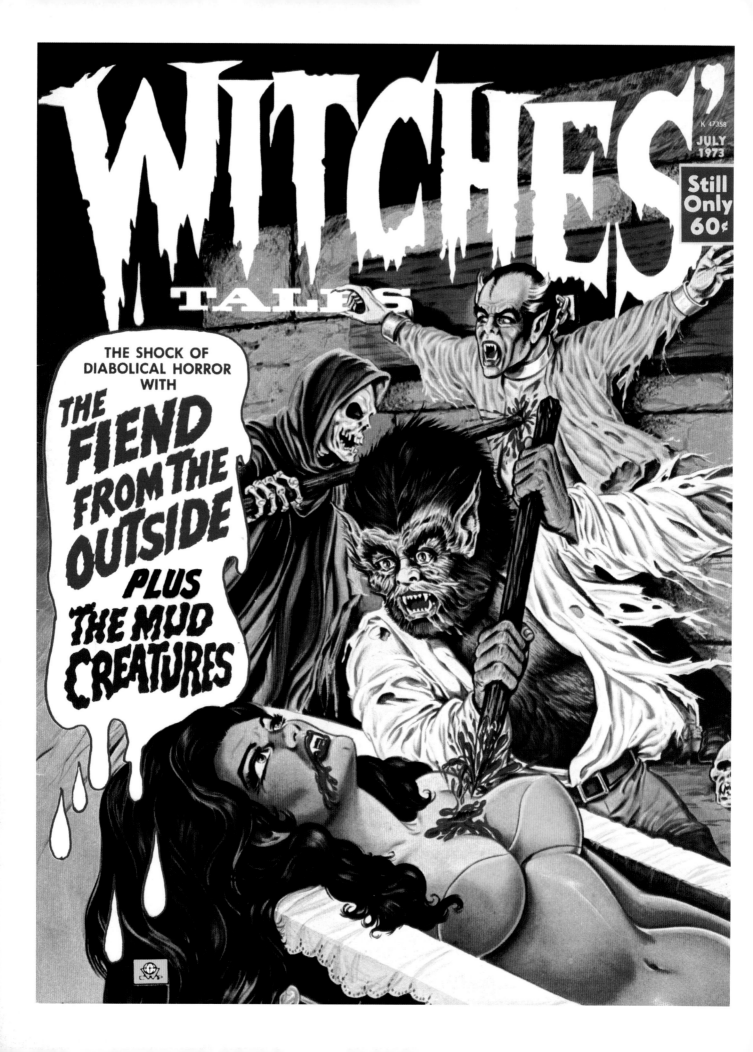

veteran Argentine comic artist named Enrique Cristóbal joined the Eerie fold in 1973 and hit the ground running, prolifically contributing stories to the sordid sextet.

Oscar Novelle, who had been around for a couple of years doing inside art for the Pubs, delivered his first cover to Burgos for the July 1973 issue of *Witches' Tales* (V5 #4). Like Alexander, Novelle commanded a vivid color palette and his covers are exciting and eye-catching (literally—*Weird* V7 #6 had the first good eyeball trauma to be seen on a Pubs cover in quite a while). Though Burgos would often supplement Novelle's covers with familiar background monsters clipped from other covers, his work stands on its own merits just fine, thank you.

Over at Skywald, things had gotten very exciting. In mid-1972, the editorial reins of the horror magazines had been handed over to a young man named Alan Hewetson, a former Marvel sideman (Stan Lee's assistant) and Warren writer. Under his tutelage, *Nightmare*, *Psycho* (and later, in mid-1973, *Scream*), became something very special. He dubbed his new concept in horror mags "the horror-mood," and set about writing some of the best horror comics of all time. Conjuring up Lovecraftian creatures, a dank, stygian atmosphere and horrible, odious scenarios, Hewetson's florid prose evoked an otherworldly hell place, filled with fetid demons, foulness and gore. He would have approved of that last sentence.

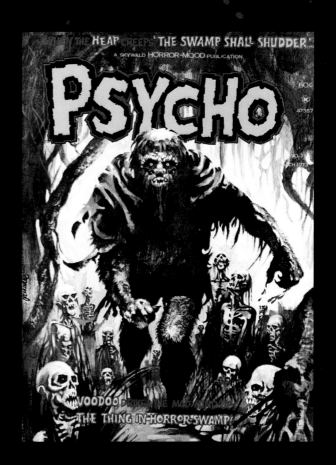

Skywald

To be honest, when I was a tot buying gruesome magazines back in the '70s, Skywald was my favorite publisher. Their art always appealed to me, their writing was more fun than their competition, and they were super gory. They were the best of both worlds: Warren's top-shelf writing and artwork and Eerie's graphic bloodletting. I also responded to the reader interaction, to being part of the gang. Plus, they offended family members.

One morning in the winter of 1972–73, my father came out from his morning "reading time" in our bathroom and slammed down my copy of *Psycho* #11 (March 1973), yelling "this is disgusting" before storming off. Of course, to me that meant that Skywald was far better than the other magazine outfits, and I was hooked.

Their output holds up very well today and I still find myself returning to them quite a bit, even now in my Golden Years. Maybe it's time to read "Make Mephisto's Child Burn" again…

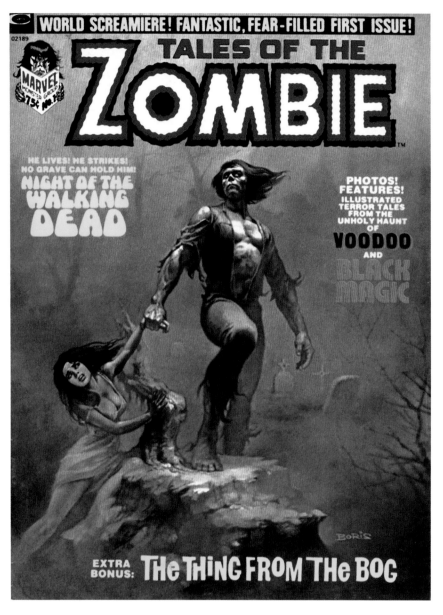

WORLD SCREAMIERE! FANTASTIC, FEAR-FILLED FIRST ISSUE!

02189

MARVEL MONSTER GROUP 75¢ NO. 1

TALES OF THE ZOMBIE

HE LIVES! HE STRIKES! NO GRAVE CAN HOLD HIM!
NIGHT OF THE WALKING DEAD

PHOTOS! FEATURES! ILLUSTRATED TERROR TALES FROM THE UNHOLY HAUNT OF VOODOO AND BLACK MAGIC

BORIS

EXTRA BONUS: THE THING FROM THE BOG

This page: Buff zombies for zombie buffs- Marvel brought its superhero mentality to the horror magazines. *Tales of the Zombie* #1 (Marvel- 1973) art by Boris Vallejo

Opposite: "The Demon is a Hag" by Ezra Jackson

The Skywald line was very reader-friendly, encouraging reader input, having giveaways, and offering fun inside peeks into the Skywald office life, with "Archaic Al" giving each member of his staff a morbid moniker (à la Stan Lee). The writers and artists were often incorporated into the stories. These magazines, my favorites at the time, were selling very well, a fact which bothered Jim Warren. He had warned his creators to stay

away from Skywald or else. Of course, many of them assumed pseudonyms and worked for both outfits. While Skywald might have been considered stiff competition to Warren, Eerie Pubs were at the other end of the spectrum. In a 1999 interview with Jon B. Cooke, Warren said, "Myron's magazines were definitely not second-rate. They were third-rate." He added, "Thinking about the number of trees that had to be cut down to make the paper for that drek makes me weep."

Marvel, no stranger to jumping onto bandwagons, had been publishing the black-and-white barbarian-themed comic magazine *Savage Tales* since 1971. In 1973, the company decided to cash in on the lucrative horror mag market. That summer saw Marvel invade with *Dracula Lives*, *Monsters Unleashed*, *Tales of the Zombie* and *Vampire Tales*. All of the titles contained very nice new stories and art, supplemented with pre-code reprints from their vast Atlas archives, with excellent covers by the likes of Boris Vallejo and Gray Morrow. Having left his post at Skywald, Sol Brodsky became the production designer for the Marvel line of magazines. Warren lost some of their talented creators, who migrated to Marvel and the higher pay rates that they offered. So, why do I find these magazines unsatisfying?

I have always found the original horror from Marvel in the '70s to be more superhero in nature than horror… kind of a supernatural hero, if you will. Most notably, Morbius, the star of *Vampire Tales*, is a buff costumed vampire. Zombie Simon Garth, for being dead, sure looked like he was in pretty damn good shape. Famous for their bestselling superhero comics, it seemed to me that the genre had seeped into everything that Marvel published. Despite excellent art, these magazines have always left me feeling a bit empty, in need of something more horrible. Of course, this is just my opinion. I wrote the book celebrating the genius of Eerie Pubs, so what the hell do I know?

With over a dozen black-and-white horror titles on the stands in 1973, it was clearly turning into a case of eat or be eaten. Warren was going strong, delivering mind-blowing, top-shelf art from a talented group of Spaniards. Skywald was riding the wave of the horror mood to good sales. Marvel, who would always turn a profit thanks to the "Marvel Zombies" who would buy anything published by the company, were poised to take a chunk of the market.

And Eerie Pubs kept chuggin' along, producing cheaply, printing cheaply and keeping their price at only 60¢, while everyone else had bumped their magazines up to 75¢. The oversaturated market was treading on thin ice, though, and there was no way it could hold forever. ✳

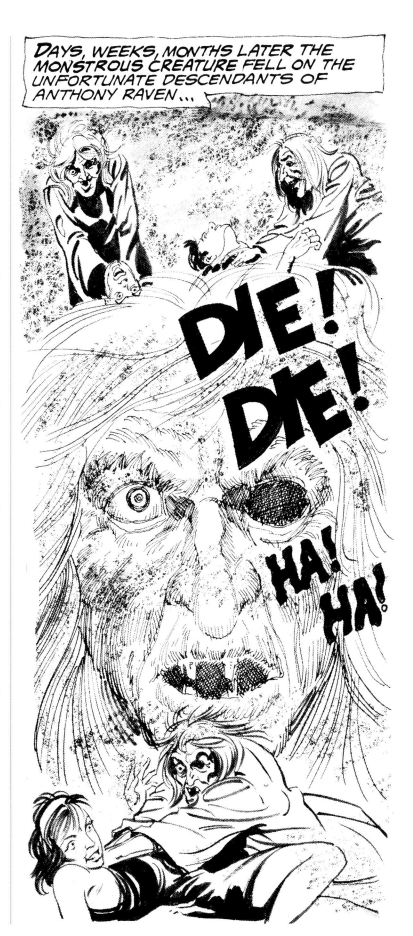

HOLD IN NEW

CHILLING PICTO-FICTION

WEIRD

K 47326

DECEMBER
1973

Still
Only
60¢

THE GRUESOME HORROR OF

THE SWAMP CREATURE

FROM BEYOND CAME

SATAN'S MAD DOG

PLUS OTHER
STRANGE TALES
FROM
WORLDS UNKNOWN

C'MON, YOU CAN MAKE IT! ANYTHING IS BETTER THAN MORE... **TORTURE!** TRY-- TRY-- **TRY!**

DON'T STOP NOW... YOU'VE MADE IT! **DON'T STOP!**

Chapter 8

THE DECLINE OF EERIE CIVILIZATION

SOMEHOW, amidst the chaos, Country-wide managed to change locations once more, this time just across the street to 257 Park Avenue. This address is where the company would reach its highest peaks. Unfortunately, Eerie Publications would not really be a factor in that success.

As original 1950s pre-code horror scripts became scarce for usable Eerie Pubs stories, Burgos turned to the ever-reliable Ajax stories. Sure, many of them had been reprinted multiple times before, but if they were reinterpreted with new artwork, who would be the wiser? At the end of 1973, dozens of Ajax stories (that had been reprinted in their more or less original form over the past seven years) became fodder for the re-draw system. Though the tales were very familiar, the new and updated art gave these stories new life and an excitement more fitting for the '70s.

Apparently, Burgos provided the artists with copies made from his own magazines this time around, rather than from the original '50s pre-code books. I say this because all of the new work was redrawn from stories that had seen print in earlier Pubs, and some of them were from the "cleaned up" Ajax stories. For example, Reynoso's "Eye of Evil"

Opposite:
Weird V7 #7 (Dec. 1973) art by Behan

This page: From "The Rack," illustrated by Cirilo Muñoz

While You Were Reading
Their Gruesome Horror Comics...

...Countrywide was putting these titles together right in the same office.

Top left to right: *JFK*, 1974, *Dogs* V2 #9 (June 1972), *Cycle* V3 #11 November 1970
Middle left to right: *Stud*-V5 #4 (Mar. 1974), *Countrywide's Build-It Book* V3 #1 (Jan. 1973), *Masters of Self Defense* V1 #3 (Oct. 1974)
Bottom left to right: *Countrywide Sports V1 #7* (Feb. 1971), *Man on the Moon* (1969), *True Romantic Confessions V8 #1* (Aug. 1974)

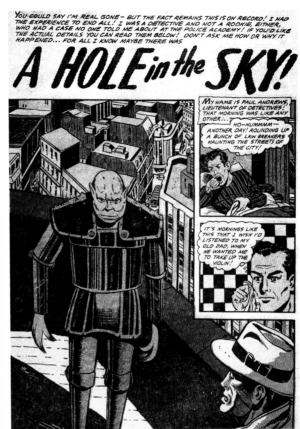

Redrawing Ajax

Top left:
"Monster in the Building," as it first appeared in **Strange Fantasy** #14 (Oct. Nov. 1954)

Top right:
The code-friendly, sanitized version "A Hole in the Sky," as it appeared in **Strange Journey** #2 (Nov. 1957) as well as in a handful of Eerie Pubs.

Bottom right:
Antonio Reynoso, handcuffed with the lame post-code version, pulls out all the stops for his Pubs redraw ("Eye of Evil")

follows the text of "A Hole in the Sky" from *Strange Journey* #2 (Ajax 1957), which was the sanitized cobble-job of "Monster in the Building" from *Strange Fantasy* #14 (Ajax 1954). That code-friendly version is what Farrell provided for early appearances in the Pubs. It would have been nice to see a remake of the original, harder-edged story but the art for it wasn't to be had. True to form, Reynoso makes the most of the weaker script and delivers a memorable monster-piece.

Ezra Jackson's work became scarce in 1974, with Burgos doing the bulk of the retouching and no new text stories being run that would need illustrations. Some of the well-known older text pieces were recycled a few times, though. The Pubs continued

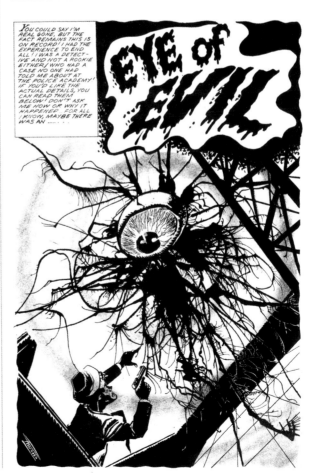

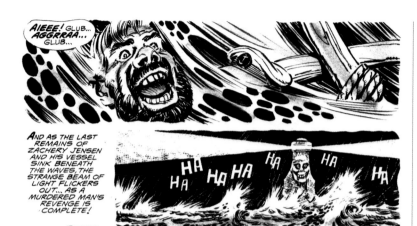

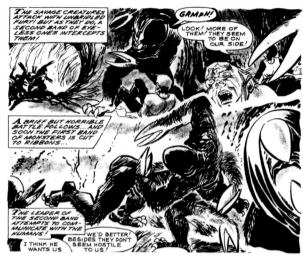

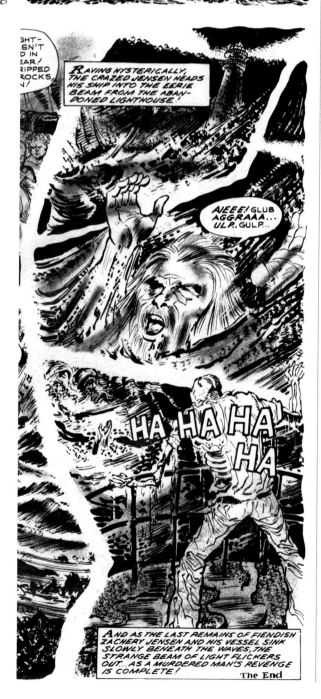

When two artists get the same story, it's fun to compare the results.

Top Left: Mandrafina's "Lighthouse of Horror"

Bottom left: Cristóbal's "Lighthouse Terror," both redraws of "Beam of Terror," from *Tomb of Terror*

Top right: Reynoso's "The Blind Monsters"

Bottom right: Casadei's "The Blind Terror," again, both redrawn from *Tomb of Terror* #7 (Jan. 1953)

Opposite page: Oops! Cirilo Muñoz gets his voice balloons mixed up and the crack editing crew didn't catch it. From "Satan's Toys"

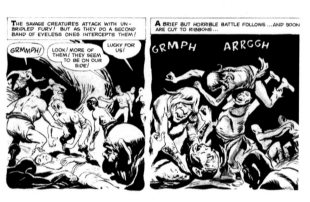

the cover cobbling, sometimes to good effect, but with some covers getting a *third* makeover, with Burgos painting over a cover he'd already painted over once before! Things were definitely getting stretched a bit tight. A couple of covers were reprinted entirely, with maybe a new monster added to the background, or the image flipped. The worst offense is the Oct. 1974 issue of *Weird* (V8 #4) that completely reused the cover for the June 1972 *Weird* (V6 #4), right down to the words in the blood splash; only the story titles had been changed. Close inspection reveals the old date in the upper left corner is blacked out, though it's still legible. They didn't even try on that one. The entire issue is a reprint, too.

Other signs of carelessness were showing toward the end: printing stories out of sequence (Marchionnes' "Shadow of Evil" in *Weird* V8 #1, Feb. 1974), more numbering inconsistencies, and having stories redrawn more than once. It seems that the entirety of *Tomb of Terror* #7 (Harvey, Jan. 1953) and some stories from Prize's *Black Magic* #32 and 33, as well as some other Harvey stories,

Let's Don't Get Personal

Warren had a letters page and encouraged reader feedback. So did Marvel's black-and-white magazines. Skywald took reader interaction to the next level, with not only a letters page, but with reader's survey questionnaires and contests, including having fans' nightmares written up and drawn into comic strips.

This just wasn't part of the Eerie Pubs plan. They had little to no reader interaction. Some of the early "Morris" pages had him talking to the reader and there are some accidental instances of a horror host speaking to us, when the pre-code comic that was being redrawn had such a character. Otherwise, everything was interchangeable and impersonal.

But then, there was the nice "free information" advertisement that ran in some issues in 1974. An eye-poppin' Ayers ghoul makes us an offer we can't refuse! Ah, it's nice to be part of the gang!

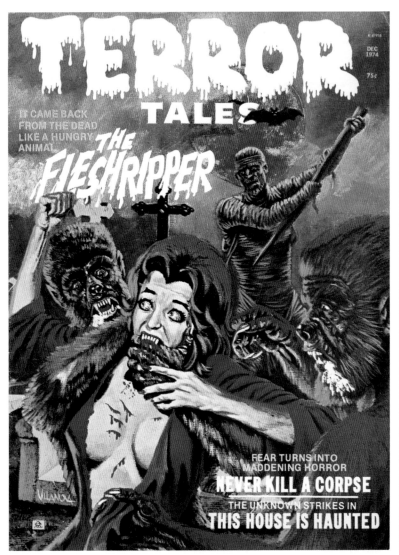

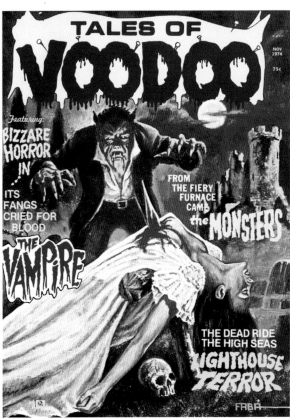

Top left: **Terror Tales** V6 #6 (Dec. 1974) art by Vilanova

Bottom left: More werewolves on the last issue of **Tales of Voodoo** V7 #6 (Nov. 1974) art by Fába

Top right: Muñoz's "Screaming Hell"

Opposite page: Mandrafina's "Pool of Horror" both interpret "Colony of Horror," again from **Tomb of Terror** #7

were divvied up to two different artists. The same story would appear twice in magazines barely a month apart, with the later one sometimes being slightly edited for text, but still very obviously copied from the same source material. Oscar Fraga drew the same story twice himself, with practically the same title given to it both times! It proves that Carl Burgos and Fass had become blasé about the operation and were just going through the motions, even more so than usual. Myron Fass was a big-time publisher and he wasn't one to waste time or money on a dying genre.

A few more nice covers appeared while the axe was falling. Some more Spanish acquisitions surfaced late in 1974, including a lovely werewolf cover from Skywald regular Salvador Fabá, which incorporates both a Warren and a Skywald art swipe. That may be how the painting became available to Fass, who obviously had no qualms about using borrowed images. Ironically, the artist of Skywald's *Scream* #3 (Dec. 1973), one of the covers that inspired the Fabá art, was painted

by Xavier Vilanova (another Skywald regular). He contributed his own fab werewolf cover to *Terror Tales* V6 #6 (Dec. 1974). There was another smattering of Novelle covers, then *pffffft…* no need for new covers. Or any covers.

The end came swiftly. Over a dozen black-and-white horror comic magazines glutted

Shadow of Death

Having the same story redrawn twice is a forgivable mistake considering all of the story piracy going on. Letting the same story get drawn by the same artist twice, however, is just plain lazy. Oscar Fraga handled the story "Shadow of Death" from Harvey's *Tomb of Terror #7* (January 1953) two times, barely a year apart. His layouts and designs are fairly similar in both (he was fond of using the originals for inspiration) and the titles are "Vampire" and "The Vampire." Let's just hope that he got paid twice.

Oddly enough, this story was blatantly ripped off back in the day as well. In the September 1954 issue of Charlton's *Strange Suspense Stories* (#21), there is a panel-by-panel and scene-for-scene remake of "Shadow of Death" called "This Bite is Sweet." Evidently, Charlton's scriptwriters (who were not against lifting an idea or two from the competition, especially EC) were so taken by the *Tomb of Terror* story that they felt the need to redo it exactly. Only the names were changed (and some dialog and text reworded), and it wasn't to protect the innocent. The Eerie versions were taken from the Harvey original. (The Pubs never used Charlton comics for stories as they were still in business during the Era of Eerie.)

For my money, the Charlton story had the best title, though.

"Vampire," first seen in *Tales of Voodoo* V7 #6 (11/74)

"The Vampire" was first seen in *Witches' Tales* V5 #5 (9/73)

103

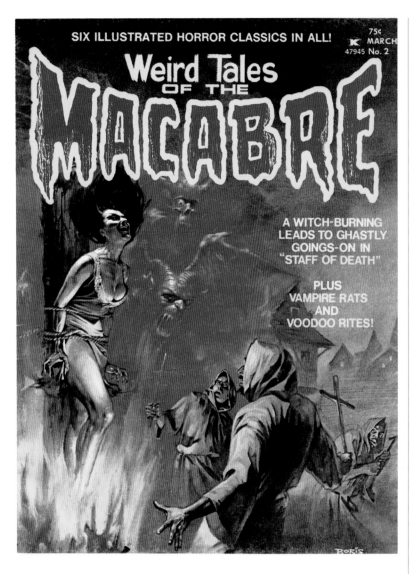

SIX ILLUSTRATED HORROR CLASSICS IN ALL!

75¢ MARCH
47945 No. 2

Weird Tales OF THE MACABRE

A WITCH-BURNING LEADS TO GHASTLY GOINGS-ON IN "STAFF OF DEATH"

PLUS VAMPIRE RATS AND VOODOO RITES!

BORIS

Atlas/Seaboard's excellent but poorly timed *Weird Tales of the Macabre* #2 (Mar. 1975) art by Boris Vallejo

the newsstands every month, fighting for the chance to attract a reader. Many of them were Marvel productions. Skywald's Alan Hewetson put it best in his book *The Complete Illustrated History of the Skywald Horror-Mood* (Headpress, 2004). Of Marvel, he says, "… they really did destroy the market in the correct and full sense of the word." He surmises that their distributors, Curtis Distribution, bullied the competitors' magazines off of the shelves. It's true, Marvel was THE big boy in the industry, and any news agent worth his

salt would rather display a surefire Marvel hit rather than a Skywald or an Eerie Pub, no matter how much those independents had sold for him over the years. The smaller companies' magazines became hard to find. The U.S. economy was in the crapper at this time and unemployment was sky high. People had less money to spend on horror comics, as hard as that might be to believe.

Coming out of the gate in a blaze of unbelievably bad timing, Atlas/Seaboard chose those turbulent months to release not only a trio of black-and-white magazines (two horror and one adventure), but nearly two dozen color titles. Martin Goodman, the founder of the company that had become Marvel Comics, decided to have a go with a new enterprise and compete with Marvel (which he'd sold in 1968 and retired from in 1972) and Warren. Goodman's son had just been sacked at Marvel, so the venture seemed vengeful and right. Seaboard's two entries into the black-and-white horror sweepstakes were *Weird Tales of the Macabre* and *Devilina*, the latter a knockoff of Warren's *Vampirella*. The artwork was top-notch and the magazines were beautifully packaged, but a little bit of market research should have told Goodman that this was going to be a losing venture… and it was.

Near the end of 1974, the horror magazine market imploded. Eerie Publications and Skywald barely squeezed out anything with a 1975 cover date. The final Pubs books, all

Is the Third Time REALLY the Charm?

In 1974, things got a bit out of hand with reusing old artwork. Carl Burgos decided to give a second face lift to a couple of older, redone covers. The results are OK, but they really do nothing to hide the fact that they are reprints… painted over, but reprints none the less. The originals are both by Alexander.

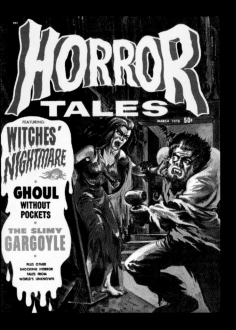
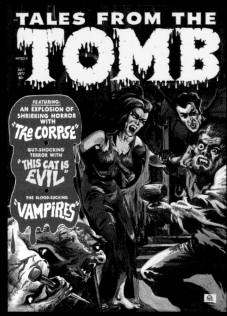
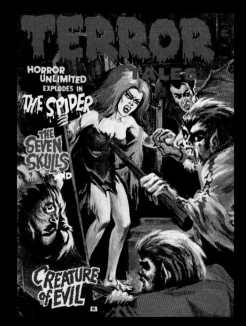
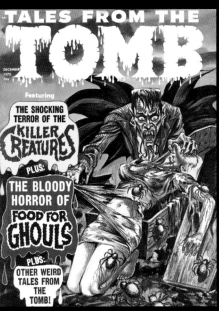
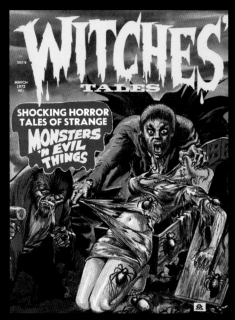
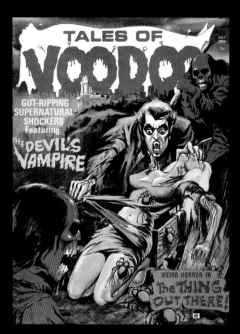

Top: *Horror Tales* V2 #2 (Mar. 1970), *Tales from the Tomb* V4 #3 (July 1972), *Terror Tales* V6 #5 (Oct. 1974)
Bottom: *Tales from the Tomb* V2 #6 (Dec. 1970), *Witches' Tales* V4 #2 (Mar. 1972), *Tales of Voodoo* V7 #4 (July 1974)

TALES FROM THE TOMB

NOV 1974

75¢

FROM THE COLD GRAVE CAME

A DEAD THING AMONG US!

FRIGHT RUNS WILD IN "MONSTER"

TERROR IN BLACK

EXPLODES WITH HORROR

cover dated February 1975, all numbered Volume 7 #1, and all with uninteresting cobble covers, are *Horror Tales*, *Tales From the Tomb*, and *Witches' Tales*. Skywald's swan song was *Psycho* #24 (March 1975), a mag that promised great things for future issues that would never see the light of day. Marvel themselves only lasted a few more months; their titles had pretty much disappeared by the summer. Seaboard's offerings only lasted two issues each and died in early spring, along with their color comics. Warren, clearly the one to beat all along, stayed their course and held on throughout the battle. They wound up being the only real survivors, with *Creepy*, *Eerie* and *Vampirella* still going strong (and continuing until 1983), along with *The Spirit*, a magazine reprinting Will Eisner's iconic noir crime fighter.

Though I'm a rabid fan of all horror comics, it's fair to say that the cream really did rise to the top. As excellent as the Skywald product was and as ballsy and unblushing as the Eerie Pubs were, Warren's magazines were arguably the best and deserved to continue carrying the torch. They lit that torch in the first place.

While this marked the end for the original Eerie Publications crew, the end of his tenure as a horror comic publisher was a mere blip on Myron Fass' screen. It was just another publishing venture; by this time it was no more important to him than his skin mags, his scandal rags or his celebrity gossip books.

When a magazine was no longer turning a profit, it was killed and replaced with something else. Carl Burgos stayed, editing Countrywide's war magazines, but soon moved on. Ezra Jackson went on to do some artwork for Gold Key, then disappeared from comics. Irving Fass would always have a job as big brother's "art director," so the folding of the Eerie Pubs line, to which Irving contributed little more than his name on the contents page, didn't shake his world too much. He still owned his share of the company's stocks.

Eerie Publications. They were fun while they lasted, and they lasted a hell of a lot longer than all of the other Warren Wannabes. ✳

Opposite:
Tales from the Tomb
V6 #6
(Nov. 1974)
Vilanova art

This page:
Novelle's last Pubs cover,
Witches' Tales V6 #6
(Nov. 1974)

COLLECTOR'S EDITION

p.d.c.
59142-1
$1.00

Nixon

cockeyed

THE GREATEST MAGAZINE EVER PUBLISHED

DICK TO PLAY KOJAK— TELLY OUT!

THE MOST SHOCKING PICTURES OF PAT EVER PUBLISHED

PERSONAL PIX OF DICK & PAT AT PLAY!

THE INTIMATE RELATIONS OF GOLDA AND DR. KISSINGER

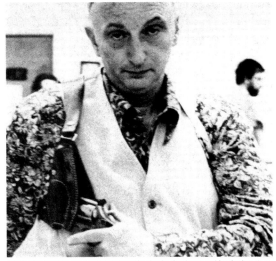

The best shot in the world will find himself quite dead unless capable of a fast draw. Myron Fass demonstrates the proper way to pull a concealed weapon from the Berns-Martin holster.

LIFE IN THE FASS LANE

IT WAS THE END of an era for horror fans. Warren would still whet our wicked appetites for black-and-white horror, but even the color comics by DC and Marvel would soon start to fade. Within a few years, the horror comics market would all but dry up again.

Myron Fass and Countrywide didn't skip a beat. So their horror comics went kaput… so what? The skin mags were selling, so a few more were introduced. *Flick* made its debut in 1975, devoting its pages to X-rated movies. *Jaguar* and *Duke* were still going, getting sleazier as the years progressed. *Stud* (formerly *Buccaneer*, which was formerly *Poorboy*) was soon joined by *Erotica* and *Brut*, an S&M mag. Fass was definitely giving his smut patrons, with their sweaty little crinkled-up dollar bills, some shopping choices.

Scandal sheets and confidential-styled magazines continued to flourish. Fass never strayed from his tried and true path of pulp perversity; he was proud of his lowbrow heritage. Sensationalism had been very good for him, so he wasn't going to mess with a good thing. TV and gossip magazines, sports magazines… anything that would sell, Countrywide had a magazine for it. If 35% of the print run sold, they would break even.

Opposite: THIS is what we lost our horror comics for?!?! ***Nixon Cockeyed*** (1976)

This page: Myron Fass—armed and ready to publish dangerous magazines

Top: Howard Smukler's premier issue of *Ancient Astronauts* V1 #1 (Winter 1975)

Bottom: Ezra Jackson's Pubs story earns its own title… in Australia, published by Gredown Pty Limited (cover courtesy of Daniel Best)

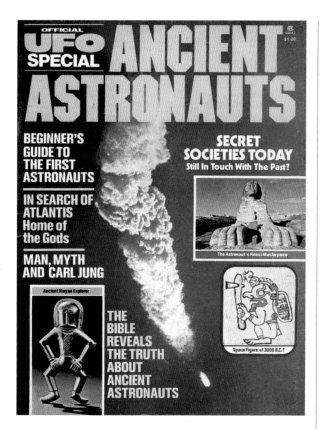

1975 also marked the beginning of one of Countrywide's most successful titles, *Official UFO*. Jam-packed with grainy shots of flying saucers and loaded with pseudo-scientific space jargon, this magazine never failed to entertain. It enjoyed a long life and spawned a spin-off, *Ancient Astronauts*, which was also very well received.

During this time, while piles and piles of artwork were lying around unused, Fass and Harris licensed some of the Eerie Publications stories to a publisher in Sydney, Australia called Gredown Pty. Limited. Gredown had some very whacked-out comics. Their innards were comprised of not only Eerie Pubs, but also Charlton's ghost comics, some Skywald stuff, Atlas/Seaboard material and other things I can't identify. The horror mags all showcased

nice, colorful covers (which were sometimes reversed or zoomed in on for reusing, in a most Pubs-esque fashion), black-and-white artwork (horribly reproduced, for the most part) and no advertisements, all printed on super cheap paper. Sounds vaguely familiar, eh?

The most fun aspect of Gredown horror comics are the names of the magazines. Very few titles were used more than once (a few series, such as *Strange Experience*, ran for 10 issues) and some of the names are quite spectacular. Among my favorites are *Vile Tales of Havoc*, *Orgy of Destruction* and *Loathsome Ghosts*. One of Ezra Jackson's excellent Pubs stories earned its own Gredown title in *The Demon is a Hag*. The covers are mostly new on these books (to American eyes, though some

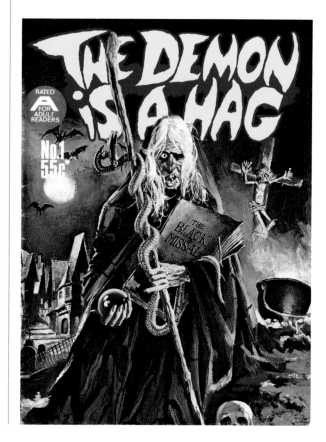

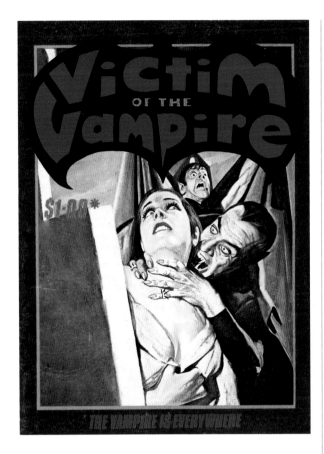

had been seen in Europe), although *Victim of the Vampire* uses the Fernando Fernández (Saldaña) cover which had first appeared on *Tales From the Tomb* V3 #6 (Dec. 1971). If Countrywide licensed their cover art as well as the inside art, I don't know why Gredown didn't use other Eerie Pubs covers.

A Day In The Life at Countrywide

Howard Smukler worked at Countrywide in 1975 and 1976, editing the magazines *Ancient Astronauts* and *ESP*. He was kind enough to

tell me some stories and offer a taste of what it was like to work for Myron Fass at 257 Park Avenue, New York City.

The Countrywide office was one huge room, lined with rows of desks for about 30 employees. There were no cubicles, just the desks in a common area. Myron Fass and Stanley Harris had their own offices.

Fass was in the habit of hiring young, inexperienced kids as editors. He would teach them the ins and outs of the industry and how to put together a magazine efficiently and quickly. He liked the youngsters because he could pay them next to nothing ($100 per finished issue, which would take roughly a month) and mold them into what he wanted: subservient employees. The young editors were not editing for money (obviously), but for exposure and experience. That said, Chuck Dixon, who did art for Countrywide's adult comic book *Gasm* in 1977, said that Fass always paid on time. Not much, but on time.

Fass, a notorious gun enthusiast, wore a loaded piece around the office and claimed to be a master marksman. He also liked to terrify the youngsters in his employ. He would call one of the green editors into his office to point out a typo in an article, all the while waving his gun or just having it in sight on his desk. "It scared the shit out of them," said Smukler. Fass told the *Village Voice* in 1977 that one kid got so scared that he vomited.

One young editor produced his first

Fernando Fernández's slightly retouched Eerie Pubs cover pops up down under on *Victim of the Vampire* (Gredown)

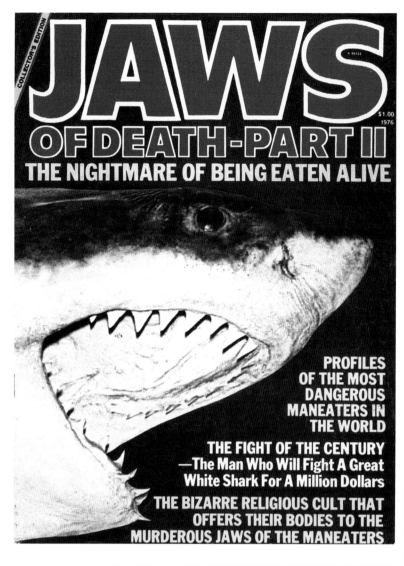

JAWS
OF DEATH—PART II
THE NIGHTMARE OF BEING EATEN ALIVE

PROFILES
OF THE MOST
DANGEROUS
MANEATERS IN
THE WORLD

THE FIGHT OF THE CENTURY
—The Man Who Will Fight A Great
White Shark For A Million Dollars

THE BIZARRE RELIGIOUS CULT THAT
OFFERS THEIR BODIES TO THE
MURDEROUS JAWS OF THE MANEATERS

magazine and, filled with pride, zapped off a few copies through the office postage meter to send to his family and friends. Fass accused him of stealing postage and had the kid arrested and spend the night in jail.

Some of Fass' favorite targets of torture were the effeminate men that he'd hired to edit the skin magazines, which were still selling well. Those editors would bring photos of that month's centerfold to the other editors' desks and lay them out. The co-workers would then improvise a name and bio on the spot… "Oh, that's Suzie Smith from Arkansas. She enjoys long walks on the beach."

Always one to help with production, Fass would have stacks of photos of "body parts" for the skin mags on his desk, and have a

Top: The second issue of *Jaws of Death* (Part II, 1976)

Bottom left: *Sea Monsters* V2 #1 (Spring 1977)

Bottom right: *Rod Power* V1 #2 (Oct. 1976)

SPECIAL EDITION
SEA MONSTERS
The Century of Sea
Serpents: 1800-1900
Water Dwelling
Monsters of
North America
Coast Guard
Diver Sights
Monster-Sized
Squid!
The Selkies: Seal People
of the North!

ROD POWER
"CHROME" YOUR CARB
FOR ONLY 4¢ PLUS
9 MORE LOW-BUCK
SUPER ROD
TIPS
More than a dozen show 'n' go street rod features
16 Color Pages
CORVETTE IRS TO A-BONE SWAP: Uses Stock Cross Member And Control Arms
Step-by-Step
INSTALL MUSTANG DISCS ON
EARLY FORD SPINDLES
THE COMPLETE GUIDE TO BASIC
ENGINE BLUEPRINTING

model come in and pick out the ones she liked best. The rest were chucked into the trash can. As soon as Fass was out of sight, the horny straight males were rifling through the garbage, looking for the choice rejects.

Myron Fass could "multi-process like crazy." He would have a line of editors leading into his office, seeking opinions and input. First up would be the guy editing a dog magazine, followed by the editor of a UFO mag. Next up was the shark magazine editor, while Fass was on the phone with a photographer for his S&M magazine…"No! No! She's gotta be in a Girl Scout outfit," followed by advice for a cat magazine editor, "I want a tabby on the cover."

Another testament to Fass' creative genius

Top: ***The Only Woman Elvis Ever Loved*** one-shot (1977–78)

Bottom left: Another Smukler title, ***ESP*** V1 #4 (Nov. 1976)

Bottom right: War is hell, but it looks staid in comparison to the typical Fass fare, ***True War*** V2 #2 (Mar. 1976)

THE THREAT OF
EPIDEMIC

HOW TO PROTECT
YOURSELF AGAINST
FLU ATTACK

THE VACCINE
AND ITS
DANGERS...
WHY THE
DRUG MANU-
FACTURERS
DEMANDED
GOVERNMENT
PROTECTION

THE MYSTERIOUS
LEGION FEVER

EPIDEMICS OF
THE PAST

Looking
suspiciously
like an issue of
Time Magazine,
Countrywide's
Swine Flu
one-shot
(Winter 1976).
It turns out
that aliens had
nothing to
do with the
disease.

was his masterful teachings of pre-Photoshop cut-and-paste techniques. (Of course, Eerie Publications used this process all too frequently.) They would have an article for a shark magazine laid out, the 10 Worst Shark Attacks, then with a little trimming and new captions change it to an article for a crime mag, the 10 Worst Mafia Hits. They had a cheapo archive service that would provide photos; however, an editor that saw a picture in a book or magazine that would suit a particular article would whip out their X-Acto knife and

take it. Smukler, now a lawyer, is amazed that they weren't constantly being sued.

The editors would lay out their pages and photograph them, send off the type, get it back, proofread and correct it, send it back out, get it back again and paste it all together; all done with sweat, X-Acto knives and glue. If an editor failed to get his book to the press in time, that title simply didn't come out that month. Hundreds and hundreds of Countrywide magazines were produced this way in the '70s.

Fass was the undisputed champ of multiple-title magazine publishing. He would publish one on any subject, as long as it would turn a profit. Smukler said that as long as it sold 20,000 units, he could publish a magazine about anything, even toilet seats. Speaking of toilets, here's a good one…

In 1976, there was supposedly a restaurant in New York City that was serving urine on its menu and the chairs at the tables were toilet seats. A group of the young Countrywide editors, including Smukler, were all ready to pay a visit to the place and do restaurant reviews and dedicate a whole one-shot magazine to it before it inevitably got shut down. Probably with good reason, Fass said no to this one. I'll bet Al Goldstein would have said yes…

Smukler and Countrywide parted ways in 1976. Fass wanted him to edit a one-shot magazine concerning the then-rampant

swine flu. Fass, however, wanted to blame the disease on extraterrestrials. Smukler, a man who took his work seriously and to whom parapsychology and UFOs meant more than just sensationalism, didn't want to compromise himself with such silliness. Upon his refusal, Fass told him gently, "Of course you know I have to fire you now."

Still, Howard Smukler has nothing but good things to say about Myron Fass. He says that Fass treated him like a son and took him under his wing, teaching him a great deal about the industry. He describes Fass as an intelligent man, very focused and very much in charge. "It was one of the more exciting times in my life," said Smukler. "And he never shot me."

It is in this atmosphere that the next phase of the Eerie Publications story begins. It's not an exciting story, filled with editorial genius and split-second decisions; rather it's a kind of "hey, we have all this crap layin' around, let's put some of it to use" story.

Rising, Phoenix-Like, From the Ashes

A handful of newer re-drawn stories had trickled into the Countrywide offices after the fall of the Eerie Empire. These new pieces, along with the well-worn older stories, would

Credit Where Credit Isn't Due

IT'S INTERESTING to note that the only time that Myron Fass' (or Stanley Harris') name is ever seen inside an Eerie Publications magazine is in the first issue back after the market implosion in 1975. *Terror Tales* V7 #1 (April 1976) has a contents page with a full credits list that has the same crew that is listed in every other Countrywide magazine at the time; the Fass brothers, Harris, Mel Lenny and many other familiar names from other magazines.

Roy Mosny, who is listed as editorial director for the issue, said that "it was a time-saving device" to just put the same credits into whatever mag was on the boards at the time. He said he never had anything to do with the comics and added that he remembered that "they were pretty bad." Well, to each his own, Sir!

It's a shame that there are five "art assistants" listed in the credits who had nothing to do with the artwork in the issue, while fine comic artists like Martha Barnes, Enrique Cristóbal and Ruben Marchionne go completely uncredited.

haunt newsstands in early 1976. After a year on hiatus, the Pubs would be back, albeit in an even more prosaic form than before.

Eerie Pubs celebrated the bicentennial by reviving three of their old titles: *Horror Tales*, *Terror Tales* and their flagship title *Weird*. As the product of assembly-line editing, this terrifying triad offered nothing new and different. With "A Horror Classic" and "Collector's Edition" plastered across the cover, consumers should have been well aware of the mags' reprint status. *Horror Tales* sported the word "CLASSIC" above the title, and earned a "Jumbo Size" stamp by having the first four issues appear as gigantic, square-bound, 116-page monoliths. These behemoth books made interesting use of small pictures, clipped from old covers, scattered about on top of the cover art. It was another clue that these new releases were a kind of Pubs' Greatest Hits Collection. Oddly enough, *Weird* still proclaimed that it was "Told in New Chilling Picto-Fiction." Still new after all these years…

Cover art was entirely made up of reprints. The trademark blood splotch had been removed and the art no longer continued onto the back cover. The inside and back covers had given way to advertising, including a wholesome offer where kids could buy some swell repro Nazi paraphernalia. Subsequent issues had an ad for iron-on T-shirt transfers, two of which were Warren's own horror hosts, Uncle Creepy and Cousin Eerie. It must have

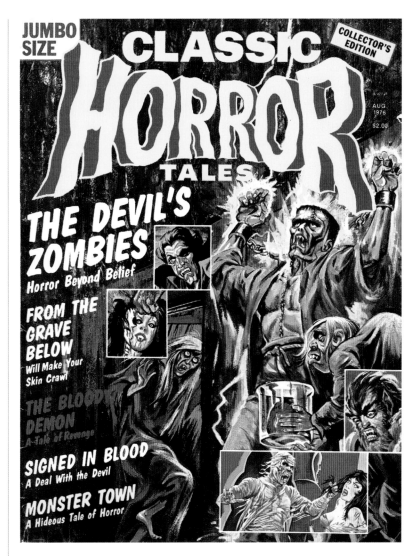

been a bitter pill for ol' Morris to swallow; not only were his competitors being pictured inside his own magazine line, but he'd failed to procure his own T-shirt deal.

Needless to say, not a lot of thought had to go into these re-releases. Young magazine apprentices were learning their craft and putting out handsome collections, but they were merely milking the withering teat of a cow that had gone dry a year earlier. Still, production-wise, things were going along smoothly enough.

Or were they? ☀

Eerie makes an uninspired return.

Opposite:
Weird V9 #3 (Sept. 1976)

This page:
Horror Tales V7 #3 (Aug. 1976)

Chapter 10

THE SHOT HEARD 'ROUND THE OFFICE

NOT EVERYBODY was comfortable in the presence of Myron Fass. He would brag that he was a crack shot with his gun and that he had been commended by the New York Detective Squad, and awarded other honors. He walked around the office with that intimidating piece strapped to his hip. Many employees wondered if it was, in fact, loaded.

Stanley Harris was present in the office every day. Fass and Harris had meetings every day. Thus, there were shouting matches every day. Myron Fass definitely did not see eye to eye with the younger Harris, and there was often bad blood between the two. This created an unpleasant atmosphere for many of the employees. A new title was expected to ship

Opposite: The bitter end of Eerie's horror comics: Modern Day's final issue… *Weird Vampire Tales* V5 #4 (Mar. 1982)

This page: Myron Fass— crack shot, crackpot, or both… you decide

ENTER THE BLOODY WORLD WHERE FANGED HORROR DRIPS A GLISTENING RED

The gore-filled hyperbole of Carl Burgos made a welcome return to the Harris Era mags

daily, and in an overcrowded, stress-filled space, emotions would often run high.

In the summer of 1976, there was the typical tension in the air, and Myron Fass was storming around the office after having a heated argument with Harris. He retreated to his office and then a gunshot rang out. "It was really loud, and everybody freaked out," Howard Smukler recalled. "We had a number of either gay editors/artists, or at least non-violent English major types, and they were really going nuts." The shot went through the wall into Harris' office, barely missing him. Fass' gun was indeed loaded.

It's hard to imagine that things could get back to normal after such an incident, and they didn't. Harris was already suing Fass for "unilaterally dealing with distributors" and Fass was threatening employees who sided against him. Harris also complained of the threatening atmosphere and general feeling of malaise that he and much of the staff suffered in the office. I asked Roy Mosny about this time at the company and he didn't want to talk about it, saying that it was a really bad time in his life.

It is rumored that Fass once beat the crap out of Stanley Harris, right there in front of the entire office. While this remains

unsubstantiated to me, it seems like that would be a bit of overkill; Harris had already had enough and decided that he was on his way out. The partnership dissolved and the magazines were divided up, with Fass keeping some and Harris taking some with him. Stanley Harris got custody of the horror comics… strange, since Myron was the comic book guy and Harris never really had any interest in them. It is here that Myron Fass' association with Eerie Publications pretty much ends.

Breaking Up Isn't Hard to Do

There was a one-month gap in the production schedule (there is no Eerie Pub dated September 1977) but, amazingly, Harris otherwise didn't skip a beat. There is an interim publisher's address for two months, then Harris Publications settled in at 79 Madison Avenue and stayed there comfortably for a number of years.

Under Harris' tutelage, some familiar features came back to the Pubs: the blood-splotch splattered its way back onto some covers and, more importantly, the stories once again ran onto the back covers. Even ol' Morris came back to a couple of issues, starting his second decade of reprints. The contents pages became more interesting again, with collages

of horror scenes akin to the pre-decline years, rather than the generic ones used during the last days of the Fass regime. Most issues were down to just one page of paid advertising, the rest was all comics. It was all reprints, of course, but by this time, nothing else could be expected.

One sad development was the introduction of the UPC code on every publication, starting on issues with a cover date of 1978. The UPC code has been an art lover's worst enemy ever since, needlessly cluttering up otherwise lovely covers with horrid little eyesores.

The better development in 1978 was the return of Carl Burgos. Called in by Harris to edit the comics, Burgos, although still saddled with the same reprints, at least made the Pubs look respectable. Nobody wrote screaming, hyperbolic horror headlines like Burgos (except maybe Alan Hewetson). His knack for conjuring up tasty horror-lettering designs returned as well, something sorely missing during the post-decline years. Reprints or not, at least the mags were looking a bit better.

Ads were becoming scarce and would soon be gone altogether. The frontispiece, back cover and inside back cover started featuring black-and-white reprints of old cover art, without any type on them. It's a good chance to see the brushstrokes of some of the artists and a great way to see the cut-and-paste jobs. The monochrome printing of the color artwork was unforgiving to the cobble covers and the

Weird V11 #2 (June 1978) A new cover (to the Pubs, at least)... The vamp looks like Burgos' art but I can't place the ship

cut lines are clearly visible. It's interesting to see just how much of an image was removed or added during the dreaded cobble-cover era.

There was one nice surprise in store for Eerie Pubs collectors in 1978: a new cover! I can't identify the source... it looks like a Johnny Bruck ship and planet, though I can find no Rhodan cover that had that art. The vampire looks vaguely like a Burgos creation. At any rate, the June 1978 issue of *Weird* (V11 #2) was going space crazy, like the rest of the world in post-*Star Wars* America. The outdated "Picto-Fiction" banner was replaced with "Space Encounters," while under the title, the mag shouted "Bloody Horror From Beyond." This gave Burgos a chance to recycle some of the old sci-fi Pubs stories. With Burgos back

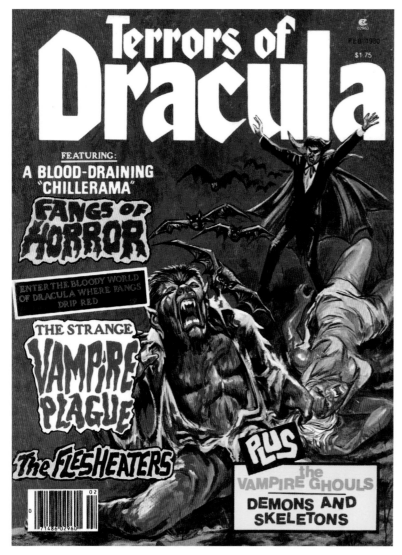

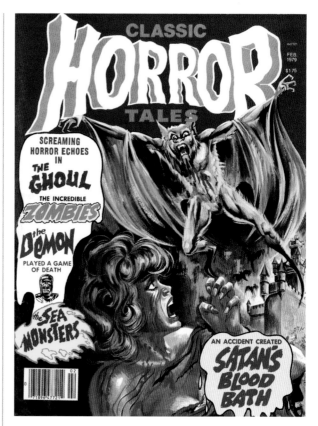

Top left:
Terrors of Dracula V2 #1 (Feb. 1980) Spiffy new logo, same ol' stuff everywhere else

Top right:
The final issue of ***Horror Tales*** V10 #1 (Feb. 1979)

Bottom left:
The final issue of ***Terror Tales*** V10 #1 (Jan. 1979)

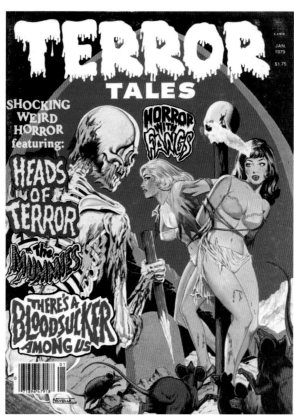

at the helm, things ran smoothy, maintaining a successful monthly schedule.

Across town, on Broadway, Frank Langella had starred in a new theatrical version of *Dracula*, and made it a huge hit for 1978. He landed the plum role of the Count in the successful movie adaptation made the next year. Dracula was hot, getting press and making people talk. It seems that a mere two years after the world went sci-fi crazy with *Star Wars*, we needed to embrace a new mania, and vampires would do just fine.

With that in mind, *Horror Tales* and *Terror Tales*, two titles that had been visible on magazine racks for nearly a decade, were folded and replaced with something that packed a bit more of a modern bite. A vampire bite.

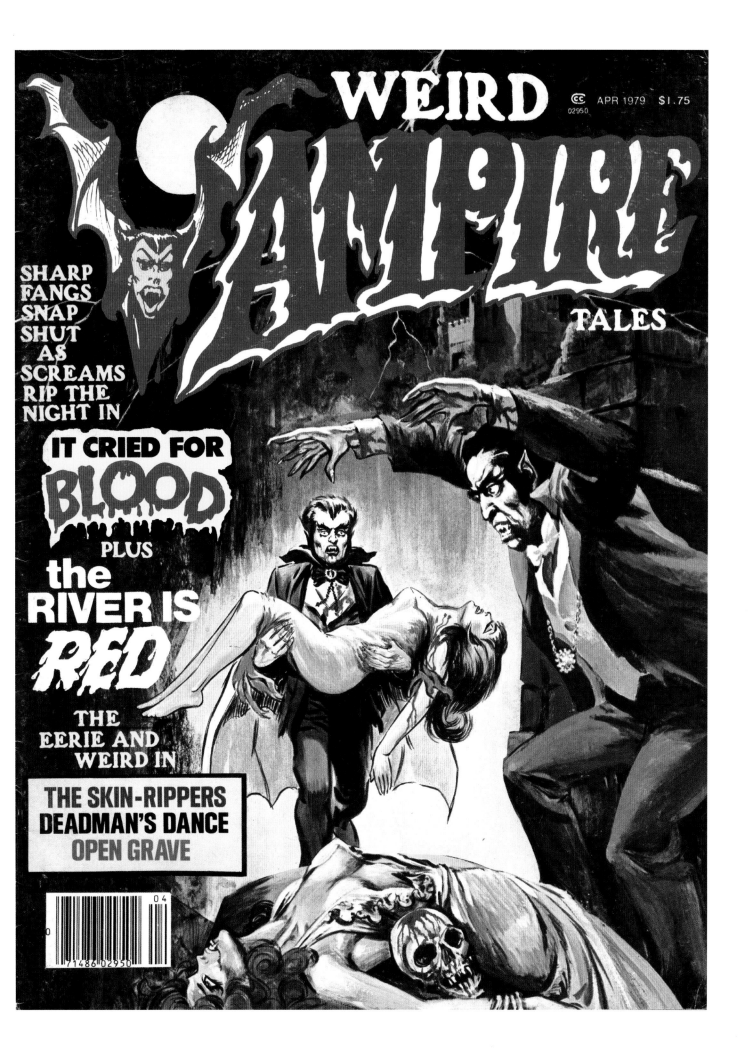

Previous:
The first issue
*Weird Vampire
Tales* V3 #1
(Apr. 1979), with
a new Burgos
image nestled
inside of a well-
worn Alexander
cover painting

Top: Burgos'
quipping bat-
narrator from
the first issue of
*Weird Vampire
Tales*

Bottom: A nice
Burgos contents-
page illustration
from the late
early '80s…
one of his
last horror
illustrations
ever

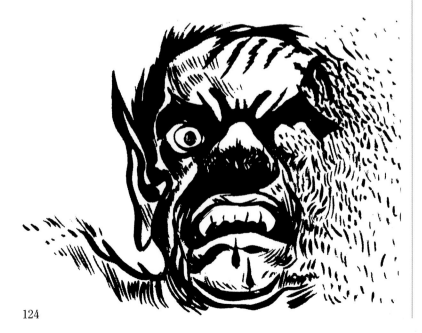

The first issue of *Weird Vampire Tales* (April 1979), with the head-scratching number of Volume 3 #1, hit the streets in early 1979. It sported an eye-catching logo and a partial new Burgos cover. (Burgos had painted a new image of Dracula, carrying a victim, to share the cover with a well-worn Alexander image from five years earlier.) There were no ad pages, but the material still consisted entirely of Pubs-

drawn reprints. An added bonus, however, was a cute li'l bat that was flitting about in many of the stories' splash panels, cracking wise and acting as the host. The bats were new Burgos illos and his lettering is easy to spot (as are his distinctive quips). Sadly, this is the only issue that this little fella appeared in.

Like its vampiric sister title, the premier issue of *Terrors of Dracula* (V1 #3, May 1979) crept onto magazine racks to share space with Warren's horror mags in the early months of the year. Despite its own striking logo, this book, as always, was interchangeable with the other Eerie Pubs. Still, fangs were flashin' and blood was flowin', so all was good. Even Warren caught vampire fever and followed the trend, devoting a few issues of its *Warren Presents* title to the cantankerous Count and his contemptible kin.

Weird Vampire Tales and *Terrors of Dracula* were published not under the Eerie Publications imprint, but by Harris' Modern Day Periodicals. The Modern Day imprint had previously published a number of different magazines, in many different genres, as early as 1958 with Fass' *True or False*. The ever-reliable and diehard *Weird* continued to proudly wave the Eerie Publications flag that it first hoisted back in 1966.

With *Weird* going strong, the new Modern Day/Eerie trio was running like clockwork, greeting the public with ad-free, black-and-white "Startling 'N Shocking tales," as *Weird*'s

masthead promised. These three titles would be in rotation, one a month, until mid-1980, when production would again become sporadic.

The later issues of these three titles are fairly hard to come by these days due to smaller print runs and the public's (and publisher's?) apparent disinterest in them. We Pubs collectors (and yes, there are quite a few) are always on the lookout for anything that was heretofore unknown, but all of our indexes start and stop in pretty much the same place. The smooth production schedule concluded with *Weird*'s September 1980 issue (V13 #3) and never got back in gear.

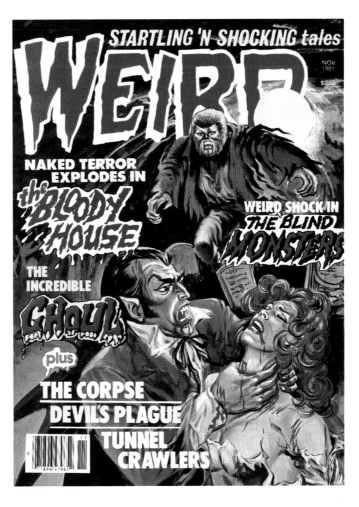

Weird V14 #3 (Nov. 1981), the very last magazine ever published with the Eerie Publications name

It's... The End

I'd love to end this story with a big, loud bang, but it all just died out with a very small sigh. Between the three titles, only seven issues were printed with a 1981 cover date. The numbering more or less continued, but these magazines were just being produced in between other projects, when there was space on the presses. The last issue of *Weird* to see the light of day (V14 #3), the final Eerie Publication ever, was dated November 1981. Four months later, out of the blue, *Weird Vampire Tales* V5 #3 (March 1982) came out

and closed the door on this fine, fascinating and frustrating family of horror comics.

Of course, rumors persist that an issue of *Weird Vampire Tales* with a 1983 cover date exists or that some of those missing months' comics were seen by a friend of a friend. Anything could turn up. Those of us who are interested will always keep our eyes peeled (and poppin') for such treasures, while everybody else will wonder just what the hell we see in that horrible garbage that was put out by those schlockmeisters at Eerie Publications. ✳

DRACULA
CLASSIC

K 4825
1976
$1.00

A New Generation Of Vampires

The Blood-Sucking Vampire From Transylvania

A History Of Vampires

DRACULA'S GUEST
by Bram Stoker

BELA LUGOSI: The Man Who Made Dracula Famous

■Native fishermen on Samoa and New Guinea will not lay their nets at night . . . On the Isle of Warimoo, in French Somaliland, every outrigger is beached at sundown, and no one will venture across the open water until the morning . . . In Djibouti—called the hottest place on earth—the sea lanes linking island to island remain closed not by law, but by choice—from early evening until the sun's rising the following day . . . On the southern terminus of the Red Sea, at the Gulf of Aden, only the big ships dare venture out after dark.

To say that the waters of the Pacific or Mediterranean, the Atlantic or Indian oceans are safe during the day is a gross misstatement. They're not. However, at night, when darkness covers the sea, sharks are known to prowl more vigorously for food. Their appetites are more voracious, their craving more violent and ravenous, and their need to fill their bellies becomes insatiable.

Every species of shark, even the Great White—known throughout

Chapter 11

EERIE ONE-SHOTS

FIRST OFF, let me take this space to address the would-be Eerie Publications one-shot called "Tales Of Terror" which has been present in the Overstreet Comic Book Price Guide for years. It's listed with a date of Summer 1964. Of course, we all know that our Pubs didn't get underway until roughly a year after that. The *Tales of Terror* that is mistakenly credited to Eerie was published by Charlton Publications. It's numbered Vol. 1 #1 (Summer 1964) and was the only issue to see print. The

magazine has a nifty painted cover and some nice drawings and photos to illustrate the (all-text) stories inside, but this definitely has nothing to do with Myron Fass or Eerie Publications. I wish Overstreet would just correct its long-running mistake.

One can't consider *Tales From the Crypt* V1 #10 (July 1968) as a one-shot, either. It was intended as a sister title for *Weird* before William Gaines (presumably) caught wind of the title and saw to it that it was changed to *Tales of Voodoo* by the next issue.

Opposite: ***Dracula Classic***, a late entry into the Eerie Pubs line (1976)

This page: Fass' shark mags go above and beyond for the gore-hounds!

The one-shots I'm talking about are the monster mags that were put out under the Eerie Publications banner after the demise of the original run of horror comics. The first one came in 1976, around the same time as the revival of the comic book line. *Dracula Classic* (simply Dracula in the indicia) had a Bela Lugosi cover and 68 pages of familiar studio stills from Universal and Hammer Studios' vampire movies. Inside, the "History of Vampires" article even goes into Manson territory with a few shots of Charlie and the Family, supposed blood drinkers. Throw in Bram Stoker's "Dracula's Guest," a short story extracted from his longer, more famous, novel, and you have a pretty good (but not groundbreaking) little one-shot.

The next (and only other) non-comic magazine published by Eerie was *Revenge of Dracula* (also just Dracula in the indicia), published in the winter of 1977. Utilizing many of the same stills as *Dracula Classic*, this sequel also failed to bring any new information to anyone who had ever seen an issue of *Famous Monsters*, but it's still of interest to Eerie Pubs completists. Sheridan Le Fanu's "Carmilla" is the prose presented in this issue. This magazine is of historical importance because it is the very last magazine published by Myron Fass under the Eerie Publications name. As mentioned earlier, Stanley Harris had taken the Eerie comics line with him after the splitup earlier in 1977. I guess, being a monster magazine, Fass deemed it worthy to publish this with the name Eerie Publications, whether he still owned it or not. The copyright in the indicia says 1976… perhaps it was prepared a year before it came out.

The man behind these two *Dracula* magazines was John Thomas Church, a prolific magazine writer who was very adept at churning out articles of all kinds by the dozens. He wrote articles for many of Countrywide's magazines, including the notorious *True Sex Crimes*, *The Private Life of Patty Hearst* and other sleaze-a-thons. Obviously a fan of monster movies and *Famous Monsters of Filmland*, Church offered no new information or real in-depth analysis on his subjects, but his information was presented nicely and the

magazines, while not slick (what Countrywide mag could really be called "slick"?), are enjoyable, if disposable.

Church was responsible for other Fass monster magazines around this time, though none of them were published under the Eerie imprint. Dino DeLaurentiis' remake of *King Kong* was big news and Church put together *Kong* (Countrywide, 1976) to capitalize on the built-in buzz around the movie. Again filled with old photos and new press release shots for the remake, *Kong* offers nothing new, but has tons of pictures and a swell painted cover. I spent my own hard-earned coins on it at the newsstand back in 1976, so they must have been doing something right. The ubiquitous Church also wrote the contents for the first issue of *Sea Monsters* and the infamous *Swine Flu* one-shot (both Winter 1976).

The Steven Spielberg film *Jaws* (1975) scared the crap out of the world upon its release, making many viewers (including my wife) afraid to go near the water. Of course, such a perfectly exploitable subject inspired many Countrywide magazines, and some titles even had significant runs. Though none of these publications examined the movie per se, they all featured the name Jaws prominently in the title: *Jaws of Blood, Jaws of Death* and *Jaws of Horror*. Church was responsible for the text in many of these magazines but they weren't big sellers because of the writing. Peppered with grainy photos of toothy sharks

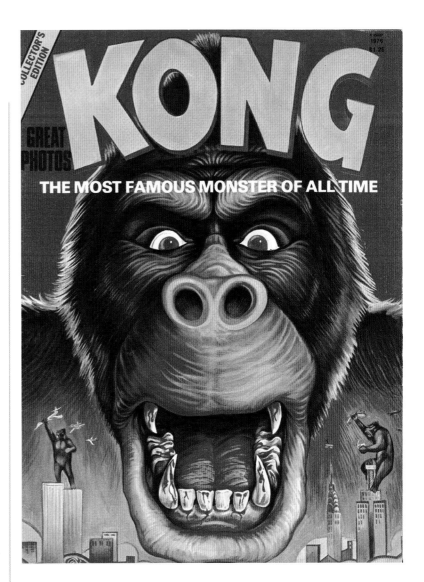

Kong
(Countrywide, 1976)

and their bloodied attack victims, these mags played on our primal fears and served up gnashing, visceral horror that even the notorious Eerie Pubs comics often could rarely equal. Consumers ate 'em up.

In early 1977, Church delivered the real sequel to 1976's *Dracula Classic*, though it wasn't a bona fide Eerie Publication. Under the Modern Day Periodicals imprint, Countrywide released *Frankenstein Classic* (Feb. 1977— yep, you guessed it… the indicia's title is just *Frankenstein*). Like the Dracula and Kong mags before it, this title was wall-to-wall photos and no advertising. Many of the photos are so blurry that they look like they were

Jaws of Gore

Eerie Pubs fans owe it to themselves to check out the Fass Gang's shark magazines. *Jaws of Blood*, *Jaws of Horror* and *Jaws of Death* deliver the depraved goods better than most magazines would ever dare. "Why Sharks have Developed a Taste for Human Flesh"… "Screaming Infants Swallowed Whole"… "Holiday Horror as Girls are Mutilated by Fish"… just the article titles are enough to make you puke. The gory photos of victims and dead sharks complete the package.

Better still are the later, Jeff Goodman-edited issues, in 1978. Photos and gory artwork are prominently featured. Artists Ken Landgraf and the late Gene Day lent their considerable talents and twisted visions to the mags, making these issues unforgettable. I cannot recommend these highly enough to fans of sick, gore-filled art… i.e., Eerie Pubs fans.

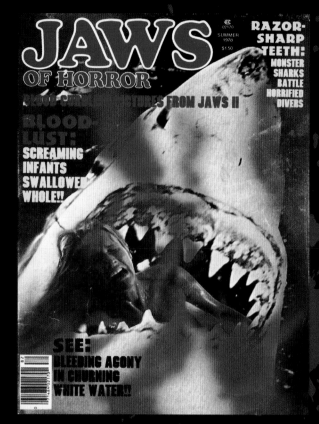

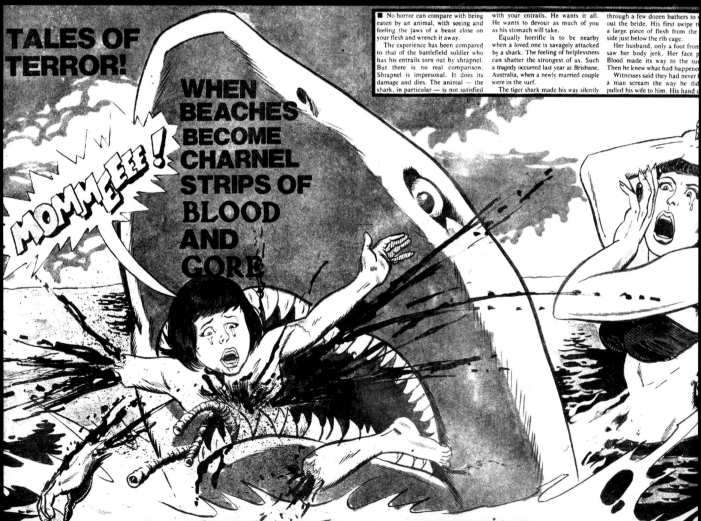

Jaws of Horror V4 #2 (Summer 1978) and one of Ken Landgraf's mind bending illustrations from the above magazine.

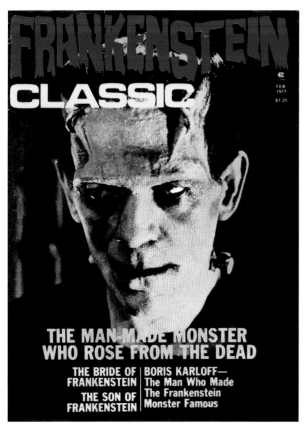

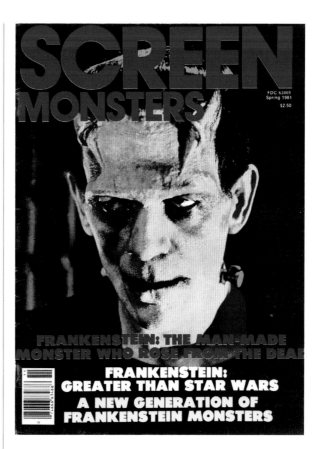

Left: ***Frankenstein Classic*** (Modern Day, Feb. 1977)

Right: ***Screen Monsters*** V1 #1 (S.J. Publications, Spring 1981) Recycling right up to the bitter end—no articles listed on the cover are actually inside the magazine, in fact the only picture of Frankenstein or his monster is on the cover

shot from the screen of a theatrical showing of the original *Frankenstein* (Universal, 1931). Although there is no literary excerpt this time around, Church includes a lovely, detailed puff piece on Boris Karloff, which is always welcome.

After the success of *Star Wars* (1977), there was little use for the gothic horrors of Dracula and Frankenstein so Countrywide leapt head first into the sea of *Star Wars* magazines. Despite that, in Spring of 1981, the cover of *Frankenstein Classic* was recycled for the first issue of *Screen Monsters* (S.J. Publications). The cover blurbs promised some Frankenstein features (some not so oddly enough with the same titles as Church's efforts four years earlier), though those articles were not

actually inside. The contents of the issue were the standard *Star Wars* and superhero movie news that already had a dozen titles devoted to them.

The Frankenstein articles did see the light of day again later that year with *Movie Monsters* V1 #2 (Summer 1981). This magazine, despite having Darth Vader as the main focal point of the cover, reprints the *Frankenstein Classic* magazine page for page, except some of the full-page photos from the original were replaced with advertisements. John Thomas Church, who wrote every word in the issue, got no credit whatsoever, nor did Carmine Fortunato, who was the designer for all of the Church-penned one-shot monster mags. Such was life for the loyal Fass employees. ⁕

EERIE CRIME?

WELL, NO... not really.

But...

Countrywide started up a pretty gruesome duo of crime magazines right around the same time as their Eerie Pubs horror comics were taking off and multiplying. If only for the later issues' jarring Bill Alexander covers, these publications deserve an honorable mention in any discussion of Eerie Publications.

Back in the '40s and '50s, *Crime Does Not Pay* was the title of one of Lev Gleason's most popular comic book series. The name was borrowed from a series of short films in the '30s, and a popular radio program in the late

'40s and '50s would also share the name. By the '60s, the phrase was a part of America's vocabulary. It's here that M.F. Publications unleashed the first issue of *Crime Does Not Pay* (V1 #10, Jan.-Feb. 1968) to a shell-shocked public in late 1967.

Eschewing comics for gritty true crime photos and stories, this title delivered gore and sensationalism under the guise of American history. Dillinger, Bonnie and Clyde, Al Capone, Bugsy Siegel, and all types of murderers, thugs, and criminals were presented to readers with grainy, black-and-white photos of the hoodlums and their victims. These true crime

Opposite:
Crime Does Not Pay V2 #7 (Dec. 1969)

This page: "Case of the Lovesick Clown" from the first issue of ***Murder Tales***

biographies were joined by the occasional *National Mirror*-esque article like "Lesbians Behind Bars" or "The Sex Swindlers." Bullet-riddled corpses were the order of the day for *Crime Does Not Pay*.

Evidently, the title was doing brisk enough business to allow for a sister magazine, and *Crime and Punishment* (V1 #10) was born later that year, with a cover date of December 1968. Not so coincidentally, *Crime and Punishment* was also the title of Lev Gleason's other long-running pre-code crime comic book. Since both comics had ceased publication with the advent of the Comics Code, Fass was more than happy to appropriate the titles for his lurid crime rags.

The credits to the crime mag duo were a collection of made-up names of detectives and investigators to give them an air of authenticity. Many detective bureaus were listed as consultants. Early issues had Bryant Hall, the man in charge of the girly mags, listed as a special investigator.

In 1967, crime and detective magazines were nothing new. They had been around since the '20s in some form or another. By the late '60s, there were many publishing outfits offering up crime fare, and the covers were getting sleazier as the months went on. Most companies would have photo covers of staged attacks, usually with bound and bleeding victims. Countrywide's magazines, despite bloody photos and leering mug shots on the covers, were looking a bit tame in comparison until somebody got a great idea.

Enter Fass' new cover artist, Bill Alexander. In the summer of 1969, he'd started painting the colorful, gory and action-packed horror covers for the Eerie Pubs comics, so he was given a shot to prove his versatility with some

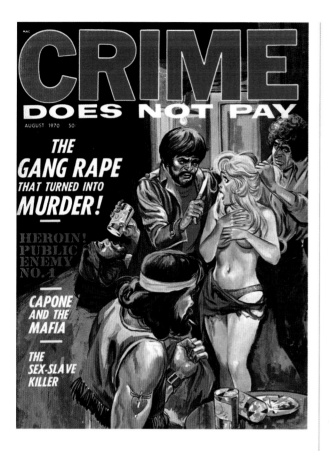

A grueling
gallery of Bill
Alexander's
Crime covers:

Top:
***Crime Does
Not Pay*** V3 #3
(Aug. 1970)

Bottom:
***Crime Does
Not Pay*** V3 #1
(Apr. 1970)

thugs point a glowing, hot poker toward her nether regions. All subtlety and taste went out the window on this one and Bill Alexander delivered one of his most grueling and memorable covers. You've got to wonder what a nice, mild-mannered news agent thought when it came time to display this puppy. *Crime Does Not Pay* certainly went out with a sleazy bang.

With the Eerie Publications group of horror comics going full blast in 1970, it was only natural that crime comics, the other forbidden fruit from the pre-code era, would get to take a spin around the block. The month after *Crime Does Not Pay* ended their run with that blast of spectacular sleaze, the Pubs crew produced their first crime comic, *Murder Tales* V1 #10

crime assignments. *Crime and Punishment* had just been dropped so the cover of *Crime Does Not Pay* V2 #6 (Sept. 1969) was the first to feature an Alexander cover. Bondage, blood and a blowtorch—the guy in this scene is in some deep shit. The smiling torturers obviously enjoy their work. This was one of the more subtle covers, too! Flying eyeballs, bullet holes, suggested gang rape and ladies in peril soon followed and Alexander would put his horror know-how, not to mention his bondage roots, to good use.

The horror (and the title) culminated with a jaw-dropping painting for *Crime Does Not Pay* V3 #4 (Oct. 1970). This final cover showcases a woman who has been tied upside down to a table, spread-eagled, while smiling

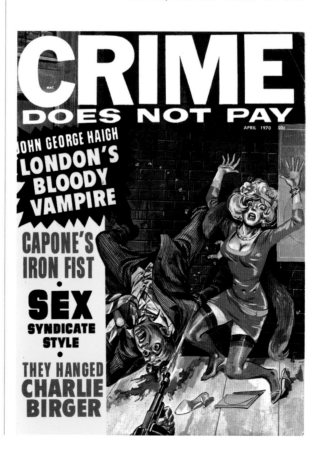

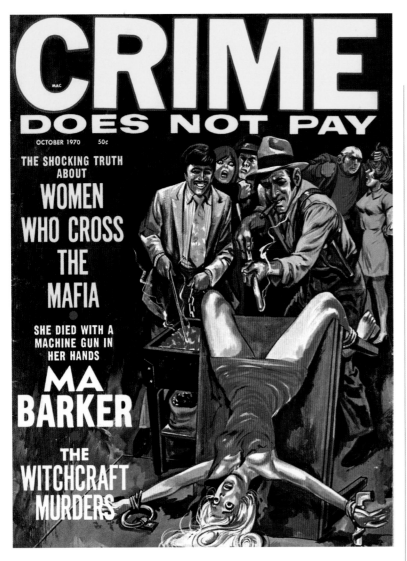

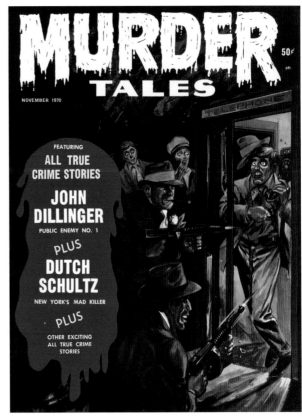

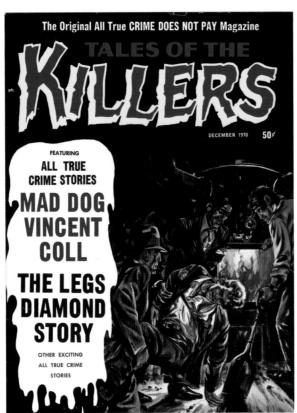

Top left:
Crime Does Not Pay V3 #4 (Oct. 1970)

Top right:
Murder Tales V1 #10 (Nov. 1970)

Bottom:
Tales of Killers V1 #10 (Dec. 1970)

(Nov. 1970). The publishing (and supposedly the editing) chores went to old friend Robert Farrell; it was published from his offices (like the first few Eerie Pubs), but this is clearly put together by familiar, Eerie hands. An energetic Alexander cover, the blood-splotch full of teasers, and drippy logo lettering—it was obvious who was behind these comics.

Besides Farrell's acknowledgements, Bill Alexander actually gets credited for the cover art, something that was never done in the horror mags. Two other artists are also mentioned. One was Frank Carin, a former animator who got into the comics field in the '50s with teen and funny-animal books. Carin was also responsible for many of the subpar covers for Stanley's line of black-and-white

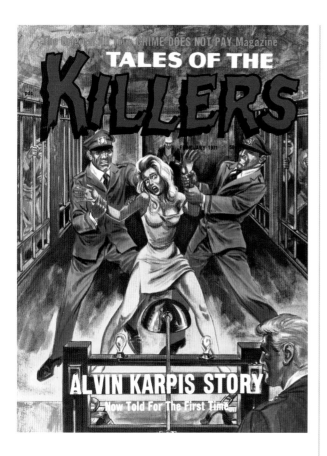

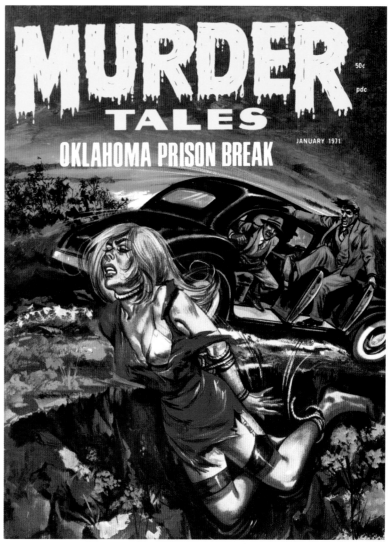

horror comics that were dying a slow and painful death on the newsstands by this time. The other one is named E.J. Simpson. I like to think that Ezra Jackson was a big Buffalo Bills fan and this nickname was his tribute to O.J., but it may not be him at all. Research tells me it's not an uncommon name.

Artist credits or not, this comic and its sister title *Tales of the Killers*, whose first issue (also V1 #10) came out dated December 1970, were made up entirely of reprints from the aforementioned Lev Gleason crime comic *Crime Does Not Pay*. That title's ghostly narrator, Mr. Crime (who was designed in 1942 by Rudy Palais, a wonderful artist whose pre-code horror work for Harvey and Comic Media was routinely pilfered by the Eerie Pubs

crew), was hosting many of the stories. Even though it's pretty vague about what dope really is, an early Frank Frazetta anti-dope PSA page entitled "We Can Stop the Enemies of Youth" is reprinted as the frontispiece of the first two offerings. Even less production design went into these magazines than went into the horror comics. They are wall-to-wall reprints, no advertising, and no filler. The closest thing to an ad is in the premier issue of *Tales of the Killers*, where one of the reprinted story's last pages included an in-house promo for their stable of comics. The original publisher's (Lev Gleason) name was removed and, in a messy scrawl, the new crime mags' titles were

Left:
Tales of Killers
V1 #11
(Feb. 1971)

Right:
Murder Tales
V1 #11
(Jan. 1970)…
my favorite
Alexander cover

137

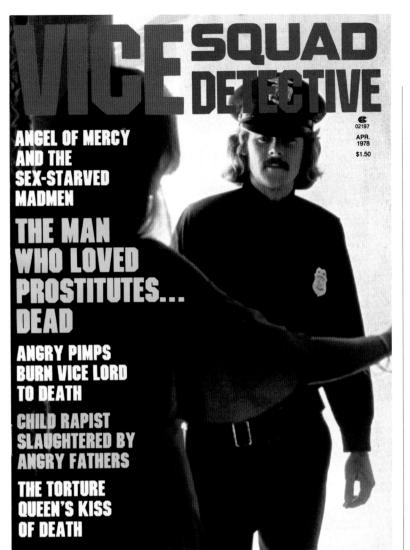

ANGEL OF MERCY
AND THE
SEX-STARVED
MADMEN

THE MAN
WHO LOVED
PROSTITUTES...
DEAD

ANGRY PIMPS
BURN VICE LORD
TO DEATH

CHILD RAPIST
SLAUGHTERED BY
ANGRY FATHERS

THE TORTURE
QUEEN'S KISS
OF DEATH

Top:
Vice Squad
Detective
V2 #2
(April 1978)

Bottom:
Old habits die
hard… not only
was extra blood
added to this
crime scene
photo but a bra
and slip were
drawn onto this
MALE victim!
It fit the story
better… From
Homicide
Detective
V2 #2
(Mar. 1978)

usual excellent use of color, movement and violence are all blending perfectly here, but the added realism of the pain in the woman's face makes this a chilling masterpiece. Brutal stuff.

Countrywide didn't dabble much in the true crime genre for a few years, but came back in a big way later in the '70s. In 1975, right after the Eerie Pubs comics folded, the company re-entered the crime sweepstakes with *Crime*, and a return to photo covers featuring the classic killers and hoodlums. It wasn't until after the Fass/Harris split that Countrywide crime mags reached their true potential.

With the post-splitup division of the written in. Interestingly, two of the touted titles, "Crimes of Terror" and "Crimes of Horror" never saw print. Smells like the first issue of *Weird* to me, while a (made-up?) letter column with readers praising *Crime Does Not Pay* rounds out the last issue of both titles. The same lettercol is used both times.

These titles lasted a mere two issues each, but all four books have superb Bill Alexander covers. My personal favorite Alexander cover of all time is the one for *Murder Tales* V1 #11 (January 1971), the final issue. It depicts a bound woman, obviously a torture victim, being kicked from off a cliff from a gangster's moving automobile. Alexander's

Stabbed to death

138

company's titles, Harris wound up with the aforementioned *Crime*, for which he reused the exact same contents page phony credits listing as the Countrywide magazines had a decade earlier. This left Fass free to turn his young editors loose on their own crime titles, to weave their mad magic on them and make them as sensational and exploitable as possible. This they did in spades.

Vice Squad Detective, *Homicide Detective*, *The Godfathers*, *Mobs and Gangs*, and *Murder Squad Detective*… these titles were the most jaw-dropping, sensational magazines on the stands at the time (and that's really saying something). Bloody photos and half-true stories were the fare in these over-the-top rags. The articles were spiced up with nudie shots

from the girly mags, the models renamed to fit the story at hand. Photos from exploitation movies were used if they illustrated the tale in a more horrific manner. Best of all, in true Eerie Pubs fashion, extra blood was drawn into crime scene photos if they were not gruesome enough already.

These magazines, many of them edited by a teenaged Robert Greene, had nudity, blood, torture, vice and all things sleazy. Like their horror comic predecessors, they sought sales through sleaze and appealing to the lowest common denominator, and by doing so put out some damn entertaining magazines. ✳

Top:
Mobs and Gangs V2 #3
(June 1978)
Movie stills make excellent crime covers!

Bottom:
Murder Squad Detective
V1 #2
(Mar. 1978)
Fass turns his kids loose and the results are mind-blowing!

OFFICIAL UFO

02289 OCT. 1978 $1.50

INSENSIBLY DRUGGED: HOW ALIENS CONTROL OUR YOUTH

SUPER EXCLUSIVE:

OFFICIAL UFO GOES TO WAR!

PROTECT YOURSELF AGAINST THE DARK ALIENS

BEWARE: POLYESTER FABRICS ARE DRIVING YOU INSANE!

OUTER SPACE ALIENS ARE IN YOUR TV SET

SECRET STAFF ORIGINS: GENESIS OF BUDDY WEISS

Publisher Myron Fass Examines New Arrival

Several Western nostalgia buffs have said that Myron Fass bears a striking resemblance to Wild Bill Hickock.

Chapter 13

WHATEVER HAPPENED TO?

AFTER FASS and Harris parted ways, things got even wackier at Countrywide, as hard as that might be to believe. Fass had brought in Jeff Goodman, a young writer eager to make the transition from porn paperbacks to the magazine world. Under Goodman's watchful eye, the post-Harris magazines took off on a wild ride and brought pure insanity

to the magazine racks of America. Unlike Howard Smukler a year before, Goodman embraced Myron Fass' desire to put out the most over-the-top, sensationalistic magazines on the market. Goodman was made editor-in-chief of a number of titles and Countrywide struck gold once again.

On the door to Fass' office hung a financial

Opposite: ***Official UFO*** V3 #8 (Oct. 1978)…

This page: The Fass/Hickok comparison from the contents page of ***.44 Mag*** V1 #2 (Fall 1978)… I'm convinced!

141

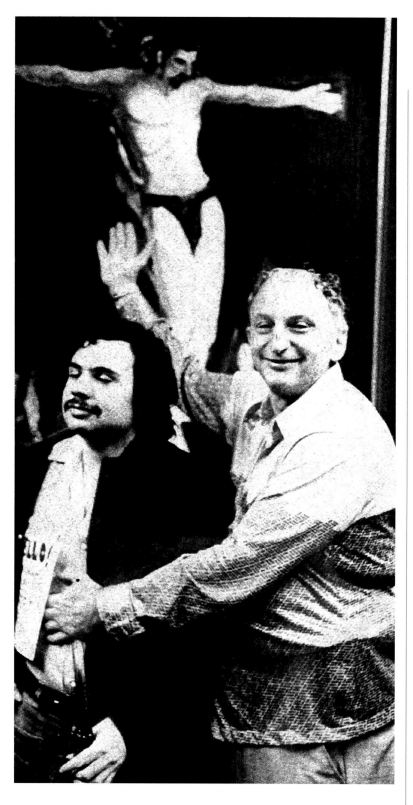

Myron Fass with Buddy Weiss in the incredible *Official UFO* V3 #8 (Oct. 1978)... Fass' self-portrait as Christ is hanging behind them

his underpaid underlings. He always had that gun nearby, and it gave him the confidence to never lose an argument. He would taunt and chase his editors. He allegedly assigned bathroom times. He would go from desk to desk with his gun out, noting who was absent into a tape recorder. He treated most of his workers as poorly as he could, just because he could. Some of his employees lived in terror of him, especially after the gunshot incident. It is said that some former employees thought Fass might be tapping their home phones after their jobs were terminated.

Joe Coleman, who is now an internationally known artist, remembers his days with Fass; "His office had telescopes and binoculars, you know he was paranoid and also a bit sick, looking into neighbors' apartments with women undressing. He was always giggling with delight about the demented things he was doing."

Fass' demeanor alone could disarm an upset employee. Creator Chuck Dixon related an incident where he'd drawn an assigned strip for Countrywide and when he brought it in to get paid, Goodman said they didn't need it after all. Furious, Dixon took his ire into Fass' office where Myron sat there, cool as a cucumber, while Dixon vented his spleen. Fass then quietly told him that if Goodman says they didn't need it, they didn't need it. His actions (or inactions) took all of the wind out of Dixon's sails. Dixon later learned about

report saying that Countrywide had grossed $25,000,000 in 1977. He'd hoped to double that mark in 1978. On the wall hung a painting of Myron Fass as Christ, crucified on the cross. He'd painted it himself.

Fass continued to make life hell for many of

the ever-present firearms. No wonder Fass remained so calm and confident.

Not all of his employees felt threatened. Of course, Fass had a good thing going with Jeff Goodman, and he knew it, so they got along very well. Goodman was his right-hand man. Brother Irving was still around, as was Mel Lenny. Myron's son David was the editor of many of the rock and punk magazines (and did quite a good job) and the third Fass brother, smelly Leo, who seemingly performed no function at all in the office, would hang around, gamble and wash his dirty underthings in the sink.

Leo, the firstborn Fass brother, didn't do much at Countrywide except get in the way. Bob Nessoff said there is a Yiddish word to describe Leo—*Nuchshlepper*, or the sixth puppy born to a mother with only five nipples. Hanging around and hoping that some of his brother's talent would rub off on him, he got the job of Official Word Counter, a task that was as important to the production of a magazine as Leo himself was to the people in the office.

The magazines came hot and heavy, sometimes nearly 50 a month, on every subject imaginable. Music mags, girly mags, animal mags, gun mags, crime mags… you name it, Countrywide had a magazine for it. One-shot magazines were a specialty. In 1978, Fass explained to Mark Jacobson in the *Village Voice*, "My lifestyle is diversified, so

Top: ***Close Encounters of the Fourth Kind*** V5 #2 (June 1978)

Bottom: ***The World of Sherlock Holmes Mystery Magazine*** V1 #1 (Dec. 1977) cover by Luis Dominguez

THE WEIRD WORLD OF EERIE PUBLICATIONS

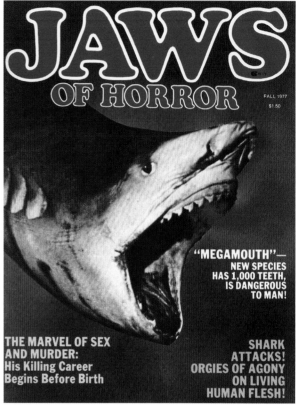

Left: ***Clones***
V1 #1
(Summer
1978)

Right:
More sharks!
Jaws of Horror
(Fall 1977)

my books are. The books reflect the different aspects of me." All of those different aspects of Fass were concerned with the same thing—making money. Joe Coleman admits, ""What made his magazines exciting... was that it was actually humiliating to buy them."

Elvis' death was a goldmine for Countrywide. Determined to be the first to capitalize on The King's death, Fass put Goodman on a red-eye jet to the printers with the magazine in hand and got his Elvis Memorial magazine on the stands first. The Beatles had remained a

big seller for Fass over the years and one-shots were still coming out, with one whole magazine devoted to the "Paul Is Dead" theory. That subject was borrowed for articles for the other music magazines "Is Gene Simmons Dead" and "Frampton Dead." Nothing sold like death.

Under Goodman's tutelage, young writers got to flex their creative writing chops for Countrywide. Especially way-out were the UFO magazines, where all manner of weirdness was encouraged. Aliens found their way into every aspect of life. The best issues from this time are the ones where the Countrywide crew was used in the pictorials. The October 1978 issue of *Official UFO* (V3 #8) tells of how editor Buddy Weiss was delivered to the Countrywide offices by a guardian angel after

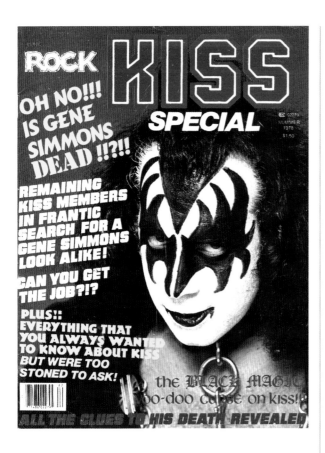

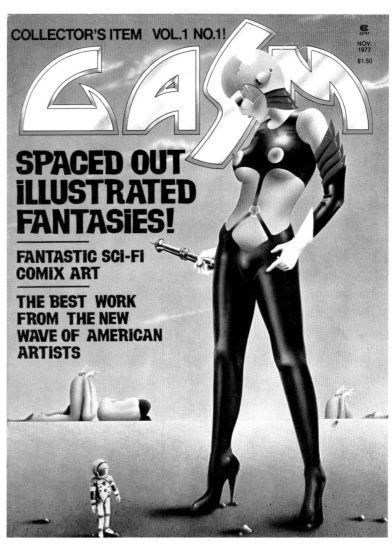

a lifetime of solitary confinement and abuse. This hilarious article is illustrated with the staff accepting this dirty, homeless illiterate as their own, and turning him into a successful editor. Myron Fass is on hand to welcome the stranger, a meeting that is pictured on the cover of the magazine.

Ever the show-off, Fass put himself all over the Fall 1978 issue of *.44 Mag and Magnum*. Not only does his likeness get compared to Wild Bill Hickok, but there are a dozen shots of him handling his massive, custom-made, auto-mag handgun, which frankly sends shivers down my spine. Fass is applauded for his continued involvement with the New York police force and his good nature and sharpshooting skills. Much of this

issue seems to have been published merely to stroke Fass' ego.

Countrywide had a brief return to comics with the Goodman-edited *Gasm*, a magazine inspired by the success of *Heavy Metal*, a dark, sexy, slick science fiction magazine. Like its inspiration, *Gasm* was very adult and very weird. Chuck Dixon, whose work appeared in the first couple of issues, told me that Goodman's submission requirements were for stories "like *Star Wars*, but with more sex and violence." That sums it up pretty well. *Gasm* lasted for five issues.

Left:
Punk Rock Special V1 #2 (Summer 1978)

Right:
Fass' return to comics—
Gasm V1 #1 (Nov. 1977) art by Terry Pastor

145

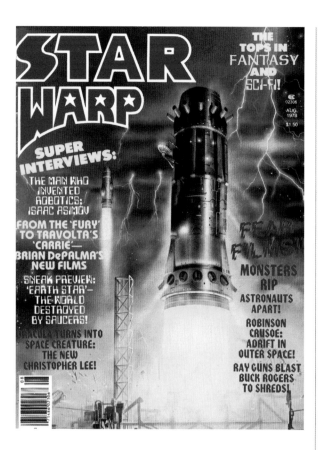

It's A Legal Matter, Baby

George Lucas' *Star Wars* (1977) had become such an incredibly popular film that Countrywide started to devote most of their press space to magazines like *Space Wars*, *Star Warp* and *Space Trek*. In early 1979, Fass cut his staff and his titles down to a reasonable size and, except for a handful of his specialty mags (in the ever-popular UFO and gun genres), the *Star Wars*-inspired magazines would be his main output. These space movie magazines were cost-efficient publications, which was a Fass-pleaser. The film studios provided the movie stills and press releases. The articles pretty much wrote themselves. Comic strips or sci-fi themed artwork rounded out most issues.

Fass had been commuting from his New Jersey home for years. In 1980, the operation moved across the river, into New Jersey. Closer to home and cutting out the George Washington Bridge traffic, the new digs in Fort Lee would house the company, now publishing mostly as S.J. Publications, for the next two years.

The reason for so much change at Countrywide was a lawsuit aimed at them in February 1980 by Quad/Graphics, whose printing services Fass had been using for his many magazines. The suit was aimed at the whole Countrywide corporation, including all of its many imprints, for over a million bucks that was "due on contracts." In an effort to

"pierce the corporate veil and impose personal liability on them," Myron and Irving Fass were also named as defendants.

This obviously put a huge damper on things, forcing the downsizing and the move. S.J. Publications was a new imprint name being used (the mind boggles as to what "S.J." might have stood for) therefore it was not part of the suit. Myron Fass carried on, but things would never be the same again. The shadow of this lawsuit hovered over his life and the company.

During this stormy period, the Fass brothers published what would be the last comic magazine that either of them would ever produce: *Rump*, which lasted for at least three issues. The title reprinted stories and covers from *Gasm*, including classic strips by Richard Corben, mixed in with other underground graphic sex/sci-fi tales from the late '70s. The final issue, Winter 1981, featured a stunning, all-new Joe Coleman cover, as well as his demented new four-pager entitled "Lust Call." Of Fass, Coleman says, "…it was fun to work with him… he fully lived up to my expectations. Really a gloriously fucked-up situation."

It was not as much fun for the younger Fass. In November 1981, much to brother Myron's indignation, Irving caved in and settled with the plaintiff for his portion of the lawsuit. "I think, emotionally, I have had enough of this case. One of the reasons of the

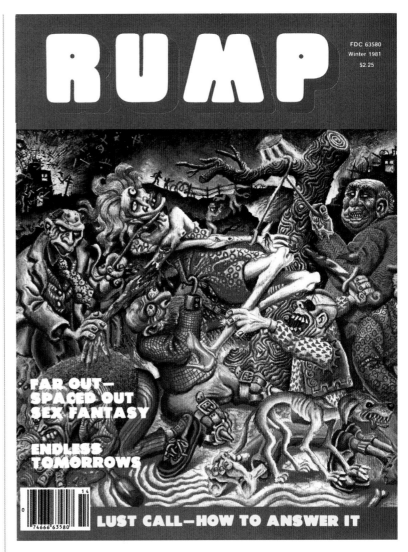

Rump (Winter 1981) art by Joe Coleman

settlement is I don't want to go into it any further," Irving explained at his deposition. He ponied up $25,000 and was released from the proceedings. Of course Myron objected, but had no legal leg to stand on. Irving had left him to fight for himself. The corporation lost the case to the tune of $1,500,000 and Myron Fass himself, whose counterclaims were dismissed, had to shell out $750,000.

At this point, the trail of Myron Fass becomes hard to follow. It's possible that he was the pseudonymous publisher behind Irving's line of magazines in the early to mid-

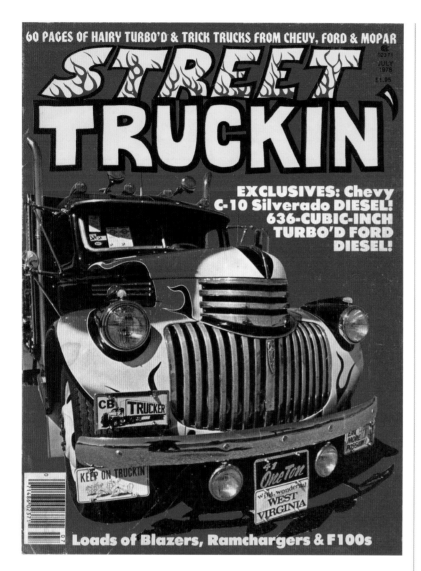

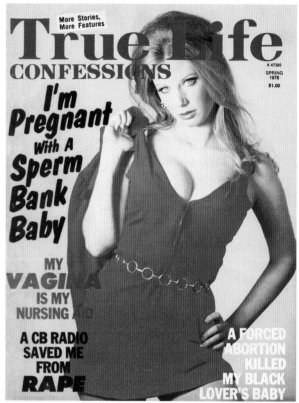

STREET TRUCKIN'

EXCLUSIVES: Chevy C-10 Silverado DIESEL! 636-CUBIC-INCH TURBO'D FORD DIESEL!

CB TRUCKER

KEEP ON TRUCKIN'

Loads of Blazers, Ramchargers & F100s

More Stories, More Features

True Life CONFESSIONS

02371 JULY 1978 $1.95

K 47385 SPRING 1978 $1.00

I'm Pregnant with A Sperm Bank Baby

MY VAGINA IS MY NURSING AID

A CB RADIO SAVED ME FROM RAPE

A FORCED ABORTION KILLED MY BLACK LOVER'S BABY

Top left:
Street Truckin'
V1 #3
(July 1978)

Top right:
True Life Confessions
V9 #1
(Spring 1978)

Bottom left:
The credits from
Systems V1 #3
(Aug. 1987)…
David Harvard
was Myron's son,
David Fass

PUBLICATION STAFF

EXECUTIVE DIRECTOR
CHIEF MERION RILEY-FOSS

EDITOR
JOSEPH CHRISTOPHER

ADVERTISING/MARKETING
DAVID HARVARD

ART DIRECTOR
MICHAEL GIDEON

PRODUCTION
RITA ELIN

PHOTO EDITOR
SCOTT CHIZANSKOS

'80s. A number of gun and *Star Wars*-type magazines continued under various publishing imprints, all with Irving at the helm, and they look very much like their Myron-published predecessors, though their editors say Myron had relocated to Florida.

It Must Be The Heat...

By the mid-'80s, Myron ended up in Ocala, Florida and had opened a gun shop. In the back of the premises were the offices to his new publishing company. Naturally, gun magazines were the order of the day, but time was made for beauty magazines and

the requisite girly mags. The name of this outfit was CFV Publishers. (Central Florida Vigilante? You've gotta wonder…)

Was Fass trying to completely start over? Had the pressure been too much and he'd finally lost it? I presume the former, but one never knows why Myron Fass really assumed the name Chief Merion Riley-Foss. Dean Speir, gun writer extraordinaire, spoke about his work for "Riley-Foss" and how one article appeared in various CFV gun mags (Fass' recycling fever never cooled, I see), and payments were hard to come by. Riley-Foss was purported to be the Chief of the Florida Bureau of Criminal Investigations.

The CFV staff knew that their boss was the one-time "King of the One-Shots," referring to the Countrywide output as "Dead Elvis" magazines. Even after some life-altering setbacks, Fass was still an energetic personality and a maverick publisher, and he still possessed the Roger Corman-like trait of hiring hungry, eager kids to work (cheaply) for his company, learning the ropes from a veteran.

Bob Hollingsworth edited some of the gun magazines in 1987 and wrote a handful of articles, for which he says he is still awaiting payment. At least he lived to tell the story. Of Fass, he says "One of his more annoying tricks was to suddenly draw a concealed weapon… and shoot into a bullet trap in the back hall." Hollingsworth's office was just across a small alley behind the door where the target was,

and bullets (misses) would stick into his walls. At least he could take comfort in the fact that he was working on, as Fass told him, "the bestselling over-the-counter English-language gun magazine in Brazil." Hollingsworth lasted for a few months and says he did not miss working for CFV when he was let go.

Of course, the Florida venture was much more low-key that the New York era. Fass quietly published a handful of cheap magazines (but was using slightly slicker paper by this time) that never made a big splash, but sold

The Chief keeps the magazine business rolling along with CFV Publications— *Gunpro* V3 #1 (June 1987)

enough to finance the next one. His son David had joined him in Ocala, and they did the magazine thing through the early '90s. The younger Fass was often credited as David Harvard. Things were not always smooth (an armed standoff between father and son was said to have taken place in the office) and the good Chief was finally succumbing to the pressures that life had been giving him.

Tom Brinkmann, author of the indispensable book *Bad Mags* (Headpress, 2008/2009), was told that in later life, Myron Fass had been forced into a home because he'd been firing his gun on the tennis courts of his condo complex. His son David passed away in 2000, and Myron Fass, a.k.a. Chief Merion Riley-Foss, a.k.a. the most successful multi-title publisher of the twentieth century, sadly died in Ft. Lauderdale in September of 2006, aged 80.

For all of his eccentricities, Myron Fass was definitely doing something right. Many of the youngsters that he broke in to the world of publishing are still in the field today. His methods were definitely unorthodox, but they worked; they taught, and they produced professionals. I've got to say that I admire that—a lot. Wherever he may be in the afterlife, I hope that Myron Fass is still packin' heat and putting out cheap, titillating, sensationalistic magazines, the kind of magazine that has always appealed to me. Thanks, Myron, for roughly a half-century of sleaze and entertainment.

Opposite: Harris steps into the world of Warren in 1985 with ***Creepy*** #146, cover by Rich Corben

This page: Vampi comes into her own with ***Vampirella: Morning in America, Book One*** (1991), a Harris Comics and Dark Horse collaboration. Art by Mike Kaluta

Harris

Things certainly went much better for Stanley Harris after his split from Countrywide. The first few years on his own were spent publishing the titles he'd acquired in the settlement, including our beloved Eerie Publications titles. When the Pubs stopped being produced at the end of 1981, Harris didn't wait too long before delving back into the world of horror comics.

Jim Warren had taken ill in the early '80s and wasn't able to put as much time as needed into his magazine enterprise. This,

Vampirella #113 (1988)... the beginning of a franchise for Stanley Harris, cover by Enrique Torres

coupled with other distractions such as bad investment advice, spelled trouble for him and Warren Communications, and in 1983 the company went bankrupt. In order to pay outstanding debts, the court ordered a "liquidation auction" of Warren's assets. This is where Stanley Harris came in and bought thousands of dollars of original artwork. In 1984, a court-appointed Warren "trustee" sold Warren Communications to Harris Publications for roughly $125,000.

With the rights to his old competitor's material in hand, Harris published a "Resurrection Issue" of *Creepy* (#146) in 1985. Behind a new cover by Warren favorite Richard Corben lurked new horror stories mixed in with some of the old Warren classics.

One hundred pages of wall-to-wall "Illustrated Weirdness" was a sight for horror-hungry eyes, but unfortunately, it was the only new issue to see print. His next comic book venture would eventually prove much more successful.

In 1988, Harris Publications resurrected another Warren title with *Vampirella* #113. This one-shot consisted entirely of reprints, and sales were fairly weak. However, the character of Vampirella was still fondly remembered from the decade before. After all, a gorgeous, dangerous woman wearing almost nothing never really goes out of style. With this in mind, Harris teamed with Dark Horse comics a few years later to produce a trade paperback full of Warren Vampirella reprints entitled *Vampirella Vs. The Cult Of Chaos*.

Now the timing was right and the world was once again ready for Vampi and her tales of bloodlust. Starting in September 1991 with a four-issue mini-series called *Vampirella: Morning in America*, Harris Pubs reinvented the character, updated her story with new twists and a more modern edge, and struck gold. Many more miniseries and one-shots would follow and the new Vampirella equaled and, eventually, surpassed the popularity she enjoyed at Warren. Vampi had ushered in the era of "Bad Girl" comics and her imitators were many. Reprint collections of *Creepy* and *Eerie* stories were also published, but nothing sold like the girl from Drakulon.

Vampirella was such a success, in fact,

that the character became fodder for a film to be made for the Showtime cable channel. Scheduled for 1996 and directed by Jim Wynorski, this film would bring Harris' Vampirella to a huge audience. One person who caught wind of its production was Jim Warren, who was finally in better health. After a decade of a hermit-like existence, Warren realized that his character was being licensed by Harris, and fought to make him stop.

Warren's people sent out a number of cease-and-desist letters to Harris, who produced his bill of sale from the liquidation a dozen years earlier. It looked as though Harris was on firm legal ground and the film was made as planned. This incident, however, ignited Warren to file a lawsuit against Harris to try to get his company's property back.

As these things do, the suit took a number of years to play out. In the end, Warren was able to get back the rights to *Creepy* and *Eerie*, but Harris held on to his leading lady *Vampirella*, who would continue to be a staple on the comic rack for years to come. It has remained, well into the twenty-first century, the flagship title of Harris Comics.

All the while, magazines were still on the menu at Harris Publications. Like he had done at Countrywide, Stanley Harris continued to engage in multi-title publishing. To this day, Harris, president and CEO of Harris Publications, publishes a wide array of titles, from sports, weapons and handguns

Thank you, Harris Publications!

(guaranteed no articles written by Chief Merion Riley-Foss) to crafting and music magazines to men's magazines, including the top-selling *King*, a mag for African American men, whose June 2008 issue has a Stacey Dash cover that is required viewing for connoisseurs of delectable derrières.

Stanley Harris not only survived working alongside Myron Fass, he succeeded after the split and excelled on his own. We owe him our gratitude for keeping the Pubs around for a few extra years post-Countrywide and for giving Carl Burgos a creative outlet near the end of his life.

Tom Brinkmann told me that when Jeff Goodman informed Stanley Harris of Fass' death, Harris looked a little bit relieved. ✳

Chapter 14

EVERYTHING'S COMING UP EERIE

EERIE PUBLICATIONS, for all of the crap that they've taken over the years by comic snobs, have certainly been embraced by other folks who knew a good thing when they saw it. When it came to eye-grabbing horror images, no one could top the Pubs. It's also probable that they were easier to borrow from than a more "respectable" company like Warren or Marvel, who would inevitably have had better lawyers, and who would really just give more of a shit. The dynamic and degenerate Pubs were always ripe for the pickin'.

Fumetti, or Italian comic strips, have been extremely popular in Italy since the beginning of the twentieth century. With the popularity of the horror genre in the late '60s and early '70s, it only makes sense that there were many fear fumetti present on the Italian newsstands.

Opposite: *Delirium* #12 (Stapem, Dec. 1973) looking a bit like *Terror Tales* V4 #5 (Aug. 1972)

This page: A familiar Ajax ghoul gets new "life" in Italy. From "Le sette morti del centurione" in *Raptus* #4 (Stormo, Sept. 1974)

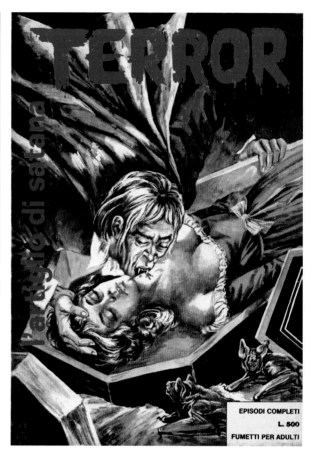

Edizionni Erregi Pubs swipes!

Top left: **Terror** V1 #1 (Nov. 1969), looking suspiciously like **Witches' Tales** V1 #8 (Sept. 1969)

Top right: **Terror** V1 #2 (Dec. 1969), channeling **Tales from the Tomb** V1 #7 (Sept. 1969)

Bottom left: **Jacula** #24 (Elvifrance, 1972), remaking the cover of the first **Terror Tales** (Mar. 1969)

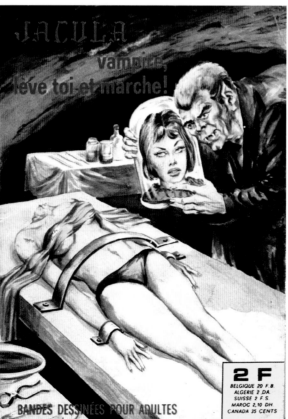

156

Writer and publisher Renzo Barbieri had set the fumetti world on its ear in 1966 with the introduction of *Isabella*, the first pocket-sized erotic adventure comic series. This bodice-ripping adult title paved the way for a more permissive, sex-filled medium. In the late '60s, with partner Giorgio Cavedon, Barbieri formed Edizioni Erregi, or RG, to publish the exploits of *Isabella* and, among others, the new horror heroine *Jacula*. In 1969, they also introduced an anthology horror title, *Terror*, for readers with short attention spans, like me, who couldn't bother following continuing characters.

The first issue of *Terror* (V1 #1, Nov. 1969) is of great interest to Pubs fans because its

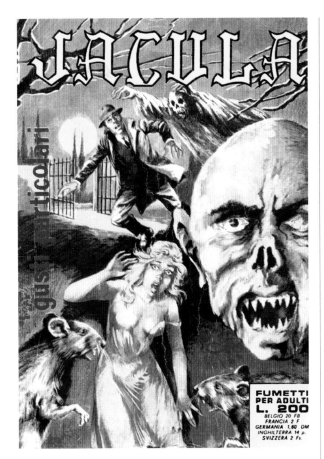

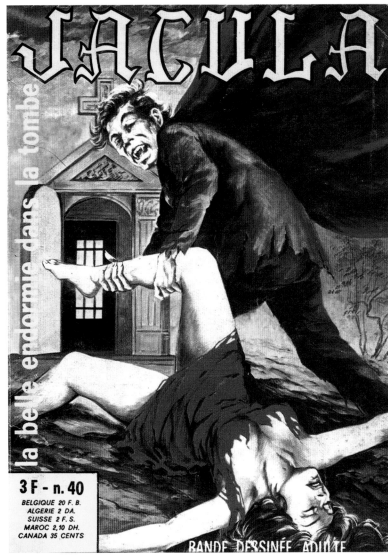

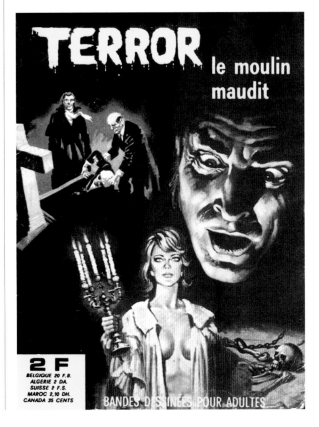

cover is a complete rip-off of Bill Alexander's artwork for *Witches' Tales* V1 #8 (Sept. 1969). The new cover added a bound, semi-nude gal in the background and shoved the victims poppin' eye back in, but it's still startling to note the Fass-esque disregard for originality. *Terror*'s second issue (Dec. 1969) goes even further. The sophomore effort has the same artist "paying tribute" to Alexander's cover for *Tales From the Tomb* V1 #7 (Sept. 1969), copying the pose, the clothing and the layout. Again, Alexander's eye-dangling was not included.

Whereas the first issue featured a 220-page comic novel, #2 filled its 250-plus pages with eight shorter horror stories. The Erregi artists

Top left: *Jacula* #60 (July 1971), uses Burgos' old *Horror Tales* contents page ghoul

Top right: *Jacula* #40 (Elvifrance, May 1974), sporting another Alexander swipe, this time from *Tales from the Tomb* V2 #2 (April 1970)

Bottom right: *Terror* #18 (Elvifrance 1972), using a bit from *Tales from the Tomb* V3 #5 (Oct. 1971)

157

Almost Beaten to the Punch

Not content to just borrow a cover image, the good folks at Edizioni Erregi also lifted two Ajax stories from early Pubs issues, redrew them and published them the same month (December 1969) as the Eerie Pubs introduced their first new original art issues. The swipers get swiped, proving that great minds, and sneaky minds, think alike.

Jacula #71 (Elvifrance Nov. 1976), incredibly close, but a totally different painting than *Tales from the Tomb* V3 #3 (June 1971)

adapted two Ajax stories that had appeared in *Tales of Voodoo* V2 #4 (also Sept. 1969) and redrew them. "Murder On the Moor" gets an Italian face-lift as "Il Gatto Nero," and takes the time to include a rape scene. "Coward's Curse" goes Italiana as "Il Monastero Meledetto" and shows us exactly what the honeymooners did when Ajax's story merely said "An hour passes…". Filled with more sex and violence than the originals, these long (32 and 30 pages respectively) redraws are audacious, to say the least. A story from Stanley's *Chilling Tales of Horror* V1 #3 (Oct. 1969) was also redrawn in this fumetti.

Another nice Fernandez swipe on *Jacula* #77
(Elvifrance, Apr. 1977)

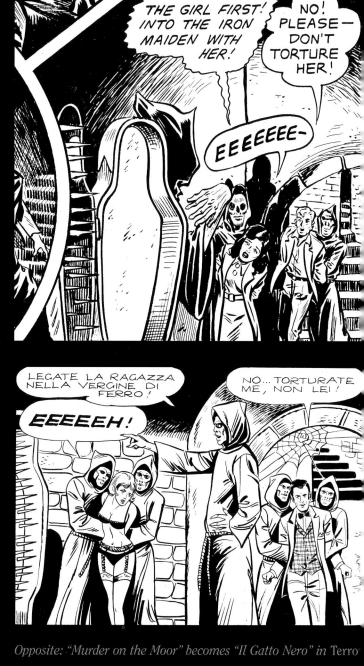

Opposite: "Murder on the Moor" becomes "Il Gatto Nero" in Terro
*V1 #2 (Erregi Dec. 1969). Above: In the same issue, "Coward's
Curse" becomes "Il Monastero Meledetto"*

Erregi's comics were quite successful and the company branched out into France, opening up Editions Elvifrance. Here, they published their comics in French, translating existing stories and recycling existing covers, including some of the Eerie Publications rips. Other paintings familiar to Pubs fans graced the covers of Barbieri and Cavedon's fumetti, such as a rip of Fernando Fernández's oft-reprinted cover that first saw print here as *Witches' Tales* V3 #6 (Dec. 1971).

At the same time, Amos Zaccara, another Italian writer, was the man behind Edizioni Stapem and its sister imprint Edizioni Stormo.

Top left: Fernández's iconic green witch gets new life in Elvifrance's *Les Envoûtés* (Serie Jaune, #11)

Top right: *Delirium* #4 (Stapem, Apr. 1973), honoring Bill Alexander's cover to *Horror Tales* V4 #6 (Oct. 1972)

This page bottom left: An odd one… *I Racconti Scritti col Mitra* #4 (Stapem, Dec. 1973), a crime comic, still swipes from the Pubs… the vampire's cape from *Weird* V6 #6 (Oct. 1972) becomes the necktie and the girl was replaced with a gun!

This page bottom right: *Delirium* #1 (Stormo, Sept. 1972) borrows the female figure from *Terror Tales* V1 #10 (Nov. 1969)

His comics *Raptus* and *Delirium*, as well as many other horror and non-horror titles, provided Italian comic fans with plenty of sex and violence to chew on in the early '70s. Inspiration for Zaccara's bullpen of artists also seems to have come from Eerie Publications.

From familiar Ajax horror stories to wild Bill Alexander covers, Eerie Pubs art swipes abound in the pages of Zaccara's product. Most of the swipes are not wholesale; rather they are used in conjunction with other (possibly swiped?) images. Even stalwart draftsmen like Pini Segna weren't above nicking an idea or two to lighten the large workload. I have identified some other company's swipes in the Stapem and Stormo comics, but the Pubs were apparently a favorite target

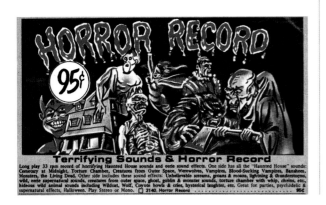

found in the form of *Weird* (February 1973), *Tales of Voodoo* (March 1973), and *Terror Tales* (April 1973), which probably sat side by side on the magazine rack in early 1973. In true Eerie Publications fashion, they created a nice collage of gruesome images borrowed from the covers, and even a bit from the innards, of these three issues. The artwork was new, but "inspired" by the Eerie mags. There was also a black-and-white illustration prepared for the record label itself, using the same inspirations. Their "Horror Record" made its debut in the 1973 catalog, much to the delight of horror-nut audiophiles everywhere.

One incredibly mysterious Eerie Pubs knockoff appeared at the end of the '70s. Jason Willis, a long-standing Eerie Pubs fan,

as their usage significantly outnumbers anyone else's.

Back in 1973, the Johnson Smith Novelty Company, a mail-order catalog outfit that had been in operation since 1914, needed some artwork to advertise their forthcoming Halloween record of scary sound effects. They sent their enterprising young designer to the newsstand to pick up some inspiration. It was

Top left:
Maxi Fumetto
#2 (Stapem), using an image from ***Tales from the Tomb*** V4 #4 (Sept. 1972) and bizarre perspective to make a perplexing cover

Bottom left:
The Pubs-filled advertisement from the 1973 Johnson Smith catalog (courtesy of Jason Willis)

Bottom right:
The label for the ***Horror Record*** (courtesy of Jason Willis)

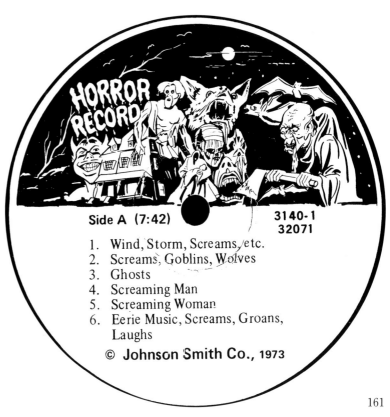

Left:
Raptus #4
(Stapem,
Apr. 1973)

Right:
Even Burgos'
old *Weird*
contents page
illustration was
fair game for
Stapem's
artists

told me that in his youth, his mother had brought him home a Spanish-language comic book called *Vampiro*, which had a familiar Pubs cobble cover on it. He provided me with a cover scan and photos of the contents and I have determined that it was taken directly from *Weird Vampire Tales* V3 #1 (April 1979). All of the text had been translated to Spanish, but otherwise, it's the same magazine exactly. Even the little bat narrator who was drawn into many of the WVT stories is present here, only his quips are now *en español*. The cover used on *Vampiro* (originally cobbled for *Terror Tales* V5 #5) was taken from the *Weird Vampire Tales* frontispiece (where it was printed in black and white) and recolored. An Ezra Jackson "Superstitions" page ("Super-

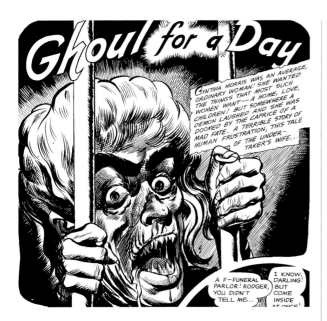

sticiones") adorned the back cover, and was also colorized.

Señor Willis' *Vampiro* was purchased in 1979 in Mexico. I have no real clues about it other than that. It's numbered as Volume 1 #1, but it's likely that no other issues materialized. I sincerely doubt that this was a licensed product. If it was, why wouldn't the original (better) cover have been used instead of a colorized copy made from an inside page? I doubt that Stanley Harris, who had custody of the comics at this time, would have bothered

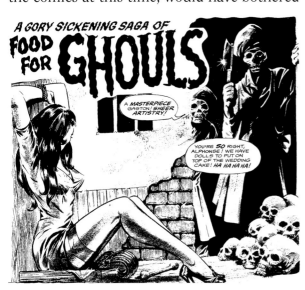

Swiperama!

Top: *Tremens Storyes* #1 (Stapem) nicked the Burgos-embellished splash panel from the Ajax story "Ghoul for a Day"

Bottom: *Raptus* #8 (Aug. 1973) wisely borrows my favorite panel from Stepancich's "Food for Ghouls" and nudes it up

The mysterious *Vampiro* V1 #1 (courtesy of Jason Willis)

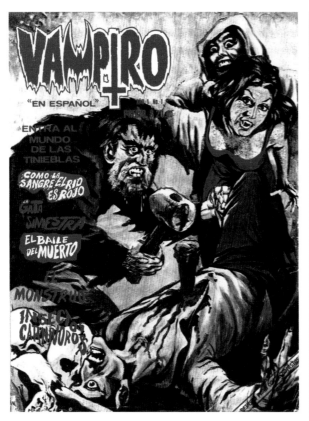

licensing this stuff for the few pesos it might have been worth. I'm sure it's a rip job.

Proving that good ideas never die, Pubs artwork again surfaced after more than 20 years of dormancy. Video Asia lifted not only the Eerie Pubs artwork for the covers of their unlicensed DVDs, but they even used the titles and logos. Their TALES OF VOODOO and TERROR TALES line of double-feature DVDs sported some well-loved Eerie Publications covers, as well as some interior panels that were used as spot illustrations. The jackets look awesome, too; the colors are pumped up and are very eye-catching. While researching this book, it did my heart a lot of good to walk into my local DVD shop and admire some Bill Alexander art that was created 30 years earlier. The last title to be issued in this series (before

Video Asia's distributor, Ventura Distributing, went under), *Terror Tales Volume 4*, even utilized the ol' Pubs standby: paste-ups. The disc contains a would-be blaxploitation double feature, so Video Asia's art department took the cover to *Horror Tales* V4 #1 (Jan. 1972) and pasted African American figures over the ones from the original cover (going so far as to put some bling on a zombie's wrist and a blunt between his fingers). No, good ideas never die.

Speaking of DVDs, Something Weird Video, who always pack their releases with tons of tantalizing extras, released a slew of titles with a supplement called the Ghastly Gallery of Ghoulish Comic Cover Art! Ghoulish indeed, as it was a smörgåsbord of Eerie Pubs covers, with a few Stanley titles thrown in for good measure. The images flicker by while the sounds of the Dead Elvi rock out behind them, prompting the casual fan to say "Ah! I remember that one!" and geeks like me to say "got it, got it, got it…" Apparently, SWV head honcho Mike Vraney is another longtime Eerie Pubs fan. The aforementioned Jason Willis has designed some video covers for SWV and he was naturally moved to toss a few Eerie images into his work. *Vive les Pubs!*

In 2007, Idea Men Productions unleashed *The Zombie Factory*, which collects 27 Eerie Publications stories (edited by Patrick O'Donnell) into one satisfying paperback book. Many Pubs favorites are in there (Stone's

"Voodoo Terror," Ayers' "Swamp Monsters") as are some surprises (Casadei's "A Cup Of Death," Fraga's "Naked Horror"), and it's rounded out with some classic Ajax stories. Lurking behind the artwork for *Tales of Voodoo* V3 #1 (Jan. 1970) on the cover, these stories made a welcome return to American bookshelves after a 25-year absence.

Band flyers, posters, T-shirts, cigarette cases—Eerie Pubs artwork has been used on dozens of different items designed to pique the interest of nostalgic gorehounds like myself. Considering how "bad" the Pubs' artwork is said to have been ever since their inception in 1965, an awful lot of it has been lifted to sell or promote other things. Their "retro" and "kitschy" style has become the darling of do-it-yourselfers and their Etsy shop projects.

Interest continues to grow for these bad boys of black-and-white horror. Prices for the Pubs are rising in dealers' catalogs and online auctions. High-grade examples fetch top dollar (and considering the cheapjack paper they're printed on, nice condition copies are extremely rare). On the internet, blogs and message boards discuss the good and bad points of Eerie Pubs and indexes and web pages are devoted to this company that was all but ignored just a decade ago. Fanzines and websites are singing the praises of Myron Fass, who is becoming a kind of mythical being in retrospect. Perhaps it is rightly so. ✳

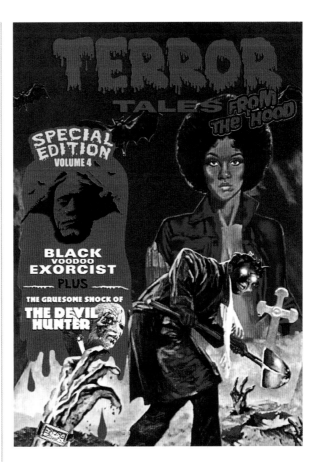

Top:
Terror Tales
4 incorporates the time-honored Eerie practice of cut, paste and repaint. Check out the bling on that zombie hand!

Bottom:
A Halloween loot bag found in New York at a Stop and Shop in 2008, modeled by the late, great Ken

BROUGHT TO YOU BY

Carl Burgos

While it is true that Myron Fass was the person responsible for launching the Eerie Publications line of horror comics, it was Carl Burgos who made them what they were. The comics were just a fraction of Myron's monthly magazine output. It was Burgos who dotted the "I"s and crossed the "T"s and was responsible for making the comics road ready; Fass was only his green light.

Born in New York in 1916, Max Finkelstein started going by the name Carl Burgos at a young age. After quitting the National Academy of Design, he got a job engraving printing plates for the Chesler Shop, Harry Chesler's art studio that competed with the Iger Shop for comic book work in the late '30s. In 1938, Burgos joined the studio as an apprentice and by early 1939, he'd begun drawing complete stories. The first all-Burgos story to appear was an eight-page pirate story in *Star Comics* V2 #2 (Centaur Publications, March 1939).

Opposite: My favorite Burgos cover for the Pubs... *Weird* V2 #6 (Apr. 1968)

This page: Carl Burgos (photo courtesy of Susan Burgos)

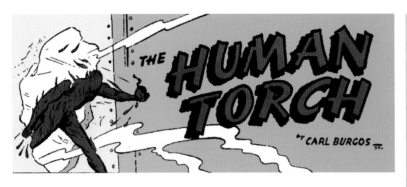

The first glimpse of Burgos' Human Torch from *Marvel Comics* #1 Oct. 1939, ©2010 Marvel Characters. Used by permission

Lloyd Jacquet, Centaur's art director, liked what he was seeing from the Chesler shop. He made the move to start his own art studio and procured Burgos and Bill Everett, another Chesler artist, to be the foundation of his staff. Called Funnies Inc., the new studio would go head to head with the other comic art shops, vying for the patronage of the early comic publishers.

After a slow start, the studio landed their first paying gig from Martin Goodman, a pulp publisher that had been convinced by a Funnies Inc. salesman to test the waters of the new and promising comic book industry. Goodman's venture was called Timely Publications, the comic book arm of his publishing house. Timely's first release was called *Marvel Comics* (#1, Oct. 1939) and it included brand new work by Funnies Inc. artists, including Burgos and Everett.

Burgos and Everett wrote and illustrated their own stories for the book and while it might have been just another comic gig for the two, they delivered work that still resonates decades later. Such was the talent that Jacquet had brought on board. Carl Burgos' story was the centerpiece of Timely's debut.

His entry was about a character called The Human Torch. An android created by Professor Phineas T. Horton to be the perfect synthetic human, the Torch had the unfortunate flaw of bursting into flame when exposed to oxygen. This made him just a bit unpopular with the inhabitants of New York City. The Torch accidentally burned up parts of the Big Apple while he learned to harness his power and use his "gift" like a proper superhero. Imbued with human-like qualities, the Human Torch was far more humane than many of the people around him, who wanted to use him "for selfish gain... or crime."

Burgos' creation was an immediate hit, as was Everett's new character Namor, the Sub-Mariner, a half-human/half-water-breathing Atlantean with a bad attitude and a vengeful streak. The two characters continued to headline Goodman's comic, known from #2 on as *Marvel Mystery Comics*. Starting with #8, a multi-issue battle between the two commenced in what was one of the first crossovers in comic book history.

In the fall of 1940, the Human Torch earned his own comic book and Carl Burgos was the man in charge, still scripting and drawing the Torch's exploits. Saddled with a requisite boy sidekick Toro, this was a very early example of a superhero starring in his own title; it was Timely's very first. New Torch tales were also created for *Marvel Mystery* and the new *All Winners Comics* for Goodman.

Timely's superheroes pitched in for America and kicked some Axis ass during World War II, as in Burgos' "Terror of the Slimy Japs" in *All Winners* #4 (Spring 1942). Everett and Burgos were both cranking out a lot of product featuring their star creations for Timely. When one hand got tired at the drawing board, the ambidextrous Burgos would switch hands and keep on goin'. In *Marvel Mystery Comics* #34 (Aug. 1942), Burgos himself, as well as Everett, Goodman and other Timely staffers join the Torch to battle Hitler and other Nazis! This was Carl Burgos' last work in comics before he entered the service for real in the autumn of 1942.

Burgos returned home from the war in 1946 and he, like the rest of the country, had to acclimate to postwar America. He met, and soon married, his girlfriend Doris, settled into advertising school, and had his name legally changed to Carl Burgos. He concentrated his efforts on advertising, but comics were in his blood and he returned to Timely on a freelance basis. Some of his assignments for Timely were in the crime genre and a couple of full-length stories in *Complete Mystery* (#3, Dec. 1948 and #4, Feb. 1949) written by Goodman's hotshot young editor Stan Lee. Burgos also made a return to the pages of *Marvel Mystery Comics* where his Human Torch was still the flagship character, though he worked only on backup strips.

As the '40s gave way to the '50s, Martin Goodman canceled his superhero comics and introduced new titles in every marketable genre: crime, Western, adventure, war and, the new hot ticket in comics, horror. Carl Burgos' intricate inks and dramatic layouts were put to very good use by editor Lee and he became the company's unofficial cover artist. Burgos illustrated over 100 striking covers for the company, which by the end of 1951 had become known as Atlas Comics. He did little story art during this time, but the covers came fast and furious in all genres, especially horror. He also contributed illustrations for some of Goodman's remaining pulps.

At the end of 1953, Atlas took one of their adventure anthology titles and reintroduced

Complete Mystery #3 (Timely, Dec. 1948)

Top: A typically great Burgos horror cover from *Mystic* #24 (Atlas, Oct. 1953)

Bottom: *Adventures into Terror* #19 (Atlas, May 1953)

skipped a beat. The horror titles changed to light fantasy titles and Burgos was there to supply the exciting covers for the less-than-exciting stories inside. His inside story work was infrequent until mid-1957 when he again illustrated stories for the fantasy, war and Western books.

1958 was another turning point for Carl Burgos and his comic book career. He had been freelancing in the *MAD*-styled humor magazines for a few small companies and enjoying working in the code-free atmosphere. He was also editing *Zany* for Candor Publishing. His humor work was excellent, displaying a gift for caricature and detailed sight gags. He continued with his Atlas fantasy

some of their previously popular superheroes. *Young Men* #24 (Dec. 1953) through #28 (June 1954) featured, among other early Timely stars, The Human Torch. Burgos supplied some stunning covers and beautiful eight-page stories to most issues. Some fans consider these covers to be among his finest work. The Torch's self-titled comic also made a brief resurgence in 1954, but Burgos only supplied the cover art for these. Ironically, future employee and friend Dick Ayers was the artist illustrating the stories. In 1954, Carl Burgos got the chance to display his humorous side with a few stories in Atlas' humor comics *Wild* and *Crazy*.

After the inception of the Comics Code, Atlas was one of the few companies who barely

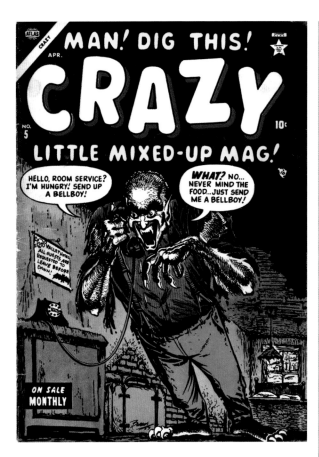

stories through the summer of the year, then his contributions abruptly stopped. A backlog of stories that had already been produced and paid for had piled up and many artists, Burgos included, were not given new work. His stories would continue to appear through the summer of 1959 but these were drawn earlier.

Except for the black-and-white, code-free humor magazines (plus the mysterious *Weird Mysteries*, which I suspect he was editing as well), Burgos did not do any comic art for a few years. He kept his chops up by illustrating covers for sheet music and, like Bill Everett, doing artwork for greeting cards. I like to think that some of my old Halloween ephemera was illustrated by Carl Burgos.

Meanwhile, Stan Lee had taken Atlas

Comics and turned it into the empire that is still known today as Marvel Comics. Inspired by DC Comics' move of returning the superhero genre to the forefront (particularly with Justice League Of America), Lee and Jack Kirby put their heads together and came up with their own super team: the Fantastic Four. The first issue of *The Fantastic Four* (Nov. 1961) hit the stands and ushered in Marvel's age of superhero superstardom. One member of the new team was a reworked Human Torch. Burgos' incendiary icon had the same powers, but Lee had pretty much changed everything else about the character, even making him human rather than android.

The Fantastic Four was a huge success, as were Marvel's numerous other new superhero titles, and the door was again open for comic

Top: Burgos' humor work still employed the horror genre. *Crazy* #5 (Atlas, Apr. 1954)

Bottom: Burgos shows his fondness for the Ripley's Believe it or Not strip with this parody from *Zany* #1 (Candor, Sept. 1958). He would revisit the style with his Morris pages in the Pubs.

171

This page: **Great West** V1 #12 (Sept. 1967) Burgos' chilling scalping cover

Opposite left: As gratuitous as any Eerie Pub, **Great West** V2 #6 (Dec. 1968)

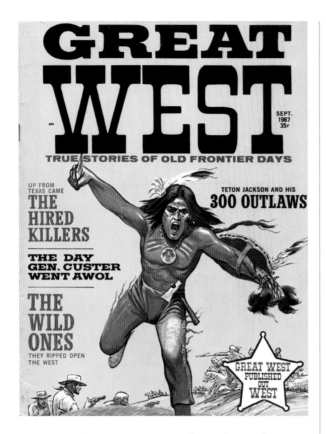

creators. Burgos returned to Marvel upon seeing his Torch revived. He provided technical sketches for Dick Ayers, who was illustrating Human Torch stories for Marvel's anthology comics. Says Ayers, "The Human Torches by Carl were paste-ups of HT that he'd drawn [pasted] over what I had drawn... until I got the movement he and Stan wanted." Despite providing this art help, Lee wouldn't offer Burgos any new, steady work. He began to realize that he'd lost the character that he'd created and it made him understandably bitter. It is said that Burgos and Stan Lee did not get along well. Both were strong-willed men who couldn't possibly see eye to eye all of the time.

Around this time, Burgos tried to rid himself of his comic book past. He tried

suing Marvel to get his creation back, but was unsuccessful. With contempt for the industry, he threw out his entire collection of old comic books. Comics were indeed in his blood, but his blood was boiling and he sought to alleviate his anger and pain. He'd been stabbed in the back by an industry that he had helped form and had done much for throughout the years. Burgos later said that he wished he'd never created the Human Torch because of all of the trouble it had caused him.

There were, however, a few movers and shakers in, or around, the comics field who could provide a better fit for Carl Burgos. Enter Myron Fass, who was looking to pounce on Marvel's success in the rejuvenated comic book market with some product of his own. Knowing full well that he was working with a comic book great, Fass gave the go-ahead to Burgos' next android character, Captain Marvel. As mentioned in Appendix 1, the hero wasn't a great success and even with Fass in his corner (attempting to sue the "enemy" Marvel), the good Captain was doomed to failure.

Joining the Fass family was good fortune for Burgos and a real coup for Countrywide. In 1965, Burgos got back into editing with *Panic*, a repackaging of the same title that folded a few years earlier (for which he had drawn some excellent humor strips), now being handled by Robert Farrell's Panic Publications. Concurrently, the same staff was

packaging the first issue of our beloved *Weird* (V1 #10, Jan. 1966).

The Eerie Publications comics weren't Burgos' only concern at Countrywide. Fass was a smart man and was quick to welcome Burgos' talent into the family. Starting in early 1966, Burgos was providing illustrations for the girlie magazines, and was soon creating editorial page logos for *Jaguar* and *Duke* and doing comic strips in *Poorboy* ("The Flower People" and "The In People," before Bill Alexander took over). The text illustrations in the Countrywide girlie mags are among my favorite Burgos pieces—they are often very stylized and always fun. His girls were buxom and smiling and the artwork was clean, loose and cheerful. None of his work in any of these magazines was signed or credited.

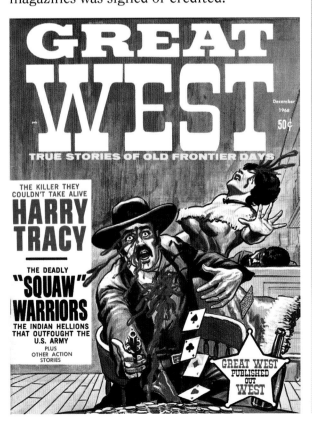

In 1967, Burgos began editing *Great West*, a magazine devoted to tales and articles of life in the Old West. Burgos also added some spot illustrations and quite a few beautiful and disturbing covers, some as violent as the Eerie Pubs themselves. The Overstreet Comic Book Price guide has had this title listed for years as a comic book but it is not. Burgos also took a "Designer" credit on the two issues of

Above: "On the Prowl" was the editorial page in Fass' girlie mag *Jaguar*. Burgos provided this illustration, which accompanied the column from 1967 until 1972.

A rare illustration signed by Burgos in an Eerie Pub, the beautiful text illo from "Cry, Ghost, Cry"

Strange Unknown in 1969. Burgos stuck it out at Countrywide after the fall of the horror comics by editing war publications like *True War* and *World War II*.

Despite being a very talented artist, Carl Burgos has had many critics over the years, perhaps none bigger than himself. In the seminal *Steranko History of Comics* (Supergraphics, 1970), Burgos himself said

"The miserable drawing was all mine, but I was having fun." He was referring to his original Human Torch strips where he, unlike most comic artists, refused to swipe ideas from other artists. His greenness in the medium was evident, but his art always told the story well and was full of action and excitement.

His horror covers for Atlas in the pre-code '50s still hold up today as some of the moodiest and creepiest of the time. Detailed cross-hatching and heavy inks alternating with light, wispy lines made striking, nightmarish images, easily catching the eye of a prospective buyer. He was very talented in the horror genre and it looks like he enjoyed what he was doing. Susan Burgos, Carl's youngest daughter said, "I surely knew he worked in the horror genre. Anytime I would walk into his studio there was an eyeball hanging off a face or a beautiful woman surrounded by some dark character or monster." She went on to say, "I probably took it for granted but I always thought it was cool. Besides, we both have a dark side to our personalities, so you could say I am my father's daughter."

While Carl Burgos may have decided against swipes back in the '30s and '40s, swipery was the name of the game at Eerie Pubs. The handful of stories that Burgos assigned to himself for redrawing stuck very close to the original layouts and character design. While the inks and brushwork are all very good, there's not a lot of creativity involved. He was

definitely just banging 'em out, trying to fill up his magazines. One wonders if this was a sort of "up yours" gesture to an industry that had done him wrong.

His Eerie Pubs covers, on the other hand, were all very much his own. He started the ball rolling in 1967 with the ultra-gory covers, stomach-churning decapitations, bound victims and limbs ripped from bloody sockets. This was the stuff that put Eerie Publications on the map and it's still the first thing that comes to mind when non-collectors remember them from their childhood. These covers traumatized a generation. With the horror and *Great West* covers, Burgos was messing with our minds (and stomachs), and that's a big part of what makes these books so memorable.

Just as effective as his horror illustrations were his screaming headlines. Strings of adjectives ballyhooed the horrific stories within, and in many cases, Burgos' hyperbole was far more creative than the stories themselves! "Spine-snapping," "squirming," "blood-curdling," "bone-chilling" and my all-time favorite adjective, "scarifying"—Burgos wove a web of sensationalist horror poetry. These exaggerated headlines coupled with the über-gory covers screamed from the newsstands, daring you to plunk down your hard-earned allowance.

Carl Burgos may have had a "dark side" from which he mined his natural talent for

A beautiful Burgos text illustration from *Jaguar*, perhaps my favorite one

the horror genre, but those who worked around him saw him as a kind and affable man. Dick Ayers says that he really liked Carl and that he'd have been happy to keep doing stories for Countrywide based solely on that fact. Most people, however, never got to get close to Burgos. A very private man, he rarely

175

One of a zillion anthologies edited by Roger Elwood in the '70s, this one is from Curtis Books (1974).

opened up to others and he routinely turned down interviews and offers to attend comic conventions. The aforementioned *Steranko History of Comics* featured the man's own words, which stands as a rare treat for fans. His disenchantment with the comic industry made him choose to keep to himself.

After a short absence, Carl Burgos returned to the magazine world to edit the Eerie Publications for the newly emancipated Stanley Harris. He brought back the fun and hype that had been lost when he left Countrywide two years prior. Of course, the comics were still all reprints, but Burgos knew how to package them attractively and make them interesting. He stayed with Harris, editing various titles, even after the cancellation of the horror magazines. Stanley Harris would be Carl Burgos' last employer. In 1984, after a lengthy illness, Carl Burgos succumbed to colon cancer.

We know little about the man himself, but know that he was passionate about art and he was wildly creative, and that's the rich legacy that Carl Burgos left for his fans to remember him by. With the Human Torch, he created a character who is arguably one of the most recognizable comic book heroes ever. He also gave us horror fans many years' worth of fantastic twisted tales to thrill and chill us. May the world remember Carl Burgos as a gifted artist, a tremendous creative talent and, above all, an innovator in the comic book medium.

Roger Elwood

Roger Elwood was a fairly small player in the Eerie Publications saga, but his name is important to readers of this book as the writer of the first story to appear in the company's output: "Frankenstein," in *Weird* V1 #10 (Jan. 1966). This retelling of the classic was illustrated by Carl Burgos and it remains the only story with an actual writing and artist credit in any Eerie Pubs mag.

Elwood's name is seen in other Country-wide publications, including as the editor of the mid-'60s teen mags *Teen Circle* and *Teen Trends*, a credit that I find amusing for a sci-fi writer. He is also the credited writer of much of the *Captain Marvel* comics series, weaving a world filled with somewhat familiar characters, trying to foil Carl Burgos' splitting android.

Elwood, a longtime science fiction writer, is best known for editing a boatload of science fiction and horror anthology books for various publishers in the 1970s. He was so prolific that he has his detractors, who suggest that Elwood flooded the market with inferior material and killed the future of sci-fi anthologies. Of course, similar things are said about Eerie Pubs themselves. Whatever one's view, it's pretty easy to find a copy of an anthology edited by Elwood on most library shelves.

In the late 1980s, well after his science fiction editing days, Elwood found new success by mixing his sci-fi leanings with his Christianity and started a successful second writing career with his "Angelwalk" and "Darien—Guardian Angel of Jesus" series. Somehow, he also found the time to write adventure novels, a Hardy Boys-styled series, Bible fiction and more throughout the 1990s, having over 30 books see print throughout the decade.

Elwood passed away in 2007 at the age of 64.

Irving Fass

In every magazine released by Eerie Publications with production credits listed, Irving Fass' name is there. Even though the horror magazines were the offspring of his brother Myron's and Carl Burgos' unholy union, Irving got a credit, proving that blood is thicker than printer's ink.

Born in 1934, Irving was the youngest of three brothers and always looked up to Myron, the middle son. Myron had taken his talent for drawing and had a lucrative career in comics,

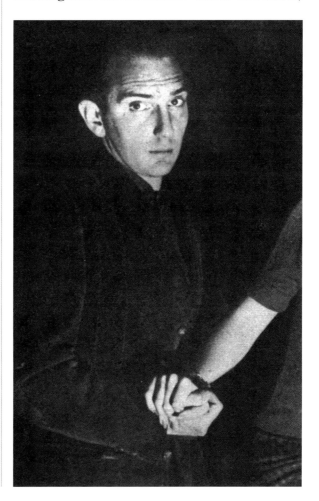

Irving Fass, as one of his brother's models, from ***Suspense*** V1 #4 (Sept. 1959)

Looking
a bit like his
brother's maga-
zines…
Star Invaders
V1 #1 (Liberty,
Autumn/
Winter 1984)

then developed his talent for huckstering and turned it into a multi-million-dollar publishing empire. Irving was impressed by, if sometimes jealous of, his older brother's talent and confidence. Irving was insecure. Editor Bob Nesoff put it best when he said "Irving was the antithesis of Myron."

Having a baby brother that looks up to you can be a handy thing in the magazine biz. Myron first utilized Irving's talents in *Suspense* Vol. 1 #4 (September 1959), where the younger brother models as a ghoul on the cover and has a few inside shots, both as a scared victim and as a vampire. The very next year finds Irving getting an art director credit in the August issue of *Ogle*. Within two years, Irving's name was appearing in every magazine

put out by his brother. His art director credit stayed with him throughout the decade and well into the '70s, including for the entire first run of the Eerie Publications.

He was an avid photographer and was said to have some ability at art, but he only did cut-and-paste and page setup for the magazines. It's a pretty sure thing that he never laid a finger on an Eerie Pub. Carl Burgos ran the Pubs and it's doubtful that he'd have let someone else tinker with his books. When prompted about what Irving Fass' job at Countrywide Publications really was, Howard Smukler explained "…I don't remember that we respected him for anything other than being Myron's brother. I'm sure we never knew what it was that he did. Everyone had a job; there was advertising, art direction, editing, etc, and the brother never had a slot."

Slot or not, he was on the payroll, was invested in the company, and made a pretty good living. In the mid-'70s, his title changed to executive director and after the Fass/Harris split, Irving assumed the title of associate publisher. If he was merely his brother's yes man, at least it paid well enough for a Mercedes. He was also a major stockholder in many of Countrywide's ventures.

After the Quad Graphics suit and Irving's payoff in 1981, it's tough to tell if the brothers parted ways. Irving started publishing a handful of magazines out of his home in Demarest, New Jersey. Under the name Victory

Publications and Liberty Communications, Irving served as "Executive Director" on a slew of magazines, mostly in the science fiction film genre and gun mags. The magazines looked suspiciously like the work of his brother, but since Myron was his teacher and role model, that wouldn't be surprising. Some of the titles were holdovers from the Myron days. Michael DePasquale, who edited some of Irving's magazines later in the decade, said the Fass brothers hadn't spoken in years.

At any rate, it was Irving calling the shots on these magazines, no matter whose name was listed as the publisher. Although it's possible that some of the names might have been a pseudonym for Myron, at least one "publisher" name was that of a local gynecologist who was a mutual friend of Irving and Bob Nesoff. The magazines were planned out and put together in Irving's living room. Unfortunately, Irving had picked up some bad business habits along the way. Nesoff says, "Irving didn't like to pay for stuff."

Former Liberty editor C.J. Henderson said, "He got a lot of work from us, made many promises, and then ran out on his obligations. No one was paid. He was an utterly contemptible snake who left me holding a particularly awful bag of crap to deal with." Bob Nesoff was also being handed lines instead of money. He was hired to produce a magazine for x-amount of dollars, but was only paid 60% of it. Irving later killed some titles for which Nesoff had

already produced material, then run with it a year later as his own, getting the work for free. Bob Nesoff was considered a friend, too.

In 1986, Irving bumped into martial arts phenom Michael DePasquale Jr. who, as a youth, had been in some of the Countrywide karate mags, and suggested they team up for some slick karate magazines. Published under the banner of Horizon Publications, these 12 mags are the last known Irving Fass ventures. They were a cut above the usual Fass fare, with slicker paper and tighter layout. The

Michael DePasquale Jr.'s ***Combat Karate*** V1 #4 (Feb. 1987), one of the last Irving Fass magazines

magazines were planned out in a diner in New Jersey, and taken home by Irving to cut and paste into the final product.

DePasquale never regretted his time with Irving, despite some turmoil. He acknowledges that it was a great opportunity for him (and his sport) that might not have arisen otherwise, and it started him on a new branch of his illustrious career. He suggests that, in addition to the oft-mentioned dark side, Irving possessed a good side as well. "He was a real character and a shrewd businessman. He had a real spark of interest in him," says DePasquale. Unfortunately, Irving's habits of nonpayment and not returning material, some of it very precious, reared its ugly head and strained the relationship.

I hate to make this biography such a downer, but this is the legacy that he left to the people that were around him. I'll admit that it must have been very tough growing up in the shadow of a personality like Myron's. When left to his own devices, he made some bad decisions. In the mid-'80s, Irving had taken in Myron's son David and helped him straighten out his life, if only for a while. Irving was not a heartless man, just a very troubled one.

It is said that Irving Fass killed himself. He died on January 14, 1991, while in Broward County, Florida, where Myron was residing. Irving was still living in New Jersey. Not being a family member, I have not been able to verify the cause of death.

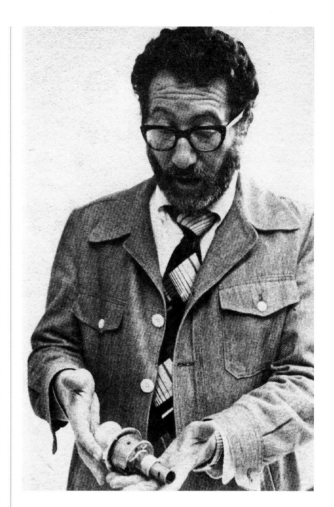

A Mel By Any Other Name

A ubiquitous name in the Countrywide books is that of Mel Lenny. Or Mel Lennie. Or Mel Lenowitz, Melvin Lenowitz or even Len Melvin. The man behind the Mel is Milton Lenowitz, a Fass crony for nearly 30 years.

His name (one of them) started appearing alongside his friend Myron's way back in 1956, credited with "research" in *Ogle* #1. He continued throughout the '50s in the same capacity for *True or False* (1958) and *Foto-Rama* (from 1957 through 1960).

With the advent of the '60s, his name got shortened and he moved over to advertising for Fass. As advertising director, representative or manager, the name Mel Lenny appears in hundreds, if not thousands, of magazines in the '60s and '70s. He is mentioned here for his credit as publisher in issues of *Weird* in 1967 and 1968, as well as a handful of *Horror Tales* a few years later. A Statement of Ownership never appeared in an Eerie Publication, so it's hard to say what Myron Fass and Stanley Harris gained by listing him as the publisher for these few issues.

Lenowitz's real name only pops up once that I can find. In *The World of Sherlock Holmes Mystery Magazine* (Dec. 1977), he is listed as a consulting editor alongside Robert A.W. Lowndes, the man who gave the Eerie Pubs their text stories. Evidently, Milton Lenowitz was a Sherlock Holmes fan who felt that his association with this publication was worthy of his real name. He is also pictured (in a group shot) in Lowndes' article about The Baker Street Irregulars, a club for Holmes enthusiasts/über-geeks founded in 1934, whose goal is the study of all things Sherlockian. Both Lowndes and Lenowitz were members.

Mel Lenny appeared in some of the comical articles in the Jeff Goodman-produced *Official UFO* magazines in the late '70s. It seems editor Buddy Weiss was shot at by an alien, and mutated into a "Mel," one of the "strange little bearded alien men." These articles and the accompanying photos are all very entertaining.

Mel Lenny's association with Fass was still going through 1981, which means he stuck by his friend to the bitter end. Many staffers over the years have no recollection of him; others only recall him hanging around and joking, or occasionally, like everybody else, getting a dressing down from Myron.

Milton Lenowitz passed away in December of 1991 in New York.

Ezra Jackson

First off, it would be best to clear up a few misconceptions.

At some point on the ever-reliable internet, it began to get around that the name Ezra Jackson was a pseudonym for the Eerie Pubs boss himself, Myron Fass. The rumor may have begun on the Empire Of The Claw (www.empire-of-the-claw.com) Eerie Pubs message board, where Jeff Goodman checked in and posted that "Ezra Jackson was a pseudonym" and people just assumed that it was a *nom de plume* for Fass. The well respected Who's Who of American Comic Books website (www.bailsprojects.com) has perpetuated the rumor and many websites from sea to shining sea

THE WEIRD WORLD OF EERIE PUBLICATIONS

Airboy Comics V3 #2 (Hillman, Mar. 1946) Maurice Whitman and Ezra Jackson as Whit Jackson, with a thrilling splash page from the Iron Ace series

have taken the pseudonym myth as gospel and run with it, without first checking the facts.

It is false. Ezra Jackson is not Myron Fass. Nor is he Ezra Jack Keats, Caldecott Award-winning children's book author (who, incidentally was also working on comics for Fawcett in the early '40s) He was, in fact… Ezra Jackson, and it is not a pseudonym.

Born in the '20s, Jackson's first foray into the comic medium was in the early '40s as an artist in the Iger Shop. He was a very proficient inker and when he wasn't inking his own work, he was given other artists' pencils to embellish. One artist that his work jelled with was Maurice Whitman and the duo became an unofficial team, producing artwork for many titles under the names Whit Jackson or the unfortunate-sounding Ezra

Whiteman. (Jackson, an African American man, deserved a more thoughtful name for the duo.) This tandem had their collaborations used in *Airboy Comics* (Hillman), various Fawcett titles including *Nyoka* (the Jungle Girl!), *Bulletman* and *Gabby Hayes*, and L.B. Cole's legendary *Suspense Comics* for Continental. As Ezra Whiteman, they even appeared in Gilberton's long-running title *Classics Illustrated*, illustrating Herman Melville's *Typee*.

Sadly, not long after World War II ended, Ezra Jackson found himself replaced by returning soldiers, artists who had been well established in comics before the war and were looking for their jobs back—and who happened to be Caucasian. Jackson was not as well established as Matt Baker, a fellow African American artist who had carved out a niche for himself, and when segregation reared its ugly head, Ezra Jackson moved on.

Always keeping his hand in the arts, Jackson took other jobs to support his family and put food on the table, but artwork remained his passion. He maintained a low profile in the industry, still occasionally working on comic art.

In 1967, Bertram Fitzgerald was putting together his *Golden Legacy* line of comic books. The comics were to be inspirational one-shots of black Americans and their achievements. After actively seeking out Jackson, Fitzgerald put him to work on Volume 3, *Crispus Attucks*

(1968), doing spot illustrations and creating a more suitable splash page than the one turned in by another artist. Calling Jackson his "most obliging, reliable and cooperative" artist, Fitzgerald gave him the whole of Volume 4, *The Life of Benjamin Bannaker* (1968) to illustrate. *Alexander Dumas and Family* (Vol. 6, 1969) soon followed, and his artwork graced several subsequent *Golden Legacy* titles as well. With Fitzgerald, Jackson was not only free to do his own pencils and inks, but he handled his own coloring as well. Bertram Fitzgerald considered Ezra "a really nice man" and they remained good friends for years.

Of course, within a year, Ezra Jackson was looking across town to the bloodier pastures

Top: ***Golden Legacy*** #6 (Fitzgerald Pub, 1969), one of many illustrated biographies that Jackson did for Bertram Fitzgerald's African American History titles

Bottom: As Ezra Whiteman, the duo illustrated Herman Melville's *Typee* for ***Classics Illustrated*** #36 (Gilberton, Apr. 1947)

of the Countrywide offices. With the addition of four new horror comics, making a total of six bimonthly titles by mid-1969, Jackson was brought in to lighten Carl Burgos' load. Assuming the title of art editor, Jackson was in charge of finishing the artwork, adding extra blood and gore should it be needed, adding shadowy inks, adding half-tones (to make the Pubs, who were reprinting almost 20-year-old artwork, look more like Warren's magazines) and establishing a visual continuity. He would often re-draw entire panels to make the story more horrific.

Ezra's first appearances in the horror comics in his new position were the May 1969 issues of *Tales of Voodoo* (V2 #2), *Terror Tales*

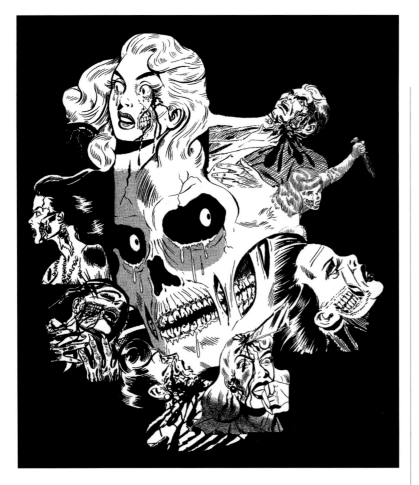

(V1 #8) and *Weird* (V3 #2). The next month, he was on hand to launch the premier issue of *Horror Tales* (V1 #7, June 1969). Within a month, Jackson was one of just three names credited in every comic published by Eerie

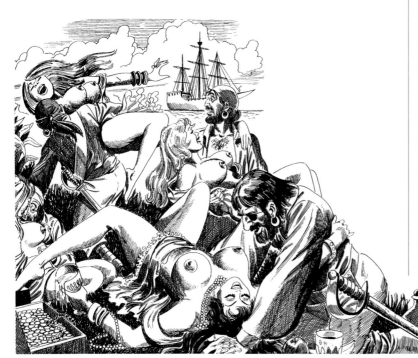

Pubs, and it would stay that way until the line ended. Alongside Burgos' editor credit and Irving Fass' art director credit (thank you, brother Myron), Ezra Jackson's name can be found in every Eerie Pub from May 1969 through February 1975.

Jackson was also listed as an art assistant in Fass' "true occult" magazine *Strange Unknown* starting at the same time as his Eerie Pubs gig. Three illustrations in the second (and last) issue bear the signature of Ricardo Rivera, but look very much like Jackson's style. Concurrently, in the Countrywide men's mags *Duke* and *Buccaneer*, Rivera gets an art assistant credit, and there are some nice, signed Ezra Jackson text illustrations within. I smell a pseudonym…

Back on the horror comics, Ezra Jackson also found the time to produce a handful of complete stories for the early new art issues. Unlike some of the Pubs' other artists, Jackson took the original story as a starting point, and took them into new directions. For instance, Jackson took "Sssshhh" from *Weird Mysteries* #7 (Gillmore, Oct. 1953), kept a few panel layouts and the no-dialogue gimmick, and turned it on end, turning the juvenile humor of the original story into a horrific terror tale. Jackson's version, entitled "The Witch and the Werewolf," appeared in *Horror Tales* V2 #1 (Jan. 1970).

"The Blob," Jackson's effort in *Weird* V4 #1 (Feb. 1970) saw

him adapting a tale from *Weird Mysteries* #5 (Gillmore, June 1953), and using art ideas from that issue's notorious cover in the splash panel. The story is the same, but Ezra delivers a more visceral ending than the original. Jackson's other full story effort from the early days was "The Claw" in *Terror Tales* V2 #1 (Jan. 1970). In this one, he didn't make any real changes; he just kept the plot and layout the same, but made it very gory. Oddly enough, these three Ezra Jackson gems were never reprinted; these issues were their only appearances. Considering how often the "outside" artists' work was reused, I find this to be very… weird.

Ezra Jackson brought the "ripped open cheek" to Eerie Pubs, and I consider it his gory trademark. Cheek flesh was ripped away, exposing two clean rows of pearly whites within. Chic Stone evidently liked it too, as he borrowed the idea for his oft-reprinted magnum opus "The Slimy Mummy." Jackson also possessed an Ayers-esque eye-poppin' ability. From the looks of things, Jackson was having a ball with the horror genre.

Throughout the Pubs years, Jackson kept his dynamic inking skills flowing. He illustrated most of the text stories that started to appear in early 1971. While the text stories are extraneous and mostly unwelcome, they did give Ezra a chance to flex his imagination and produce some excellent drawings. He

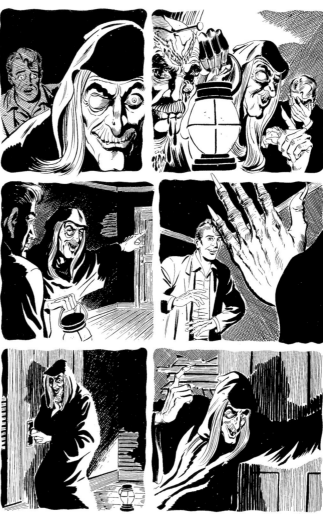

eventually did two more full stories toward the end of the Pubs' run, but after the end of 1973 and into the decline, Ezra Jackson's presence wasn't being felt much at all in the horror books.

After the implosion of the black-and-white horror comic market in early 1975, Ezra Jackson went over to Gold Key to do a handful of supernatural stories for their *Ripley's Believe it or Not* and *Grimm's Ghost Stories* four-color comics. Alongside fellow Eerie Pubs alumnus Oscar Novelle, Jackson's work was being seen in color for the first time in five years.

Opposite top: Getting cheeky: Ezra Jackson's toothy trademark made no storytelling or anatomical sense, but it was always gory fun

Opposite bottom: A very nice Ezra pen-and-ink illustration that accompanied the story "Cutlass Alley" in the skin mag ***Buccaneer*** V1 #8 (Sept. 1969)

This page: Jackson's excellent inks highlight the Pubs story "The Witch and the Werewolf," which was only printed once, in ***Horror Tales*** V2 #1 (Jan. 1970)

Text illustration for "This Tomb is Ours"

Ezra Jackson was not only a superb artist but he was a dedicated family man. Bertram Fitzgerald said that the happiest he had ever seen him was the day Jackson's daughter went off to Princeton. He was bursting with pride as she became a judge. She would later say that he "believed that no job was beneath him to support his family." He certainly did an excellent job as a parent; his daughter is now a

well-respected Congresswoman. Rudy Svezia, who worked as an art assistant for a short time at Countrywide, remembers Jackson as "a real sweet guy" and was impressed with his hard work that was putting his girl through school.

Sadly, due to poor access to health care, Ezra Jackson was dying of undiagnosed prostate cancer. Metastasizing to his lungs and brain, he succumbed to the deadly disease in the mid-'80s, long before his time.

Chic Stone

When one thinks about Eerie Publications, they usually think first about those gruesome covers. Nobody's covers were more gruesome than Chic Stone's. This genial and fun-loving guy really pulled out all the stops and destroyed our young minds with some superb, over-the-top covers and stories for the Pubs.

Born in New York in 1923, Stone was a wee niblet of 16 when he hooked up with the Iger shop, doing page cleanup and various low-level artwork jobs. It was a great learning experience and he soon landed a few real gigs writing and drawing humor strips. Some of his earliest work was for Timely, the predecessor of Marvel Comics. Throughout the '40s, he also drew for Lev Gleason's *Boy* comic book and a handful of Fiction House's titles.

In the early '50s, Chic Stone was back with the publisher Timely, now called Atlas Comics. His Atlas work was mostly in Westerns, which is odd because horror was very popular at the time and he later proved that he'd definitely had it in his blood. He did, however, produce horror work for Ace, along with every other comic genre they published.

Some sources say that Chic Stone got out of comics after the senate hearings and subsequent initiation of the code (and near-demise of the industry) but he was still drawing for Charlton's teen and Western titles. He worked as an art director for some slick mags and storyboarded TV commercials, in addition to advertising jobs. He even published his own short-lived magazine, *Boy Illustrated*, for which he produced tons of artwork. Comic-wise, he also showed up doing work in the light fantasy fare offered up by ACG, doing a couple of dozen stories for *Adventures Into the Unknown* and *Forbidden Worlds* between 1957 and 1964. Then his star really began to rise.

Back to Atlas, now known as Marvel Comics, Stone began to get recognition for his inks. Working with Jack Kirby, the duo resuscitated the comic book industry with the wildly popular Marvel superhero universe. Thor, The Hulk, the X-Men, the Fantastic Four—these two drew every character for the company and the fans ate it up. Stone always said that he loved inking Kirby's pencil; they were so easy to do a great job on. These iconic comics set a

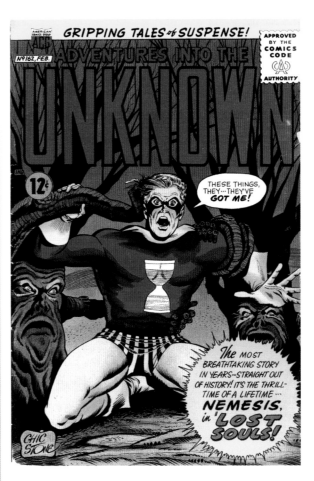

Even the trees had Stone's little white-person noses; checking out the meaty thighs of Nemesis on the cover of ***Adventures into the Unknown*** #162 (ACG, Feb. 1966)

new standard for the industry and Chic Stone got a lot of fans and a lot of respect.

Throughout the '60s, while working on the groundbreaking books, the prolific Chic Stone kept his penciling skills fresh at ACG. He did dozens more fantasy yarns for the company and even did a few Superboy stories for Marvel's archenemy, DC. He also contributed to Wally Wood's Tower Comics line and Dell's *Flying Saucers*, among other titles.

So why would such a busy and well-respected man lower himself into the gurgling cauldron of slimy horror comics where new levels of depravity were not just encouraged but demanded? Who knows, but we're all sure glad he did.

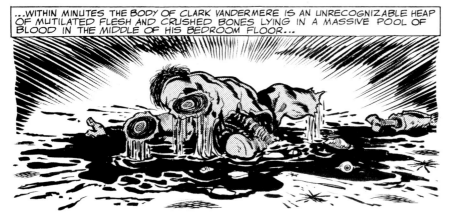

...WITHIN MINUTES THE BODY OF CLARK VANDERMERE IS AN UNRECOGNIZABLE HEAP OF MUTILATED FLESH AND CRUSHED BONES LYING IN A MASSIVE POOL OF BLOOD IN THE MIDDLE OF HIS BEDROOM FLOOR...

Top: Chic Stone's "Voodoo Terror," as bloody as the Pubs ever got!

Bottom left: A ghoulish Stone pinup from *Chilling Monster Tales*

Bottom right: Chic Stone's painted cover for the one-shot *Chilling Monster Tales* (M.M. Publishing, 1966)

With a scant seven covers and even fewer stories to his credit, Chic Stone's Eerie Pubs work is some of the most notorious and nauseating art to ever grace the newsstands. His human corn-on-the-cob cover for *Terror Tales* V1 #8 (May 1969) may never be equaled for sheer in-your-face gore. His covers had squishing, beheading, acid baths, stakings and blood running in streams from open wounds. Stone definitely took Carl Burgos' instructions to "make it gory" to the next level.

When Bill Alexander came on board to provide the Pubs with covers, Chic Stone turned to storytelling. Although he did some redraws, his other Eerie Pubs stories are believed to be written by himself. And what doozies they are: "Blood Bath," an LSD story to end all others, is arguably the most gruesome and memorable Eerie Pubs story of all time. Dismemberment, piles of flesh and pools of blood are dished up with relish, all in the name of just saying NO. The character in "Voodoo Terror" fares no better, with screaming, bloody horror culminating in "an unrecognizable heap of

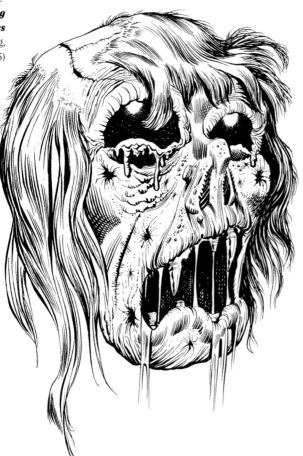

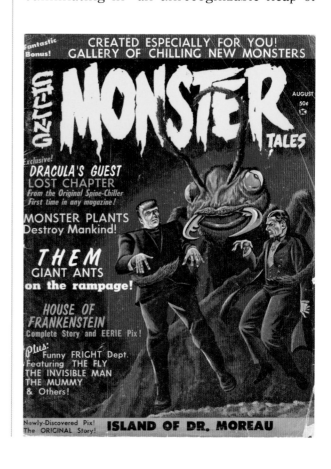

mutilated flesh and crushed bones lying in a massive pool of blood in the middle of his bedroom floor." As you see, Stone was adept at the written word, too.

Chic Stone drew his stories with thick, bold lines and solid black shadows. The half-dozen Pubs stories he produced are a testament to his legendary inking skills. His pencils had also picked up a bit of the Kirby action gene, as his characters move dynamically and dramatically. His people are instantly recognizable— turned-up little white-person noses, all-American boy-next-door haircuts; it's no wonder he moved to Archie Comics later in the '70s. Luckily, Archie, Betty and Veronica were never treated the way his Eerie Pubs characters were (although I'd pay good money to see even a panel of it)…

After a few short months with Eerie Pubs, Stone took his black-and-white horror stories over to the greener pastures (and greener paychecks) of the new kids on the block, Skywald Publishing. He did a half-dozen good stories for them, but gore-wise, they paled in comparison to the Eerie Pubs product.

As mentioned, Chic Stone wound up at Archie Comics, doing the regular characters and the specialty adventure titles. All the while, the work at Marvel had kept on coming. He finished the '80s with Archie, and then

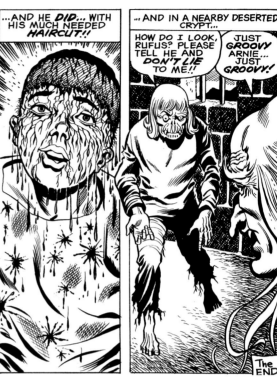

retired, though he was still occasionally available to produce special work. He later moved to Alabama to relax and reflect.

Chic Stone died from pancreatic cancer in 2000.

The silly yet satisfying ending to Stone's "Gruesome Haircut" from Skywald's **Psycho** #3 (May 1971)

Bill Alexander

Whether they know it or not, when most people think of Eerie Publications, they're probably thinking of Bill Alexander's artwork. His brightly-hued, multi-monster mayhem graced roughly one quarter of the original covers (more than 70!) and that number doubles when figuring in reprints and cobbled bits and pieces. Bill Alexander was THE Eerie Pubs cover artist.

Bill Alexander's charming record label art for Roy Milton, **When I Grow Too Old to Dream** (Miltone 202-A)

It should be noted that our Bill Alexander was not the eighteenth-century British painter William Alexander, though his work should be hung in museums the world over. Nor was he the *Magic of Oil Painting*'s Bill Alexander, who had the weekly painting show on public TV in the '80s. (I would have loved to see such a thing—"Now we'll paint the bound and bloodied victim over here…") Our Bill Alexander had a far more interesting résumé, especially for the sleaze fanatic.

Alexander had a very long and incredibly prolific career. As a young man in Los Angeles in the mid-'40s, he lent his considerable cartooning skills to blues pioneer Roy Milton. Milton was making records on his own label (Miltone), recording them and pressing them himself, and Alexander was supplying cartoon art for the label. Each release had a different cartoon label; some were humorous and some were serious but they all were very hip, urban and fit the mood of the song.

Alexander was a big music fan and his knowledge of the genre shines through. There were not many outlets for a talented African American artist back in the '40s, but Alexander had a steady gig with Milton. He drew dozens of record labels, which he signed as Wm. Alexander, Wm. Alex or just WA.

Roy Milton eventually signed with another label and started having hits, so Miltone Records closed its doors. He did hold onto the labels Ace and Foto for a while longer, and Alexander supplied the art for the labels. Looking to stay in the illustration field, later in the decade he convinced his friend Gene Bilbrew to collaborate with him on a comic strip for the *Los Angeles Sentinel*, a weekly African American newspaper that is presently still going very strong. The strip they concocted was called "The Bronze Bomber," a black superhero akin to Superman. Alexander handled most of the art and Bilbrew wrote the scripts. The strip ran for about a year.

Some sources have suggested that Bill Alexander was Gene Bilbrew's art protégé, but I think the opposite might be true. Alexander always had the passion for illustration, while Bilbrew was more interested in music. Alexander, it seems, nudged Bilbrew toward the art field. That said, Bilbrew certainly wound up having a very illustrious career in illustration, working for Will Eisner's comic studio in the early '50s, studying with Tarzan artist Burne Hogarth, and going on to be one

of the most respected and collected fetish artists of all time. His influence on Alexander's life and art cannot be denied.

Moving eastward, Alexander and Bilbrew were among the many artists drawing bondage comics for Irving Klaw in the early '50s. Klaw, the man who (eventually) made Bettie Page a household name, sold pinup photos and comic strip serials by mail order out of his family's bookstore. The comic serials, usually two to five panels per page, were printed on photo paper and offered up alongside sexy photos (no nudity, please!) of Ms. Page and other smiling, bound cuties. Klaw advertised them in his sales catalog (Nutrix Co.) and the pages sold for about 50 cents apiece.

Bilbrew adopted his *nom de plume* "Eneg" (Gene spelled backwards) and was very prolific, but not as much so as Eric Stanton, who is said to have introduced Bilbrew, and more than likely Alexander, to Klaw. Stanton produced dozens of serials and was Klaw's top illustrator. Shortening his name to Ander, Alexander contributed the serial "Peggy's Distress on the Planet Venus" (20 episodes, appearing in 1952), "Castle of Terror" (10 episodes) and later "Belle of the Plains" (15 episodes). His panels are very slick, with thick blacks and smooth lines. Due to their close relationship, Alexander's and Bilbrew's work share many similarities in this period; they were studio mates and possibly helped each other finish projects.

Blues in My Heart, (Roy Milton Records 1-11-B)

In the early '60s, Stanton founded Satellite Distribution with Stanley Malkin and successful smut peddler Eddie Mishkin. Miskin had been under fire for indecent material as far back as the Kefauver hearings in 1955 (where Klaw was subpoenaed as well), the same hearings that destroyed horror comics. Mishkin was busted for indecent material in 1962. One of the pieces of evidence against him was Alexander's "Peggy's Distress on the Planet Venus," found in one of his many stores. His partner Malkin founded a line of softcore books that would sport the imprints of After Hours, Wee Hours, Nitey Nite, First Niter and Unique. Unique they were, because all of the illustrated covers were done by Bilbrew, Stanton, Golden Age comic artist-cum-fetish genius Bill Ward, and Bill Alexander. This line of books is probably Alexander's best-known work.

All four artists are very adept at drawing stacked women in tight dresses, high heels and, when we're lucky, over-the-elbow opera

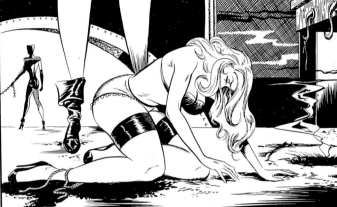

① FTER WHAT SEEMED AN ETERNITY TO PEGGY, SHE IS RELEASED FROM HER STRINGENT BONDAGE AND BROUGHT BY HER GUARD TO THE URANIUM MINES WHICH ARE BEING MINED BY CAPTIVE SLAVE LABOR.

② INCE MULES ARE NOT AVAILABLE ON PLANET VENUS, HUMAN GIRL PONYS ARE USED TO HAUL THE ORE IN CARTS UP THE STEEP SLOPES TO THE REFINERY. PEGGY IS FITTED INTO THE PONY GIRL HARNESS.

③ HILE PEGGY IS BEING FITTED TO HER ORE CART, THE GUARD EXPLAINS THAT UNDER NO CIRCUMSTANCES MUST THEY STOP PULLING THE CARTS, OR THEY WILL SUFFER THE CONSEQUENCES, SUCH AS HAS BEEN METED OUT TO A FORMER CAPTIVE WHO WAS TOO SLOW AND CARELESS.

The third episode from Alexander's serial "Peggy's Distress on the Planet Venus" (Irving Klaw, 1952) © Irving Klaw

gloves. The covers of these books all feature bright, vivid colors that must have really made an impact on the dingy bookstore's shelves. Though the stories themselves were strictly softcore, the covers promised many a boner. Alexander's smooth, colorful paintings stood shoulder to shoulder with his better-known companions' and compare very well. His first covers appeared in 1966 and in two years, nearly 50 of his paintings were used. In 1968, the market took a turn for the hardcore and the successful Satellite books stopped, leaving a colorful legacy that is in demand by collectors over 40 years later. Not bad for a line of books that were put together in the upstairs offices of Malkin's New York strip club.

Mid-1968 brought Bill Alexander into the open arms of Countrywide. He took over the comic strips in the girlie mags *Jaguar* (Jaguar Bond) and *Duke* (Pussy Katz), filling in for Bob Powell, who had passed away the previous year. The strips were usually four pages of color, followed by a black-and-white page. Alexander displays a marvelous sense of humor in these strips, loading the panels with Will Elder-esque sight gags and puns, as well as the prerequisite top-heavy women and sex-starved men. The anthropomorphic feline Bond and the platinum blonde Katz were both secret agents so Alexander got to have a field day with gadgets as well.

In addition to contributing text illust-

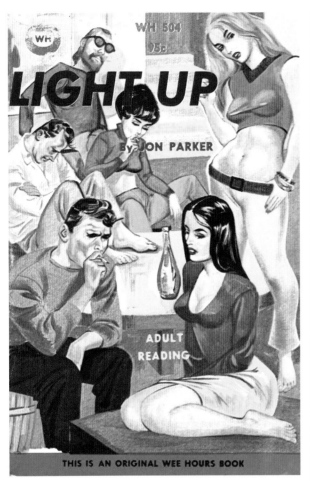

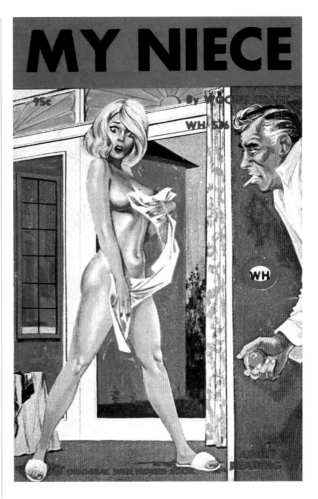

A duo of softcore sleaze from Bill Alexander

Left:
Light Up
(Wee Hours, 1966, WH-504)

Right:
My Niece
(Wee Hours, 1967, WH-536)

rations in pen and ink or charcoal (some of which I think are among his best works), Alexander also took over the cartoon strip in *Poorboy* and its next incarnation, *Buccaneer*. He inherited Burgos' pedestrian comic "The In People," then in the March 1969 issue of *Poorboy* (Vol. 1 #5), Alexander premiered "Madam Mary Worthless," based on the old Mary Worth strip. He got to flex his satiric muscles and drew spot-on versions of some of comicdom's venerable icons. Not only was Mary Worth(less) now a prostitute (who, despite her matronly appearance and gray hair, was built like a brick shithouse), but Dick Tracy and Prince Valiant (and others)

were her horny patrons. Her exploits ran for a year or so, being replaced once (in *Buccaneer* V1 #10, March 1970) by "Cockeye the Buccaneer," Alexander's take on E.C. Segar's famous sailorman.

Of course, while he was juggling humor for the Fass gang, he was also leaving indelible images in horror fans' heads, ones that still haunt us today. Some of his bondage work (for Klaw) hinted at his aptitude for horror, but his Eerie Pubs covers epitomize what the mags were all about: thrashing action, violence, monsters and bondage, all presented with vivid colors and a good sense of humor.

While at Countrywide, Bill Alexander had

This page top: Bringing gore to the frontier… Alexander's cover for *Great West* V3 #5 (Dec. 1969)

This page bottom: It's a kitten! My wife and I are endlessly amused by this cover. Weirdness from the Harding File books (HF-133, 1973)

Opposite: Alexander's Countrywide nudie strips

Opposite top left: Taking over for Bob Powell, Alexander continued the horny anthropomorphic exploits of Jaguar Bond in *Jaguar*

Opposite top right: He got to show off his aptitude for mocking the comic masters in the Madame Mary Worthless strip in *Poorboy*

Opposite bottom left: Alexander's later, more realistic bondage work—from *Hard Bound* #8 (London Enterprises, 1987)

Bottom right: A rare black-and-white illustration for "Where do Witches Live?" in *Strange Unknown* V1 #2 (July 1969)

started at Star Distributors, a mob-run porn publisher that was pushing the boundaries of good taste with fiction books dedicated to every kind of kink imaginable. Alexander painted hundreds of covers for these specialty books on bestiality, bondage, watersports, incest, rape, pedophilia and other exploitable subjects. They are jaw-dropping and certainly not for the squeamish. Masquerading as true textbook cases, the series Dr. Lamb's Library and the Harding File deliver some of the most over-the-top titles and covers, all in the name of sleazy self-help. Am I a sick bastard because I keep hoping to find a necrophilia title with a gruesome Alexander cover?

His work for Eerie Pubs ended during the decline year of 1974, His last cover was on *Horror Tales* V6 #3 (June 1974), a typical monsterfest that looks like it was finished by Burgos. Despite being finished with Countrywide, he was in the busiest phase of his career. The Star Distributors work was coming fast and furious. In addition to the color work (which became sporadic after 1975), Alexander was doing hundreds of pen-and-ink covers for Star's many imprints. It looks like he even took the time to write the perverse parable *First Time for Cherry Sherry* (Castle Library 512), published in 1975 and attributed to Bill Alexer. He kept up this incredibly prolific output for a few years; his last Star Distributors covers were in 1978.

From there, Bill Alexander went back

to California and became the art director for London Enterprises, a slick magazine publisher specializing in bondage periodicals. He worked for them at least through the mid-'80s. I have lost track of him after that.

For 40 years, Bill Alexander produced sure-handed, creative, and colorful artwork on many subjects that at times seemed beneath his talent. Still, he always added a spark of realism that could be chilling or a sense of humor that could be relieving. His massive output has yet to be compiled and his full story yet to be discovered.

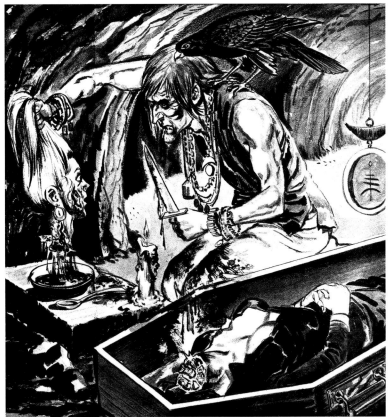

Top: Larry Woromay in his later years, doing what he loved to do… oil painting (photo courtesy of the artist)

Bottom: Woromay's illustration for a story by Paul W. Fairman in *Fantastic Adventures* V14 #2 (Ziff Davis, Feb. 1951)

Larry Woromay

Larry Woromay's Eerie Pubs artwork epitomizes the madness of the early original art issues: hyper, gory and downright dizzying. Dripping with atmosphere and generously ladled with blood and guts, Woromay's output is some of the most nightmare-inducing and stomach-churning of the line. Therefore, it's some of the best-loved—a fact which amused him 30 years later.

Born in April 1927, Lawrence Woromay got his start in the illustration field in the early 1950s with illustrations for Ziff Davis' science fiction pulps. He composed some excellent full-page line drawings and spot illustrations for stories by the likes of Rog Phillips and Stephen Marlowe. His horror pedigree began in 1951 when he drew a number of terror tales for Stan Lee (whom he later referred to as "that Spider-Man guy") at Atlas Comics. Doing excellent stories for *Strange Tales, Adventures Into Terror*, and other titles, Woromay established himself as a talented and able comic book artist. Woromay's wife, Ida, told me that back in the day he was considered "the horror guy"—the artist that his peers would turn to for horror

The children were no longer unhappy in Dead End Alley. They were dead.

art tips. He especially liked the horror stories. He also supplied artwork for ACG and Ace's horror comics.

In the 1960s, he was busy creating comics for Harry Harrison's art studio, predominately doing pencils while Harrison and others handled the inks. During this period, he did a lot of work for Charlton's ghost and war comics. Charlton sometimes used the name Bill Woromay for his work, though Larry wasn't aware of that fact. He also went knocking on comic company doors looking for some extra work. Ironically, this got him a nice six-page story in Warren's *Eerie* magazine in 1967... shades of things to come. Another door he knocked on was that of his old Atlas peers Fass and Burgos. Luckily for us, they opened up.

Woromay's Eerie Pubs artwork is crazy and *way* over the top—super gory, full of action and oozing with dread. He really stamps the stories with his own style, ignoring the previous panel layouts and going off on a wild, creative tangent. His first work for the company hit the newsstands in December 1969: "The Blackness Of Evil" in *Weird* V3 #5, and a twofer in *Witches' Tales* V1 #9, "The Devil's Monster" and "Over Her Dead Body"! Over the next two years, he contributed nearly three dozen gruesome tales for the Pubs. My own personal favorite might be "The Witches' Coven," with its disturbing inverted crucifixions and a real feeling of decay throughout. Great stuff, indeed!

Top: Showing off his Jack Davis influence—the first page from "Twanng!" in **Weird Worlds** #11 (Atlas, Oct. 1952) © 2010 Marvel Characters. Used by permission.

Bottom: From "Gruesome Shock"

Woromay did what was asked of him by Carl Burgos… he laid the gore on thick!

Top: "Demons and Vampires"

Bottom: "Vampire Flies"

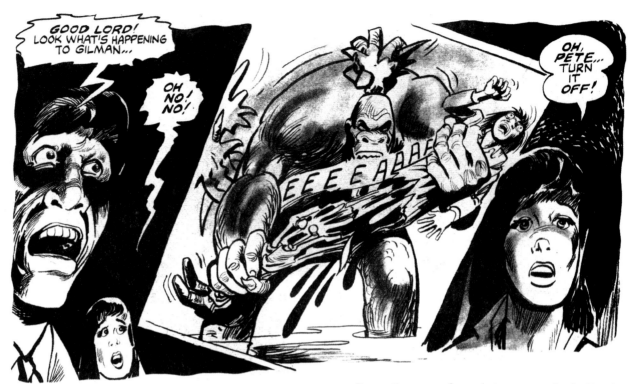

By 1971, Larry Woromay's tenure at Eerie Pubs ended and he moved on to other projects. One project was as puppeteer, and then the director of the Puppet Theater in Nassau County, New York. He designed countless large puppets for their productions, a job he enjoyed. This work lasted for 20 years.

Sometimes referred to as a Jack Davis imitator, his affection for Davis' comic work is obvious. He said he'd always loved Davis' use of many different-sized pen points and brushes to put real texture and depth into a drawing. He emulated his style because he thought, and I would agree, that it's how comic art should look. In a discussion on an online message board about whether or not some of Woromay's artwork was really done by Jack Davis, the webmaster responded with a definite "no" and added, "It looks like it was drawn by a mentally disturbed 13-year-old who might have grown into a mass murderer. But hell, I like it anyway!"

Woromay also cited Milton Caniff and, especially, Burne Hogarth (whose Cartoonists and Illustrators School he attended in 1946) as strong influences on his style. Hogarth's book *Dynamic Anatomy* was a huge inspiration to

him and he studied it religiously. The book taught him to keep his work from getting static, to use movement, and to draw a comic page as a whole, not just as individual panels but as a complete composition. This is certainly evident in his Eerie Pubs work. Even when he was knocking one out in the quickest, sketchiest style, his pages have an exciting sweep to them, always treating the eye to a swirl of motion.

He had no real memories one way or another concerning his Countrywide work. It was just another gig, and a long time ago at that. After the Puppet Theater years, the Woromays packed up and moved to Albuquerque, where Larry settled down and pursued his greatest artistic love: painting. Many of his paintings are Southwest-flavored and have a superb textural quality to them; thick with layers of paint from a palette knife and brush strokes, he created an almost 3D effect. His pastoral portraits and landscapes are a very far cry from his crazed and violent work for Carl and Myron, but just as beautiful to behold.

He had plans to add digital art to his repertoire as he got better acquainted with new technology. Sadly, on August 26th, 2007, within a week of my being fortunate enough to speak with him, Lawrence Edward Woromay passed away. He was 80 years old.

Oscar Fraga

Oscar Fraga is one of the many artists that worked for Eerie Pubs about which nothing seems to be known. I have made many attempts to locate the artist himself, potential

Larry Woromay's oil paintings were the culmination of a lifetime of experience and talent.

Top: *Fading Bosque*— Larry's wife said she knew I'd like this painting because, like Larry himself was at times… it's weird! So I bought it!

Bottom: *Migration* (courtesy of Larry's daughter, Lisa Villanueva)

¡Ah!... ¿Y por muchos días, señor?

Asigún...

¿Asigún?... ¡Muy bien, muy bien!...

Me voy a retirar, con su permiso. Tengo que ver los animales.

¿Los monos de Palermo? También son curiosos...

No, señor; me refiero a los caballos que trujimos. Asigún parece, para ver los monos aquí no hay que ir muy lejos...

Top: Some nicely detailed inkwork from Fraga's early days—from the story "¡Al Campo!" in Columba's *Intervalo* (March 1958)

Bottom: A nice title panel from *Intervalo* (Columba, Feb. 1961)

family members, or anyone who can provide even a tiny piece of biographical information about him, but found only dead ends. One person named Oscar Fraga that I contacted by email responded with extreme hostility, made me promise to never contact him again and put me onto his spam chain-letter list. Ouch.

Wherever he came from and whatever his upbringing was, Oscar Fraga's artwork was frequently seen during Argentina's Golden Age of comics. In the late 1950s and early 1960s, Fraga was well represented in Columba's comic magazines. His work runs the gamut from romance to Western to war

and historical dramas. Fraga's artwork from this period displays a sure hand with inks: bold, graceful lines for one story, or wispy, feathery-light lines for another. His stories were always well planned, often using interesting "camera angles" and panel setups to tell the tale.

Admittedly, Oscar Fraga, especially in this early period, was a somewhat static artist. He hadn't mastered the art of movement yet, and until he was copying ideas from other artists for his Eerie Pubs stories, he never really did. Many of his figures sit or stand there, looking ahead. His people also tended to have boxy heads, square jaws, flat foreheads and small

EL CARIÑO IMPOSIBLE
POR HENRY GRIMM
DIBUJOS DE OSCAR FRAGA

El soldado alemán Markus Berg consiguió escapar de un campo de concentración en Rusia. Con enorme esfuerzo y constante zozobra cruzó una buena parte del globo terráqueo, hasta llegar a su casa de troncos en una de las márgenes de la Selva Negra, en su país natal, Alemania... "¡Oh, Dios...! ¡Graciás, Gracias!"

Top:
Oscar Fraga, Western-style; from the story "El Rapto," from the series Cheyenne in *el Gigante de la Historieta* #31 (1961)

Bottom left: Detailed inks highlight one of Fraga's first Eerie Pubs efforts, "Dead Dummies"

Bottom right: Mid-era Fraga, looking sketchier but delivering the gore… "The Deadly Corpse"

noses. Despite this, when Fraga put effort and detail into his art, the results were very good. When he did a hurried job, it showed.

Oscar Fraga came into the Eerie Pubs fold at the very beginning of the "original art" phase, right there alongside Larry Woromay, Dick Ayers and Chic Stone. His first appearances for the company are in *Weird* V3 #5 (Dec. 1969) and two stories in *Witches' Tales* V1 #9 the same month. In the latter book, Fraga handled the redrawing of Basil Wolverton's classic story "Robot Woman," a thankless task at best. His version, "Until Death Do Us Part," isn't half bad, though.

Fraga's early Pubs work is rife with shading lines and crosshatches, done in fine pen, and the effort that went into the stories is very evident. Only rarely did he swipe a panel layout wholesale from the story he was adapting. Again, Fraga's figures would tend to

Top: More
Fraga gore
from "The Blood-
Dripping Head"

Bottom: Oscar
Fraga got to
redraw Myron
Fass' old story
"Lost Souls."
Compare this
to Fass' original
in Chapter 2

be a bit flat, especially when compared to Larry Woromay, whose art was appearing in the same issues, but his detailed inking make these stories from 1969 and early 1970 among his finest Pubs work. Light on the gore, Ezra Jackson was on hand to bloody up a few of his panels here and there.

With a steady gig at Countrywide, Fraga started banging out quantity, somewhat at the expense of quality. He moved away from the detailed line work in favor of sweeping brushstrokes and washes. He was obviously finishing his stories more quickly and, let's face it, he was going to get the same measly page rate either way. Sounds like an economically smart move to me. Fraga signed many of his stories but even

when he didn't, his style was easy to recognize, particularly by the wide-open eyes of many of his characters. His artwork was always solid and workmanlike; it's good but never terribly exciting. I do think, however, that Fraga drew excellent skeletons.

Fraga's stories appear in most Eerie Pubs from the beginning to the end in late 1974, and reprints of his work appeared throughout, up until the very end of the Harris era. Next to Antonio Reynoso, Oscar Fraga drew the most pages for Eerie Pubs, delivering nearly 80 stories in five years. On one of those stories, "Witches' Ghosts," Fraga had to reinterpret his boss Myron Fass' telling of "Lost Souls" from *Beware* #8 (Trojan, March 1954). Chances are he never knew the connection.

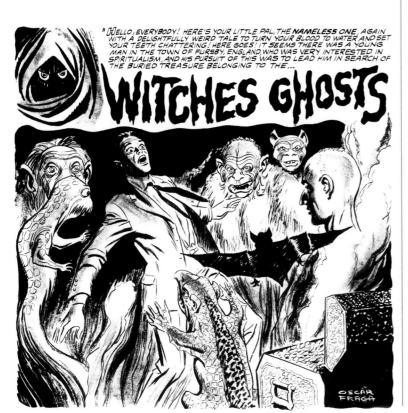

Dick Ayers

A true comic book legend. Nothing more needs to be said. But please indulge me…

Born in Ossining, New York in 1924, Dick Ayers' comic book career has been around almost as long as the medium itself. His first published story was for Siegel and Schuster, Superman's creators. Since then, he's been active almost nonstop in every genre of comic book, always dependable and always delivering good, solid work.

In the early 1950s, Ayers helped create the venerable Western mystery character Ghost Rider, who has stood the test of time and is still considered Ayers' signature character. He even drew future boss Carl Burgos' Human Torch for a spell in this period. Ayers also did plenty of gruesome horror work for Charlton and, mostly, Atlas during these years. This work would just hint at the nightmares that would flow from his brush in the next decade.

After the fallout of 1954, Dick Ayers stayed busy with Westerns, war, and the burgeoning superhero genre. Ayers' superior inking ability made him a favorite of Atlas Comics editor Stan Lee. In the late 1950s, he set up Ayers to ink Jack Kirby's pencils for a slew of giant monster comics for titles like *Amazing Adventures* and *Journey Into Mystery*. The monsters were always world-threatening and had names like Grogg, Fin Fang Foom and Vandoom.

Left: The man himself, Dick Ayers, at a con in 2006, wearing a hat made by some psychotic fan who was writing a book about Eerie Pubs (photo by Andrea Howlett)

Right: Bringing horror to the Western: *Bobby Benson* #14 (Magazine Enterprises, May/June 1952) Cover courtesy of Bruce B. Mason

Dick Ayers and Dan Adkins

Two of Dick Ayers' Eerie Pubs stories ("Monster from Dimension X" and "The Strange Corpse") have artwork sporting the mysterious signature of "A + A." Mr. Ayers doesn't remember why they are signed that way; he thought he had done all of the artwork on those stories himself. Stylistically, however, they do look slightly different from Ayers' other work.

Artist Ken Landgraf thought so too. He thought that the inkwork looked a lot like that of one of his favorites—Dan Adkins, a long time assistant to EC's Wally Wood in the '60s and a busy artist at Marvel. Later, when Landgraf was working with Adkins at Marvel, he asked about the possibility of an Eerie collaboration.

Adkins said that he did indeed help out with a couple of Ayers' Eerie Pubs stories, doing the inks over Dick Ayers' penciling. Ayers doesn't recall Adkins' assistance on the Pubs stories, though it's possible; he remembers the same set up on a few stories for DC.

Apparently, A + A = Ayers plus Adkins.

Many thanks to Ken Landgraf for this bit of Pubs trivia!

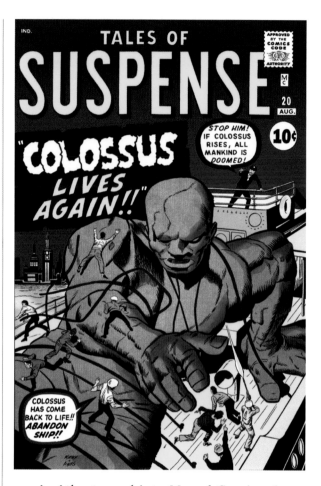

As Atlas turned into Marvel Comics, Ayers stayed on board and entered his most prolific and well-respected era. The company found everlasting fame with their powerhouse super-hero titles in the early '60s, and Ayers had great success inking Kirby's Fantastic Four and the Incredible Hulk. He stayed incredibly prolific with the company through the decade.

Ayers told me that in 1969, he was contacted by Carl Burgos, a fellow Atlas artist back in the day (though they'd not met before), to draw some horror comics. Burgos told him the concept of the Eerie line, mainly… lots of gore. Ayers was initially hesitant, saying he wasn't interested, his mind going back to 1954, the hearings, Dr. Wertham and the

furor over violent comics. Before he could walk out, Burgos urged Ayers to talk to Myron Fass, who simply suggested that Ayers go see Sam Peckinpah's new film *The Wild Bunch* (1969) before finalizing his decision. He went to the movie, came back to the office and said "I'll do it."

"They were cribs," admits Ayers of the stories, but nobody can accuse him of copying the original stories' artwork. Ayers took the "tear sheets" (as he calls the copies) and reinterpreted them the way he was instructed: with boatloads of gore! Eyes dangling from optic nerves or blown right out, tongues lolling, heads dangling at perverse angles, limbs severed, gouts of blood—Dick Ayers' Eerie Pubs artwork is simply amazing. It's hard to believe that such a sweet man in real life dredged his imagination for such visceral and violent images, but thank heaven he did.

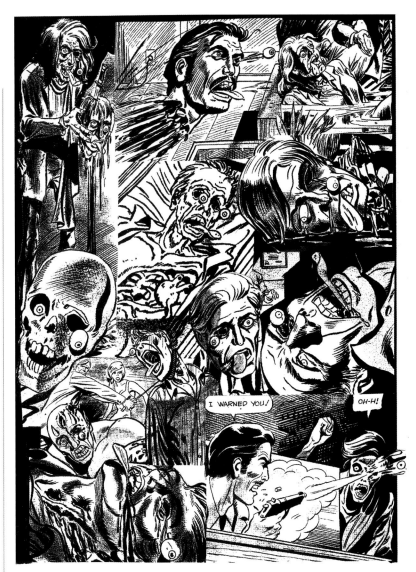

He is most Eerie Pubs fans' favorite purveyor of pain, and has referred to himself as "the eye-popping artist."

Late 1969, with covers dated January 1970, Mr. Ayers' first Pubs stories hit the newsstands: "House of Monsters" in *Horror Tales* V2 #1 and the immortal "I Chopped Her Head Off" in *Terror Tales* V2 #1. The first printings of all-new stories were printed as drawn, in glorious pen and ink. In subsequent reprints, half-tone shading was added, to make the comics more resemble Warren's successful magazines. While Ezra Jackson did most of the half-tones, Ayers preferred to do his own. His method was to use the flat side of a pencil and rub the lines

Opposite: One of the many Jack Kirby/ Dick Ayers collaborations from Marvel's pre-hero era: *Tales of Suspense* #20 (Atlas, Aug. 1961)

This page above: Sockets just couldn't contain 'em! The eye-poppin' art of Dick Ayers

This page left: A tender moment from the Ayers masterpiece "I Chopped Her Head Off"

The handsome Walter Casadei in the late '50s (photo courtesy of his daughter, Nelida Alicia Casadei)

smooth with tissue. Simple and effective, he could shade a whole story in half an hour.

Although the Western comics were his favorites, Ayers enjoyed his horror work and makes no apologies. He liked the surprise endings, saying the stories were like a riddle. He had no problem with the gore, as it was a paying gig, and he never gave less than 100%. He cites "I Chopped Her Head Off" as his favorite Eerie Pubs work. In 2006, he did a page-for-page redrawing of the story for a lucky fan who commissioned him.

29 stories... 158 pages at $27 a page. That's a bargain at 10 times the price.

After his Eerie Pubs years, Dick Ayers stayed incredibly busy in the field, drawing stories for both of the big boys, DC and Marvel, throughout the '70s. He added to his résumé in the mid-'70s by assuming the role of a teacher at the Joe Kubert School of Cartoon and Graphic Art for a few years and teaching continuing education courses for adults. The '80s saw Ayers doing a lot of work, including some horror stuff, for DC as well as adventure stories for Archie Comics, alongside fellow Pubs artist Chic Stone.

Retirement has never been a consideration. When not illustrating comics, he does fan commissions. There always seems to be a pen in his hand. He is a frequent guest at Comic Conventions and is one of the nicest men I have ever met. It's been a thrill and an honor to have had him work with me on this book.

Walter Casadei

Walter Casadei is one of the most prolific and recognizable artists whose work appeared in the Eerie Publications horror comics. The people that he drew, both male and female, always had what I call "Paul McCartney eyes"— downturned and heavy-lidded, and it makes his art easy to identify. Dashing and attractive, Casadei's male characters often looked like the artist himself. Comfortable with a quick and easy flow of light lines, Casadei was rarely

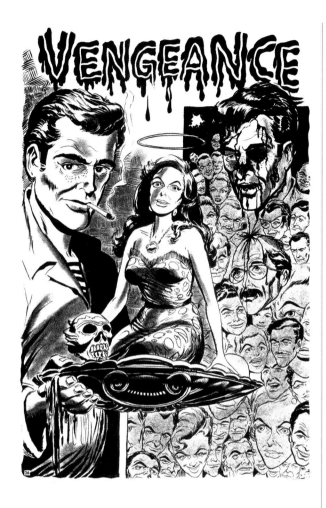

Top left: The splash panel of "Vengeance" and a look into the Paul McCartney eyes of the story's players

Top right: Some examples of Casadei's gag humor, from *Loco Lindo* #12 (Editorial Mazzone, June 1963)

Bottom left: War action and a gal that looks like Allison Hayes! From the story "Solo un cabarde," *D'artagnan* #42 (Columba, Nov. 1960)

Bottom right: Casadei's successful strip with HG Oesterheld— Star Kenton, from *El Tony* #1544 (Columba, 1959)

one for thick, brooding shadows or ominous atmosphere. He told the stories with effective (if not particularly memorable) artwork that often borrowed setups from the original stories' layouts, but it always managed to look very much his own.

Though Walter Casadei was one of the many Argentine artists that drew stories for Eerie Pubs, he was not a native of that country. Born in Forli, Italy in 1924, he arrived in South America in the late '40s on naval duty and stayed on, working in Buenos Aires. He was offered a job on the naval base in Veronica; he moved and resided there for the rest of his life.

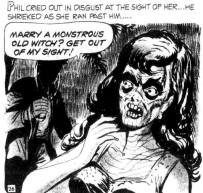

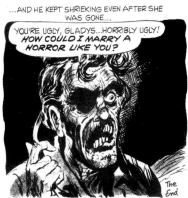

Top: The gruesome ending from "The Weird Old Man"

Bottom: An excellent panel from "Death is an Artist"

While there, he developed his lifelong love for illustration and he began to have his nudie cartoons appear in the early '50s in risqué Argentine humor magazines like *Loco Lindo* and *Dinomita*. In 1958, he hooked up with future comic-writing legend Hector German Oesterheld for the strip "Star Kenton" (was this a nod to Avon's pre-code sci-fi hero Kenton of Star Patrol, who appeared in their *Strange Worlds* comic?), a science fiction serial that appeared in the long-running weekly anthology magazine *El Tony*. He was also drawing strips

for the same publisher (Editorial Columba) in the magazines *Intervalo* and *D'artagnan*, alongside many of his future Eerie Pubs co-stars. He was proficient in all genres including war, romance and adventure. All the while, his excellent gag cartoons could still be found in the Argentine humor magazines.

With the change in Argentina's political power in the mid-'60s, Casadei, like many other artists, was forced to look elsewhere to make a living in his chosen field. Of course, this brought him into the open arms of Countrywide. Along with Oscar Fraga and Antonio Reynoso, Casadei was with the Pubs from the very beginning of the "original art" phase. His first published Pubs stories appeared in magazines dated January 1970: "The Spirits" in *Horror Tales* V2 #1 and "The Man Who Didn't Believe" in *Terror Tales* V1 #9.

From there, he would illustrate over 60 more stories for the company, drawing horror stories for Fass and Burgos until the magazines folded in 1974.

Casadei was proficient in many art mediums, including oil painting, and he successfully took care of his wife and three children with his considerable artistic abilities. Sadly, after a year of suffering with lung cancer, Walter Casadei succumbed to the disease on December 15, 1977.

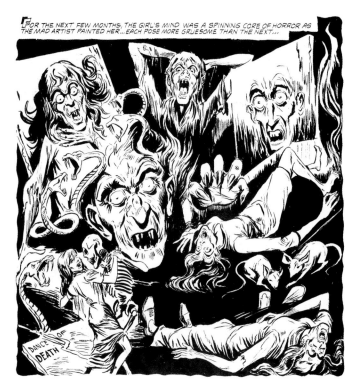

Antonio Reynoso

If Oscar Fraga is a bit of a mystery, then Antonio Reynoso is downright mysterious. He is another Eerie Pubs artist who hailed from Argentina and yet another enigma. I can find only one other instance of published artwork, from the early '60s in his homeland. Regardless, he remains the undisputed champ of Eerie Pubs art, turning in over 80 stories in five years. His ink-heavy, moody style can be found in most of the company's mags from early 1970 until the end.

Reynoso's style could often be somewhat cartoonish, with thick inks and a somewhat Jack Davis-ish touch that makes me think he was probably a good caricaturist. There were many other artists working in Argentina in the '50s and '60s who drew with a similar style. Whether or not Reynoso worked under any aliases is unknown at this time.

Rayo Rojo was a diminutive (roughly 4 x 7") weekly comic book that began in Argentina in the '40s and was published by Editorial Abril. The comic specialized in action and adventure strips, including "Colt— El Justiciero," an Argentine take on the popular Western fumetti character Tex Willer. Alongside ol'

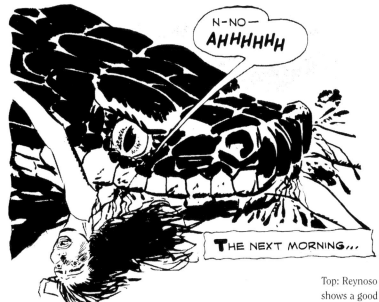

Colt, appearing during the first three weeks of May 1961 (*Rayo Rojo* #598, 599 and 600) was one "Misión Suicida" drawn by Antonio Reynoso. The style is unmistakable: thick

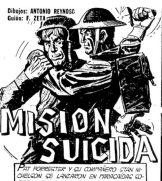

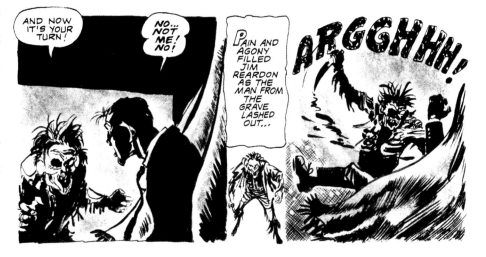

Top: Reynoso shows a good eye for serpentine scalation in this panel from "The Tomb of Terror"

Middle: A rare look at a non-Pubs Reynoso war strip, from the serial "Misión Suicida"— *Rayo Rojo* #599 (Abril, May 13, 1961)

Bottom: A typically well laid-out sequence from "Deadman's Hand"

The Good, the Bad, and the Ugly

As a horror artist, Reynoso was excellent with the mood, shadows and lighting. Some of his people, however, drifted into unfortunate caricature at times.

Top left: The Good— "Demon"… mood, monsters and darkness

Top right: The Bad— "Voodoo Doll"… this cartoony kid has no place in a horror mag

Bottom: The Ugly— "The Demon is a Hangman"… I rather like ugly characters in my horror comics, as long as they're supposed to be ugly!

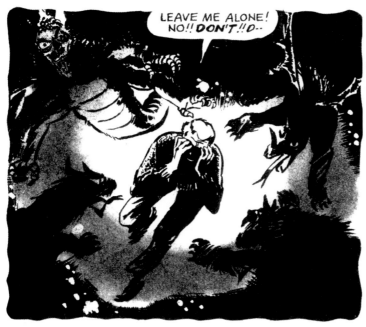

black lines, dark shadows, cartoony faces and film-like "camera angles"… all trademarks of Reynoso's Pubs artwork. This war tale ran for these three issues and it stands as the only non-Pubs work I've seen by him.

Antonio Reynoso's first efforts for Fass and Burgos were in the February 1970 issues of *Weird* (V4 #1) and *Witches' Tales* (V2 #1).

The *Weird* story "Demon" was an excellent introduction to the stygian blackness of his brushes. A dark and gloomy masterpiece, this story showcases Reynoso's penchant for thick, shadowy inks and ominous lighting.

Reynoso is a frustrating artist to critique. At times, he was brilliant. He was fond of using interesting panel layouts and his pages have a very fluid flow to them. The aforementioned shadows and lighting were always expertly handled, and his panel composition and movement make me think that he would have excelled at storyboarding movies.

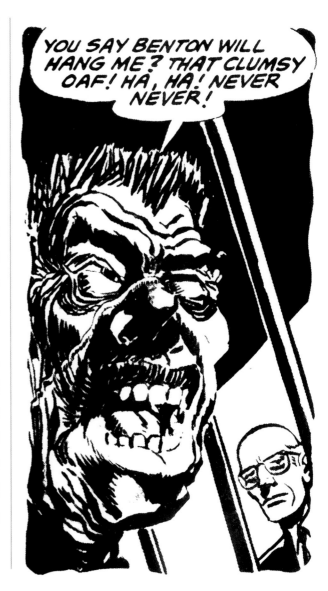

Top: A moment of terror from Reynoso's "The Zombies' Vault"

Bottom: Stepancich supplies an excellent deep black splash panel for "The Corpse That Lives"

there is plenty of thought and technique to admire in his work. An unmistakable style, always adorned with his slashing signature, Reynoso is far and away the easiest Pubs artist to identify.

Other times, Reynoso could be pretty bad. To be honest, the man could not illustrate attractive females. Many of his characters, both male and female, could get downright ugly. That said, these were horror comics, and ugly was as welcome as blood and guts. With all due respect to Sergio Leone, I like to think of Reynoso's Eerie Pubs efforts as The Good, The Bad and the Ugly.

Reynoso was never one to copy artwork or panel ideas from the stories he was redrawing. He would completely re-imagine it and tell the tale in his own style. He dutifully kept the text and voice balloons the same, but his monsters, characters and settings were always very much his own. He was an excellent choice for the science fiction stories as well as supernatural creature tales. Alongside his trusty brush that he used to ladle on the inks, Reynoso would occasionally employ zip-a-tone, white ink splotches or an airbrush to create different textures and tones.

Antonio Reynoso's imagination shines through in every story that he illustrated for Eerie Publications. Even when he churned out an obvious quickie (and he did sometimes),

Oscar Stepancich

Not only unknown here in the U.S., Oscar Stepancich is unfamiliar to most comic fans even in his homeland of Argentina. But we, the readers of Eerie Publications, will remember him forever because of the more than 20 stories that he illustrated for the company.

Stepancich was born in the Cordoba Province in Argentina to a Czech mother who passed away when he was born. Raised by his aunts, he kept his mother's Eastern European

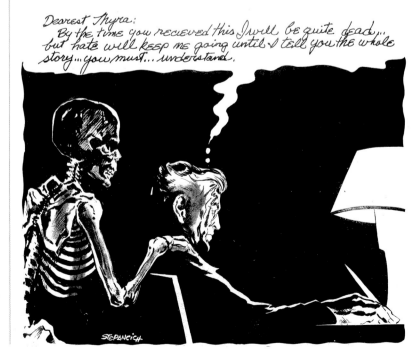

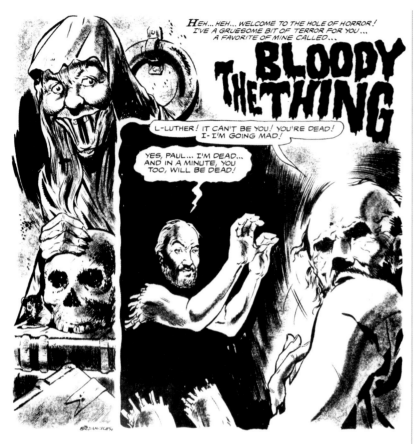

EC's Vault Keeper gets a story-hosting gig, unbeknownst to Bill Gaines, in "The Bloody Thing" (a.k.a. "The Gory Thing")

surname. Living his entire life in Argentina, Stepancich always had a focus on the arts. He was a longtime art teacher as well as an illustrator. He did some work on Argentine comic strips, including Meteoro (Speed Racer) and Tarzan. His only known work to appear in the USA was in the Eerie Pubs horror comics and a handful of Charlton Romance stories. These were produced, as was all of his comic book work, while living in Argentina.

Stepancich was right there at the beginning of Eerie's original art phase, with his first story, "The Mummies," seeing print in *Witches' Tales* V2 #1 (Feb. 1970). Most of his subsequent stories were drawn between then and 1972, though he was sporadically contributing new stuff right up through 1974,

his last being a redraw of the Ajax classic "Bloody Mary."

Stepancich is an interesting artist to critique. His inking skills were second to none in the Eerie Pubs bullpen. His blacks were bold, his lines were confident and his feathering was very smooth. He even showed a Wrightson-esque style at times. I would have loved to see him inking someone else's pencils, perhaps a Fraga or a Casadei. Contrarily, his own figures could run the gamut from good to anatomically fucked. His characters' eyes were often lopsided or inappropriately small and some of his figures had awkward twists in their bodies and limbs. He was prone to lifting panel layouts and poses from the original pre-code stories, but his work probably benefited from it.

Interestingly, Stepancich put some familiar swipes into his horror stories, perhaps as a tribute to the genre that he was obviously well versed in. "The Bloody Thing" (a.k.a. "The Gory Thing") featured The Vault Keeper himself serving as host. The images were lifted straight from the pages of EC's *Vault of Horror*. He also utilized images from horror movie posters such as *The Embalmer* (1965) and *Horror Hotel* (1960). It's worth noting that Stepancich never shied away from the gore; some of his stories get pretty gruesome.

At the other end of the comic book spectrum reside Stepancich's other known North American efforts. At the same time he was pouring on the gore for Eerie's fear fables,

he was doing some well-told tales of love and heartbreak in Charlton's Romance comics. His style takes on a lighter tone here (thank goodness!), though his inks are still excellent and his storytelling is fine. I'm unable to identify any comic swipes in these stories.

His U.S. comic work stopped in mid-1974. A decade later, Stepancich (who occasionally

Top left: Mike and Wendie, falling in love in "Fancy Meeting You Here," from *Romantic Story* #121 (Charlton, Aug. 1972)

Stepancich got back into the re-draw game for Editorial Abril in the mid-'80s, this time interpreting Marvel and DC superheroes

Top right: *Los Vengadores* #7 (June 1986)

Bottom left: *Los Superamigos* #4 (Oct. 1986)

Bottom middle: *Los Superamigos* #5 (also Oct. 1986)

Bottom right: Some extremely interesting body language by Submariner on *Los Fantasticos Cuatro* #2 (Mar. 1986)

THE WEIRD WORLD OF EERIE PUBLICATIONS

Top: Cover painting for the **Rastros** series of pulp digests (from the original art)

Bottom: Muñoz supplied a handful of beautiful noir-ish illustrations to accompany the text of "El Sombrero" in **D'artagnan** #42 (Columba, Nov. 1960)

signed his work Stepan) produced covers for Abril's Marvel Comics reprints in Argentina. He drew the covers for the full 11-issue runs of *Los Fantasticos 4* (The Fantastic Four) and *Los Vengadores* (The Avengers).

Stepancich's interpretations of Marvel's popular heroes are interesting as they still have those squinty, uneven eyes that he always drew. (It works to good effect on Submariner.) Abril also handled the Argentine reprints of DC's *Super Friends* in 1986 and 1987, with Stepancich illustrating the new covers. It should be noted that the new artwork for Abril's covers were redrawings, based on the originals.

Oscar Stepancich died of cancer in the early '90s.

Cirilo Muñoz

In his book *Ghastly Terror* (Headpress, 1999), author Stephen Sennitt suggests that the artwork of Cirilo Muñoz (whom Sennitt does not identify by name) could hold its own next to Reed Crandall and Joe Orlando's art in any early issue of *Creepy*. I agree; Muñoz was already a veteran comic book illustrator when he was churning out dozens of stories for Eerie Publications. His style was clean and accomplished, with meticulous cross-hatching, showing the sure hand of a maestro.

Muñoz was a big player during the boom years of Argentina's comic industry. His artwork was ever-present in Columbra's titles *Intervalo* and *D'artagnan*, illustrating every genre. His dramatic eye for shadow and texture gave much of his adventure work a noir look that also translated well to other genres, including sprawling Gothic romances and Westerns.

One of Cirilo Muñoz's greatest triumphs was landing the art gig for Héctor German

Hizo el resto del camino a pie, pegado a la sombra de las construcciones que bordeaban la ruta.

214

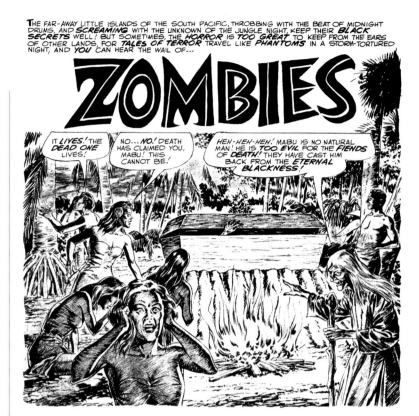

Oesterheld's popular Western series "Randall: The Killer." Published by Oesterheld's own Ediciones Frontera in the monthly comic *Hora Cero*, Muñoz took over the art chores from the departing Arturo del Castillo. Picking up the strip in July of 1960, Muñoz illustrated the exploits of the wild Western vigilante until the end of 1961. Oesterheld was always quick to mention Muñoz's name as one of the greats that he was fortunate enough to have illustrate his words.

Indeed, the Western genre is where Muñoz seemed the most comfortable. In addition to various strips, he also painted covers for pulps including Western-themed covers for Editorial Acme's digest-sized *Rastros*. His paintings display the same fine detail as his distinctive pen-and-ink work.

Muñoz arrived into the open arms of Eerie

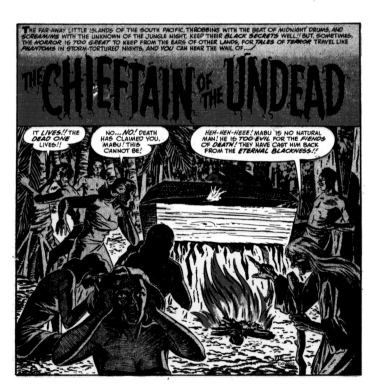

Publications just after the initial launch of the original art phase. His first work to be published by the Pubs, "Zombies," appeared in *Tales From the Tomb* V2 #4 (Aug. 1970). Though he arrived at Countrywide a few months later than some, he stayed until the end of the party, illustrating over 50 horror tales by the end of 1974. He also painted the cover for *Horror Tales* V2 #5 (Sept. 1970) which was chopped up and reused once or twice.

I love Muñoz's art. I have always loved detailed pen-and-ink with fine cross-hatching and moody shadowing. From Gustav Doré right up through Ghastly Graham Ingels, intricate black lines and elaborate inking has always appealed to me. That said, Cirilo Muñoz's masterful Eerie Pubs work still manages to disappoint me.

Top: Muñoz's splash panel for "Zombies" is breathtaking, until you check out Vic Donohue's original (bottom) from the first issue of Harvey's **Chamber of Chills** #21 (June 1951)

215

WALTER'S BEEN WAITING FOR YOU, HAROLD... WAITING FOR REVENGE... THE FLESH HANGS FROM HIS ROTTED CORPSE AND HIS HANDS CLUTCHING YOUR THROAT ARE THICK WITH GREEN SLIME...

Top: A look at "The Slimy Corpse"

Bottom: When not copying the originals, Muñoz could come up with some great stuff, like this splash for "The Sea Monsters"

master inker, his later work looks great but his lines got wider and his hand quicker. As he got more comfortable "interpreting" other artists' work, his copying became less rigid and he freed himself up to flex his creativity a bit.

Biographically, Cirilo Muñoz is another tough nut to crack. Every bit of information that can be found about him and everything that fellow creators say about him pertains to his excellent workmanship. While his life will remain a riddle to us at this time, there is a huge body of excellent illustrative work for us to enjoy and remember him as his peers do: as a superlative artist.

The man was one hell of a talented draftsman. His best work for the Pubs, however, was a complete copy of the original story that he was redrawing. Compared side by side, it's evident that Muñoz put no creativity whatsoever into his stories. He just copied the figures, the layout and the details, panel by panel. Of course his work looks gorgeous but, to be fair, it's just not entirely his own. I suspect that one reason for this might have been an inability to understand English. If one doesn't know what the word balloons and text panels say, they would be less likely to improvise on the art for fear of storytelling mistakes.

Like many of his fellow Eerie Pubs artists, the detail and effort that went into his early stories for the company started to wane after a while. Still a

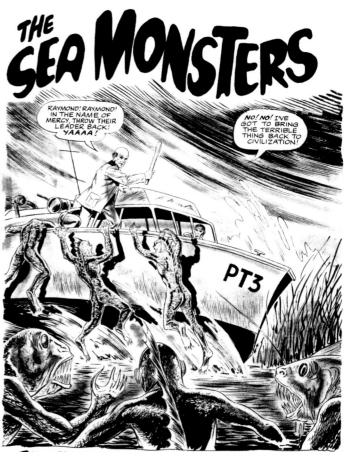

THE SEA MONSTERS

RAYMOND! RAYMOND! IN THE NAME OF MERCY, THROW THEIR LEADER BACK! YAAAA!

NO! NO! I'VE GOT TO BRING THE TERRIBLE THING BACK TO CIVILIZATION!

PT3

THE STRANGE TALE OF THE AQUATIC MAMMALS THAT APPEAR TO BE HALF MAN AND HALF FISH!

Oswal

Left:
Oswal himself
(photo courtesy
of the artist)

Right:
The first
Argentine
superhero,
Sónoman
(courtesy of
the artist)

Checking in with only eight stories, Oswal's work should still be familiar to Eerie Pubs fans as some of the most distinct and well-told tales in the horror mags. As comfortable with science fiction as he was with horror, Oswal's thick, fluid lines were full of movement, drama and, quite often, a sense of playfulness.

Osvaldo Walter Viola was born in Argentina in November of 1935. He started to make a splash in the comic world in the early '60s, illustrating stories for the comic magazines *Hora Cero* (Zero Hour) and *Frontera* for publisher Emilio Ramírez. This gig included handling the art chores for Oesterheld's "Ernie Pike" strip. Mid-decade, he found success with acclaimed comic adaptations of the literary classics *David Copperfield* (by Charles Dickens) and *Robinson Crusoe* (by Daniel Defoe) in the

magazine *Anteojito*. In 1966, Oswal created the first all-Argentine superhero for the same comic magazine: Sónoman. More human than superhero, the character could control and use sounds, including the music of Mozart (of whom Oswal is a devoted fan), to gain and maintain his powers. The strip was a big hit and Oswal continued to write and illustrate his stories for the next 10 years. Sónoman and his creator were honored with a postage stamp in Argentina in 2003.

During the Sónoman years, Oswal did some freelancing on the side, and this is when he was welcomed into the Countrywide fold. His first work to appear for them was in *Terror Tales* V2 #6 (Nov. 1970), a seven-pager called "The Glass Corpse" (subsequently retitled "The Glass Morgue" for its multiple reprintings). The rest of his Eerie Pubs work was done within the next year, with his last new story, "Beyond Evil," appearing in *Weird* V6 #1 (Feb. 1972).

217

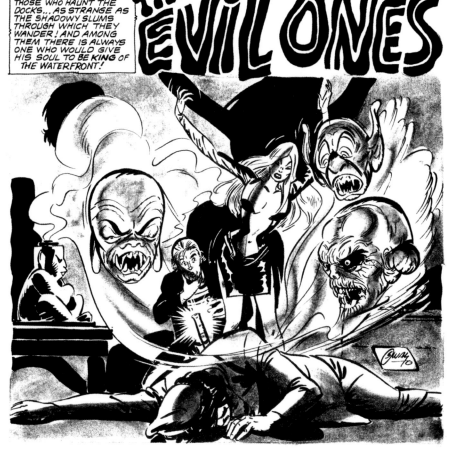

Oswal's Pubs work is highly stylized and is instantly recognizable. He may have borrowed ideas from the original stories, but he used his excellent imagination to take the stories off into exciting new artistic directions. He employed a caricatured, cartoon style at times and it's easy to liken his art to that of Alex Toth, who also used bold lines and thick inks. Oswal's artwork is action-packed and his science fiction is filled with weird and interesting monsters. Loose yet confident, his artwork flows with effective simplicity.

During this same period, Oswal dabbled a bit in Charlton's romance comics, like his Eerie Pubs cohorts Stepancich and Torre Repiso. His style transferred nicely to the lighter tone of the stories, and his story's splash panels were occasionally blown up and used as that issue's cover. His mastery of the brush is evident in every panel.

Oswal went from strength to strength during the '70s and '80s, scripting and drawing many strips, not only in Argentina but internationally. His work regularly appeared in *Lanciostory*, which brought his art to Spain, Italy and Holland. In the early '80s, Oswal illustrated the title strip in the revived comic title *L'Eternauta*. Originally written by Oesterheld in the late '50s, this politically charged story was penciled by Oswal for the

first 30 issues of the revival. *Skorpio* was another international publication to which he frequently contributed with both serials and one-shot stories, some of which are wonderfully horrific in content.

Other milestones in Oswal's extensive résumé include "El espíritu de Mascarín," which he wrote and illustrated, "Lejos Pratt," a weekly eco-historical adventure strip for school kids, "13 historias negra," a black comedy written by Spaniard Enrique Abulí, and more recently *Tango en Florencia*, a graphic novel he wrote and illustrated himself.

Oswal is still going strong with his career. In addition to his publishing work and advertising illustration, he also finds the

time to teach drawing. He is a very talented cartoonist and storyteller. His website, www. oswalcomic.com.ar, is a great place to get acquainted with his non-Pubs work.

Torre Repiso

Hernan Antonio Torre Repiso was a young man when his teacher and good friend, Oscar Novelle, suggested he try his hand at some horror comics for an American publisher that was seeking new talent. He agreed and over the next year and a half illustrated over 15 comic stories for Eerie Publications. These tales of terror were Repiso's first professional comic book work.

Opposite top: Check out the bat in the guy's scowl lines, from "Beyond Evil"

Opposite middle: Oswal's weird aliens from "Planet of Horror"

Opposite bottom: The splash panel for "The Evil Ones"

This page top: Sex and soda pop and rock and roll— *Romantic Story* #122 (Charlton, Sept. 1972)

This page bottom: A self-caricature, by Hernan Torre Repiso

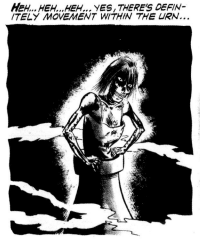

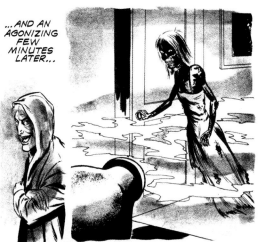

HEH...HEH...HEH... YES, THERE'S DEFINITELY MOVEMENT WITHIN THE URN...

...AND AN AGONIZING FEW MINUTES LATER...

Top: A series of panels from one of Torre Repiso's first Pubs stories, "The Flaming Ghost"

Bottom: Wiggin' out in "The Weird Thing"

Born in June of 1944 in the Corrientes Province of Argentina, Torre Repiso grew up in a family that enjoyed comics. At an early age he got serious about drawing and completed an American correspondence art course. At 18, he moved to Buenos Aires and immersed himself in art, taking lessons from Oscar Novelle and the great Alberto Breccia. In 1965, Torre Repiso enlisted, and while serving he got his first chance to draw editorial cartoons.

Returning from the service and having a tough time getting into the comic field, Torre Repiso landed a job in the country's largest supermarket chain where he headed up the art department, constructing graphs and doing lettering and illustrations. This was followed by more advertising work before he got the call from Novelle. Comics were beckoning and Torre Repiso was happy to answer.

Late in 1970, he began working on his first strips for Eerie Publications. His work hit the streets in force with two magazines dated February 1971, *Weird* V5 #1 and the brand new sci-fi experiment *Strange Galaxy*

V1 #8. The latter was special because it contained two gruesome Repiso stories, "Flaming Ghost" and "Terror of the Dead." Both of these tales, taken from Story's great pre-code title *Mysterious Adventures,* deliver the gory goods in spades. Torre Repiso did not shy away from showing us the blood and gore.

Being new to the field, Torre Repiso's Eerie Pubs work was never daring or extravagant, but always solid and efficient. He never strayed far from the original artwork's layouts, but often introduced new "camera angles" and character ideas. Storyboarding a comic was a learning process and he was learning well. His Pubs artwork was never cluttered; he preferred telling the story with clean, minimal lines and washes. Though he usually signed his artwork, one way of identifying a Repiso story is by the character's noses—they are often long and shapely.

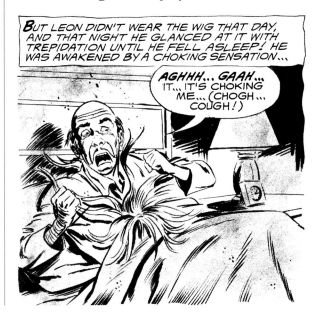

BUT LEON DIDN'T WEAR THE WIG THAT DAY, AND THAT NIGHT HE GLANCED AT IT WITH TREPIDATION UNTIL HE FELL ASLEEP! HE WAS AWAKENED BY A CHOKING SENSATION...

AGHHH... GAAH... IT... IT'S CHOKING ME... (CHOGH... COUGH!)

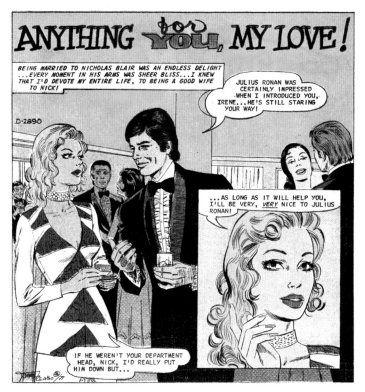

His last story for Eerie Pubs, appearing first in *Tales of Voodoo* V5 #6 (October 1972), was "The Weird Thing," a tale about a killer wig. It has always been one of my favorite Pubs stories. "Bloody Talus," Torre Repiso's sci-fi entry, is fondly remembered by Eerie Pubs aficionados as a genre favorite.

After getting his feet wet with the Eerie Pubs work, Torre Repiso's comic career took off. He followed up with strips and cartoons for many Argentine magazines, including *Loco Lindo* and Columba's publications. He became proficient in every genre of comic, from Westerns to children's books. He continued working for U.S. publishers as well,

illustrating love stories for Charlton's romance comics. His artwork went truly international when he illustrated stories for Fleetway and DC Thompson in Europe. Doing covers, stories, cartoons and book illustrations, he stayed very productive throughout the '70s. He even had a story in DC's popular horror title *The Unexpected* (#202, Sept. 1980). By this time, his skills had matured and his artwork was more confident.

In 1982, Torre Repiso was chosen to be the cartoonist for *Ambito Financiero*, the Argentine *Wall Street Journal*. Here, he perfected his editorial cartoons and political humor. Adopting the nickname

Left: Torre Repiso's lighter side, from *I Love You* #99 (Charlton, Sept. 1972)

Bottom: The groundbreaking "Yo accuso. ¿O no?" from *Tiras de cuero* V1 #1 (Editorial Latino-americana, No. 1983)

Yacaré, named after the crocodiles of the region he grew up in, he continued this work for many years and it made him famous.

1983 saw the release of the first issue of the short-lived *Tiras de Cuero*, an adult-oriented comic magazine. Torre Repiso teamed up with writer Dalmiro Saenz to produce the hard-hitting and controversial "Yo accuso. ¿O no?," a strip that led to a new type of more adult and political comic in Argentina. This two-parter is a harrowing, realistic tale and Torre Repiso's artwork treads the line between cartoon and realism, with a gorgeous woodcut-like result.

As Yacaré, Torre Repiso went on to prominence as a cartoonist, caricaturist and political humorist. His work caught the eye of *La Prensa*, Argentina's oldest newspaper (and one of the largest in the world), and he got on board with them. He became one of the most sought-after cartoonists and illustrators in the country. His work has also been collected into book form and his artwork is still in demand today. In addition, he is a popular and successful teacher, teaching all aspects of art from landscapes to cartoons. He also serves as president of La Liga de Amas de Casa, a group that helps men get comfortable with homemaking and household needs, something I heartily applaud.

Not a bad career for an artist whose humble beginnings were with Eerie Publications! Check out his website www.yacarehouse.es.tl for a look at his post-Pubs art.

Johnny Bruck

Johnny Bruck, Perry Rhodan cover artist extraordinaire, had more than 30 Eerie Pubs covers to his credit, whether he knew it or not.

Johannes Herbert Bruck was born in Hamburg in 1921, but spent his youth in the U.K., learning many languages and developing his artistic skills. Tumultuous teenage years took him to various parts of the world, and later, when World War II hit, he became a reluctant member of the German Navy. He decided Russia would be a better place to be once things heated up. His desertion caught up with him and he was condemned to death. Luckily, Germany surrendered the very next day and Bruck was spared.

Postwar years were busy for Bruck, who continued his prewar work as a journalist and illustrator. In the '50s he also entered

Bruck found inspiration in the Mario Caria cover from ***I racconti di Dracula*** #27 (Editore ERP, Jan. 1962)

occasionally recycled his own images and was known to find inspiration elsewhere as well. The U.S. science fiction mag *Analog* had a couple of covers inspire the canvas on Bruck's easel, including one by Frank Kelly Freas. The image for *Perry Rhodan* #156, which traveled to the U.S. as the cover of *Weird* V5 #2, was borrowed from an old Italian horror novel in the *I racconti di Dracula* series. One can hardly blame Bruck for seeking helpful ideas from other artists, considering his titanic workload.

Johnny Bruck, with his long white hair and beard, deerstalker hat and Vespa scooter, was a common sight in Andechs, his hometown in Bavaria. At age 74, Bruck was involved in a traffic accident; he was hit by a car while on his scooter. The injuries were severe, and he died on October 6, 1995. The local paper read *"Der alte Herr mit der Vespa ist tot,"* which translates to "the old gentleman with the Vespa is dead."

Bruck not only produced the covers of almost 1800 Perry Rhodan pulp digests, but he painted over 200 PR paperback covers, and more than 700 covers for the Rhodan spin-off *Atlan*, as well as covers for *Utopia*, *Terra* and many other sci-fi publications. He had nearly 6000 paintings published in his lifetime. He also drew the interior pen-and-ink illustrations for the pulps. He was incredibly prolific and is one of the most-published science fiction artists ever. In 1973, he received the German

the field of painting covers for various pulp adventure series and paperback books. This work brought him to the attention of the Perry Rhodan publishers, Pabel-Moewig Verlag KG, who hired him to do cover art. Needless to say, his work for PR was a huge success, and it was to be his bread and butter for 30 years. Bruck's paintings were the first visual exposure to the genre for many German science fiction fans. Full of color, explosions, weird creatures and excitement, the Rhodan covers attracted a lot of readers.

Like Eerie Pubs a decade later, Bruck wasn't one to let a good image go to waste. He

Top: A gorgeous Western cover for the pulp *Supplemento de Rastros* #80 (Acme, Sept. 1954)

Bottom: O.A. Novelle himself, from an old Argentine newspaper photo

Hugo award for his outstanding contributions to the genre. We Pubs fans are lucky to have gotten a chance to enjoy the work of Johnny Bruck, even if most of us didn't know whose work it was.

O.A. Novelle

Though Oscar Antonio Novelle only drew a handful of stories for Eerie Pubs, he supplied some memorable covers for the company and, more importantly, was a catalyst for bringing many of his fellow countrymen into the pages of American comic books. His departure from Argentina's troubled comics scene in the early '60s spearheaded a movement that brought

the work of many fine Argentine artists to these shores.

Born in 1920 in Buenos Aires, Oscar Novelle was a big art fan as a child and picked up the pencil to emulate his favorite cartoons. Obviously, he showed a great ability, and by the time he was 21 he was doing illustrations for Tor Publications. Throughout the '40s and '50s, his artwork was featured in many comic magazines, including the seminal *El Tony*. He drew the Argentine version of The Saint, "El Santo," as well as other serialized characters, and he put three years into the daily comic strip "La Razon" (The Razor). He also did advertising and book illustrations, some in gorgeous, very realistic paintings, but his favorites were the comic strips.

Novelle was an excellent Western artist and illustrated many stories for *Pancho Negro* and other Western titles. When the early '60s became a tumultuous time for the industry in Argentina, Oscar Novelle moved to the USA to show off his clean and crisp art to another country with a huge appetite for comics.

He landed a backup gig on Charlton's *Blue Beetle* superhero comic and also did some romance work for them, but his real coup was getting a steady job at Gold Key, illustrating for their horror titles. His art appeared in dozens of stories for their titles *Ripley's Believe It or Not*, *Boris Karloff Tales of Mystery*, *Grimm's Ghost Stories* and *Twilight Zone* for over 10 years.

In 1971, O.A. Novelle supplemented his Gold Key income with a short string of stories for Eerie Publications. His first story for them was "Voodoo Doll" which appeared in *Strange Galaxy* V1 #8 (Feb. 1971). Despite premiering in a sci-fi title, "Voodoo Doll" is a pure horror story. Novelle's inks are very tight and feathered, creating a smooth texture. Unfortunately, he didn't often stray too far from the original layout of the story he was re-drawing, though his interpretations usually displayed a superior technique. His fine brush and pen work always showed a very smooth and confident style, and he had a knack for shading with uncannily straight, tight lines.

After a mere seven stories for Eerie Pubs, most of which appeared in 1971, Novelle disappeared from their pages, except for the inevitable reprints of his stories. He came storming back in a big way on the cover of *Witches' Tales* V5 #4 (July 1973), with his first painted cover for the company. He delivered everything that had been asked of Pubs cover artists like Chic Stone and Bill Alexander... lots of action, lots of blood, some pulchritude, and bright, eye-catching colors. All 10 of his original covers for Eerie Pubs are exciting, gory and fun.

Top: A good look at Novelle's incredibly straight lines, from "No House for the Living" in ***Ripley's Believe it or Not*** #61 (Gold Key, Apr. 1976) (from the original art)

Bottom: ***Terror Tales*** V6 #2 (Apr. 1974), a painting that stands up to the gruesomeness of the early Stone and Burgos covers

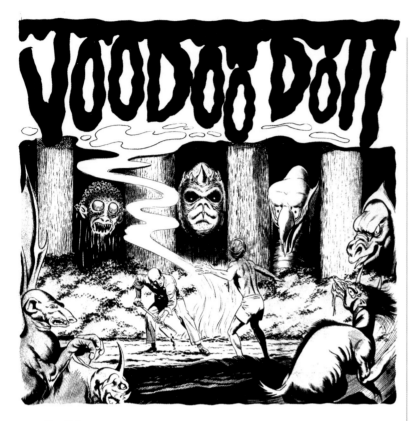

Novelle's impressive inks are showcased in the Pubs story "Voodoo Doll"

Moving to the U.S. as early as he did, Oscar Novelle was very helpful in bringing other Argentine artists and their work to North America. He hooked up Luis Dominguez with a few jobs and got him settled in the U.S., helping his career take off and to become a real success story. (Unfortunately, Dominguez never did any Eerie Pubs work; the closest he came was illustrating a Countrywide Sherlock Holmes magazine in 1977.) Novelle also acted as a liaison with agents back home in Argentina, getting the word out that there was a gig in the States that didn't pay much, but it would get their clients' artwork onto U.S. newsstands. He was responsible for introducing many young Argentine artists to the U.S. comic industry, by way of Eerie Pubs.

All the while, Novelle kept drawing horror comics for Gold Key. He also had the chance to put his exquisite inks into a couple of DC comics in 1976, including over Dominguez's pencils for a Johan Hex story in *Weird Western Tales* #36 (Sept.-Oct. 1976).

Oscar Novelle passed away at the very young age of 58 in 1978. He was still residing in the USA.

Hector Castellon

Of all of the Eerie Pubs artists, Hector Castellon might have the most distinctive art style. He was a very painstaking artist; his fine, spidery lines seemed almost too delicate for the cheap, pulpy paper on which they were printed. Though he only did seven stories for the Pubs, his memorable style stands out in every issue.

A member of the Union Studio, which brought artwork from Spain and Latin America to the U.S., Castellon's work first started showing up on these shores in 1965. The mid-'60s saw him providing story illustrations for many U.S. science fiction pulps, as well as the occasional cover. His chimerical artwork was perfect for the genre and appeared in *If*, *Amazing Stories* and *The Magazine of Fantasy and Science Fiction*.

1967 brought his talents to the world of comic books with a helping of stories for

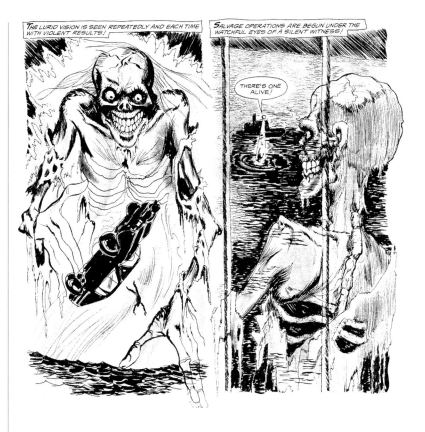

Charlton's horror title *The Many Ghosts of Doctor Graves*. These early issues display his emerging style of weird art; psychedelic and surreal, his scratchy and off-kilter lines foreshadow the crazy stories that would see print in the Pubs. *TMGODG* #6 (May 1968) has a freaky story called "Whatever Happened to Reality?" that showcases his art with black-and-white panels mixed in among the color pages, an effect that works beautifully.

More important to horror fans was the handful of stories that Castellon contributed to Warren's horror magazines starting that year. His sketchy yet very detailed artwork and abstract page layouts are worthy additions to the late-'60s Warren issues. *Creepy* #20 (May 1968) contains a story called "Inheritors of Earth," a whacked-out tale that Castellon not

Top left: An early sci-fi pulp cover, *The Magazine of Fantasy and Science Fiction* #181 (Mercury, June 1966)

Top right: Wacky shit from "Morgan's Ghost"

Bottom left: An excellent page from "Whatever Happened to Reality" from *The Many Ghosts of Dr. Graves* #6 (Charlton, May 1968)

being inked by Vince Alascia (a Charlton regular) with less than impressive results. A style like Castellon's should never have been inked by someone else, especially someone who didn't share his twisted vision.

In early 1971, Hector Castellon's work started to grace the pages of the Eerie Pubs. All seven of his stories appeared that year. His stories showed a great deal of weirdness, a preoccupation with hands and super-textured panels, mixing fine pen lines, thicker brushwork and charcoal scratches. Unafraid of borrowing images, he incorporated interesting "swipes": a Neal Adams hand from a *House of Mystery* cover and, most notably, the hooded

only illustrated, but wrote. He would put his creative storytelling mind to good use for Carl Burgos a few years later.

He finished up the '60s with a few more stories for Charlton's ghost comics, but was

HIS HEART TREMBLED AS HE BEHOLD THE TERRIBLE APPARITION HIS BLOOD RAN COLD WITH DREAD AS ITS CLAMMY HANDS SEIZED HIM IN A GRIP OF DEATH! HE KNEW ONE WEAPON COULD SAVE HIM, BUT COULD IT BE USED IN TIME?

druids from Julian Roffman's 1961 film *The Mask* in his story "Creatures of Stonehenge."

That particular story also got the Castellon special treatment; he rewrote the script from the second page on, making it a more satisfying thriller, replete with a '70s downer ending. He condensed many of his stories, pruning out unnecessary panels and dialogue, spicing up the 20-year-old stories with taut storytelling and loose, wild artwork. The undaunted artist also handled a redraw of Basil Wolverton's "The Monster from Mars" (from *Weird Tales of the Future* #3, Sept. 1952) with "Space Demon," a story which features a monster hand, right up the *mano*-minded Castellon's alley.

Castellon's last known artwork in the U.S. was the cover for Charlton's comic book *The Six Million Dollar Man* #3 (Oct. 1976). His trail dries up after that and I have been unable to find out what happened to him, but in the 11 years' worth of output that we do know about, Castellon left a legacy of wild and woolly horror art that looks like nothing else that came before or after.

Cerchiara

I have failed.

I don't have the slightest idea who this artist might be. There are some online sources that suggest that this was an artist named Mariana

Cerchiara, but my own research has led me to believe that this is erroneous. This artist has baffled the experts in Argentina, though I'll bet that's where the work was produced.

Whoever it might be, Cerchiara started with Eerie Pubs in early 1971 with their first two stories appearing in mags with a cover date of April of that year. Four more stories appeared within a year, and one lone story, "The Fighting Vampire," didn't see print until the June 1974 issue of *Horror Tales* (V6 #3). It is probable that it was drawn around the same time as the others and held back; it was cribbed from an issue of Comic Media's *Weird Terror*, a title that had been exhausted for stories a couple of years earlier.

So, how do Cerchiara's seven Pubs stories look? They're all right.

Looking a bit like Tony Tallarico's art (or more accurately "Tony Williamsune's" art

Opposite left: Castellon had a preoccupation with hands, as is evident in this example from "The Creatures of Stonehenge."

Opposite right: Making Lee Majors look like six million bucks—***The Six Million Dollar Man*** #3 (Charlton, Oct. 1976)

This page: Cerchiara's excellent inking makes "The Deadly Demon" a standout.

Fernandez contributed a few covers to the Pubs' rival Skywald. Here is a stunner for **Scream** #5 (Apr. 1974)

which was Tallarico's inks over Bill Fraccio's pencils), Cerchiara was all about intricate ink work. While the figures could be stiff and awkward, the inks were always meticulously detailed—thick and cartoonish, looking a bit like a woodcutting. Every panel shows that a great deal of effort and time went into the art, by the hand of an excellent inker. Still, the faces and figures were acceptable but often subpar.

So, was Cerchiara another Italian expatriate living and drawing in Argentina, like Walter Casadei? Maybe an artist who, like Hernan Torre Repiso did with the name Yacaré, named himself or herself after a region they grew up in? (Cerchiara is a town in Italy.) Or is it Mariana and I'm just dead stupid? Any of these scenarios could be correct. At any rate, we have seven Pubs stories to study and enjoy by this mysterious artist.

Fernando Fernández

When one thinks of Fernando Fernández's horror comic work, Eerie Publications don't exactly spring to mind first. Better known for his beautifully illustrated masterpieces for Warren Publishing in the mid-'70s, Fernández did indeed leave an indelible mark on the good ol' gritty Pubs.

Born in 1940, Fernández joined Selecciones Illustradas (SI), Josep Toutain's prolific art

studio in Barcelona, Spain, at the tender age of 16. SI provided comic art to publishers all over Europe and, eventually, the USA. There, he did extensive comic book work in many genres. In the mid-'60s, he concentrated on illustration and painting rather than comic work, painting many book and magazine covers.

In the early '70s, Fernández was very much in demand for his realistic and action-packed paintings. His work was full of color, violent action and beauty all at the same time. *Man's Story*, *Men Today* and *Man's Book* were all lurid exploitation magazines, published by Emtee/Reece Publishing, with stories of bikers, Nazis and scantily clad women. Exquisite Fernández covers highlighted many issues.

In 1970 Fernandez was commissioned to do a collection of horror paintings to be used as

covers for a U.S. comic company. Warren had recently introduced covers by talented Spanish artists, so Eerie Pubs once again followed suit. Working for another U.S. publisher at the time, Fernández adopted the *nom de plume* Saldaña to avoid a conflict of interest, and produced many memorable covers for Fass and Burgos. The Saldaña covers brought a mature look and a much higher level of art to the magazines, though Burgos still couldn't leave well enough alone and managed to paint over a few of them. Like his men's mag covers, curvy victims in tattered dresses faced menacing danger, only here the danger was from monsters rather than thugs. Subject matter aside, the artwork was done by a true maestro.

From there, Fernández went on to superstardom with stories that he both wrote and illustrated for Warren's *Vampirella*. His narratives are emotional, adult and often very moving, and his exquisitely detailed pen-and-ink work is breathtaking. From late 1973 until mid-1975 he created nearly a dozen excellent works for the magazine.

The late '70s brought Fernández's talents to Toutain's own publishing house where he created multiple series, including "Zora y los Hibernautas" for the sci-fi magazine *1984*. This series would later be reprinted in the U.S. in *Heavy Metal*. One of his best-known serials was an adaptation of Bram Stoker's "Dracula" which appeared in Toutain's Spanish version of *Creepy*. These two series were full-color

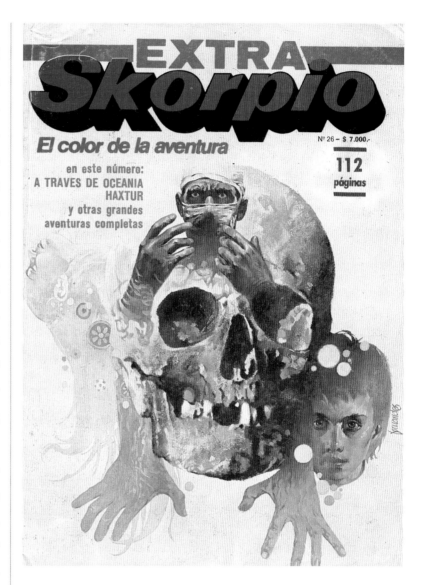

painted strips that are, in my opinion, as good as anything that has ever been produced in comic strip form. Each panel on each page is a treasure.

Throughout the '80s, Fernández continued to produce work in and out of the field, including comic adaptations of Isaac Asimov's science fiction. With the '90s looming, Fernández again concentrated on his fine art painting. His elegant portraits and colorful scenes have since been featured in galleries and have graced collections all over the world. In 2004,

Extra Skorpio #26 (Record, Apr. 1981)

This page top left: Alberto Macagno in a 1981 issue of **Bang!**

Opposite top left: From "The Hanged"

This page bottom left: Macagno's really stacked heroine gets abducted in "The Mummies," his first Pubs story

Opposite top right: A memorable moment from "Satan's Blood Bath"

Opposite bottom: Bringing on the noir, in a sequence from "El Cazador" in Josef Touitan's Spanish edition of **Creepy** #40 (Oct. 1982)

Ediciones Glénat published his autobiography *Memorias Ilustradas*, which tells the story of his life in art, in particular his time with SI. For a further look at this incredibly talented artist who even made the Eerie Pubs look top-shelf for a few issues, take a look at his website www.fernandofernandezcomic.com.

Alberto Macagno

With work starting to appear in late 1971, Alberto Macagno spearheaded the second wave of South American artists who would appear in the pages of Eerie Publications. A master at various styles and techniques, his artwork is sometimes hard to identify, but was always effective and dramatic. Starting out with only sporadic contributions in 1971, Macagno soon became very prolific and by the end, he'd illustrated over 30 terror tales for the Pubs. Most issues from 1973 on had a Macagno story or two.

Born in Buenos Aires in 1942, Macagno's first paying art job was providing illustrations for science publications and medical journals. He also worked in advertising before getting into comics. In 1967, he started doing strips for Columba's comic magazines, doing movie adaptations. He became skilled in many genres, including crime and Western. In mid-1971, a local agent, Raphael Dente, offered him some work for an American comic company and, thankfully, he accepted.

Macagno's first work for Eerie Pubs appeared in *Weird* V5 #4 (Aug. 1971). Entitled "The Mummies," this seven-pager showcased his fine lines as well as his bold brush strokes.

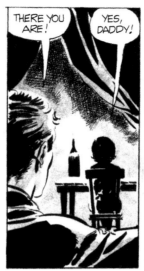

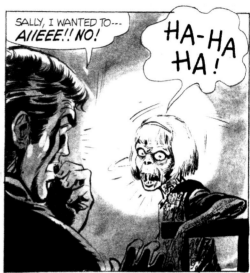

He also gave the male readers a really stacked female lead, something that Eerie Pubs weren't exactly known for. He would follow with only one more story in 1971, "The Corpse," but he would hit his stride soon. Eight stories followed in 1972 and then more than 20 in 1973 and 1974. Alongside Reynoso, Fraga and Muñoz, Macagno had become one of Eerie's most visible artists.

That's not a bad thing, either. Macagno's artwork was always interesting. His people (and more importantly, his ghouls) were always well composed, with good facial expressions and believable, sometimes acrobatic, poses. He would often utilize layouts from the original stories, but his interpretations tended to look better.

He, along with Mandrafina and Marchionne, also brought some much needed sex appeal to these comics. He utilized many different techniques in his art, with thin pen tips, thick black brushes, gray washes, ink splatters and board scratching included in his storytelling arsenal.

Like many of his Pubs contemporaries, Macagno was also drawing stories for Fleetway in the U.K. For Columba, he teamed up with writer Robin Wood for many successful strips in the '70s. In 1981, Macagno contributed to an upstart magazine called *Bang!* for Editores Blotta. His work was taking on an Eisner-esque feel, with deep shadows and scenes of urban angst. It was a style that would serve him well.

The next year brought Macagno's gritty and violent art to Spain, in Toutain's version of the Warren title *Creepy*. The rest of Europe was conquered later in the '80s as he started working extensively for Eura Editoriale in Italy. His work regularly appeared in their weekly comics *Lanciostory* and *Skorpio*, often alongside fellow Eerie Pubs alums Marchionne and Mandrafina. He was a fixture in these magazines right up through the '90s. Of course, he also continued doing artwork in his home country. Alberto Macagno had become an internationally sought-after artist.

In 1994 Macagno teamed up with old friend Domingo Mandrafina and writer Ricardo Ferrari to produce "Il Golem," a very successful three-part series that appeared in Euro's *Euracomix* magazine. The same team produced the fantasy series "Diario di bordo" in *Skorpio* which was also popular. In the past decade, Macagno has stepped in to occasionally take over the art chores for the very successful series "Julia" for Editore

Bonelli. This series about a criminologist (who happens to look like Audrey Hepburn) is still going strong today.

Alberto Macagno is another talented artist who honed his skills on the Eerie Pubs and subsequently went on to international fame.

Rubèn Marchionne

Rubèn Marchionne, along with friend and colleague Alberto Macagno, rang in the second wave of Argentine artists into Eerie Publications and rode that wave until the very end. His work can vary from light to dark, but his best Pubs stories are shadowy, moody and downright evil.

In 1968 Marchionne attended the Instituto de Directores de Arte (I.D.A.) in Buenos Aires, learning the comic art craft from the maestro Alberto Breccia. Among his classmates were Alberto Macagno and Domingo Mandrafina, two artists whose early careers would mirror his own.

In 1970, the young Marchionne had the honor of illustrating "Tres por la ley," a strip written by H.G. Oesterheld. It was not an HGO original creation, but sharing credits on this work for hire must have been pretty exciting for a newcomer. This strip appeared in the long-running *Fantasia*, which was a

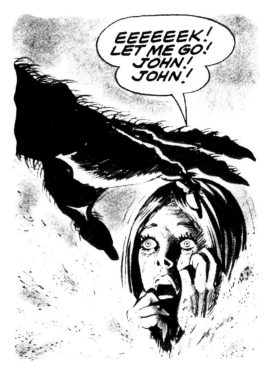

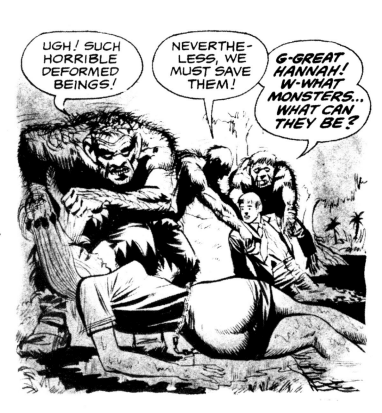

Columba title that, much like the Pubs, served as a springboard for novice creators to get experience in the field. His next step was, of course, into the pages of Eerie Publications.

Marchionne established himself right away as a force to be reckoned with in "Monster Town" in *Tales From the Tomb* V3 #4 (Aug. 1971). He delivered a tale full of loathsome, ugly monsters, dark shadows and a heroine in a dress so tight that it must have shrunk while she was wearing it. Pulchritude aside, this story has many great panels that demonstrate various drawing techniques and a talent for portraying different emotions, even with deformed faces.

Marchionne could go from light sketchy lines ("The Day Man Died") to a heavily inked, dark fright-fest ("Stage of Horror") or utilize both in the same story ("Bagpipes from Hell"). He displayed a real flair for horror, favoring the dark, shadowy inking that made his characters ooze evil. He didn't often copy panels from the originals and his interpretations are always as good as (or

Top: Loathsome creatures and chicks in tight dresses— Marchionne brought this winning combination to Eerie Pubs in "Monster Town"

Bottom: A great horror panel from Marchionne... "Stage of Horror"

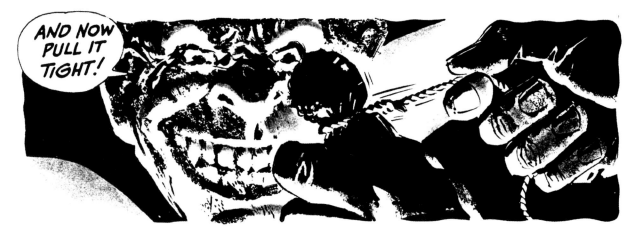

Top: The splash page for "Monster in Cloth"

Bottom: Marchionne and Robin Wood's "Dax" wandered the pages of Columba's **D'artagnan** for years before living on in a reprint afterlife. (Courtesy of Jorge at Filocomic)

better) than the original story's artwork. With his signature housed inside a fancy scroll, his stunning stories were favorites for reprinting; seven of his 25+ stories were reprinted at least five times each over the years.

After the fall of Eerie Pubs, Marchionne continued his winning ways, illustrating film adaptations and strips in his homeland, as well as seeing his work published in the U.K. He enjoyed enduring success in the pages of Columba's *D'artagnan* with the strip "Dax," written by Robin Wood. This had nothing to do with Warren Publishing's character of the same name that appeared in *Eerie*. Wood's Dax was a boy, alone in the world, trying to

Y luego hay una explosión. Los ojos del niño ni pestañean.

make his way through life in China during the Boxer Rebellion. This strip was wildly successful and has been reprinted numerous times since it started in 1976. Eura Editorial in Italy has reprinted the entire saga in 1983 (in *Lanciostory*), 1990 (in *Euracomix*), and again in 1998 and '99 (in *Gigante Dell'Avventura*). Columba reprinted it in 1996 as well.

Among Marchionne's other successes have been *Alias Flic* for Ediciones Record, which started in August 1977 and ran for over two years, and helping Angel Fernandez (a one-off Eerie Pubs contributor) with the art chores on *Martin Hel* (also for Eura) which ran for two full series in the '90s. The latter was kind of a James Bond meets the X-Files and was quite good.

Once again, the good folks at Eerie Pubs provided work for a young and hungry artist who stepped up and delivered the goods before going on to become an internationally renowned comic book artist. Rubèn Marchionne eventually left the comics field to become an evangelistic pastor.

Mandrafina

Mandrafina is better known on these shores than most of the Argentine artists who worked for the Eerie Pubs. Like many of his peers, he used the Pubs as a springboard to

Domingo Mandrafina

catapult himself to more important comic work, and he soon became internationally recognized.

Domingo Roberto Mandrafina was born in Buenos Aires in September of 1947. (Other sources conflict this year, but this is according to the man himself.) His entry into the comic field came in 1969, drawing for the long-running title *Patoruzito*, a children's comic that he'd enjoyed as a kid and which was nearing the end of its run. Two years later, still trying to make a name for himself in comics, he accepted an offer from a contact in the U.S. This was, of course, his entry into the weird world of Eerie Pubs.

Already displaying a very sure hand at his craft, Mandrafina's first story for the Pubs came late in the second phase of the "original" art phase, roughly a half-year after Macagno

Left: Mandrafina made his mark right away with "This Cat is Evil"

Right: The amazing splash page to "Derek: La Madera del orgullo" from *Skorpio* #82 (Record, July 1982)

and Marchionne first graced their putrid pages. His story "This Cat is Evil" (*Tales From the Tomb* V4 #3, July 1972) is rife with confident lines, detailed cross-hatching and strong, believable figures. Having the knack for drawing a scantily clad female didn't hurt his debut, either. Over the next two years, Mandrafina produced 18 more features for the horror mags and they all flaunt his solid, effortless style.

Mandrafina was good about not stealing layouts and poses from the originals, though if he had to rely on them for storytelling purposes, he would mix up the angles or introduce a new way to say the same thing. His creativity lifted much of his fare above the work of his peers, making his stories really stand out. His versions of the Ajax re-draws breathed new life into the age-old, often-seen stories. His detail was always excellent because he took his time to get things right. He describes himself a slow, deliberate artist. He did his Pubs gig through mid-1974, and then moved on to begin his world conquest.

In his home country, he'd begun illustrating strips for Editorial Columba, doing movie adaptations and series work. He continued working with them right up through most of

TRILLO MANDRAFINA

THE IGUANA

Venture

its sequel *The Iguana* as handsome graphic novels in English. The duo's strip "The Spaghetti Brothers" is another series that has become world-renowned. Dozens of his wonderful stories have graced magazines all over the world. Mandrafina, who sometimes goes by the nickname Cacho, is still going strong in his chosen field and is probably the most "in print" artist from Eerie Pubs.

Mandrafina—back in the USA. **The Iguana**—Strip Art and Dark Horse teamed to bring this Trillo/ Mandrafina collaboration to an English-speaking audience in 2001

the '80s. He worked for other publishers as well, and hooked up with many important writers in his post-Pubs years, including Robin Wood and especially Carlos Trillo. Some of his most popular strips were picked up for publication in Europe, making him an international star. Europe in the '80s was busy for Mandrafina; he and Trillo appeared in Toutain's *Creepy*, and also in EPC's *L'Eternauta*. In the '90s, he was all over *Euracomix* (including producing "Il Golem" with Alberto Macagno and Trillo) and *Lanciostory*.

A group of Trillo/Mandrafina stories from *L'Eternauta* were picked up in the early 2000s for reprinting in *Heavy Metal*, the long-running U.S. adult sci-fi magazine. In 2001, Dark Horse Comics released the Trillo/ Mandrafina masterpiece *The Big Hoax* and

Enrique Cristóbal

Enrique Cristóbal is another mysterious artist from Argentina. He's a man who contributed prodigiously to the Eerie Pubs mags for a short amount of time, but little biographical information can be found about him, either online or from colleagues. What we do know, however, is pretty impressive.

Cristóbal was twice the artist of choice for H.G Oesterheld's comic fiction. In 1955, immediately after Oesterheld left his gig at Editorial Abril, he and Cristóbal collaborated on the desert adventure strip "Dragón Blanco" in a magazine of the same name for Editorial API. This short-lived series (four issues) was one of Oesterheld's many forays into action comics that year.

Remembered now (in his homeland) as one of Cristóbal's triumphs, "Capitán Lázaro," his second teaming with Oesterheld, appeared in

This page top:
The Steve Patterson strip, in all of its square-jawed glory, appeared in the magazine *Totem*, published by Editorial Cromodinámica in 1959 (Scan courtesy of Luis Rojales)

This page bottom: Cristóbal's famous war serial "Veteran's Club" appeared in *Hora Cera*, published by HG Oesterheld's Editorial Frontera

Opposite top: Some of Cristóbal's Pubs pages were a collage of panel-bursting action. From "Skeleton"

Opposite bottom: "The Vampire's Plague"

build the legend of HGO, and Cristóbal was establishing himself as the master of drawing manly, square-jawed heroes.

Meanwhile, in 1957, Enrique Cristóbal had become a member of SyndiPress, an Iger-like comic agency who produced art for both local and international distribution. With the shop housed in a picturesque, antique mansion (which must have inspired the hell out of them!), the writers and artists created strips and characters for a comic-hungry world. Eugenio Zoppi, a small player in the Eerie Pubs canon, was also a member of SyndiPress. The agency provided artwork for the usual suspects in Argentina (Columba and others) and Europe (Fleetway).

It was here that Cristóbal developed his other best-known comic strip, Veteran's Club. Written by Marco Bruni, another SyndiPress-mansion resident, this war strip appeared in Argentina in *Patrullo*, the studio's own publication. It was also successfully exported to Europe. When searching for art from this series, I bought an acetate of the original art from Spain! Cristóbal also created "Terry Winters" for the same magazine.

In the early '60s, Cristóbal had a minor hit with "La vida en 5 naipes" in the Western mag *Bala de Plata* for

1958, in *Hora Cero*, published by Oesterheld's own Editorial Frontera. This spy strip, set in WWII, was a small success and helped to

Ediciones Vima, and was still producing work for Oesterheld's financially failing *Hora Cero*. After the bottom dropped out of Editorial Frontera, he graced the pages of Columbra's *D'artagnan* and *Fantasia* on a regular basis, right up through the early '70s.

Cristóbal arrived on the scene at Eerie Pubs fairly late in the game, with his first story, "A Thing of Evil," appearing in *Witches' Tales* V5 #2 (Mar. 1973). His easy, fluid style, slightly reminiscent of Oswal's, was effective and professional, but within a few months, he started to let out all the stops and began splitting his pages up with crazy, chutes-and-ladders-like panel borders. With ornate detail spilling out of the panels' edges, he often decked his characters out in funky clothes and groovy '70s hairdos. Needless to say, he was NOT a slave to the original art; he sometimes stretched out his borders and pages so much that the page count exceeded the original. That's a pretty smart way to get a few extra bucks, if you ask me.

Obviously an artist possessing great speed, Cristóbal drew 30 stories for the Pubs in just over a year and a half. He stayed right up to the end of the original run of Eerie Pubs… and beyond. His story "The

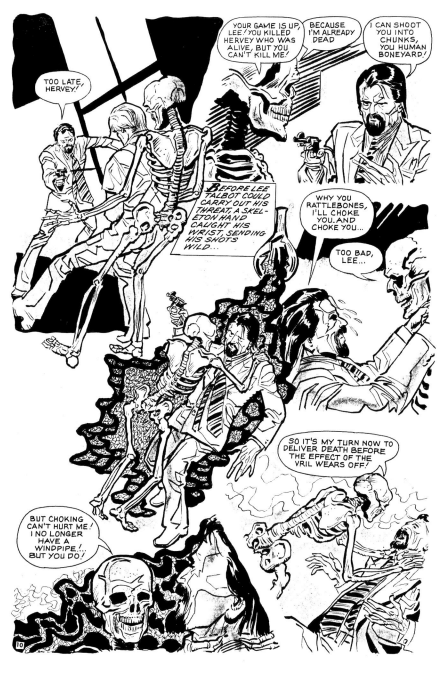

Vampire's Plague" didn't see print until the first issue back, after the decline, in *Terror Tales* V7 #1 (Apr. 1976). It's a good thing that Fass hung on to it—it's one of Cristóbal's finest stories, replete with a decrepit castle, a wiry, bat-like vampire and a hero with a kickin' white-boy 'fro.

The late '70s brought Cristóbal's art to Europe in the pages of *Lanciostory* and *Skorpio* and he kept the home fires burning in Ediciones Record's *Tit-Bits* with "In Trapolla." What became of Enrique Cristóbal after the dawn of the '80s remains a mystery to me. Hopefully, he produced much more art and it's out there waiting to be discovered by his fans, eager to see more of his unique style.

Néstor Olivera

Néstor Olivera was another fine Argentine artist who came very late to the Eerie Pubs but made a real impact with his sometimes sketchy, sometimes cartoony, but always sure-handed artwork. His first Pubs story, "Skin Rippers," was published in the December 1973 issue of *Weird* (V7 #7) and he followed with six more memorable entries.

Entering the comics field at 22, Olivera was already an established artist when he hooked up with H.G. Oesterheld, to illustrate the maestro's scripts for *Hora Cero*. Showing

an aptitude for drawing excellent war stories, Olivera next moved on to Columba where he worked in every style of comics. One of the best war artists going, he always returned to the genre; it was his favorite and it showed in his art. By the early '60s, his work was found in most of the popular comic magazines in Argentina.

Later in the decade, like many of his peers, his art started showing up in the USA in Charlton comics; not surprisingly, *Fightin' Army* #81 (Sept. 1968) featured one of his first U.S. stories. He also appeared in a handful of the company's romance comics. Like so many other Argentine artists, his talents were also seen in the U.K., in Fleetway's comics.

Eerie Publications were heading into their decline when Olivera came on board in late 1973. His style was very well suited to the black-and-white comics. His sketchy and loose lines were supplemented with vigorous cross-hatching, heavy blacks and the occasional zip-a-tone. Two of his Pubs stories had a (more or less) army theme ("The Thing Out There" and "Deadman's Dream"), so he found himself in familiar and comfortable territory. His decrepit castles, stately interiors and superb masonry displayed an excellent vocabulary in Gothic horror as well. His work sometimes resembled Alberto Macagno, an artist with whom Olivera had worked.

Joining the Eerie club as late as he did, Olivera got mostly Ajax stories to reinterpret. Though the originals weren't known for their gore, Olivera often turned it up a notch, lovingly portraying skewerings, decapitations and eye trauma… the stuff of Eerie legend.

Though he only illustrated seven stories, they were heavily reprinted during the resurgent years of 1976–1981, making him very visible to Pubs collectors.

Like many of his co-conspirators from the Pubs, Néstor Olivera also had strips published in Eura Editoriale's *Lanciostory* and *Skorpio*, and kept the home fires burning in various Argentine comic magazines. He is still going strong and is one of the most respected war artists in his country—an Argentine Joe Kubert, if you will.

Left:
Olivera shows off some nice gothic chops in "Horror without a Head"

Right:
Some nasty eye trauma from "Skin Rippers"

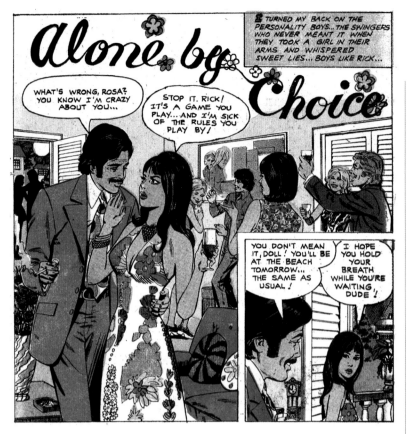

Top: Romero romance from **For Lovers Only** #78 (Charlton, Apr. 1975)

Bottom: A fine feline splash panel

Romero

The name Romero started showing up very early in 1974, signed with a neat, cursive script on pages of artwork that was just as tidy as the signature. Ten stories appeared in the Eerie Pubs by this mysterious, single-named artist, all in the declining company's final year.

Romero was a pseudonym adopted by Hernan Torre Repiso and his teacher (and dear friend) Oscar Novelle. Torre Repiso would pencil the story because Novelle considered himself too slow at that particular job. Conversely, Novelle, a skillful and quick inker, would finish the art; Torre Repiso thought of himself as a

slow inker. The combined efforts sped up the process and produced very good results.

The close relationship and mutual admiration (Torre Repiso says that he loved Oscar Novelle like a father) between the two artists shows in the tight panels and expressive artwork. The Romero art displays nice movement, with believable action shots. The similarity of the two artists' styles mesh together into a very satisfying new look, though it's not hard to tell from whose drawing board the work came. It's not at all surprising to find out that Romero was really Torre Repiso and Novelle.

Besides the Eerie Pubs, the Romero name turned up in Charlton's romance comics. The duo also produced artwork under the less cryptic moniker of Novelle-Torre Repiso. Their collaborations appeared mostly in Argentina and Europe. Late in Novelle's life, Torre Repiso would procure work for the two of them, keeping his friend happy with comic

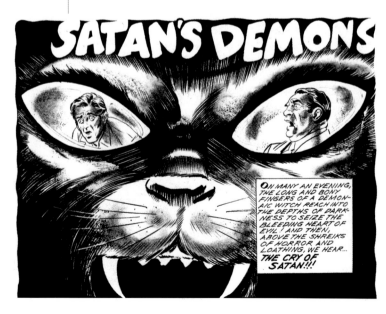

work, despite the older artist's failing health. They worked in this fashion right up until Novelle's death in 1978.

Martha Barnes

Martha Barnes is the First Lady of Argentine Comics and, while she may not have had too much competition in the field, she's managed to keep that title for nearly 50 years.

Starting out while still a teenager, Barnes had strips in many of the famous comic magazines published by Columba and Acme.

Martha (née Marta) was very prolific and kept her output and quality high, prospering in a male-dominated field. Action, Western and war comics were all illustrated by this young woman. Her paintings were also well-received and would adorn many comic and pulp covers in the '60s, including some for *Gran Bucanero* (Tarzan) for Editorial Bois.

Left: Painted cover for the pulp novel "Two Guns for Hire"— *Rastros* #345 (Acme, 1960) Courtesy of the artist

Right: The beautiful and talented Martha Barnes as a young artist in the '50s (photo courtesy of Armando Fernandez)

VALLEY OF HELL

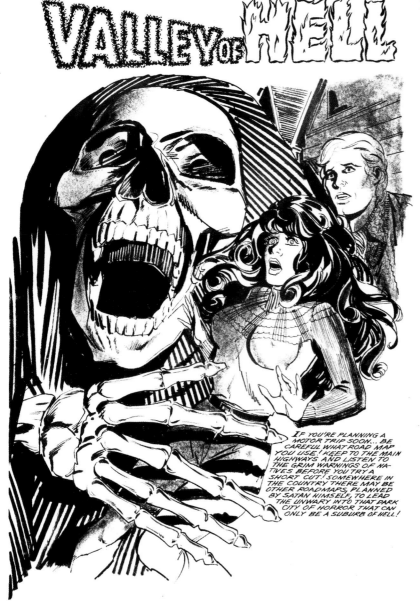

IF YOU'RE PLANNING A MOTOR TRIP SOON... BE CAREFUL WHAT ROAD MAP YOU USE! KEEP TO THE MAIN HIGHWAYS AND LISTEN TO THE GRIM WARNINGS OF NATIVES BEFORE YOU TRY A SHORT CUT! SOMEWHERE IN THE COUNTRY THERE MAY BE OTHER ROADMAPS, PLANNED BY SATAN HIMSELF, TO LEAD THE UNWARY INTO THAT DARK CITY OF HORROR THAT CAN ONLY BE A SUBURB OF HELL!

She arrived so late to the Pubs party that three of her stories appeared after the fall and eventual rise of the mags in the spring of 1976. Her first effort, "Skin Rippers," appeared in *Tales From the Tomb* V6 #4 (July 1974), reinterpreting the Ajax favorite "Black Death." All of her stories were drawn within the next six months.

Barnes is a big fan of horror in both comics and film, which helped fuel her Eerie Pubs work. Her horror style is scratchy and sketchy, which suits the genre very well. Her fast lines are purposeful and thick, with subtle details added in with smaller brushes. Not surprisingly, she's adept at drawing the female form and endowed her characters with generous curves (and hairdos), with sweeping, luxurious strokes. Her characters, both male and female, have thick, full hair that a baldie like me

Barnes mixed beauty, horror, hair and inventive brush strokes for her Pubs stories…

Top: "Valley of Hell"

Bottom: "Dead Thing Among Us"

She stayed very active through the '70s, spearheading the romance comic movement in Argentina. She was still ubiquitous in Columba's books, particularly in *Intervalo*, and supplemented her workload with artwork for children's books, religious publications and even television programs. Her résumé didn't stop there; she also did some acting in theater, radio and television.

So where did she find time to draw for Eerie Pubs?

In a very small space of time, Martha Barnes belted out nine redraws for Burgos.

can only dream of. Coming to the Pubs so late, she was often saddled with weaker stories from Prize's *Black Magic*, but her dynamic style always made them worthwhile. Curiously, she signed "The Fanged Freak" (a redraw of the Simon and Kirby classic "The Greatest Horror of them All" that had recently been reprinted by DC) as Schmode, her husband's surname.

In addition to the Pubs, Barnes made the usual inroads into Europe through the Euro Editoriale books *Lanciostory* and *Skorpio* in the '70s and the Fleetway comics in the U.K. In the '80s, she found a slot in three issues of DC's perennial war title *G.I. Combat*, proving that she had not lost her talent for illustrating testosterone-laden war comics.

Still very active with her art, Martha Barnes continues to draw every day. "Ink runs through my veins," she says, and her thousands upon thousands of pages of comic art, paintings, and other illustrations are a testament to that fact.

Fernand

Fernand's horror stories came very late in the Eerie game and thus were very few, but he deserves mention here for his seven memorable tales of twisted torment. His style was a bit more "cartoony" than many of his

peers, but his work was always dramatic, lovingly inked, and often very exciting.

Born in Entre Rios in 1917, Fernando Fernàndez Eyre was a young man when he relocated to Spain, only to wind up in the middle of the Spanish Civil War. Being on the side of the Republicans (which he was) was reason enough to be hunted by the usurping rebels, and Fernando was shot and left for dead. He survived this but, like thousands of other people who were against the new fascist regime and its leader, General Francisco Franco, he was sent to a concentration camp in Algeria. He lived, which made him luckier than most, but his only way out was to join the Foreign Legion, so he did, only

Fernand shows off his war chops in "Por tierra de hidalgos"— *Intervalo Album* (Columba) Feb. 1961

THE BLOODLUST WAS ON NADYA! URGED EVER ON BY THE UNSPEAKABLE THINGS OF EVIL, SHE PROWLED THE STREETS OF PARIS FOR A VICTIM TO SATE THEIR DESIRE...

ENJOY THE FUN, MY PETS! HE ALMOST DIES OF FRIGHT!

AARGH!

MERCY! THAT HIDEOUS CREATURE!

A VAMPIRE!

BY THE WAY, LEFEVRE I HAVEN'T HAD THE PLEASURE OF MEETING YOUR WIFE!

BUT OF COURSE! COME COME HOME WITH ME TONIGHT FOR DINNER!

THAT NIGHT...

IT WAS NICE OF YOU TO COME FOR

MY PLEASURE, MADAME, I WAS MOST ANXIOUS TO MEET YOU!

A HUE AND CRY WAS RAISED THROUGHOUT PARIS WHEN, IN THE DAWN THE BLOODLESS

An exciting sequence from from "Vampire's Bride"

to desert in 1940 and restart his life back in Argentina.

One can only wonder what such a tumultuous introduction to adulthood could do to a person, but Fernand put his energies into illustration and, not surprisingly, he excelled at adventure comics. He was ever-present in Columba's magazines like *El Tony* (where he did a well-received strip on Henry XIII) and *Intervalo*, where he produced some grueling war stories. He also developed successful cartoon characters and displayed a flair for illustrating humor strips. Some of his work was published under the pseudonym "B. Bayley"; perhaps he was a fan of U.S. golden-age artist Bernard Bailey? Or Beetle?

His entrance to the Eerie Pubs was at the

very end, first checking in with "Horror in Slime" in the May 1974 issue of *Tales of Voodoo* (V7 #3). His next five stories all squeezed in just before the demise of the original run and his last (and best), "Vampire's Bride," only saw print during the resurrection of the horror comics in 1976.

Fernand's style was a bit stiff and cartoony, but he was a masterful inker and his panels are finely detailed. What his characters lacked in fluidity and movement was made up for with dramatic shadowing and lighting. He was one of the few Eerie Pubs artists that I think might have benefited from coloring. His stuff would have looked great in a DC "mystery" comic.

Fernand passed away in August of 1987.

And the Rest

Among the excellent artists who contributed to the Eerie Pubs are some who were not quite as prolific as the mainstays like Oscar Fraga and Antonio Reynoso. Still, these draftsmen lent a slightly different flavor to the mags in which they appeared, few though they were.

Eugenio Juan Zoppi (1923–2004) was an extremely capable storyteller who checked in with five stories for the Pubs, sporadically contributing over the course of two years. An

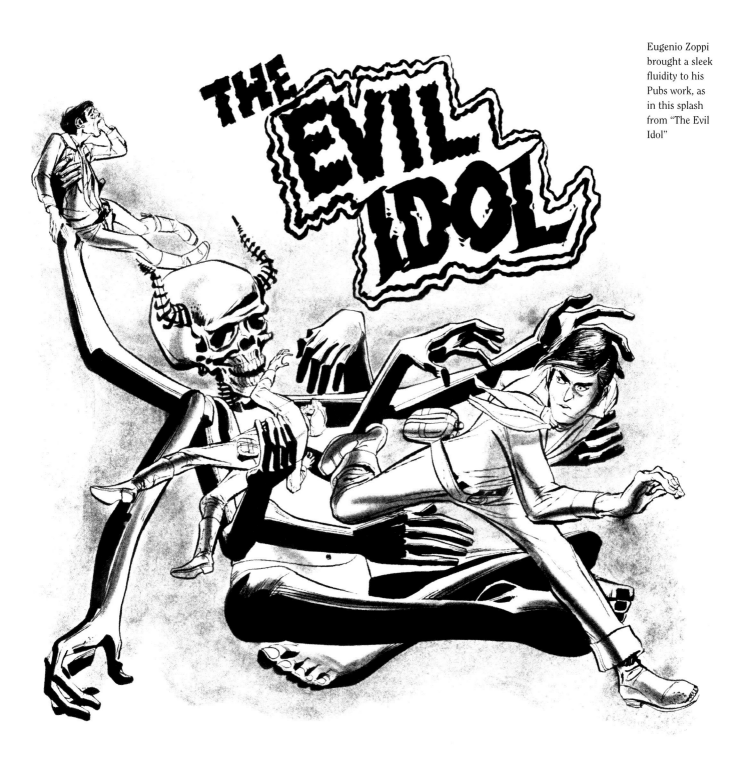

Eugenio Zoppi brought a sleek fluidity to his Pubs work, as in this splash from "The Evil Idol"

Argentine artist (who also wrote, sometimes under the pseudonym of Ray Collins), he was ever-present in his country's comics from the late '40s on. He holds the honor of being the first artist to illustrate a comic written by H.G. Oesterheld ("Alan y Crazy" in Editorial Abril's ***Cinemisterio*** in 1951). Ubiquitous internationally in familiar places like Fleetway and Eura Editoriale, Zoppi became the president of the ADA (Asociación de Dibujantes de la Argentina) in the '80s. His extremely fluid lines, reminiscent of Bernard

From Kato's "Death's Path"

Krigstein, bring a beauty and grace to his Pubs stories that was often missing from his contemporaries' artwork, making one wish that he had done many more.

Sounding more like an artist from Asia, Kato (real name: Oscar Campdepadròs) is another talent who came to the Pubs in the Argentine Invasion, supplying four stories at the bitter end. In Argentina, his work started appearing in *Top* (Cielosur Editora) in 1971 and it was there that he got to illustrate Oesterheld's "Russ Congó" later in the decade. His art was familiar to Columba's readers during the '80s and '90s through his prolific contributions to their comics *D'artagnan*

and *Nippur Magnum*. His Pubs stories show a varying style, somewhat scratchy and static, but definitely drawn with aplomb. His scared faces are quite good (and that's important in the horror genre). Two of his stories first appeared after the Eerie resurgence in 1976.

Looking very out of place in the pages of the Pubs are the three stories by Toño Gallo (José Antoño Gallo). Gallo, one of Argentina's leading caricaturists and cartoonists, had his work published in comedy magazines like Loco Lindo and had a long-running feature in the newspaper *El Razón*. His brother Robert was also a cartoonist. Respected by his peers and loved by his fans, Gallo's heavy inking and meticulous line shading does nothing to disguise the cartooniness of his Pubs stories, of which he drew one a year from 1970–1972.

Leandro Sesarego was another gifted Argentine artist whose career echoes many of his contemporaries. He was ubiquitous in various Argentine comics and newspapers in the '60s and hit U.S. soil with Charlton's war and romance titles in 1969–1970. Latecomers to the Pubs, Sesarego's three stories are beautifully illustrated, with thin wispy lines, an eye for movement, attractive people and decent snakes. He went on to do a few stories for DC's mystery titles before moving over to Eura Editorial in Europe, where his work appeared throughout the '90s.

Carlos Clemen drew only two stories for Eerie Pubs, but he was incredibly prolific for a

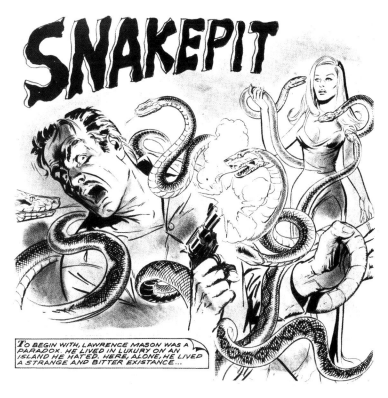

TO BEGIN WITH, LAWRENCE MASON WAS A PARADOX. HE LIVED IN LUXURY ON AN ISLAND HE HATED. HERE, ALONE, HE LIVED A STRANGE AND BITTER EXISTANCE...

cartoons, dramatic tales, and even successfully mimic other artists, all with great success. His only Eerie Pubs story, "Satan's Demon," saw print four times and is an excellent example of what he can do. Employing a realistic style with excellent inking and lighting effects, this story is a real standout in Pubs history.

Both Angel Fernández (a.k.a. Lito) and Eduardo Miranda (1932–1990) were born in Buenos Aires, studied under Alberto Breccia, and had just one story (that was printed only once) in the Pubs. Fernández's art was perhaps a bit

For goodness' snakes! Such different artwork!

Top: Leandro Sesarego brings you "Snakepit"

Bottom: Toño Gallo delivers "Deadly Fangs"

very long time in his homeland of Argentina. From the '30s through the '80s, Clemen was all over the pages of Columba's magazines, as well as those of many other publishers. In 1954, he illustrated one of that country's first sci-fi comics and he hooked up with H.G. Oesterheld for "Russ Congó" in 1971, preceding Kato's work on the strip. His work is capable, if nondescript, but it manages to look a bit like Cirilo Muñoz's art for his corpse-buddy tale "The Strange Friend."

Felix Saborido has been a major player in Argentine comics for years. An artistic chameleon, he can do anything:

HUGO THOUGHT OF A DOZEN POSSIBLE MOVES... AND A DOZEN TIMES HE REJECTED THEM...

MAYBE IF I SHOUT FOR HELP? NO! THEY MIGHT HAVE PUT IT IN HERE TO KILL ME! ANYWAY... ONE ABRUPT SOUND... AND IT'LL SPRING!

Carlos Clemen's buddy tale "The Strange Friend"

prolific and highly collectible Golden Age artist, painted a few covers in the early days. He was also working on Fass' girly mags at the same time, doing cartoons and nice painted comic strips in the style of Playboy's "Little Annie Fanny." Like Burgos, Powell was unsatisfied with the comic book industry and found freedom with Myron Fass, and also as art director for *Sick*, Joe "Captain America" Simon's *MAD* knock-off. It should be noted that dozens of Bob Powell's stories done for Harvey's pre-code horror comics were redrawn by various Pubs artists in the '70s. He passed away in 1967, taken by cancer at only 51 years of age.

Two covers by Enrique Torres greeted U.S. magazine racks in 1971, reprinted from Spanish pulps, years before he became one of Warren's top illustrators. Besides a handful of covers by Skywald regulars Xavier Vilanova and Salvador Fabá, mystery names like Behan and Luke pop up on minor covers late in the run. Other unidentified artists make sporadic cover contributions to the Eerie Pubs, making me wish that Fass and Burgos gave some goddamn credits every once in a while. ☀

too scratchy to fit Burgos' needs but he's been immensely successful at home and in Europe, working with (and becoming one of) the top names in international comics. His story "The Bloody Corpse" appeared in the April 1972 issue of *Horror Tales*. Miranda, who was comfortable in many styles, had a lucrative gig with a daily strip in *La Nacion*, a huge Argentine newspaper. His one story, "This House is Haunted," came at the end (*Terror Tales,* Dec. 1974) and makes me wonder if he was keen to do more, but the work dried up.

There are still a few stories that I have not been able to identify by artist.

Likewise, there are many covers painted by artists who are not as well represented in the Pubs as Alexander, Burgos, Bruck and Fernández. Bob Powell, a well-respected,

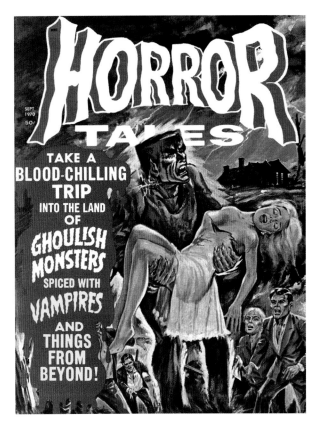

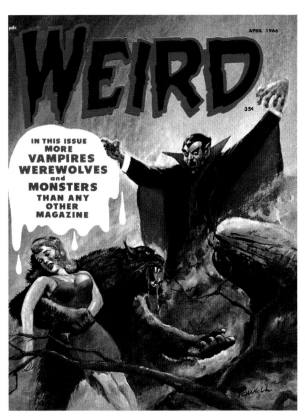

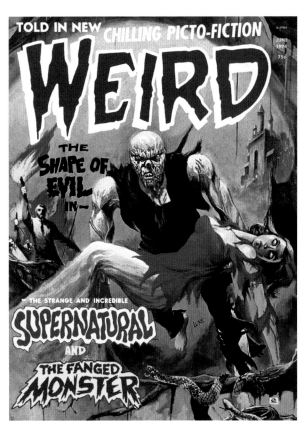

Top left:
Horror Tales
V2 #5 (Sept.
1970) art by
Cirilo Muñoz

Top right: The
second issue of
Weird V1 #11
(Apr. 1966) art
by Bob Powell

Bottom left:
Terror Tales
V5 #6 (Dec.
1973) art
by Behan

Bottom right:
Weird V8 #3
(June 1974)
art signed
by "Luke"

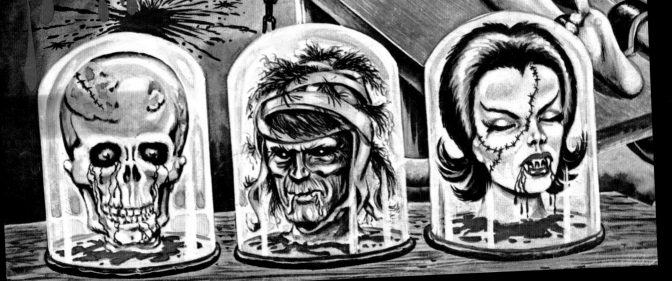

TERROR TALES

PDC

TALES
March 1969
35¢

FEATURING

SKULLS OF DOOM!

•

SCALES OF DEATH

•

PLUS OTHER
TERROR TALES
FROM BEYOND

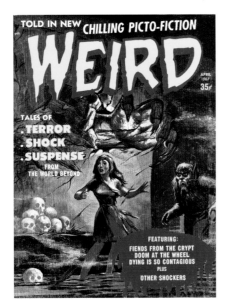

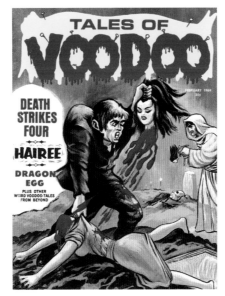

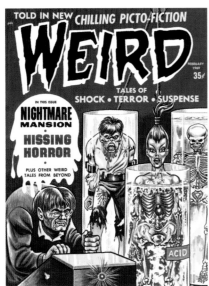

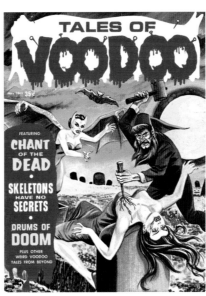

Opposite:
Terror Tales
V1 #7
(Mar. 1969)
art by Chic
Stone

This page:
Top left:
Weird V2 #2
(Apr. 1967)
art by Carl
Burgos

Top right:
**Tales of
Voodoo** V2 #1
(Feb. 1969)
art by Burgos

Bottom left:
Weird V3 #1
(Feb. 1969) art
by Stone

Bottom right:
**Tales of
Voodoo** V2 #2
(May 1969)
art by Stone

Chapter 16
COVER GALLERY

What's the first thing that you think about when someone says Eerie Publications? It's got to be those sickening covers! Here is a chronological look at the magazines that delighted and disgusted us, and made the newsstand a dangerous place for nearly two decades.

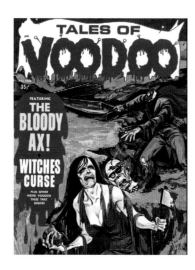
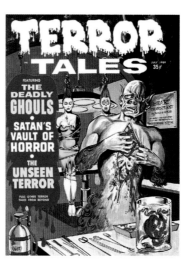
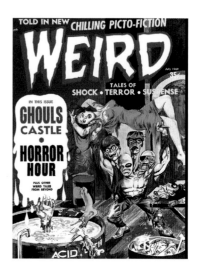
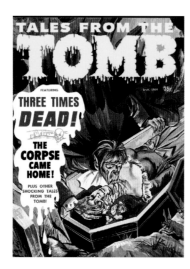
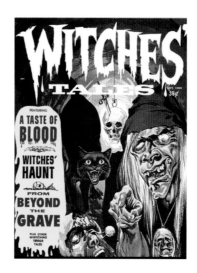
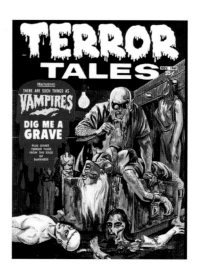
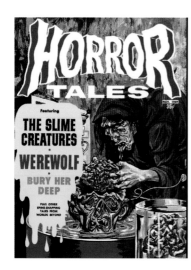
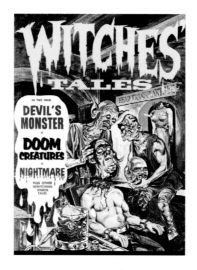
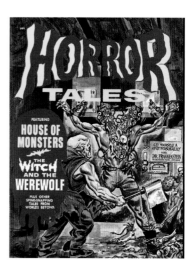

Top: *Tales of Voodoo* V2 #3 (July 1969), *Terror Tales* V1 #9 (July 1969), *Weird* V3 #3 (July 1969)
Middle: *Tales from the Tomb* V1 #7 (Sept. 1969), *Witches' Tales* V1 #8 (Sept. 1969), *Terror Tales* V1 #10 (Nov. 1969)
Bottom: *Horror Tales* V1 #9 (Nov. 1969), *Witches' Tales* V1 #9 (Dec. 1969), *Horror Tales* V2 #1 (Jan. 1970)
All art by Bill Alexander

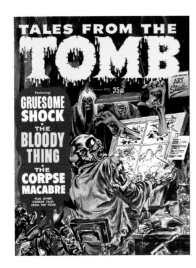 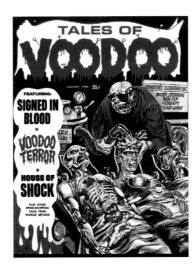 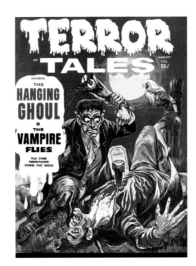

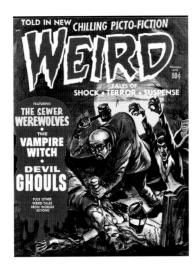 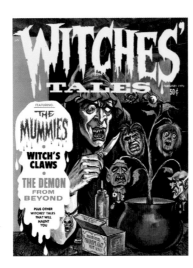 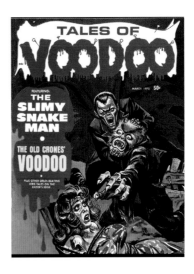

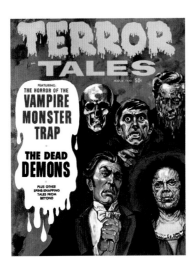 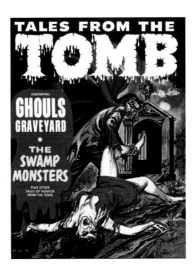 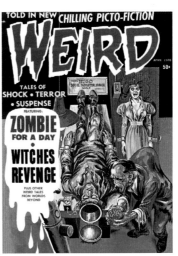

Top: ***Tales from the Tomb*** V2 #1 (Jan. 1970), ***Tales of Voodoo*** V3 #1 (Jan. 1970), ***Terror Tales*** V2 #1 (Jan. 1970)
Middle: ***Weird*** V4 #1 (Feb. 1970), ***Witches' Tales*** V2 #1 (Feb. 1970), ***Tales of Voodoo*** V3 #2 (Mar. 1970)
Bottom: ***Terror Tales*** V2 #2 (Mar. 1970), ***Tales from the Tomb*** V2 #2 (Apr. 1970), ***Weird*** V4 #2 (Apr. 1970)
All art by Alexander

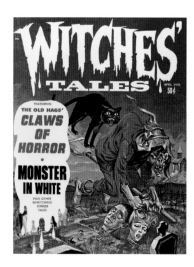
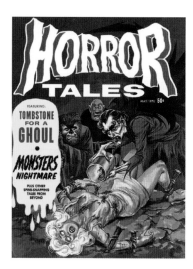
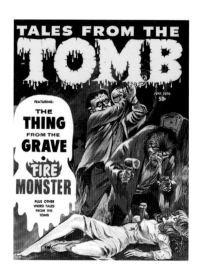
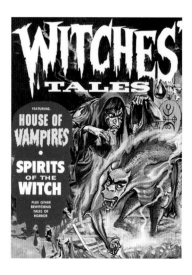
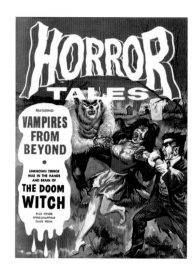
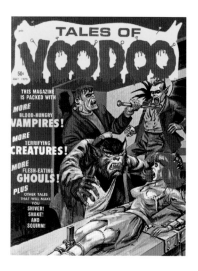
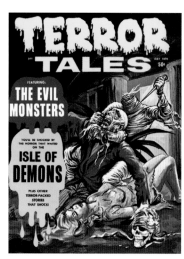
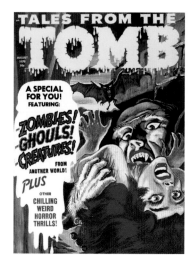
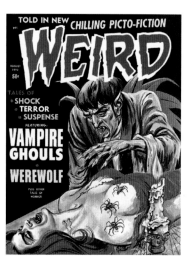

Top: *Witches' Tales* V2 #2 (Apr. 1970), *Horror Tales* V2 #3 (May 1970), *Tales from the Tomb* V2 #3 (June 1970)
Middle: *Witches' Tales* V2 #3 (June 1970), *Horror Tales* V2 #4 (July 1970), *Tales of Voodoo* V3 #4 (July 1970)
Bottom: *Terror Tales* V2 #4 (July 1970), *Tales from the Tomb* V2 #4 (Aug. 1970), *Weird* V4 #4 (Aug. 1970)
All art by Alexander

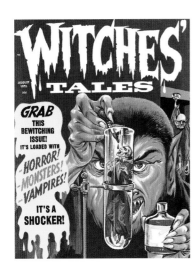 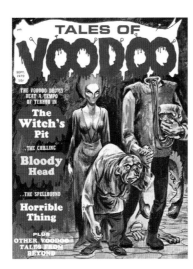 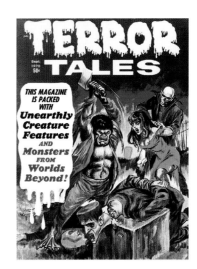

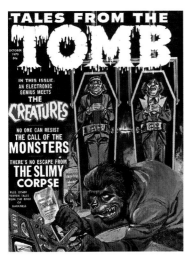 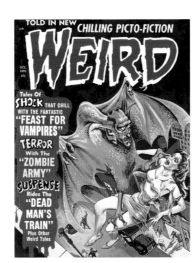 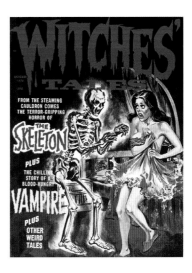

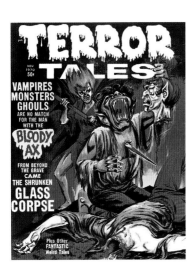 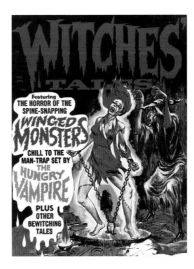 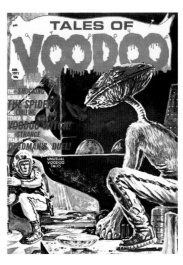

Top: ***Witches' Tales*** V2 #4 (Aug. 1970), ***Tales of Voodoo*** V3 #5 (Sept. 1970), ***Terror Tales*** V2 #5 (Sept. 1970) All art by Alexander
Middle: ***Tales from the Tomb*** V2 #5 (Oct. 1970), ***Weird*** V4 #5 (Oct. 1970), ***Witches' Tales*** V2 #5 (Oct. 1970) All art by Alexander
Bottom: ***Terror Tales*** V2 #6 (Nov. 1970) art by Alexander, ***Witches' Tales*** V2 #6 (Dec. 1970) art by Alexander, ***Tales of Voodoo V4 #1*** (Jan. 1971)
art by Johnny Bruck

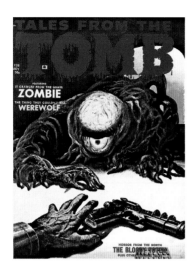
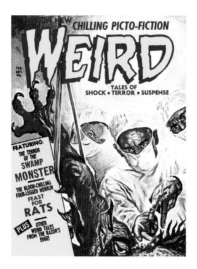
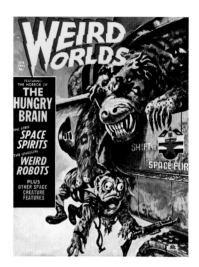
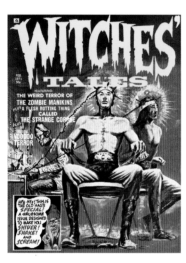
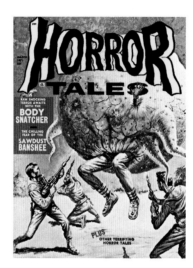
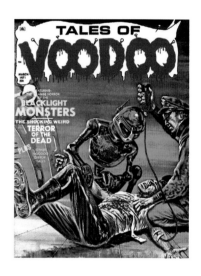
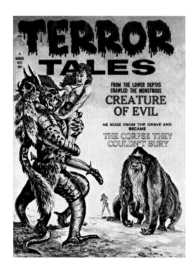
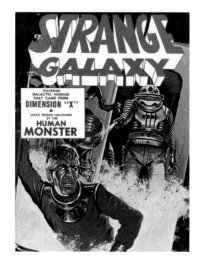
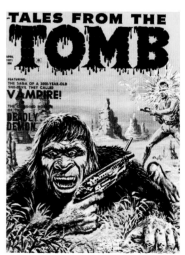

Top: ***Tales from the Tomb*** V3 #1 (Feb. 1971), ***Weird*** V5 #1 (Feb. 1971), ***Weird Worlds*** V2 #1 (Feb. 1971)
Middle: ***Witches' Tales*** V3 #1 (Feb. 1971), ***Horror Tales*** V3 #2 (Mar. 1971), ***Tales of Voodoo*** V4 #2 (Mar. 1971)
Bottom: ***Terror Tales*** V3 #2 (Mar. 1971), ***Strange Galaxy*** V1 #9 (Apr. 1971), ***Tales from the Tomb*** V3 #2 (Apr. 1971)
All art by Bruck

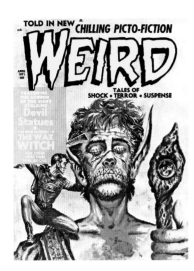 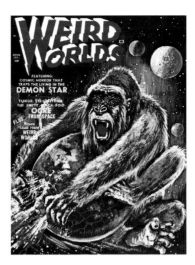 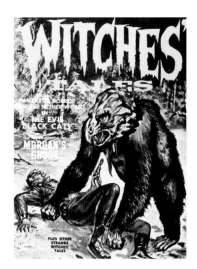

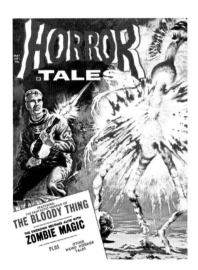 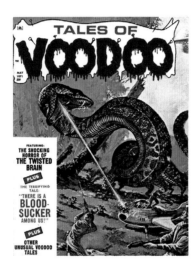 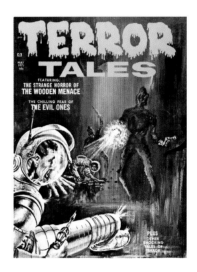

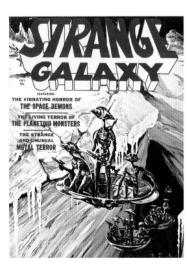 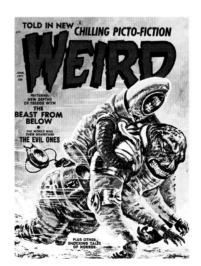 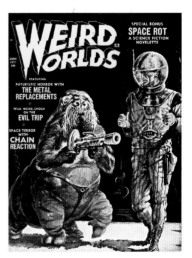

Top: **Weird** V5 #2 (Apr. 1971), **Weird Worlds** V2 #2 (Apr. 1971), **Witches' Tales** V3 #2 (Apr. 1971)
Middle: **Horror Tales** V3 #3 (May 1971), **Tales of Voodoo** V4 #3 (May 1971), **Terror Tales** V3 #3 (May 1971)
Bottom: **Strange Galaxy** V1 #10 (June 1971), **Weird** V5 #3 (June 1971), **Weird Worlds** V2 #3 (June 1971)
All art by Bruck

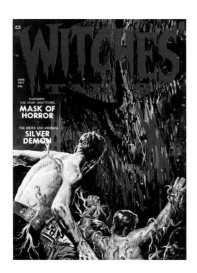
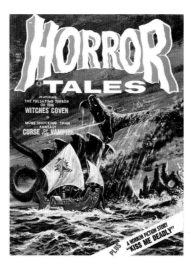
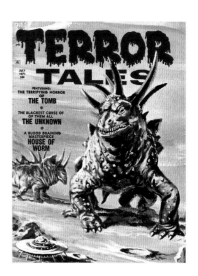
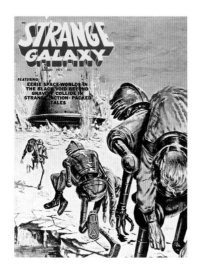
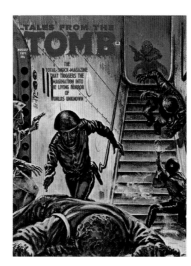
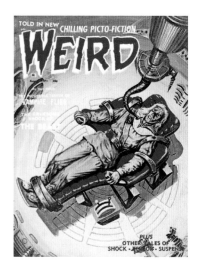
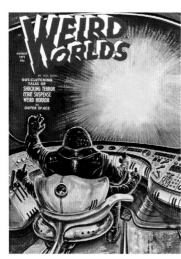
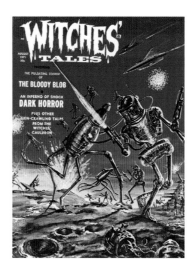

Top: *Witches' Tales* V3 #3 (June 1971), *Horror Tales* V3 #4 (July 1971), *Terror Tales* V3 #4 (July 1971)
Middle: *Strange Galaxy* V1 #11 (Aug. 1971), *Tales from the Tomb* V3 #4 (Aug. 1971), *Weird* V5 #4 (Aug. 1971)
Bottom: *Weird Worlds* V2 #4 (Aug. 1971), *Witches' Tales* V3 #4 (Aug. 1971), *Terror Tales* V3 #5 (Sept. 1971)
All art by Bruck

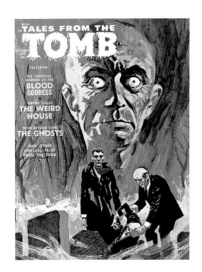 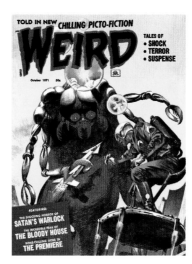 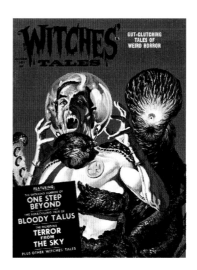

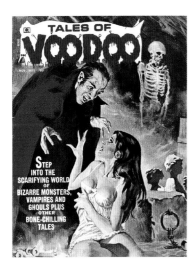 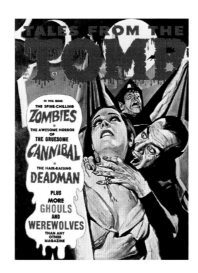 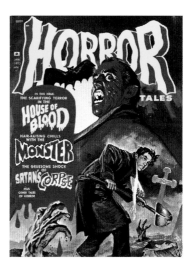

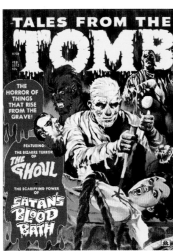 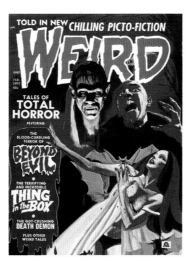 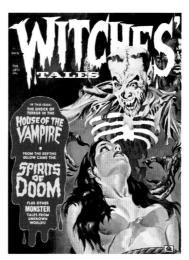

Top: ***Tales from the Tomb*** V3 #5 (Oct. 1971) art by Fernando Fernández, ***Weird*** V5 #5 (Oct. 1971), ***Witches' Tales*** V3 #5 (Oct. 1971) art by Fernández
Middle: ***Tales of Voodoo*** V4 #6 (Nov. 1971), ***Tales from the Tomb*** V3 #6 (Dec. 1971), ***Horror Tales*** V4 #1 (Jan. 1972) All art by Fernández
Bottom: ***Tales from the Tomb*** V4 #1 (Feb. 1972), ***Weird*** V6 #1 (Feb. 1972), ***Witches' Tales*** V4 #1 (Feb. 1972) art by Fernández

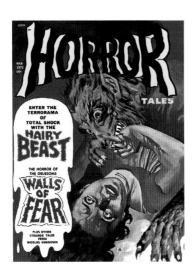 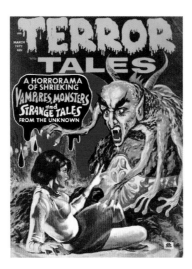 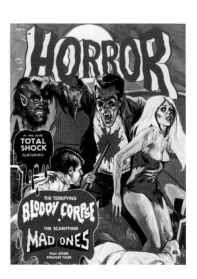

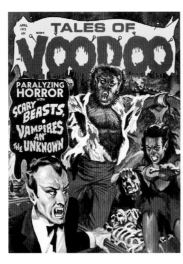 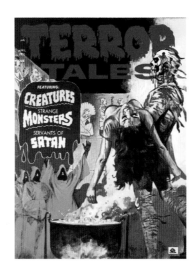 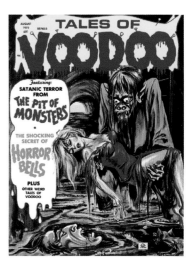

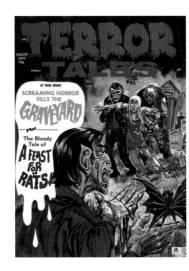 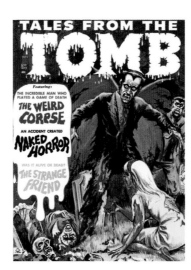 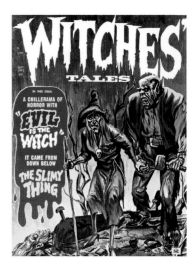

Top: ***Horror Tales*** V4 #2 (Mar. 1972) art by Fernández, ***Terror Tales*** V4 #2 (Mar. 1972) art by Fernández (plus Burgos), ***Horror Tales*** V4 #3 (Apr. 1972)
Middle: ***Tales of Voodoo*** V5 #3 (Apr. 1972), ***Terror Tales*** V4 #3 (Apr. 1972) art by Fernández, ***Tales of Voodoo*** V5 #5 (Aug. 1972) art by Alexander
Bottom: ***Terror Tales*** V4 #5 (Aug. 1972), ***Tales from the Tomb*** V4 #4 (Sept. 1972), ***Witches' Tales*** V4 #5 (Sept. 1972) All art by Alexander

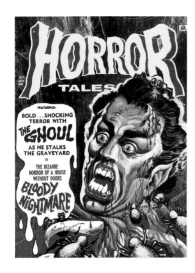
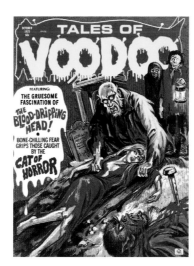
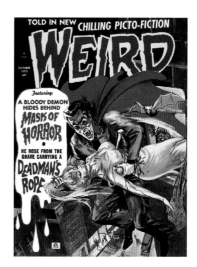
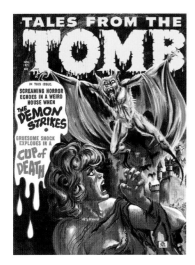
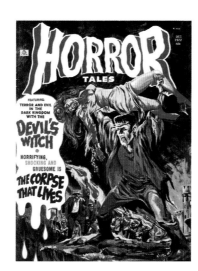
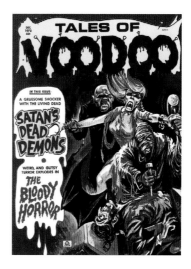
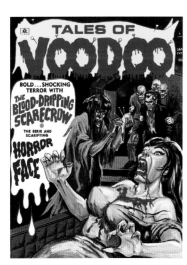
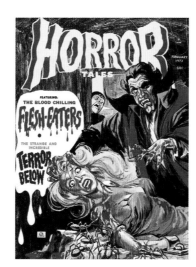
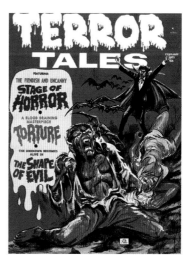

Top: **Horror Tales** V4 #6 (Oct. 1972), **Tales of Voodoo** V5 #6 (Oct. 1972), **Weird** V6 #6 (Oct. 1972)
Middle: **Tales from the Tomb** V4 #5 (Nov. 1972), **Horror Tales** V4 #7 (Dec. 1972), **Tales of Voodoo** V5 #7 (Dec. 1972)
Bottom: **Tales of Voodoo** V6 #1 (Jan. 1973), **Horror Tales** V5 #1 (Feb. 1973), **Terror Tales** V5 #1 (Feb. 1973)

All art by Alexander

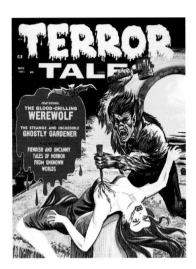
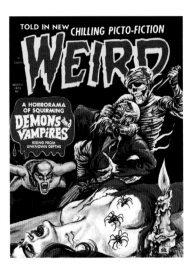
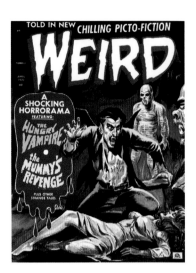

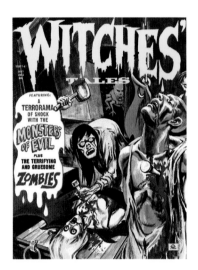
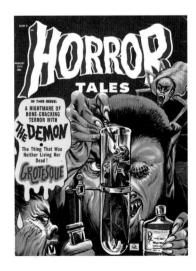
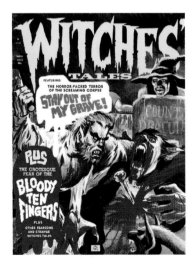
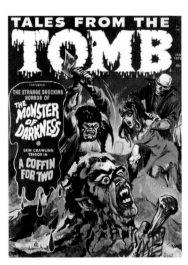

This page: Reprints and repaints; Burgos cobbles and confuses his readers!
Top: *Terror Tales* V3 #6 (Nov. 1971), *Weird* V6 #2 (Mar. 1972), *Weird* V6 #3 (Apr. 1972)
Middle: *Horror Tales* V4 #4 (June 1972), *Tales of Voodoo* V5 #4 (June 1972), *Witches' Tales* V4 #4 (July 1972)
Bottom: *Horror Tales* V4 #5 (Aug. 1972), *Witches' Tales* V4 #6 (Nov. 1972), *Tales from the Tomb* V5 #1 (Jan. 1973)

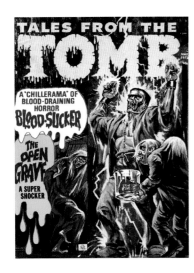
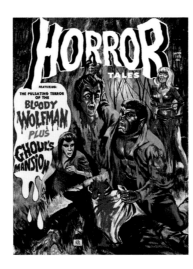
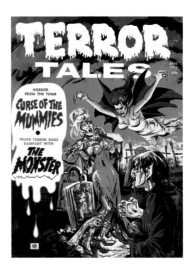
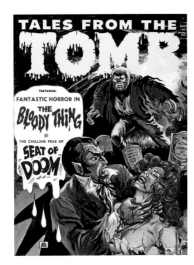
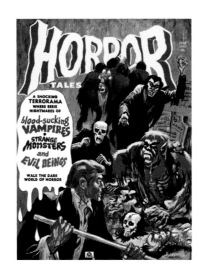
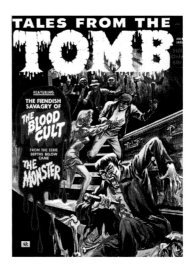
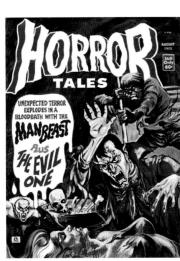
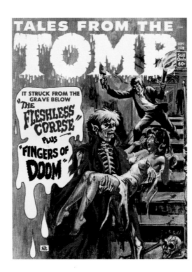
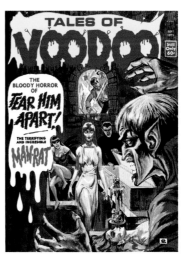

Top: *Tales from the Tomb* V5 #2 (Mar. 1973), *Horror Tales* V5 #2 (Apr. 1973), *Terror Tales* V5 #2 (Apr. 1973)
Middle: *Tales from the Tomb* V5 #3 (May 1973), *Horror Tales* V5 #5 (Incorrectly numbered—June 1973), *Tales from the Tomb* V5 #4 (July 1973)
Bottom: *Horror Tales* V5 #4 (Aug. 1973), *Tales from the Tomb* V5 #5 (Sept. 1973), *Tales of Voodoo* (Sept. 1973)
All art by Alexander

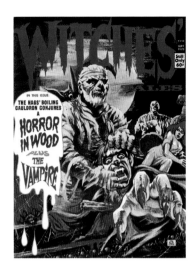 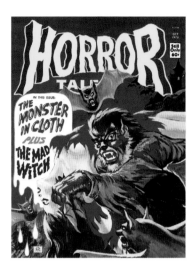 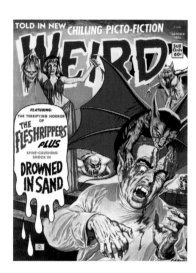

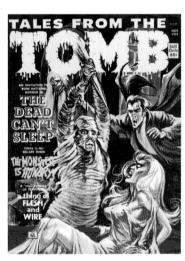 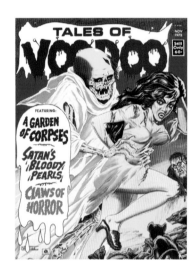 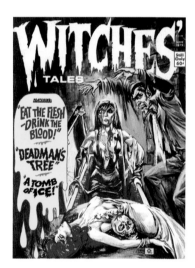

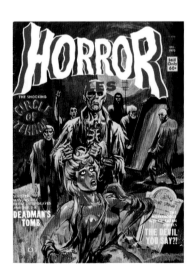 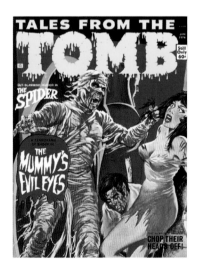 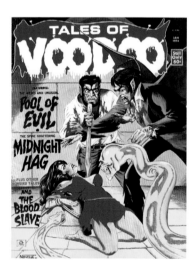

Top: **Witches' Tales** V5 #5 (Sept. 1973), **Horror Tales** V5 #5 (Oct. 1973), **Weird** V7 #6 (Oct. 1973) art by Oscar Novelle
Middle: **Tales from the Tomb** V5 #6 (Nov. 1973) art by Alexander, **Tales of Voodoo** V6 #6 (Nov. 1973) art by Novelle,
Witches' Tales V5 #6 (Nov. 1973) art by Alexander
Bottom: **Horror Tales** V6 #6 (Dec. 1973) art by Alexander, **Tales from the Tomb** V6 #1 (Jan. 1974) art by Novelle,
Tales of Voodoo V7 #1 (Jan. 1974) art by Novelle

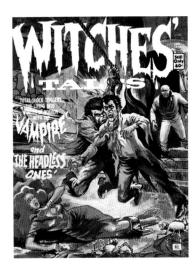 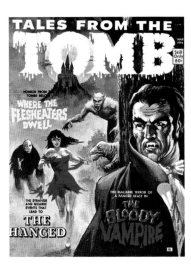 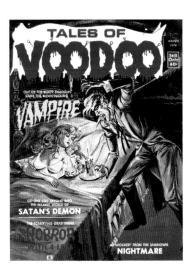

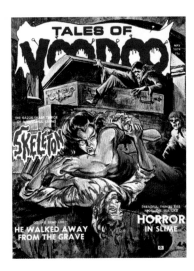 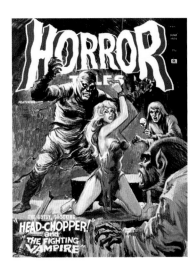 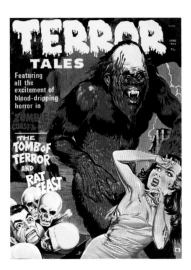

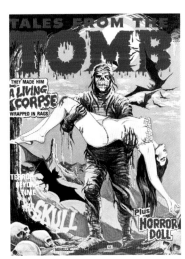 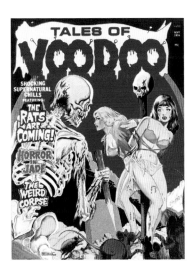 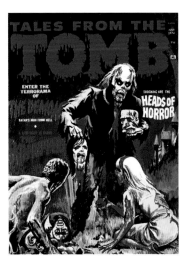

Top: ***Witches' Tales*** V6 #1 (Jan. 1974) art by Alexander, ***Tales from the Tomb*** V6 #2 (Mar. 1974) art by Burgos,
Tales of Voodoo V7 #2 (Mar. 1974) art by Alexander
Middle: ***Tales of Voodoo*** V7 #3 (May 1974) art by Alexander, ***Horror Tales*** V6 #3 (June 1974) art by Alexander (his last) with Burgos,
Terror Tales V6 #3 (June 1974) art by Novelle
Bottom: ***Tales from the Tomb*** V6 #5 (Sept. 1974) art by Novelle, ***Tales of Voodoo*** V7 #5 (Sept. 1974) art by Novelle,
Tales from the Tomb V6 #4 (July 1974) Cobble and repaint

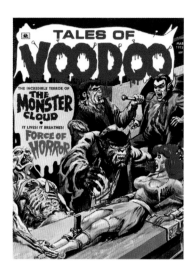
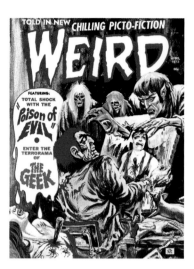
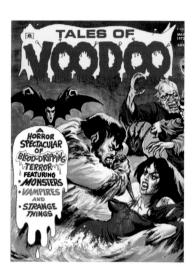

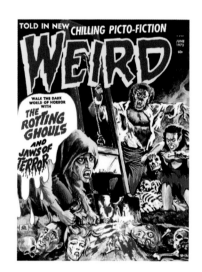
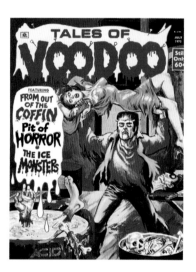
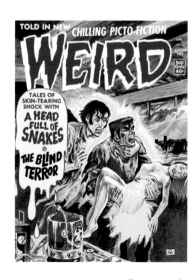
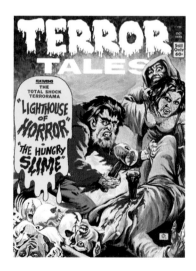
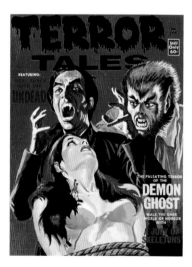

Burgos put in some serious overtime amending the covers on these two pages…
Top: ***Tales of Voodoo*** V6 #2 (Mar. 1973), ***Weird*** V7 #3 (Apr. 1973), ***Tales of Voodoo*** V6 #3 (May 1973)
Middle: ***Terror Tales*** V5 #3 (June 1973), ***Weird*** V7 #4 (June 1973) ***Tales of Voodoo*** V6 #4 (July 1974)
Bottom: ***Weird*** V7 #5 (Aug. 1973), ***Terror Tales*** V5 #5 (Oct. 1973), ***Terror Tales*** V6 #1 (Feb. 1974)

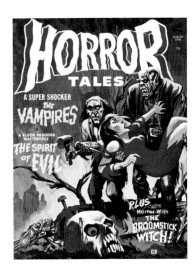 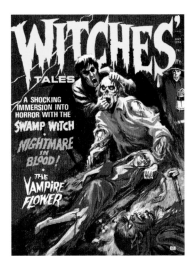 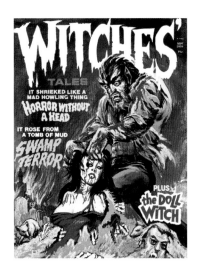

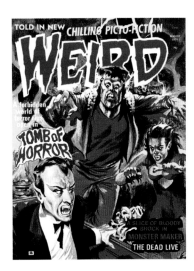 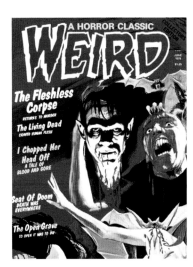 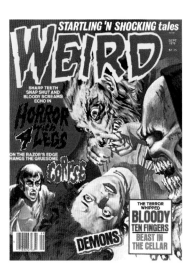

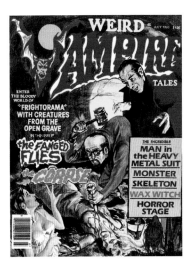 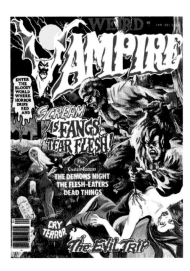 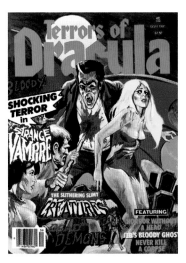

Top left to right: ***Horror Tales*** V6 #4 (Aug. 1974), ***Witches' Tales*** V6 #4 (July 1974), ***Witches' Tales*** V6 #5 (Sept. 1974)
Middle left to right: ***Weird*** V8 #4 (Oct. 1974), ***Weird*** V9 #2 (June 1976), ***Weird*** V12 #3 (Sept 1979)
Bottom left to right: ***Weird Vampire Tales*** V4 #3 (July 1980), ***Weird Vampire Tales*** V5 #2 (Apr. 1981), ***Terrors of Dracula*** V3 #2 (Sept. 1981)

Chapter 17

HYBRID HORROR

DICK AYERS emailed me in early 2008 with the words "Fun Art" in the subject line. He suggested that he draw a new Eerie Pubs story for the book, either a new interpretation of one of his Pubs classics or something new. He offered the job at a reasonable price, but as my finances were a bit tight, I told him that I'd think it over.

The more I thought, the more excited I got about the possibilities. I knew that I had to have a new story, in order for the book to be the best that it could be.

Like many other aficionados of pre-code horror, one of my favorite sickies from the '50s is "Horror of Mixed Torsos" from *Dark Mysteries* #13 (Story, August 1953). For unknown reasons, Carl Burgos had stories redrawn from Story's other title, *Mysterious Adventures*, but never touched its sister title. That left this twisted gem ripe for the pickin'. I had to have it!

I sent Dick photocopies of the original story. I even asked him to make the sheriff look like me. His email updates were very gratifying, saying he was having a blast and it was "just like working for Carl and Myron."

I'm very pleased with the result. The gothic setting was a surprise to me (and it makes my specs and muttonchops look appropriate). Dick's son Rich helped with some finishing touches, just as he has for many years. The two Ayers men turned out a tale that should please the Eerie Pubs fan in all of us. It is the first new Ayers horror story in over 35 years! ✴

Opposite: *Dark Mysteries* #13 (Story, Aug. 1953)

This page: a sequence from "Horror of Mixed Torsos"

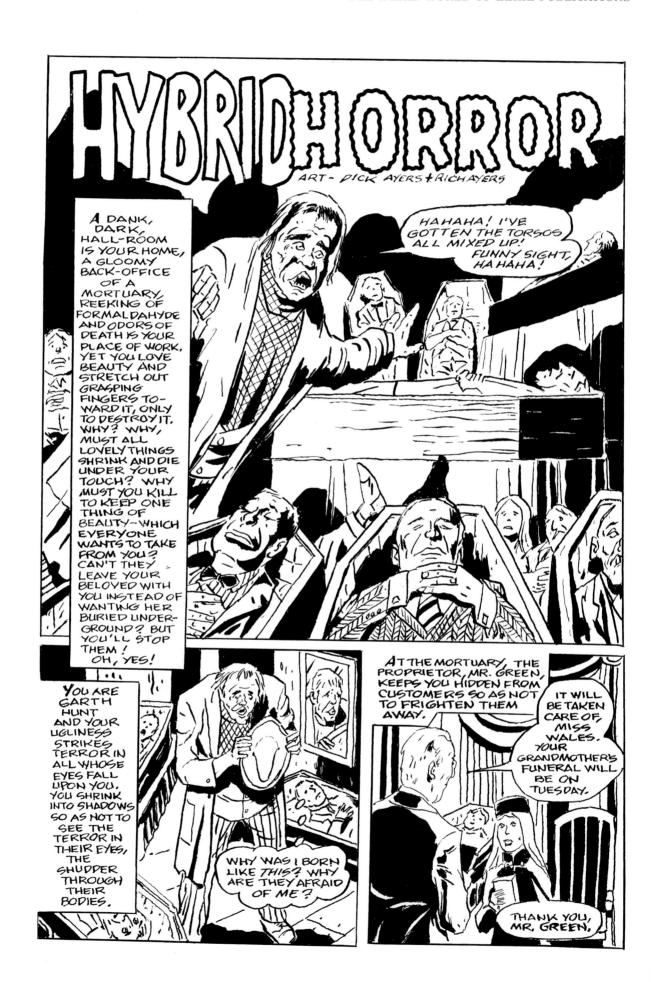

THE YOUNG LADY TURNS AND PEERS INTO THE SHADOW WHERE YOU LURK. THE SIGHT OF HER FACE MAKES YOUR HEART POUND AND HAMMER AGAINST YOUR RIBS. YES, YOU, TOO, UGLY MONSTER THO YOU ARE, POSSESS A HEART, HUNGRY FOR LOVE.

WHAT WAS THAT? I HEARD A SOUND, MR. GREEN!

JUST MY ASSISTANT, GARTH HUNT.

IT—IT'S FAITH WALES! MY LOVE, MY ADORED ONE!

I MUST GO, MR. GREEN. GOOD DAY.

GOOD-DAY, MISS WALES.

GO ON, RUN FROM ME. BUT SOME DAY I'LL HAVE YOU!

SO YOUR NAME MAKES HER HURRY OUT! ALL SHE SEES IS YOUR UGLY FACE, NOT THE BEAUTY IN YOUR SOUL, THE BURNING LOVE IN YOUR HEART. EVER SINCE YOU WENT TO SCHOOL TOGETHER YOU HAVE LOVED THE EXQUISITE FAITH AND NOW YOU ARE A MAN AND CONSUMED WITH A BURNING LOVE FOR HER.

YOUR LONELY LIFE GOES ON, BROODINGLY, DESOLATELY, SHUNNING PEOPLE AND BEING SHUNNED BY THEM. SURELY THE FLOWERS WILL LET YOU LOOK AT THEM!

AH FAIR TULIPS, YOU CAN'T RUN FROM THE SIGHT OF ME!

BUT YOUR TOUCH WITHERS THEIR FRAIL BEAUTY. EVEN A MINDLESS THING RESENTS, HATES YOUR SHEER UGLINESS.

THE FRIGHTENED CHILDREN FLUTTER AWAY IN PANIC.

ONLY THE SILENT *DEAD* DO NOT RUN FROM ME! THAT'S WHY I WORK NEAR THEM.

EVEN A DOG, MAN'S FRIEND ATTACKS YOU AS THO YOU WERE A STRANGE BEAST. YOU RUN HOME TO HIDE ONCE MORE IN THE SHADOWS WHERE YOU BELONG.

SOB! SOB!

YOU GO ON EXISTING FROM DAY TO DAY, SORELY WOUNDED IN MIND AND HEART. THEN ONE DAY EVERYTHING CHANGES. LOVE AND BEAUTY BECOME YOURS AND ALL THE PAIN OF LIVING DROPS AWAY.

GARTH, WHERE ARE YOU? NAIL UP THIS COFFIN. HER FAMILY IS IN EUROPE, ONLY A NEIGHBOR OR TWO WILL ATTEND THE FUNERAL TOMORROW.

YES, SIR, WHO DIED, SIR?

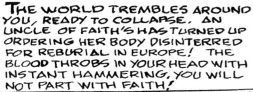

THE WORLD TREMBLES AROUND YOU, READY TO COLLAPSE. AN UNCLE OF FAITH'S HAS TURNED UP ORDERING HER BODY DISINTERRED FOR REBURIAL IN EUROPE! THE BLOOD THROBS IN YOUR HEAD WITH INSTANT HAMMERING, YOU WILL NOT PART WITH FAITH!

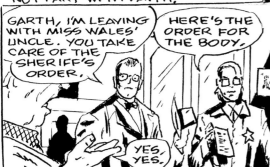

GARTH, I'M LEAVING WITH MISS WALES' UNCLE. YOU TAKE CARE OF THE SHERIFF'S ORDER.

HERE'S THE ORDER FOR THE BODY.

YES, YES.

THERE'S ONLY ONE WAY TO STOP THEM. YOU ARE ENTITLED TO YOUR BIT OF HAPPINESS AND BEAUTY AFTER ALL THE YEARS OF TORTURE. YES, THERE'S A WAY TO STOP THEIR PLOT TO TAKE FAITH AWAY...

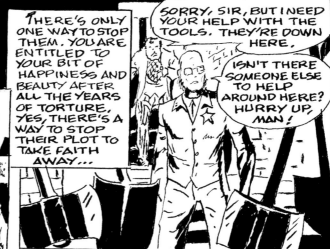

SORRY, SIR, BUT I NEED YOUR HELP WITH THE TOOLS. THEY'RE DOWN HERE.

ISN'T THERE SOMEONE ELSE TO HELP AROUND HERE? HURRY UP, MAN!

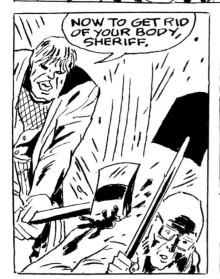

NOW TO GET RID OF YOUR BODY, SHERIFF.

BEHIND THE TOOL CHEST! THAT'S A GOOD HIDING PLACE! NO ONE EVER GOES THERE BUT YOU, GARTH. BEFORE LONG YOUR FRIENDS THE RATS WILL HAVE DEVOURED ALL EVIDENCE.

THE LEGS HERE...

WHAT A BLOODY MESS YOU'VE MADE! YOU'LL HAVE TO CLEAN UP FAST BEFORE MR. GREEN RETURNS. THE SMELL OF BLOOD IS SICKENING! YOU'LL HAVE TO SWAB THE PLACE TO REMOVE ALL TRACES.

...AND THEN THE UPPER TORSO IN THAT OLD, BROKEN COFFIN.

YOU STUFF THE REST OF THE SHERIFF INTO THE COFFIN, AS YOU TINGLE ALL OVER WITH A SENSE OF ACHIEVMENT. YOU'VE SAVED YOUR DARLING — SHE IS STILL YOURS IN YOUR LITTLE APARTMENT THERE IN THE COAL BIN!

GET IN THERE, MR. SHERIFF! AND STOP STARING AT ME!

SEE, DEAR, YOU ARE STILL MINE!

277

THE JOB'S ALMOST FINISHED WHEN YOU HEAR A VOICE UPSTAIRS IN THE MORTUARY SHOP, CALLING LOUDLY, INSISTENTLY. MORE COMPLICATIONS? NEVER MIND! SOMEHOW YOU FEEL THEY CAN NEVER BEAT YOU.

ANYONE HERE? I WANT SOME ATTENTION, PLEASE!

RIGHT AWAY! COMING UP!

YOU SEE FAITH'S UNCLE IN THE STORE, BUT YOU FEEL PREPARED FOR ANYTHING.

WHERE'S EVERYONE? OH, THERE YOU ARE? WHERE'S THAT SHERIFF? DID YOU GET MY NIECE'S BODY?

THE SHERIFF LEFT, BUT THE BODY'S DOWNSTAIRS. COME THIS WAY, PLEASE.

COME, FOLLOW ME, THE NIECE'S BODY IS DOWNSTAIRS... FOLLOW ME...

A LOT OF MESSY WORK, ALL OVER AGAIN, BUT IT WAS QUITE EASY TO HACK THE OLD UNCLE IN TWO. AND NOW YOU PLACE HALF THE BODY IN THE OLD COFFIN, QUITE FUNNY, THE TOP OF THE SHERIFF AND THE BOTTOM OF THE UNCLE — EQUAL ONE MAN! YOU DON'T KNOW IT, BUT THAT'S YOUR FIRST MISTAKE.

NOW, LET THE RATS GET TO WORK ON THEIR FEAST, MAYBE THE BATS'LL HELP.

HA! HA! QUITE A COMBINATION!

THAT WAS QUITE A LOT OF WORK. YOU RETURN "HOME" TO RELAX IN THE CONTEMPLATION OF YOUR BELOVED'S WHITE BEAUTY. SHE MUST KNOW ALL YOU'VE DONE FOR HER — AND SHE MUST LOVE YOU ALL THE MORE FOR YOUR DARING AND COURAGE.

OH, MY BEAUTIFUL ONE, I AM TIRED. YOU SEE, I SHALL NEVER LET THEM TAKE YOU FROM ME.

SOME MONTHS LATER...

CREEEEK!

THE CREAKING SOUND? YOU GO TO SEE — AND BEFORE YOUR EYES AN AMAZING FUSION OCCURS! THE UPPER TORSO OF THE SHERIFF TOGETHER WITH THE LOWER OF THE UNCLE HAS RISEN FROM THE OLD COFFIN!

UGH--- NO - NO!

YOU JERK TOWARD THE TOOL BIN.

GET AWAY — GET BACK...

THE OTHER FIGURE APPROACHES THE UNCLE'S TORSO ATTACHED TO THE SHERIFF'S LEGS!

YOU RUN INTO YOUR COAL BIN AND BOLT THE DOOR. NOW YOU KNOW YOUR LITTLE JOKE OF MIXING TORSOS MADE WHOLE BODIES GROW, DON'T YOU?

YOU NEVER FEARED GHOSTS BEFORE BUT THIS IS DIFFERENT AND YOU RUN — RUN TOWARDS — FAITH — BUT SHE IS DEAD AND CANNOT HELP...

YOU TRY TO PROTECT FAITH, A COLD CURRENT RUSHING THROUGH YOUR LIMBS, AS CRASH, CRASH, COMES THE SOUND OF AXES SPLINTERING THE COALBIN DOOR, AND THE TWO MIXED BODIES ADVANCE INEXORABLY...

YOU CAN'T HAVE HER! SHE'S MINE!

AS OBLIVION STRIKES YOU IN AN AGONY OF PAIN, THE LAST THING YOU SEE FROM THE ENSHROUDING DARKNESS IS THOSE FIGURES, DIVIDING UP INTO FOUR PIECES AGAIN AND — COLLAPSING ON THE FLOOR — *UNMIXED AT LAST!*

THE END

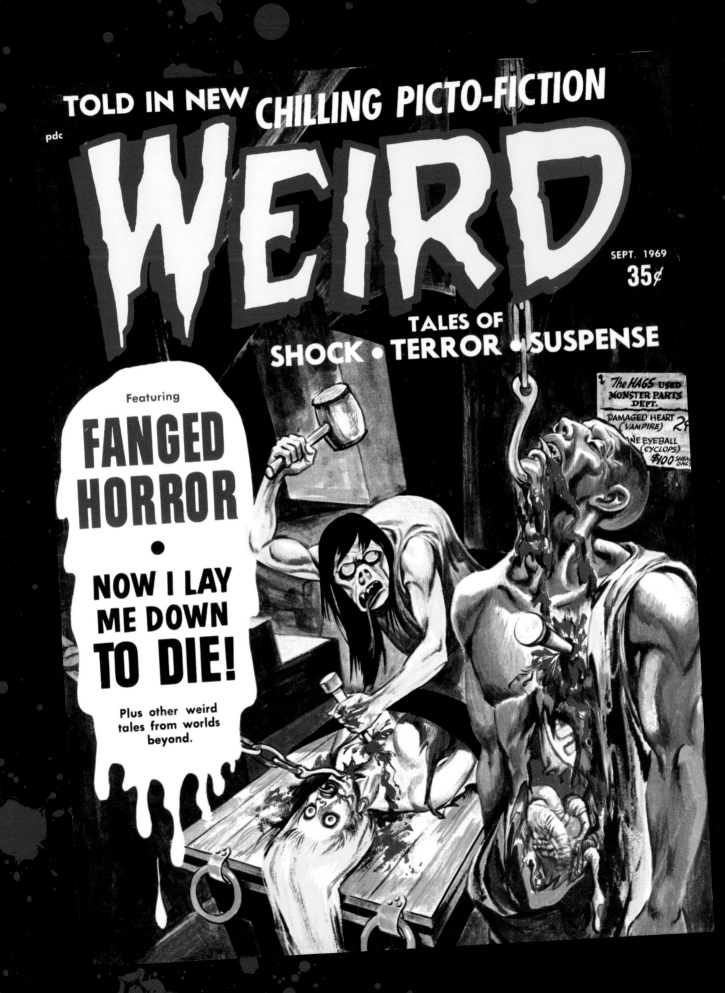

APPENDICES

Appendix 1
The Sordid History of Captain Marvel

Captain Marvel was first introduced in Fawcett Comics *Whiz Comics* #2 (Feb. 1940), created by Bill Parker and illustrated by C.C. Beck. The story of young Billy Batson, intrepid kid radio reporter, who, when he says the name "Shazam," transforms into the powerful grown-up superhero Captain Marvel, the world's mightiest mortal. Earning his own book, *Captain Marvel Adventures*, the title was a huge seller for Fawcett.

No great success goes unnoticed and National Publications (known as DC Comics since the '50s) noticed a certain similarity between the "big red cheese" (as Captain Marvel's fans sometimes refer to him) and a certain Superman, National's bestselling superhero. National ordered them to cease and desist early on and after a decade's worth of court battles and appeals, it was decided that Captain Marvel was a copyright infringement of Superman. Unwilling to fight anymore (as by 1952, superhero titles weren't selling too well—horror was the big moneymaker at the time) Fawcett settled out of court and ceased not only Captain Marvel books, but they dropped or sold their entire comic line.

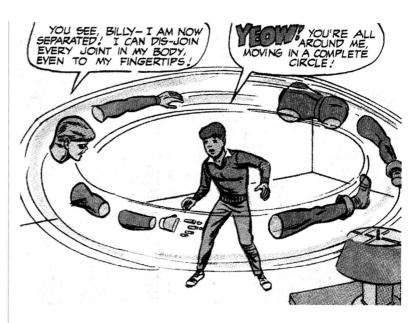

With all of the confusion of the case and a perfectly good superhero name just sitting there in 1965, it's no wonder that a young upstart company like M.F. Enterprises should fashion their own Captain Marvel. This, however, was no mighty mortal. Carl Burgos created the weirdest superhero ever! He was a robot who, when he yells "Split," can separate his body into segments, beat the shit out of opponents, and yell "Xam" and return to form. Laser-beam eyes and the ability to fly didn't hurt either.

If any of this sounds familiar, you ain't heard nothin' yet.

The first few issues, Captain Marvel (whose secret identity is mild-mannered professor Roger Winkle!) pals around with a kid named Billy Baxton, and together they thwart the evil plans of Plastic Man (later called Elastic Man, as the real Plastic Man was enjoy-

Opposite:
Weird V3 #4 (Sept. 1969) Is that an appendix hangin' out? Art by Bill Alexander

This page: I'm sorry... Captain Marvel would freak my shit out!

281

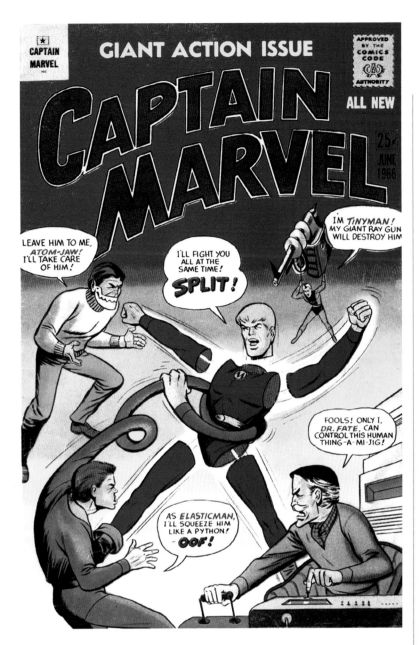

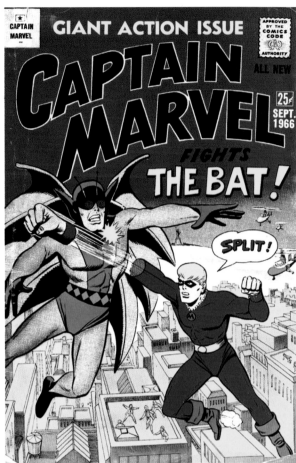

Left: *Captain Marvel* #2 (June 1966)

Right: *Captain Marvel* #3 (Sept. 1966)

ing a revival over at DC), Dr. Fate (another DC character name), Tinyman (similar to DC's The Atom) and most notably The Bat, whose extremely close resemblance to DC's Batman in V1 #3 of *Captain Marvel* forced a rapid name change to The Ray. The last issue (V2 #5, Sept. 1967) has an Aquaman clone named Tarzac. Ironically, this issue, called *Captain Marvel Presents The Terrible 5*, has only four villains, not five, as Tinyman changed to the side of good a few issues earlier. I just thought you should know.

This is the second robot hero in a red uniform created by Carl Burgos, the first being, of course, Timely's classic golden-age hero The Human Torch. Roger Elwood scripted early issues and #1 has "Francho" credited as the artist, though it looks like Burgos' work. It may be Arnoldo Franchione, who went

by Francho when cartooning and later acted as a liaison between Argentina and New York for Burgos and the Eerie Pubs. Veteran Carl Hubbell, who worked for Atlas alongside Fass and Burgos, handled the art chores for some later issues. Other writers include Hubbell and Leo August (a better pseudonym than Sagittarius December or Cancer July, to be sure). Whichever artist was drawing the character, the separated body parts flying through the air makes for a slightly unsettling hero. Kinda gross, really.

The title was one of two four-color comic tryouts for Fass in 1966, the other being Bob Powell's Archie-inspired *Henry Brewster*. Burgos' latest superhero android didn't catch on and after the five 1966 entries, only one more issue would surface, nearly a year later in September 1967. They were all Jumbo-Sized issues.

In late 1967, Marvel Comics revived the name for their own hero called Captain Marvel.

With superheroes popular again, and Fawcett legally unable to bring back the Big Red Cheese, DC acquired the character rights from them in 1972. To avoid stepping on anyone's copyright, DC called the new book *Shazam!*, and featured new stories as well as classic golden-age reprints. Myron Fass made a ballsy attempt to sue Marvel over use of the name but his comic fizzled out, making his case moot.

DC is still reprinting the original exploits of Billy Batson and Captain Marvel, but the six issues of M.F. Publications' *Captain Marvel* are still the only superhero comics in my entire collection!

Captain Marvel April 1966 V1 #1
Captain Marvel June 1966 V1 #2
Captain Marvel presents The Terrible Five
 Aug. 1966 V1 #1
Captain Marvel Sept. 1966 V1 #3
Captain Marvel Nov. 1966 V1 #4
Captain Marvel presents The Terrible Five
 Sept. 1967 V2 #5

Appendix 2
Henry Brewster

Counrtywide's first foray into the world of four-color comics was a spiffy little teenage title called *Henry Brewster*. Written and drawn by the amazing Bob Powell, *Henry Brewster* won't win any originality contests, but this *Archie* clone has a lot going for it.

The similarities to the Riverdale gang are obvious: red-headed, all-American every-boy Henry, big jock Animal, brainy nerd Weenie, and Henry's two gal pals, the rich Melody and the nice girl Debbie. Derivative, yes, but Powell's pun-filled dialogue and hip

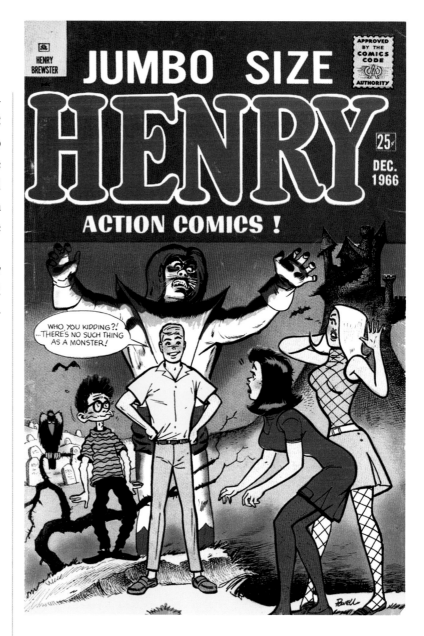

lingo raise these comics above their *Archie*-inspired peers. A 50-year-old man at the time, Powell sure had a pretty good ear for teen talk. He had been doing quite a bit of other teen work at the time, including the *Teen-A-Go-Go* syndicated strip and work in various teen mags. Bob Powell brought his delightful, light art style to the book and the seven issues that were published are all highly recommended.

Powell's penchant for portraying pretty girls came to the forefront in the *Henry Brewster* books. As adept at mod fashion as he was with mod dialogue, Melody's and Debbie's frames were always adorned with super cool skirts, swimsuits and sweaters. It's easy to see why Henry was always distracted.

In late 1966, when the *Batman* TV show, James Bond and all of the crime-fighting super spies were

Henry Brewster V1 #6 (Dec. 1966) art by Bob Powell

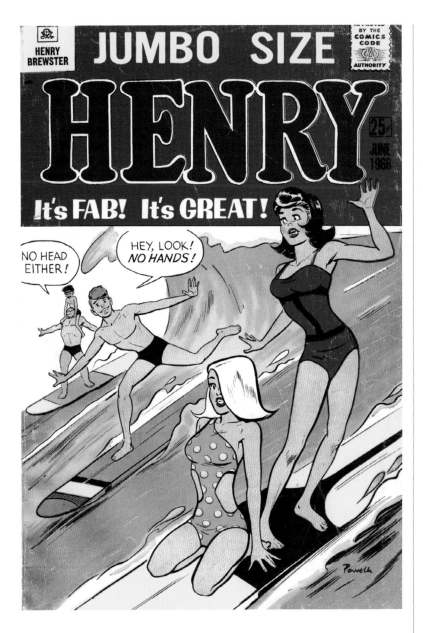

the cover title never says "Henry Brewster"—it usually just says "Henry" under "Jumbo Size." The cover title for the September 1967 issue is "Henry's Mod Teen Adventures." The indicia for every issue, however, states that the comic's title is *Henry Brewster*.

Henry Brewster Feb. 1966 V1 #1
Henry Brewster April 1966 V1 #2
Henry Brewster June 1966 V1 #3
Henry Brewster Aug. 1966 V1 #4
Henry Brewster Oct. 1966 V1 #5
Henry Brewster Dec. 1966 V1 #6
Henry Brewster Sept. 1967 V2 #7

Appendix 3
Strange Unknown

Strange Unknown, published under the Tempest imprint, was a magazine that had a very short lifespan of two issues, but it exhibited plenty of content that is of interest to fans of Eerie Pubs. A precursor to the very successful UFO and ESP mags that Countrywide would corner the market with in the next decade, *Strange Unknown* dealt with all things weird and paranormal.

A scan down the contents page in the first issue (V1 #1, May 1969) will show you that Carl Burgos has a "designer" credit, though I'm not sure what that job description entailed. At least he's credited. He had many illustrations in the girlie magazines over the years and never got a credit at all. Also listed, as an art assistant, is Ezra Jackson. This is the same month that Jackson's name appeared for the first time as art director for the entire Eerie Pubs line of comics.

The second issue (V1 #2, July 1969), the "Complete Witchcraft Special," is much more interesting;

Henry Brewster V1 #3 (June 1966) art by Bob Powell

in vogue, Henry and his gang also became honorary secret agents. The gang clashed with all forms of villains and bad guys, helping (and hindering) their teacher/secret agent Mr. Secrett, as well as handling cases on their own. In these later issues, Powell had a bit of fun, giving the kids a tricked-out car and fun spy gadgets.

All seven of these Jumbo-Sized issues are very entertaining, due to Powell's brand of storytelling and artwork, but like its sister comic book *Captain Marvel*, *Henry Brewster* only lasted through 1966, with a bonus issue appearing in September 1967. Collectors interested in pursuing this short run should note

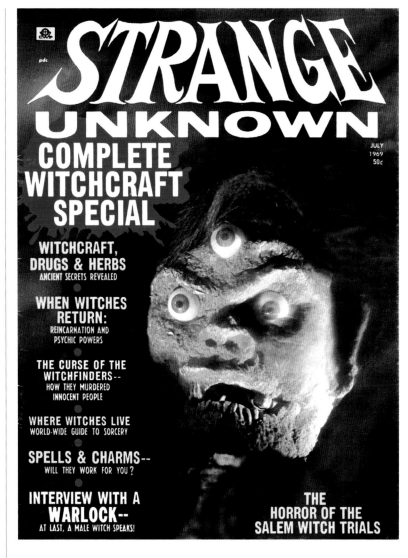

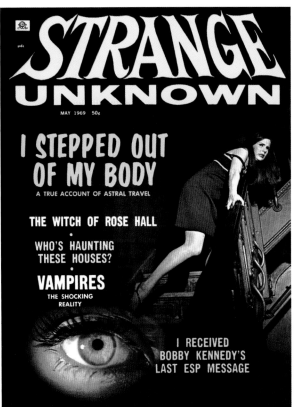

it contains two black-and-white horror illustrations by Bill Alexander, the only two that I can think of that saw print inside a Countrywide magazine. The drawings are gorier than much of his subsequent cover work. The first issue of *Horror Tales* (V1 #7) would also street this month, which was Alexander's first of many Pubs covers. His grueling topless illo for "Voodoo's Queen of Witchcraft" is violent and hard, and exhibits his excellent technique in pen, ink and wash.

This second issue also reprinted Burgos' cover from *Weird* V2 #6 (April 1968), in black-and-white, as a story illustration. More interesting still are three pen-and-ink illustrations signed by (Ricardo) Rivera, which look suspiciously like the work of "art assistant" Ezra Jackson. The putrescent face that il-

Top left: Looking very much like an Ezra Jackson creation, Ricardo Rivera's illo from "Are You a Witch?" from *Strange Unknown* V1 #2 (July 1969)

Top right: *Strange Unknown* V1 #2 (July 1969)

Bottom left: *Strange Unknown* V1 #1 (May 1969)

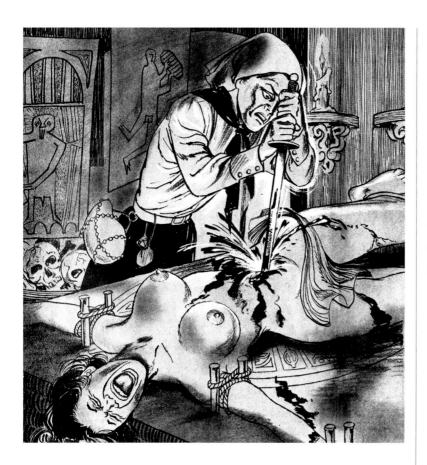

Bill Alexander's
unsettling
illustration for
"Voodoo's Queen
of Witchcraft"
in *Strange
Unknown*
V1 #2
(July 1969)

lustrates "Are You a Witch?" even boasts the man-
datory torn cheek/exposed teeth look that Jackson
made into his trademark over the next few years.
Two of the stories in this issue were later reprinted
(literally—they were cut and pasted right from these
pages, differing font sizes and all) as text stories for
the Eerie Pubs in 1972.

So, if you're into ghosts, Satan, voodoo, witch-
craft, vampires, ESP and UFOs (and really, who
isn't?) *Strange Unknown* was definitely published
with you in mind.

Appendix 4
The Thing In the Cellar

To the right is a rare look at Chic Stone's original
version of his Pubs classic "The Thing in the Cellar"
as it appeared in Stone's own publication *Boy Illus-
trated* #1 (CSTR, June 1962).

Many thanks to Ken Eriksen for the scan.

Appendix 5
Perry Rhodan
Original Covers
From Pabel-Moewig Verlag KG

All of these covers were painted by Johnny Bruck.

HORROR TALES (Mar. 1971) from *Perry
Rhodan* #136 Bestien der Unterwelt (Mar.
1964)
HORROR TALES (May 1971) from *Perry
Rhodan* #142 Agenten der Vernichtung (May
1964)
HORROR TALES (July 1971) from *Perry
Rhodan* #388 Götter aus dem Kosmos (1969)
TALES FROM THE TOMB (Feb. 1971) from
Perry Rhodan #243 Raumaufklärer 008 (April
1966)
TALES FROM THE TOMB (April 1971)
from *Perry Rhodan* #421 Report eines
Neandertalers (Sept. 1969)
TALES FROM THE TOMB (Aug. 1971) from
Perry Rhodan #342 Die Bestien sollen
sterben (Mar. 1968)

The THING in the CELLAR

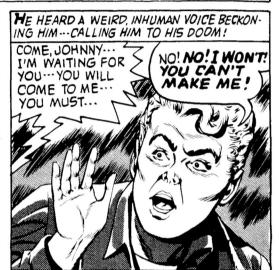

THE END

TALES OF VOODOO (Jan. 1971) from *Perry Rhodan* #166 Im Labyrinth von Eysal (Oct. 1964)

TALES OF VOODOO Mar. 1971) from *Perry Rhodan* #384 Die Welt der Unsichtbaren (1968)

TALES OF VOODOO (May 1971) from *Perry Rhodan* #354 Experimente mit der Zeit (May 1968)

STRANGE GALAXY (Feb. 1971) from *Perry Rhodan* #134 Die Kanonen von Everblack (Mar. 1964)

STRANGE GALAXY (April 1971) from *Perry Rhodan* #82 Schach dem Universum (Mar. 1963)

STRANGE GALAXY (June 1971) from *Perry Rhodan* #168 Die Eisfalle (Nov. 1964)

STRANGE GALAXY (Aug. 1971) from *Perry Rhodan* #78 Thoras Opfergang (Feb. 1963)

TERROR TALES Mar. 1971) from *Perry Rhodan* #186 Die Hypno-Kugel (Mar. 1965)

TERROR TALES (May 1971) from *Perry Rhodan* #126 Die Schatten greifen an (Jan. 1964)

TERROR TALES (July 1971) from *Perry Rhodan* #363 Nacht zwischen den Sonnen (1968)

TERROR TALES (Sept. 1971) from *Perry Rhodan* #271 Die Welt der Körperlosen (Nov. 1966

WEIRD (Dec. 1966)) from *Perry Rhodan* #131 Das Versteck in der Zukunft (Feb. 1964) * partial used

WEIRD (Feb. 1971) from *Perry Rhodan* #51 Jagd nach dem Leben (Aug. 1962)

WEIRD (April 1971) from *Perry Rhodan* #156 Lemy und der Krötenwolf (Aug. 1964)

WEIRD (June 1971) from *Perry Rhodan* #236 Im Camp der Gesetzlosen (Mar. 1966)

WEIRD (Aug. 1971) from *Perry Rhodan* #99 Ein Freund der Menschen (July 1963)

WEIRD WORLDS (Dec. 1970) from *Perry Rhodan* #106 Der Götze von Passa (Sept. 1963)

WEIRD WORLDS (Feb. 1971) from *Perry Rhodan* #216 Aufbruch der Oldtimer (Oct. 1965)

WEIRD WORLDS (April 1971) from *Perry Rhodan* #345 Verfolgungsjagd im Halbraum (1968)

WEIRD WORLDS (June 1971) from *Perry Rhodan* #292 Der Bahnhof im Weltraum (Mar. 1967)

WEIRD WORLDS (Aug. 1971) from *Perry Rhodan* #357 Die Arenakämpfer (June 1968)

WITCHES' TALES (Feb. 1971) from *Perry Rhodan* #85 Kampfschule Naator (April 1963)

WITCHES' TALES (April 1971) from *Perry Rhodan* #329 Ein Planet läuft Amok (Dec. 1967)

WITCHES' TALES (June 1971) from *Perry Rhodan* #254 Die Geistersonne (July 1966)

WITCHES' TALES (Aug. 1971) from *Perry Rhodan* #198 Die letzte Bastion (June 1965)

Appendix 6
Please Draw for Me, Argentina

Comics and illustrations have been a respected and beloved form of art in South America for over a hundred years. Argentina has one of the longest love affairs with comic books of any country on the planet. What was once just editorial cartoons and sketches blossomed into one of the richest comic histories in the world, right up there with the good ol' U.S. of A.

In the early part of the twentieth century, Argentine comics began to evolve from single-panel cartoons into full strips, and soon started to feature recurring characters that became very popular. By the '20s, daily newspapers were carrying these strips, and many magazines featured their own comic characters. Later in that decade, the weekly magazine *El Tony* was launched, making it the first all-comic strip magazine in South America. To say it was a hit would be a gross understatement; it was published continually until the '90s.

Superheroes and other comics from the USA were translated and imported into Argentina, and these too were very popular. The public's thirst for *historietas de cómic* was huge and all major magazines and newspapers had comic pages. In the mid-'40s, *El Tony* publisher Editorial Columba (founded by brothers Ramón and Claudio) released another all-comic anthology title, *Intervalo*. Like its predecessor, *Intervalo* was very popular and enjoyed a long life. Many Argentine art legends had work appear in the Columba magazines, including many some that would become fixtures at Eerie Pubs a decade later.

Argentina's boom years for comics were definitely the '50s and early '60s. There were many publishers putting out competing comic magazines, creating a thriving market. Hector German Oesterheld, who was rapidly becoming a comic book icon, became very prolific in the '50s. In addition to running his own publishing business, he was writing extremely successful strips that were illustrated by a multitude of superb artists, including many future Pubs stars. A collection of Italian artists that had stayed in South America following World War II were also on hand making amazing contributions to the comic art pool.

One thing that illustrates how important illustration was to the people of Argentina was the advertising in comic books. Along with house ads for other titles and the occasional consumer product, whole-page advertisements for drawing schools and art lessons abounded. While in the U.S., publishers were shilling breakfast foods and *Grit* newspapers, their Argentine counterparts were offering a chance for someone to learn to express themselves through art.

Perhaps because of this nurturing, artistic atmosphere, there have always been scores of incredibly talented Argentine artists. There are many different styles to be found in any given comic book. Some artists favored a more caricatured, cartoon line while others were heavy into realism and dramatic, detailed brushwork. Sometimes, the same artist could be adept at both styles. Leafing through an old *Intervalo* or *D'artagnan* comic from the '50s or '60s, one just can't help but be impressed by the incredible and varied artwork on display.

Heading into the '60s, the industry was still very healthy, though foreign comics continued to trickle in and take away some of the local business. Eventually this, coupled with the country's political unrest, caused a few tears in the fabric of the local scene. Oesterheld's company, Ediciones Frontera, and a handful of other publishers, began to close their doors. In 1966, with a change in political power, censorship became a big problem, as did the economy,

and many comic artists found themselves out of work. Many artists left the country.

The popular anthology magazines stayed in print, producing action strips for their dwindling audience. Of course, stalwarts and visionaries like Oesterheld held on, producing thought-provoking work despite the repressed atmosphere. Oesterheld's writing got more confrontational and more political in the midst of a military government. He was definitely pushing the boundaries. In 1976, he mysteriously vanished and was never seen again. The same fate also befell his daughters.

Of course, Oesterheld's groundbreaking work had inspired many great writers and artists to follow in his footsteps. Writers Carlos Trillo and Robin Wood stepped up and wrote many important works in Oesterheld's absence, following his lead with hard-hitting and realistic stories. The Argentine comics industry rejuvenated in the early '80s and continues to grow. Comics are still a big part of the culture in Argentina and the people have a very storied history in the medium to study and admire.

One great place to see some of these artists is, of course, in the Eerie Publications horror comics. From the very beginning of the original art phase, Oscar Fraga, Antonio Reynoso and Walter Casadei, all working from Argentina, were presented side by side with American greats Dick Ayers and Larry Woromay. Cirilo Muñoz, Oswal and Oscar Novelle soon followed, and by 1973, dozens of artists from Argentina had been represented in Eerie's magazines.

With Argentine agents located in New York and others in Buenos Aires, Eerie Pubs stories were supplied to hungry artists in South America. Oscar Novelle and Arnoldo Franchioni, a.k.a. Francho, a celebrated cartoonist in both the USA and Argentina, handled the New York end. (Other Argentines living in the U.S. may have done this as well.) Rafael Dente, a retired journalist and comic writer, and Pedro Flores, another gifted cartoonist, were part of the connection in South America. The agents would get the stories to the artists and then ship the fin-

ished product back to New York. These agents were doing the same thing for Charlton, whose comics were also alive with Argentine flavor. On these shores, one of the South American comic shops was called Union Studio, which was possibly Estudio Géminis (a.k.a. La Oficina) in Buenos Aires, an artist collective that housed many of the Pubs regulars starting in 1970.

Myron Fass and Carl Burgos knew they had a good thing going; they were getting good artwork at a good price. The American dollar was strong in the '60s and '70s and they could get quality art from Argentina at a lower rate than they could from local artists. After the money conversion, the South American artists still had a decent paycheck and everyone was satisfied.

Appendix 7
Taking Up Space

While the text stories that appeared in the Eerie Publications were a nuisance to flip past while getting to an actual comic story, on their own they form a pretty formidable lineup of fantasy fiction. Some originally appeared in magazines like *Weird Tales* and *Strange Tales* during the Golden Age of pulps and in turn-of-the-century fiction anthologies. The folks at Countrywide didn't have to invest much money or effort in putting together this collection of stories. They had it in-house already.

The stories were all reprinted from the magazines published by Health Knowledge, Inc. Robert A.W. "Doc" Lowndes, a science fiction author and hardcore fan, was the editor of the magazines. He had been writing fantastic fiction since the early '40s and editing sci-fi and crime pulps almost as long. He was given the reins to Health Knowledge's new

The last issue
of *Strange
Mystery Tales*
#18 (Mar. 1971)

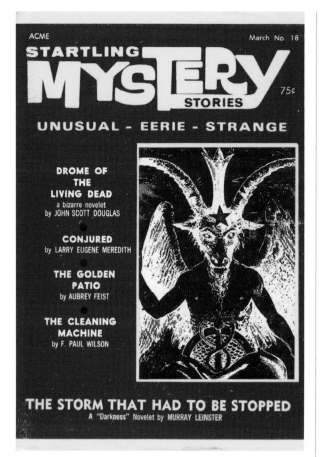

fiction digest *Magazine of Horror* in 1963. His intention was to unearth rare stories from the Golden Age of pulps, overlooked gems that hadn't been seen in 30 years and were new to fantasy fans of the '60s. Alongside the hard-to-find yarns of yore, Lowndes wanted to mix in new dark fiction by young fledgling authors.

The magazine was successful enough to spawn two sister titles in 1966, *Startling Mystery Stories* and *Famous Science Fiction*. This trio of digests was very accommodating to the fans, taking requests for reprints and bringing the best of the old pulps to the newsstand, often complete with excellent covers by Virgil Finlay reprinted from the past. New writers continued to make a splash as well. *Startling Mystery Stories'* Fall 1967 issue (#6) featured Stephen King's first commercially published story. *Famous Science Fiction* folded in 1969 and gave way to two more (short-lived) horror titles, *Weird Terror Tales* and, later, *Bizarre Fantasy*.

In addition to occasionally retitling the Golden Age pulp stories for the Health Knowledge mags, Lowndes would sometimes revise the original stories (or have an author revise his own story) to make them more relevant for the s readers or just to make them fit better into the publication. Naturally, these revisions are what later appeared in the Eerie Pubs. Many of the stories chosen for the Pubs had made their debut in the Health Knowledge digests.

In the fall of 1970, just as the first issue of *Bizarre Fantasy* was coming out, Myron Fass and Countrywide moved in and took over the operations of Health Knowledge's parent company, Acme News, Incorporated. Acme was mainly a distributor and it's anybody's guess as to why Countrywide, who were well represented distribution-wise, wanted the company. With the acquisition of Acme came the Health Knowledge publications, including the Lowndes mags, and Lowndes himself. Fass promptly canceled *Weird Terror Tales* (to make bookkeeping less confusing; the comics *Weird* and *Terror Tales* were more important to him) and left the other three magazines in Lowndes' hands.

With all of these perfectly good stories now in hand, Burgos asked Lowndes, who had relocated into the Countrywide offices, to pick out some public domain (i.e., free) stories that would be a good fit in the Pubs. Before his sacking, Lowndes selected the stories that would appear in text form in the horror comics. After only four of Lowndes' fiction magazines were published on the premises, Fass decided to liquidate Acme News, and with that, the mags were axed as well. The last Health Knowledge publication was *Magazine of Horror* #36, with an April 1971 cover date. This effectively ended Robert A.W. Lowndes 30-year sci-fi editing career.

Like the comic redraws, new titles were usually given to the stories, but otherwise the text was usually taken verbatim from the digests. A very few stories were amended by Burgos or Lowndes to allow for illustrations to fit, in particular "Space Rot," which was shorn of many descriptive paragraphs. In

other instances, the text was cut directly from the digests and pasted onto new pages with the new illustrations. Even misspellings were kept, thus author Violet M. Methley remained Violet A. Methley, a mistake started in 1932 upon the original printing of "The Milk Carts" in *Weird Tales*, and not fixed for its reprint in *Magazine of Horror* #26 (Mar. 1969). At least she enjoyed a writing credit in the Pubs (for the retitled "This Tomb is Ours"); many fine authors, such as Rudyard Kipling, H.P. Lovecraft, H.G. Wells and Charles Dickens, did not.

Nonfiction texts were culled from *Exploring the Unknown*, a Health Knowledge digest edited by Lowndes before (and during) his fiction work for the company. Two of the text stories came from Fass' own *Strange Unknown* #2, which was published under his Tempest imprint in July 1969. Every other story was supplied by Lowndes. "Abductor Minimi Digit," which saw print in *Witches' Tales* Vol. 3 #4 (August 1971), was never published in one of the Health Knowledge mags; it was probably one of the stories that was part of either the third issue of *Bizarre Fantasy Tales* or *Startling Mystery Stories* #19, both of which were prepared and delivered when the axe fell, never coming out. "Wind Demon" may be another such story.

This list (alphabetical by Eerie Pubs title) gives the story's Pubs title and appearances, original title, author, where the story was originally printed by Lowndes, and if it was an older story that Lowndes had reprinted, where it first appeared.

13th Man, The (*TOV* V5 #6 10/72) "The Trial for Murder" by Charles Collins and Charles Dickens (*Startling Mystery Stories* #3, Winter 1966/67) *Originally published as "To Be Taken with a Grain of Salt" in* All the Year Round, *Christmas 1865.*

Abductor Minimi Digit (*WT* V3 #4 8/71) by Ralph Milne Farley *Originally published in* Weird Tales, *January 1932.*

Antartic [sic] **Horror** (*SG* V1 #10 6/71, *TFTT* V6 #3 5/74) "In Amundsen's Tent" by John Martin Leahy (*Magazine of Horror* #18, November 1967) *Originally published in* Weird Tales, *January 1932.*

Beast, The (*TFTT* V4 #2 3/72) "The Mark of the Beast" by Rudyard Kipling (Magazine of Horror #4, May 1964) *Originally published in Kipling's collection entitled* Life's Handicap, *1891.*

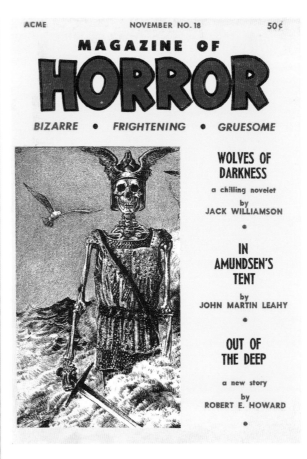

Magazine of Horror #18 (Nov. 1967) cover by Virgil Finlay

Believe It Or Not (*W* V5 #5 10/71, *WT* V5 #6 11/73) "Conjured" by Larry Eugene Meredith (*first published in* Startling Mystery Stories #18, March 1971).

Bloody Bookworm, The (*TOV* V4 #5 9/71, *TFTT* V5 #2 3/73) "The Bibliophile" by Thomas Boyd (*Magazine of Horror* #18, November 1967) *Originally published in* The Bookman, *January 1927.*

Body in the Potato Patch, The (*TT* V3 #6 11/71) by Nellie M. Nielson (*first published in* Exploring the Unknown #54, October 1969).

Bodyguard, The (*TFTT* V4 #1 2/72) "Our 'Sooner' Bodyguard" by Paul Johnstone (*first published in* Exploring the Unknown #47, July 1968).

Cannibal House (*TOV* V5 #3 4/72) "Nice Old House" by Dona Tolson (*first published in* Startling Mystery Stories #7, Winter 1967/68).

Cosmic Monster, The (*WW* V2 #4 8/71) "The Woman in Gray" by Walker G. Everett (Bizarre Fantasy Tales #2, March 1971) *Originally published in* Weird Tales, *June 1935.*

Cottingley Haunts, The (*HT* V4 #2 3/72) "The Cottingley Fairies" by F. Terry Newman (*first published in* Exploring the Unknown #47, July 1968).

Creature, The (*W* V6 #1 2/72, *TT* V6 #3 6/74) "The Ultimate Creature" by R.A. Lafferty (*first published in* Magazine of Horror #18, November 1967).

Creatures, The (*TT* V4 #3 4/72) "The Slim People" by Robert A.W. Lowndes (Exploring the Unknown #55, December 1969) *Originally published in* Future, *August 1942, under Lowndes' pseudonym* Wilfred Owen Morley.

Cry, Ghost, Cry (*TT* V4 #1 1/72) "Cry, Baby, Cry" by Henry Slesar (*first published in* Startling Mystery Stories #15, Spring 1970).

Curse of the Sword (*TOV* V4 #4 7/71) "Spell of the Sword" by Frank Aubrey (*Magazine of Horror #17, Fall 1967*) *Originally published in* Pearson's Magazine, *February 1898.*

Dark Horror (**WT** V3 #4 8/71) "A Taste of Rain and Darkness" (Uit een gordijn van regen en duisternis) by Eddie C. Bertin (*first published in English [translated from Dutch by the author] in* Bizarre Fantasy #1, Fall 1970).

Decision from Beyond (*TFTT* V4 #4 9/72) "The Question" by J. Hunter Holly (*first published in* Famous Science Fiction #1, Winter 1966/67).

Devil's Belt, The (*WT* V3 #3 6/71, *TFTT* V4 #5 11/72) "The Girdle" by Joseph McCord (*Weird Terror Tales #3, Fall 1970*) *Originally appeared in* Weird Tales, *February 1927.*

Elixir for Demons (*TOV* V4 #2 3/71, *W* V6 #6 10/72) "The Phantom Drug" by A.J. Kapfer (*Magazine of Horror #28, July 1969*) *Originally published in* Weird Tales, *April 1926.*

End, The (*W* V6 #4 6/72, *WT* V6 #5 9/74) "The Last Dawn" by Frank Lillie Pollock (*Magazine of Horror #1, August 1963*) *Originally published as "Finis" in* Argosy, *June 1906.*

Fireball (*TFTT* V4 #4 9/72) "Electric Fireballs" by Gaston Burridge (*first published in* Exploring the Unknown #47, July 1968).

Focus into Yesterday (*W* V6 #5 8/72) "Pictures from the Past" by Michael Hervey (*first published in* Exploring the Unknown #54, October 1969).

From Worlds Beyond (*W* V6 #5 8/72) "The Little Monk" as told to B. Ann Slate (*first published in* Exploring the Unknown #61, April 1971).

Ghost Client (*SG* V1 #11 8/71) "The Settlement of Dryden vs. Shard" by W.O. Inglis (*Magazine of Horror #36, April 1971*) *Originally published in* Harper's Magazine, *September 1932.*

Ghostly Gardener, The (*TT* V3 #6 11/71) by E. Rhea (*first published in* Exploring the Unknown #56, March 1970).

Ghosts, The (*TFTT* V3 #5 10/71) "A Night of Tahitian Ghosts" by Doug Edson (*first published in* Exploring the Unknown #61, April 1971).

Ghoul, The (*HT* V4 #3 4/72) "What Was It?" by Fitz-James O'Brien (*Magazine of Horror #4, May 1964*) *Originally published in* Harper's New Monthly, *1859.*

Golden Patio, The (*TT* V3 #5 9/71) by Aubrey Feist (*Startling Mystery Stories #18, March 1971*) *Originally published in* Strange Tales, *June 1932.*

Hairy Humanoids, The (*TFTT* V3 #5 10/71) "Sasquatch—the Hairy Humanoid" by Desmond Martin (*first published in* Exploring the Unknown #56, March 1970).

Hanging Man, The (*HT* V4 #1 1/72) "The Shadow on the Sky" by August Derleth (*Weird Terror Tales #2, Summer 1970*) *Originally published in* Strange Tales, *January 1932.*

Horror of the Salem Witch Trials, The (*WT* V4 #4 7/72) by Robert Norton (*first published in* Strange Unknown #2, July 1969).

House of Worm (*TT* V3 #4 7/71, *TOV* V6 #5 9/73) "The House of the Worm" by Mearle Prout (*Magazine of Horror #5, September 1964*) *Originally published in* Weird Tales, *October 1933.*

Immortal, The (*TOV* V5 #1 1/72) "Transient and Immortal" by Jim Haught (*first published in* Magazine of Horror #18, November 1967).

Innerspace (*WW* V2 #4 8/71) "Cacillia" by Reinsmith (*first published in* Bizarre Fantasy Tales #2, March 1971).

Kiss Me Deadly (*HT* V3 #4 7/71) "The White Domino" by Urann Thayer (*Startling Mystery Stories #14, Winter 1969*) *Originally published in* Ghost Stories, *July 1928.*

Lady is a Demon, The (*WT* V4 #2 3/72) "Mrs. Kaye" by Beverly Haaf (*first published in* Startling Mystery Stories #11, Winter 1968/69).

Locked in Time (*WW* V2 #2 4/71, *TT* V4 #6 10/72) "The Eternal Man" by D.D. Sharp (*Famous Science Fiction #8, Fall 1968*) *Originally published in* Science Wonder Stories, *August 1929.*

Machine, The (*SG* V1 #11 8/71) "The Cleaning Machine" by F. Paul Wilson (*first published in* Startling Mystery Stories #18, March 1971).

Menace of the UFO (*WT* V3 #5 10/71, *TT* V5 #1 2/73) "Historic UFO Fleets" by Lucius Farish (*first published in* Exploring the Unknown #54, October 1969).

Monomania (*WT* V4 #3 5/78) "John Bartine's Watch" by Ambrose Bierce (*Startling Mystery Stories #7, Winter 1967/68*) *Originally published in Bierce's collection* Can Such Things Be?, *1893 as "John Bartine's Watch—A Story by a Physician."*

Monster, The (*TOV* V4 #5 9/71, *TOV* V6 #2 10/72) "Out of the Deep" by Robert E. Howard (*first published in* Magazine of Horror #18, November 1967 from a manuscript found in his estate).

Ms. Found in a Bottle (*TOV* V5 #4 6/72) by Edgar Allen Poe (*Weird Terror Tales #1, Winter 1969/70*) *Originally published in the* Baltimore Saturday Visitor, *October 19, 1833.*

Mummy, The (*W* V6 #1 2/72, *W* V8 #3 6/74) "The Curse of Princess Amen-Ra" by Michael Hervey (*first published in* Exploring the Unknown #56, March 1970).

Nightmare (*HT* V3 #5 9/71) "Dread Exile" by Paul Ernst (*Magazine of Horror #36, April 1971*) *Originally published in* Strange Tales, *June 1932.*

Noose, The (*TT* V4 #2 3/72) "A Dream of Falling" by Attila Hatvany (*first published in* Magazine of Horror #4, May 1964).

Premier, The (*W* V5 #5 10/71, *TOV* V6 #6 11/73) "The Ashley Premier" by Eddy C. Bertin (*first published in* Bizarre Fantasy Tales #2, March 1971).

Premonition, The (*WT* V4 #5 9/72) "The Other" by Robert A.W. Lowndes (*Startling Mystery Stories #3, Winter 1966/67*) *Originally published in* Stirring Science Stories, *April 1941.*

Sacrifice (*W* V5 #6 12/71, *W* V7 #1 2/73) "The Artist of Tao" by Arthur Styron (*Magazine of Horror #36, April 1971*) *Originally published in* Strange Tales, *October 1932.*

Space Rot (*WW* V2 #3 6/71, *TT* V4 #7 12/72) "Death from the Stars" by A. Rowley Hilliard (*Famous Science Fiction #9, Spring 1969*) *Originally published in* Wonder Stories, *October 1931.*

Spiders Anyone? (*WT* V4 #5 9/72, *TOV* V7 #4 7/74) "Esmerelda" by Rama Wells (*first published in* Startling Mystery Stories #3, Winter 1966/67).

Spook Coffin (*W* V5 #4 8/71) "The Black Laugh" by William J. Maki (*Magazine of Horror #8, April 1965*) *Originally published in* Strange Tales, *January 1932.*

Strange Dream, The (*WT* V4 #1 2/72) "The Murder of Mary Moore" by Nellie M. Neilson (*first published in* Exploring the Unknown #61, April 1971).

Strange Haunt, The (*WT* V3 #5 10/71, *TFTT* V5 #2 3/73) "Virginia's Strangest Haunt" by Nathaniel R. Carter (*first published in* Exploring the Unknown #53, October 1969).

Strange Tales (*TFTT* V3 #6 12/71) "The Unfolding of Psychic Events" by Kenneth L. Larson (*first published in* Exploring the Unknown *#54, October 1969*).

Thing from the Sea, The (*TOV* V5 #2 3/72, *TT* V6 #2 4/74) "Beyond the Breakers" by Anna Hunger (*first published in* Magazine of Horror *#4, May 1964*).

Thing in the Cave, The (*WT* V4 #3 5/72) "The Voice in the Cave" by Nellie M. Neilson (*first published in* Exploring the Unknown *#56, March 1970*).

Thing, The (*TT* V4 #2 3/72, *W* V8 #2 4/74) "The Whispering Thing" by Eddy C. Bertin (*first published in* Weird Terror Tales *#1, Winter 1969/70*).

This Tomb is Ours (*TFTT* V3 #3 6/71, *HT* V4 #7 12/72, *W* V8 #4 8/74) "The Milk Carts" by Violet M. Methley (*Magazine of Horror #26, March 1969*) *Originally published in* Weird Tales, *March 1932.*

Thought Wave (*HT* V4 #4 6/72) "The Dying King's Thought Wave" by Casha Lindon (as told to Irene Bird) (*first published in* Exploring the Unknown *#56, March 1970*).

Unknown, The (*HT* V4 #6 10/72) "Shadows of Coming Events" by Harold Steinour (*Exploring the Unknown #55, December 1969*) *Originally published as a chapter in Steinour's book* Exploring the Unseen World *(Citadel, 1959).*

Unknown, The (*TFTT* V4 #1 2/72) "Clairvoyance" by Harold Steinour (*Exploring the Unknown #54, October 1969*) *Originally published as a chapter in Steinour's book* Exploring the Unseen World *(Citadel, 1959).*

Vampires, The (*TFTT* V4 #3 7/72) "After Sunset" by Philip Hazelton (*Startling Mystery Stories #11, Winter 1968/69*) *Originally published in* Strange Tales, *November 1931.*

Vampires, The (*TOV* V4 #6 11/71) "A Rendezvous in Averoigne" by Clark Ashton Smith (*Magazine of Horror #35, February 1971*) *Originally published in* Weird Tales, *May 1931.*

Voodoo's Queen of Witchcraft (*HT* V4 #5 8/72, *TT* V6 #4 8/74) by Miriam Benedict (*Strange Unknown #2, July 1969*)

Web of Terror (*W* V5 #3 6/71, *TOV* V5 #7 12/72) "The Strange Case of Pascal" by Roger Eugene Ulmer (*Startling Mystery Stories #2, Fall 1966*) *Originally published in* Weird Tales, *June 1926.*

Weird Fat Man, The (*W* V6 #3 4/72, *HT* V6 #3 4/72) "The Truth About Pyecraft" by H.G. Wells (*Magazine of Horror #4, May 1964*) *Originally published in Welles' collection* Twelve Stories and a Dream, *1897.*

Weird Ones, The (*WT* V4 #1 2/72) "The Ghosts at Pelican Inn" by Lisa Proctor (*first published in* Exploring the Unknown *#61, April 1971*).

Weird Restaurant, The (*WT* V3 #6 12/71, *TOV* V6 #3 5/73) "The Laundromat" by Dick Donley (*first published in* Weird Terror Tales *#2, Summer 1970*).

Weird Thing, The (*TT* V4 #4 6/72) "He" by H.P. Lovecraft (*Weird Terror Tales #1, Winter 1969/70*) *Originally published in* Weird Tales, *September 1926.*

Wild One, The (*HT* V3 #6 11/71) by Paul J. Johnstone (*first published in* Exploring the Unknown *#54, October 1969*).

Wind Demon (*TFTT* V3 #4 8/71)

Xebico (*W* V5 #2 4/71, *TT* V4 #6 10/72) "The Night Wire" by H.F. Arnold (*Magazine of Horror #9, June 1965*) *Originally published in* Weird Tales, *September 1926.*

This page:
Ajax's "Death on Ice"

Next page
top left:
Eerie's rewrite,
the appended
"Mummies"

Next page
bottom left:
Néstor Olivera's
redraw as
"A Tomb of Ice"

Appendix 8
Seeing Double...
Or Triple...
Or Quadruple

Perusing a stack of Eerie Pubs, one can think that they've read a story before but not recognize it. Reprints and redraws always kept the Pubs reader wondering. When the end was nigh and the Ajax stories were being redrawn, variations started racking up.

For example, the Pubs first ran this tale as "Death on Ice," faithfully reprinting the old Ajax tale intact:

After two printings, they turned Ezra Jackson loose on it. He drew on bandage lines and changed it into a mummy story titled, appropriately enough, "Mummies."

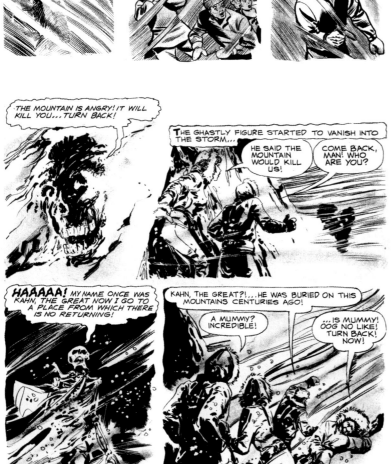

Then it came time to redraw it, so they handed the revised Mummy story to Nestor Olivera and they came up with "A Tomb of Ice."

Sometimes, when an Ajax story wasn't revised, it was still seen in three different versions: two artists were given the same story to redraw. Thus, Ajax's "Skulls of Doom" became both "Give Me Back My Brain" (art by Nestor Olivera) and "The Thing with the Empty Skull," with art by Cirilo Muñoz.

How about a story that got printed, redone by Jackson and *then* handed out to two artists?!

"Night of Terror" was printed once with its original splash panel before it was given to Jackson to splash some blood around. He turned it into a decap-tastic and memorable panel. Later, as the Ajax stories were being used for redraws, Walter Casadei did a version as "The Head Chopper" while Domingo Mandrafina turned in "House of Blood" (later known as "The House that Dripped Blood"— thank you Amicus films...).

Opposite
top right:
"Skulls of Doom"

Opposite
middle right:
"Give Me Back
My Brain"

Opposite bottom
right: "The Thing
with the Empty
Skull"

This page:
The four faces of
"Night of Terror"

Top left: The Ajax original, "Love Trap" from *Strange Fantasy* #6 (June 1953)

Top right: "Space is a Secret," the sanitized version from *Strange Journey* #2 (Nov. 1957)

Opposite page left: Burgos mixed a wild one in "Land of No Return," which only appeared once, in *Weird* V3 #4 (Sept. 1969)

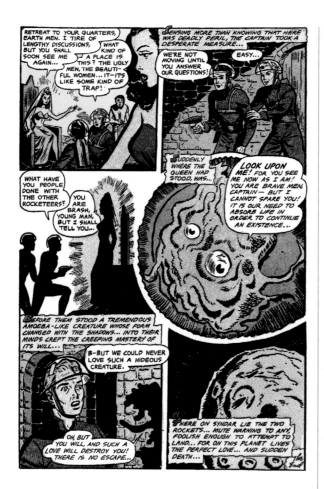

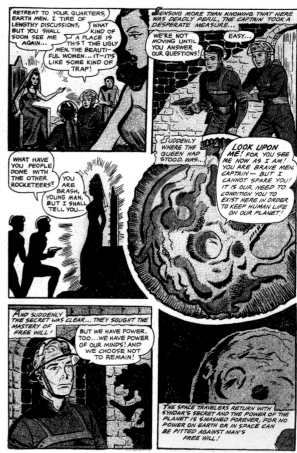

Appendix 9
Living in Syndar

This is one of the more bizarre reworkings that appeared in Eerie Publications.

The story began its existence as "Love Trap" in Ajax's *Strange Fantasy* #6 (June 1953). In this version, female astronauts in search of a suitable planet for habitation land on the planet Syndar which is inhabited by handsome men and ugly women. A second ship, commandeered by men, follows when contact is lost. When they find the ship on Syndar, they are greeted by comely females. Visiting Syndar's queen, it all becomes clear: they are shapeshifting amoeba-like monsters who want to mate with the humans to absorb their life. All of the humans die in the end, presumably fucked to death by the alien race.

Such debauchery would never fly in post-code America, so Ajax rewrote the story and softened the artwork for its reappearance as "Space is a Secret" in the code-approved *Strange Journey* #2 (Nov. 1957). All mention of "love" was removed (because we all know that meant S-E-X, right?) and the aliens were now interested in conditioning the humans for life on Syndar. The cleaned-up artwork is amusing, with the queen's bulbous eyeballs censored, cleavage and midriffs covered and all traces of fear removed from the astronauts' faces. Free will wins out and the astronauts get to return to Earth with their minds and dignity intact. Of course, the story started with them looking for a new planet to inhabit, but…

As usual, Eerie Pubs were given the redone story to work with. In the Pubs' "Land of No Return," the alien queen once again got a wild makeover (by Burgos) and extra ugly Syndarians were added to

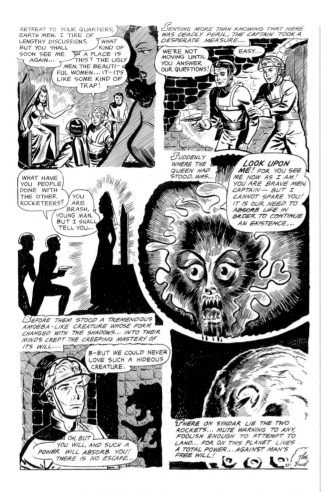

some panels. Curiously, the artwork was from the cleaned-up "Space is a Secret," but it also contains some text and dialogue from "Love Trap," making me think that Burgos peeled off the sanitized version's paste-ups, returning some of the doom and gloom to the story.

In a final bit of confusion, it appears that Burgos kind of liked the free will angle and changed some of the text from "perfect love" to "total power" and made the aliens interested in destroying man's free will. Mercifully, this returned the downer ending and the astronauts were again dead.

This story isn't the only instance where some peelin' might have been going on, creating hybrid stories. For instance, "This Head is Mine," which only appeared in *Horror Tales* V1 #8 (Aug. 1969), has so much peeled away from "Long Live Good King Charles" from *Dark Shadows* #2 (Ajax, Jan. 1958) that I have indexed it under its original title of "The Vanishing Skull" (*Haunted Thrills* #8, Apr.

1953). The humongous Jackson decap splash panel aside, great pains were taken to restore the story and art to its original specs. Some of the reworked 1958 panels survive, but not enough to list it as such in the Ajax index.

Appendix 10
Eerie Publications Posters

Rare, mysterious and unseen by most, there exist a handful of posters of Eerie Pubs prints that were derived from the original cover art. Roughly 11 x 14" and printed on flimsy paper, these turned up on eBay in the early 2000s for a pretty good chunk of change per print.

Their origins are not really known. The eBay listings had no history mentioned. A dozen or so prints have been spotted, some from the Eerie Pubs and a

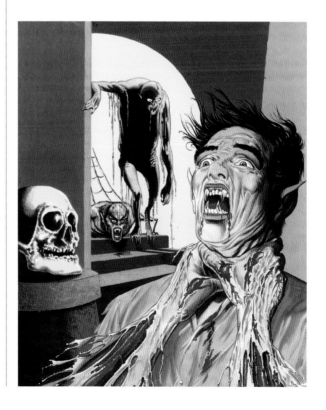

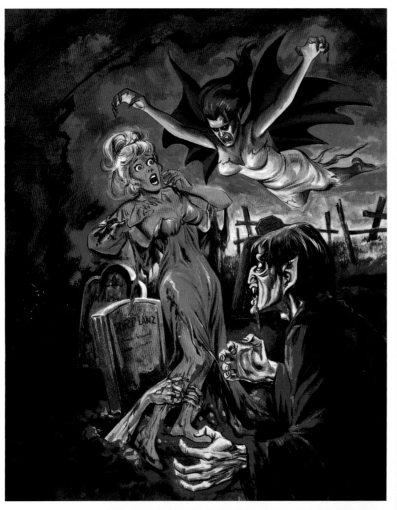

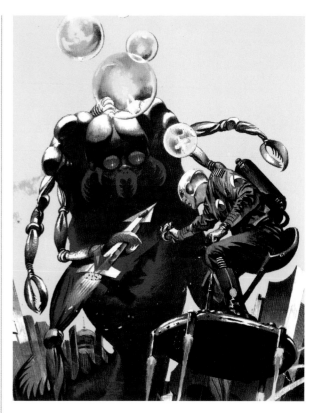

few from Myron Fass' other mags like *Crime Does Not Pay* and *Great West*. In his loving article "Through the Eerie Years" in Peter Normanton's 'zine *From the Tomb* #23 (Halloween 2007), Gene Broxson tells a tale that is just weird enough to be true…

Evidently, a serviceman was doing work at a house in New Jersey and the owner offered him some of these horrific art paintings as payment for services rendered. The serviceman took a bunch of them and had planned to return for more the next day. Upon returning, the house owner's frantic wife was screaming that the man had committed suicide and she was going to destroy all of those horrid paintings! The serviceman left and eventually sold the paintings he'd acquired.

OK, Irving Fass did live in New Jersey until his death and is thought to have taken his own life. His death records are in Broward County, Florida, however, leading one to believe that he shed his mortal coil in that state. Then again, the "owner" in this story doesn't have to have been Irving at all; maybe it was a friend or relative. It's possible the cover paintings would have been someone else's possession.

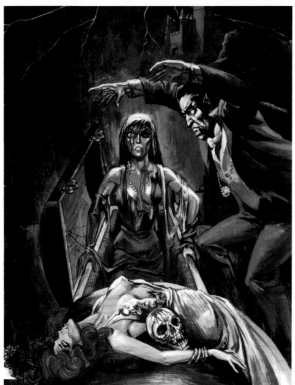

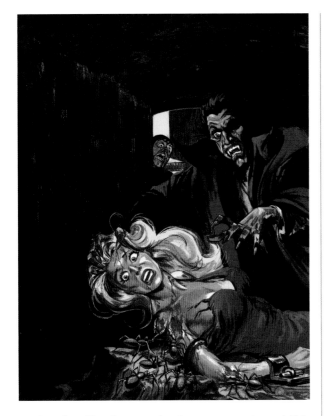

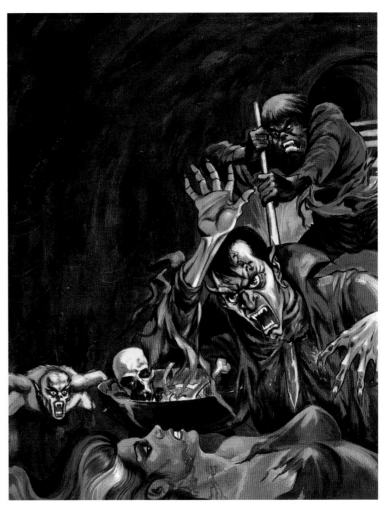

Stanley Harris was the last person to publish the comics, though his magazines were not printed from original art. Some of the covers that turned up as prints had last been published by him after he'd acquired the Pubs comics (in the split between him and Myron Fass in 1977). Since nobody has ever seen any of the original *inside* artwork turn up, one would assume that it's somewhere in Harris' possession, or in a dingy warehouse or storage bin, rotting away, forgotten. But the covers make me wonder.

Some of the covers that turned up among the prints are the original Bill Alexander (or other artists) paintings, before Carl Burgos painted over some of the figures. Others have Burgos' clippings pasted on. I'm inclined to think (and hopeful!) that Burgos didn't paint directly over the original art for his re-paints. Whatever the hell the story is with these, they are very interesting and beautiful. Alexander especially knew the game; the action in his artwork takes place in the lower right section of the page, allowing ample room for blood splotches and title logos.

I can't thank Jason Willis and Gene Broxson enough for sharing these rare birds. It's such a joy

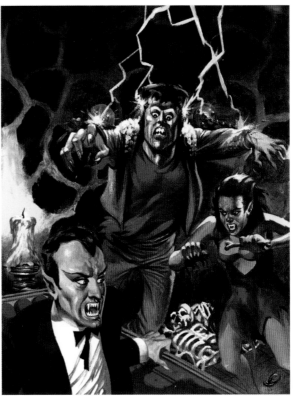

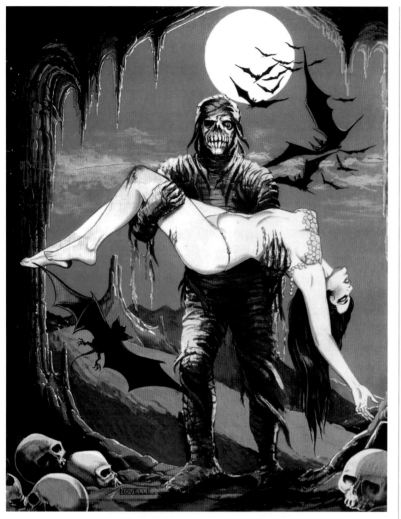

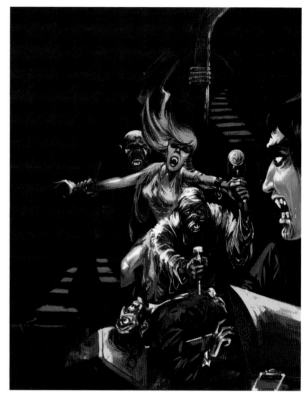

to admire these pieces of art *au naturel*, without the blurbs and logos.

The original artwork of many of these covers are in the collection of Bob Murawski. ✳

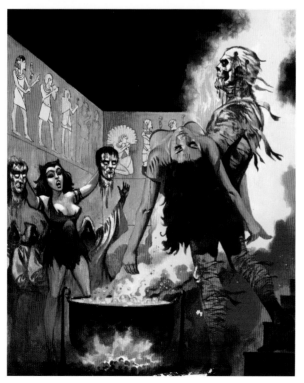

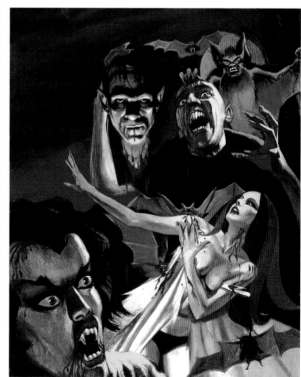

Ajax/Farrell Index

Next to the gruesome covers, one of the things most remembered about Eerie Publications might be the Ajax/Farrell pre-code horror comics that were reprinted in their pages. Over 200 stories that originally appeared in Ajax's horror books between 1952 and 1954 (and a couple of dozen of the cleaned-up versions from 1957 and 1958) again saw the light of day in the '60s and '70s, courtesy of the Pubs. Most of the stories were produced in Jerry Iger's comic studio and they are prime examples of over-the-top, twisted '50s horror.

Not all of the stories were new when they appeared in Farrell's books in the early '50s. For instance, the story "Skeletons Have Secrets," which appeared in several Eerie magazines, started its print life as "Terror Tide" in Superior's *Ellery Queen* #2 (July 1949). The title was changed (as was Ellery's name, to Johnny Jeremy) for its next incarnation in *Haunted Thrills* #1 (Ajax, June 1952) and that is how it stayed throughout its Eerie Pubs reprinting. A handful of other Ellery Queen stories from Superior, Rulah, the Jungle Goddess stories from Fox, Grimm Ghost Doctor stories from Elliot Publishing, and others suffered similar changes for their reappearance in the Ajax books. It is the revamped versions from Ajax being indexed here, as those were the ones that were provided to Eerie Pubs for reprinting.

The cleaned-up versions of the Ajax stories (see Ajax section in Chapter 5) will be listed under their new titles as, again, they are the versions reprinted in the Eerie Pubs. One oddball exception is "Land Of No Return" which was printed only once, in *Weird* V3 #4 (Sept. 1969). See Appendix 9, "Living in Syndar." The stories "Boomerang Backlash," "Ghost Bait," and "The Genius" were Ajax tales cleaned up for post-code printing, but I can't confirm that they were ever published before the Pubs ran with them.

Most of the Ajax stories were retouched by Carl Burgos and/or Ezra Jackson before they appeared in the Eerie Publications horror comics. This index will not be making note of the changes. Even I am not that anal-retentive. This is just a guide to make it easier to find a particular reprint. For cross-referencing purposes, the Eerie Pubs re-titlings will be included (in *italics*). The story title will be followed by its original publication and date, then by its Pubs appearances.

KEY

HT—HORROR TALES

SG—STRANGE GALAXY

TFTC—TALES FROM THE CRYPT

TFTT—TALES FROM THE TOMB

TOV—TALES OF VOODOO

TT—TERROR TALES

W—WEIRD

WW—WEIRD WORLDS

WT—WITCHES' TALES

A

All This Is Mine (*Midnight* #3, Sept. 1957) W V3 #3 7/69, TFTT V2 #6 12/70

And Death Makes Three (*Fantastic Fears* #7 [#1], May 1953) W V2 #9 10/68, HT V2 #3 5/70, TFTT V2 #5 10/71

Antilla Terror (*Voodoo* #2, July 1952) WT V1 #7 7/69, TFTT V2 #6 12/70

B

Beast of Baghdad (*Voodoo* #9, May 1953) W V2 #1 12/66, W V3 #4 9/69

Beautiful and the Dumb, The (*Strange Journey* #2, Nov. 1957) TFTC V1 #10 7/68, TOV V3 #1 1/70, TFTT V3 #1 2/71

Bedeviled Puppet (*Midnight* #1, Apr. 1957) TFTT V1 #6 7/69, TT V2 #6 11/70, WT V4 #3 5/72

Bedeviled Vault, The (*Strange Journey* #1, Sept. 1957)
 As *Satan's Vault of Horror* TT V1 #9 7/69

Be My Ghost (*Fantastic Fears* #8 July Aug. 1954) W V1 #11 4/66
 As *Pull Up a Coffin* HT V1 #9 11/69, W V4 #4 8/70, HT V4 #2 3/72

Black Death (*Fantastic Fears* #4, Nov. 1953) W V1 #12 10/66, TOV V2 #7 7/69, WT V2 #5 10/70, TFTT V4 #2 3/72

Blade of Horror (*Haunted Thrills* #16, July Aug. 1954) W V2 #4 10/67
 As *Off With Their Heads* W V3 #4 9/69

Bleeding Ruby, The (see Thief of Souls)

Blood and Old Bones (*Voodoo* #9, May 1953) TFTC V1 #10 7/68, WT V1 #9 12/69, TT V2 #9 7/70, TFTT V3 #5 10/71

Blood Blossom, The (*Fantastic Fears* #7 [#1], May 1953) W V1 #12 10/66, TOV V2 #7 7/69, TFTT V2 #6 12/70

Blood in the Sky (*Haunted Thrills* #11, Sept. 1953) W V3 #2 5/69, TT V2 #3 6/70, HT V3 #5 5/71, TFTT V4 #1 1/72

Blood of the Rose (*Haunted Thrills* #2, Aug. 1952) TFTT V1 #6 7/69

Bloodsuckers (see Scream No More My Lady)

Bloody Ax (see Thirsty Blade, The)

Bloody Horned Terror (see Kimbo, Boy of the Jungle)

Bloody Mary (*Strange Fantasy* #10, Feb. Mar. 1954) TOV V1 #11 11/68, TT V2 #3 5/70, WV5 #5 10/71

Bloody Things, The (see Gruesome Garden)

Boomerang Backlash (?) HT V1 #7 6/69, TOV V3 #4 7/70, TT V4 #5 8/72

Broom for a Witch (*Fantastic Fears* #9, Sept. Oct. 1954) WT #7 7/69, TT V2 #6 11/70, WT V4 #3 5/72

Bury Her Deep (see In a Lonely Place)

C

Cadaver's Revenge (*Strange Fantasy* #5, Apr. 1953) TOV V2 #1 2/69, WT V2 #3 6/70, HT V3 #5 9/71

Careless Corpse (*Fantastic Fears* #8 [#2], July 1953) W V2 #6 4/68, TOV V2 #3 2/70, HT V3 #4 7/71

Carnival of Terror (*Fantastic Fears* #8 [#2], July 1953) W V3 #1 1/68, WT V2 #2 2/70, TOV V3 #4 7/70

Caught in the Graft (*Fantastic Fears* #5, Jan. 1954)
 As *Until Dead, Rot* WT V1 #8 9/69

Chant of the Dead (*Strange Fantasy* #2, Oct. 1952) TOV V2 #2 5/69, HT V2 #4 7/70, TT V2 #6 11/71

Congo Terror (*Strange Fantasy* #3, Sept. 1952) TOV V2 #1 2/69, W V4 #4 8/70

Corpse Came Home, The (see Corpse Came to Dinner, The)

Corpse Came to Dinner, The (*Strange Fantasy* #13, Aug. Sept. 1954)
 As *Corpse Came Home, The* TFTT V1 #7 11/69

Corpses... Coast to Coast (*Voodoo* #14, Mar. Apr. 1954) W V2 #8 7/68, W V4 #3 6/70, HT V4 #1 1/72

Corpses of the Jury (*Voodoo* #5, Jan. 1953) W V2 #1 12/66, TOV V2 #4 9/69

Corpse Who Killed, The (*Haunted Thrills* #7, Mar. 1953) W V2 #2 4/67, W V4 #2 4/70, SG V1 #10 6/71

Coward's Cursevv (*Haunted Thrills* #8, Apr. 1953) W V1 #10 1/66, TOV V2 #4 9/69

Crack Up (*Fantastic* #10, Nov. Dec. 1954) TOV V1 #11 11/68, W V4 #3 6/70, WT V3 #4 8/71

Crawling Death (*Haunted Thrills* #6, Feb. 1953) TOV V1 #11 11/68, WT V2 #2 2/70, TT V3 #2 6/71

Crawling Horror, The (*Voodoo* #4, Nov. 1952) HT V1 #7 6/69, TT V2 #4 7/70, HT V3 #5 9/71

Creatures from the Deep (*Voodoo* #17, Sept. Oct. 1954) W V1 #10 1/66
 As *Slime Creatures, The* HT V1 #9 11/69, TOV V3 #4 7/70, TOV V5 #2 3/72

Cry from the Coffin (*Strange Fantasy* #8, Oct. 1953) W V1 #12 10/66, TFTT V1 #7 11/69

Cult of Evil (see Cult of the Cruel)

Cult of the Cruel (*Voodoo* #17, Sept. Oct. 1954) W V2 #2 4/67, HT V2 #2 3/70
 As *Cult of Evil* TOV V4 #3 5/71, TFTT V4 #5 11/72

Cup of Death (see Tee Off a Tomb)

D

Dancing Ghost, The (*Strange Fantasy* #3, Dec. 1952) W V2 #8 7/68, TT V2 #3 5/70

Dead Man's Pajamas (*Voodoo* #15, May June 1954)
 As *Now I Lay Me Down to Die* W V4 #4 9/69

Dead Went Marching By, The (see Trumpet of Doom)

Deadly Ghouls, The (see Golden Ghouls, The)

Deadly Pickup (*Voodoo* #16, July Aug. 1954) W V1 #10 1/66, TFTT V1 #7 11/69

Deadly Wish (*Fantastic Fears* #9, Sept. Oct. 1954)
 As *Hell Below* TFTT V1 #6 7/69, WT V2 #5 10/70, WT V4 #2 3/72

Dearest, Deadest Dummy (*Haunted Thrills* #6, Feb. 1953) W V2 #6 4/68, WT V2 #2 3/70, TOV V4 #3 5/71, W V6 #1 2/72

Death at the Mardi Gras (*Haunted Thrills* #10, July 1953) TT V1 #8 5/69, WT V2 #6 12/70

Death Claws (*Strange Fantasy* #2 [#1], Aug. 1952) TT V1 #8 5/69, HT V3 #1 1/71

Death Dance (*Strange Fantasy* #2, Dec. 1952) W V2 #4 10/67, W V3 #5 12/69, TFTT V3 #2 5/71

Death Is No Stranger (*Strange Fantasy* #4, Feb. 1953) TT V1 #8 5/69, TT V2 #5 10/70,
 WT V4 #4 7/72

Death Is Only Skin Deep (*Haunted Thrills* #2, Aug. 1952) W V2 #4 8/70

Death on Ice (*Strange Fantasy* #6, June 1953) W V2 #10 12/68, W V4 #2 4/70
 As *Mummies* TOV V4 #4 7/71

Death's Shoes (*Voodoo* #9, May 1953) W V2 #6 4/68, TOV V3 #2 3/70, HT V3 #4 7/71

Death Strikes Four (*Strange Fantasy* #8, Oct. 1953) TOV V2 #1 2/69, TT V2 #4 7/70,WT V4 #1 1/72

Death to a Traitor (see Voyager of Death)

Death Trap (see Safe, But Not Sound)

Debt of Fear (*Strange Fantasy* #4, Feb. 1953) W V2 #9 10/68, W V4 #1 2/70, TFTT V3 #2 4/71, HT V5 #2 4/73

Demon (see Dragon Egg)

Demon Fiddler (*Fantastic Fears* #7, May June 1954) W V2 #4 10/67, TOV V3 #1 1/70, HT V3 #5 3/71, TFTT V4 #1 2/72

Demon in the Dungeon (*Strange Fantasy* #4, Feb. 1953) W V3 #1 1/68, TT V2 #2 3/70, WT V3 #3 6/71

Demon's Doom (*Strange Fantasy* #14, Oct. Nov. 1954) TOV V2 #5 5/69, TT V2 #4 7/70
 As *Doom of Evil* SG V1 #9 4/71, TOV V6 #1 1/73

Devil Collects (*Haunted Thrills* #15, May June 1954) W V3 #1 2/69, TOV V3 #5 5/70, TT V3 #5 5/71, TOV V5 #1 2/73

Devil Flower (*Voodoo* #7, Mar. 1953) W V2 #9 10/68, HT V2 #1 1/70, W V5 #1 2/71

Devil On His Shoulder (*Haunted Thrills* #9, May 1953) WT V1 #7 7/69, WT V3 #1 1/71

Devil's Bride (*Haunted Thrills* #16, July Aug. 1954) W V1 #10 1/66, HT V1 #9 11/69
 As *Satan's Bride* TOV V3 #4 7/70, W V6 #4 6/72

Devil's Sketchbook (*Fantastic Fears* #4, Nov. 1953) HT V1 #7 6/69, TOV V3 #3 5/70, W V1 #12 2/72

Dig Me a Grave (see Three in a Grave)

Dollars and Doom (*Voodoo* #8, Apr. 1953) HT V1 #7 6/69, WT V2 #4 8/70
 As *Money for a Corpse* W V6 #4 6/72

Doom at the Wheel (*Voodoo* #10, Nov. Dec. 1954) W V2 #2 4/67, TOV V2 #3 2/70, HT V3 #4 7/71

Doomed (*Voodoo* #15, May June 1954) W V1 #10 1/66, TOV V2 #4 9/69

Doom of Evil (see Demon's Doom)

Dragon Egg (*Fantastic Fears* #7, May June 1954) TOV V2 #1 2/69
 As *Demon* WT V2 #3 6/70, TFTT V3 #4 8/71, HT V10 #1 2/79

Dream of Death (see Dream of Horror)

Dream of Horror (*Strange Fantasy* #9, Dec. 1953)
 As *Dream of Death* TT V1 #9 7/69
 As *Nightmare* W V1 #12 10/66

Druid's Castle (*Fantastic Fears* #3, Sept. 1953) TOV V1 #11 11/68, TFTT V2 #4 7/70, SG V1 #10 6/71

Drums of Doom (*Voodoo* #4, Nov. 1952) TOV V2 #2 5/69, W V2 #4 8/70, HT V4 #5 8/72

Dying Is So Contagious (*Haunted Thrills* #14, May June 1954) W V2 #4 4/67, TT V2 #2 3/70, W V5 #6 12/71

E

Eerie Bones (*Haunted Thrills* #4, Dec. 1952) TOV V1 #11 11/68, TFTT V2 #4 7/70

Empty Coffin, The (see Spiteful Spirit, The)

Escape From Hell (*Fantastic Fears* #5, Jan. 1954) W V3 #2 5/69, TOV V3 #5 9/70, TT V4 #2 3/71

Exit the Lone Ghost (*Strange Journey* #3, Feb. 1958) W V3 #3 7/69, WT V2 #5 10/70, TT V4 #3 4/72

Experiment in Terror (*Haunted Thrills* #13, Jan. 1954) TFTC V1 #10 7/68, W V3 #5 12/69, TT V2 #5 9/70, TT V3 #6 11/71

F

Fanged Horror (see Fanged Terror)

Fanged Terror (*Haunted Thrills* #18, Nov. 1954) W V1 #12 10/66
 As *Fanged Horror* W V3 #4 9/69

Fangs of Fear (*Strange Fantasy* #12, June July 1954) W V1 #11 4/66, TFTT V1 #7 11/69

Fatal Horror (*Strange Fantasy* #3, Jan. Feb. 1952) TT V1 #8 5-69, W V2 #5 10/70, WT V4 #3 5/72

Fatal Scalpel (*Haunted Thrills* #5, Jan.1953) W V2 #1 12/66, TFTT V1 #7 11/69

Fate Laughs at Clowns (*Fantastic* #10, Nov. Dec. 1954) W V2 #6 4/68, WT V2 #3 6/70, HT V3 #5 9/71

Fear Has a Name (*Voodoo* #12, Nov. 1953) W V3 #1 2/69, TOV V3 #3 5/70, WW V2 #2 4/71
 As *Rat Race, The* WT V5 #1 1/73

Fear of the Witch (*Haunted Thrills* #15, May June 1954) W V2 #10 12/68, TOV V2 #2 4/70, W V5 #4 8/71

Fiends From the Crypt (*Fantastic Fears* #8 [#2], July 1953) W V2 #2 4/67, TOV V2 #2 3/70, WW V2 #3 6/71, TFTT V5 #1 1/73

Forever and Ever (*Midnight* #2, July 1957) TT V1 #8 5/69, TFTT V2 #5 10/70, TT V4 #5 8/72

Forever Dead (*Voodoo* #17, Sept. Oct. 1954) TFTC V1 #10 7/68, HT V1 #11 1/70, WT V4 #1 1/72

Frigid Fear (*Haunted Thrills* #14, Mar. Apr. 1954) TT V1 #7 3/69, TFTT V2 #5 10/70, TT V4 #5 8/72

From Beyond the Grave (see Ghost Gloves)

From the Grave Below (see Permanent Partners)

G

Game Called Dying, The (*Voodoo* #3, Sept 1952) W V3 #1 2/69, W V4 #3 6/70, WT V3 #5 10/71

Gateway to Yesterday, The (*Midnight* #2, July 1957) W V3 #3 7/69, WT V2 #5 10/70, TT V4 #3 4/72

Genius, The (?) W V3 #4 9/69

Ghost Gloves (*Haunted Thrills* #1, June 1952)
 As *From the Grave Below* W V3 #4 9/69

Ghostly Guillotine (*Voodoo* #8, Apr. 1953) W V2 #4 10/67, TOV V2 #7 7/69, TFTT V2 #6 12/70

Ghoul, The (see Three in a Grave)

Ghoul and the Guest, The (*Strange Fantasy* #2 [#1] Aug. 1952) W V2 #8 7/68, WT V2 #4 7/70, TFTT V3 #6 8/71, HT V5 #1 2/73

Ghoul for a Day (*Voodoo* #5, Jan. 1953) W V2 #3 6/67, HT V1 #9 11/69
 As *Undertaker* TOV V3 #4 7/70, W V4 #1 2/72

Ghoul's Bride (*Haunted Thrills* #, Feb. 1953)
 As *Hanging Ghoul, The* TT V1 #10 1/70, W V5 #2 4/71

Ghoul's Castle (*Haunted Thrills* #4, Dec. 1952) W V3 #3 7/69, WT V2 #6 12/70

Golden Ghouls, The (*Voodoo* #1, May 1952)
 As *Deadly Ghouls, The* TT V1 #9 7/69

Grave Rehearsal (*Strange Fantasy* #7, Aug. 1953) W V3 #3 7/69, TOV V3 #3 5/70, HT V4 #4 7/72

Gravestone for Gratis (*Fantastic* #11, Jan. Feb. 1955) TT V1 #7 3/69, TOV V3 #5 9/70, HT V4 #3 4/72

Green Horror (*Fantastic Fears* #8, July Aug. 1954) WT V1 #7 7/69, HT V2 #6 11/70, TFTT V3 #4 8/71

Grimm, Ghost Doctor (see Music and Mayhem)

Gruesome Garden (*Haunted Thrills* #13, Jan. 1954) W V2 #3 6/67, W V3 #5 12/69
 As *Bloody Things, The* TFTT V3 #6 12/71
 As *Gruesome Things, The* W V4 #6 12/70

Gruesome Things, The (see Gruesome Garden)

H

Hair Yee-eee (*Strange Fantasy* #9, Dec. 1953) TOV V2 #1 2/69, TOV V3 #5 9/70, HT V4 #3 4/72

Hammer of Evil (*Voodoo* #15, May June 1954) TOV V2 #2 5/69, WT V2 #3 6/70, WT V3 #1 1/71

Hands of Terror (*Haunted Thrills* #5, Jan. 1953) W V2 #6 4/68, TFTT V2 #2 4/70, WW V2 #4 8/71

Hanging Ghoul, The (see Ghoul's Bride)

Haunted Hero (*Midnight* #3, Sept. 1957) TOV V2 #3 7/69, TFTT V2 #6 12/70

Haunted Lighthouse (see Lighthouse Keeper Wanted)

Hawk's Folly (*Fantastic Fears* #7 [#1], May 1953)
 As *Werewolf* TFTT V1 36 7/69, TT V2 #6 11/70, W V6 #3 4/72

Heads of Hate (see Heads of Horror)

Heads of Horror (*Voodoo* #14, Mar. Apr. 1954) W V1 #12 10/66, As *Heads of Hate* W V3 #7 9/69

Hell Below (see Deadly Wish)

He Rose from the Grave (see Horror in the Hills)

Hissing Horror (*Fantastic Fears* #, Nov. 1953) W V3 #1 2/69, TFTT V2 #3 6/70, TT V3 #3 5/71, TOV V5 #1 2/73

Hole in the Sky, A (*Strange Journey* #1, Nov. 1957) W V2 #10 2/68, WT V2 #3 6/70, SG V1 #11 8/71

Horribly Beautiful (*Voodoo* #11, Sept. 1953) W V2 #6 4/68, TOV V3 #2 3/70, TT V3 #5 5/71

Horror Comes to Room 1313 (*Voodoo* #11, Sept. 1953) W V3 #1 1/68, HT V2 #3 5/70, WT V3 #4 8/71

Horror Harbor (*Haunted Thrills* #8, Apr. 1953) TFTC V1 #10 7/68, WT V2 #1 2/70, TT V3 #2 3/71,WT V4 #6 11/72

Horror Hour (*Haunted Thrills* #3, Oct. 1952) W V3 #3 7/69

Horror in the Hills (*Voodoo* #2, July 1952)
 As *He Rose from the Grave* TFTT V1 #6 7/69, WW V2 #1 2/71

Horror in the Mine (*Haunted Thrills* #2, Aug. 1952) V2 #3 6/67, TT V1 #10 11/69, WW V2 #1 2/71

Horror Unlimeted [sic] (*Voodoo* #16, July Aug. 1954)
 As *Terror Unlimited* W V2 #6 4/67, TT V1 #10 11/69, TOV V3 #6 11/70, SG V1 #9 4/71, TT V4 #7 12/72

House of Chills (*Haunted Thrills* #5, Jan. 1953) W V2 #9 10/68, HT V2 #1 1/70, TOV V4 #2 3/71

I

Idol of Evil (*Voodoo* #10, July 1953) W V2 #10 12/68, TOV V3 #2 3/70, TT V3 #4 7/71

If I Should Die (*Haunted Thrills* #18, Nov. 1954) W V2 #8 7/68, TT V2 #3 5/70, WT V3 #3 5/71, TOV V5 #1 1/72

In a Lonely Place (*Strange Fantasy* #11, Apr. May 1954) W V2 #4 10/67
 As *Bury Her Deep* HT V1 #9 11/69, TT V2 #4 7/70, TT V3 #5 9/71

Invisible Terror, The (*Rocketman* #1, June 1952)
 As *Unseen Terror, The* TT V1 #9 7/69

I, the Coffin (*Fantastic Fears* #7, May June 1954) W V1 #11 4/66, TT V1 #10 11/69, W V4 #6 12/70, TOV V4 #5 9/71

J

Jinxed Genius, The (*Dark Shadows* #1, Oct. 1957) W V3 #3 7/69, WT V2 #6 12/70

K

Killer Lady (*Voodoo* #6, Feb. 1953) W V2 #8 7/68, HT V2 #3 5/70

Kimbo, Boy of the Jungle (*Vooda* #20, Apr. 1955)
 As *Bloody Horned Terror, The* HT V2 #8 8/69

King of Hades, The (*Voodoo* #11, Sept. 1953) TOV V1 #11 11/68, TT V2 #3 5/70, V5 #2 4/71, TFTT V4 #5 11/72

L

Last Chapter, The (*Midnight* #3, Sept.1957) W V4 #4 8/70

Last Laugh, The (*Midnight* #5, Feb 1958) W V3 #3 7/69, WW V2 #1 2/71

Lighthouse Keeper Wanted (*Midnight* #1, Apr. 1957)
 As *Haunted Lighthouse* HT V1 #8 8/69

Little Red Riding Hood and the Werewolf (*Fantastic Fears* #8 [#2], July 1953) W V1 #11 4/66
 As *Werewolf* HT V1 #9 11/69, TOV V3 #6 11/70, W V5 #6 12/71

Locked in Time (*Midnight* #3, Sept. 1957) TOV V2 #3 7/69, W V4 #6 12/70, SG V1 #11 8/71

M

Madness of Terror (*Haunted Thrills* #9, May 1953) W V2 #4 10/67, TFTT V1 #7 11/69

Man Beast (see My Dear Friend)

Mask of the Monster (*Voodoo* #10, July 1953) TOV V2 #1 2/69, TOV V3 #3 5/70, WT V3 #2 4/71,TFTT V4 #9 9/72

Meet Me in My Tomb (*Strange Fantasy* #14, Oct. Nov. 1954) TT V1 #8 5/69, TFTT V2 #2 4/70, TT V2 #5 10/70,

Mirror of Death (*Strange Fantasy* #9, Dec. 1953) W V2 #10 12/68, TFTT V2 #2 4/70,WT V3 #6 12/71

Mirror of Madness (*Haunted Thrills* #17, Sept. Oct. 1954) WT V1 #7 7/68, TOV V3 #6 11/70,HT V3 #6 11/71

Money for a Corpse (see Dollars and Doom)

Monster (see Monster Mill)

Monster in the Mist (*Haunted Thrills* #17, Sept. Oct. 1954) W V1 #11 4/66, TT V1 #10 11/69, TOV V3 #6 11/70, HT V3 #5 3/71, TOV V5 #1 1/72

Monster Mill (*Haunted Thrills* #6, Feb. 1953) W V3 #2 5/69
 As *Monster* TOV V3 #5 9/70, HT V4 #3 4/72
Monsters for Rent (*Haunted Thrills* #3, Oct. 1952) W V2 #4
 10/67, HT V2 #1 1/70, TFTT V3 #1 2/71
Mummies (see Death on Ice)
Music and Mayhem (*Haunted Thrills* #3, Oct. 1952)
 As *Grimm, Ghost Doctor* WT V1 #7 7/69
Murder on the Moor (*Haunted Thrills* #10, July 1953) W V1
 #11 4/66, TOV V2 #4 9/69
Murder Pool, The (*Strange Fantasy* #13, Aug. Sept. 1954) W
 V2 #8 7/68, W V4 #2 4/70,W V6 #7 12/72
My Dear Friend (*Dark Shadows* #1, Oct. 1957)
 As *Man-Beast* TFTT V1 #6 7/69, TOV V3 #6 11/70, W V5 #5
 10/71

N

Needless Night, The (*Midnight* #2, July 1957) W V2 #6 4/68,
 WT V2 #2 4/70, WT V3 #6 12/71
Nightmare (see Dream of Horror)
Nightmare Island (*Voodoo* #15, May June 1954) W V2 #1 12/66,
 TOV V2 #3 7/69, WW V1 #10 12/70, HT V4 #6 10/72
Nightmare Mansion (*Haunted Thrills* #3, Oct. 1952) W V3 #1
 2/69, TOV V3 #3 5/70,WT V3 #2 4/71
Nightmare Merchant (*Strange Fantasy* #7, Aug. 1953) TT V1
 #7 3/69, W V4 #5 10/70,TOV V5 #3 4/72
Night of Terror (*Voodoo* #16, July Aug. 1954) W V1 #11 4/66,
 TT V1 #10 11/69, HT V4 #6 11/70,TFTT V3 #4 8/71
Now I Lay Me Down To Die (see Dead Man's Pajamas)

O

Ohhhh, Brother (*Voodoo* #11, Sept. 1953) WT V1 #7 7/69,
 TT V3 #1 1/71
One Very Wide Coffin (*Strange Fantasy* #10, Feb. Mar. 1954)
 TOV V2 #2 5/69, HT V4 #7 7/70, TT V3 #6 11/71
Our Green-Eyed Princess of Dumbrille (*Strange Journey*
 #2, Nov. 1957) W V2 #10 12/68, HT V3 #5 3/70, TFTT V3
 #6 12/71

P

Permanent Partners (*Dark Shadows* #1, Oct. 1957)
 As *From Beyond the Grave* WT V1 #8 9/69
Phantom Express (*Strange Journey* #1, Sept. 1957) TT V1
 #9 7/69
Pit of Horror (*Haunted Thrills* #6, Feb. 1953) W V2 #2 4/67,
 W V4 #2 4/70, WW V2 #4 8/71
Portrait of Death (*Haunted Thrills* #4, Dec. 1952) WT V1
 #8 9/69
Primitive Horror (see Primitive Peril)
Primitive Peril (*Strange Fantasy* #2 [#1], Aug. 1952)
 As *Primitive Horror* W V3 #4 9/69
Project Final X (*Midnight* #4, Nov. 1957) TT V1 #9 7/69
Promise, The (*Midnight* #2, Sept. 1957) HT V1 #8 8/69
Pull Up a Coffin (see Be My Ghost)

R

Rendezvous with Doom (*Haunted Thrills* #13, Jan. 1954) W V2
 #3 6/67, HT V1 #9 11/69, TFTT V2 #4 8/70, HT V4 #4 6/72
Rest in Hate (see Rest in Peril)
Rest in Peril (*Strange Fantasy* #6, June 1953) W V1 #12 10/66
 As *Rest in Hate* W V4 #4 9/69
Riddle of Manitou Rock, The (*Strange Fantasy* #8, Oct. 1953)
 TFTT V1 #6 7/69, TFTT V3 #1 2/71
Risky Report, A (*Midnight* #4, Nov. 1957)
 As *Unknown, The* HT V1 #8 8/69

S

Safe, But Not Sound (*Dark Shadows* #1, Oct. 1957)
 As *Death Trap* TFTT V1 #6 7/69, TT V2 #6 11/70, TT V4 #4
 6/72
Satan's Bride (see Devil's Bride)
Satan's Plaything (*Voodoo* #8, Apr. 1953) HT V1 #7 6/69, W V4
 #4 8/70, HT V4 #2 3/72
Satan's Vault of Horror (see Bedeviled Vault, The)
Scales of Death (*Strange Fantasy* #12, June July 1954) TT V1
 #7 3/69, W V4 #5 10/70, TOV V5 #3 4/72
Scream No More, My Lady (*Fantastic* #10, Nov. Dec. 1954)
 W V1 #11 4/66
 As *Bloodsuckers* TFTT V4 #3 7/72
 As *Vampires* TT V1 #10 11/69, HT V4 #2 6/11/70
Screams in the Night (*Haunted Thrills* #7, Mar. 1953) HT V1
 #7 6/69, W V4 #4 8/70, TOV V5 #2 3/72
Screams in the Swamp (*Haunted Thrills* #10, July 1953) W V3
 #1 1/68, HT V2 #2 3/70, TOV V4 #3 5/71
Secret Coffin (*Fantastic Fears* #9, Sept. Oct. 1954) W V3 #1
 1/68, W V4 #2 4/70, SG V1 #10 6/71
Shelf of Skulls, The (*Voodoo* #1, May 1952) TT V1 #8 5/69, W
 V4 #6 12/70, HT V4 #1 1/72
Skeleton in the Closet, A (*Strange Fantasy* #7, Aug. 1953)
 TFTC V1 #10 7/68, WT V2 #1 2/70, TT V3 #3 2/71, WT
 V4 #6 11/72
Skeletons Have Secrets (*Haunted Thrills* #1, June 1952) TOV
 V2 #2 5/69, TT V2 #4 7/70, SG V1 #9 4/71, TT V4 #1 1/72
Skull Scavenger (*Strange Fantasy* #6, June 1953) W V2 #9
 10/68, W V4 #2 4/70, TT V3 #4 7/71
Skulls of Doom (*Voodoo* #12, Nov. 1953) TT V1 #7 3/69, W
 V4 #5 10/70
Slime Creatures, The (see Creatures from the Deep)
Sound of Mourning (*Voodoo* #18, Nov. Dec. 1954) W V3 #1
 2/69, TT V2 #3 6/70, TV V3 #3 5/71, HT V5 #1 2/73
Speedy the Sport (*Midnight* #1, Apr. 1957)
 As *Wall of Blood* HT V1 #8 8/69
Spiteful Spirit, The (*Voodoo* #5, Jan. 1953)
 As *Empty Coffin, The* W V2 #5 2/69, TFTT V2 #5 10/70,
 TOV V5 #5 8/72
Stretching Things (*Fantastic Fears* #5, Jan. 1954) W V2 #8 7/68,
 WT V2 #2 4/70, TT V3 #4 7/71, HT V5 #2 4/73, WT V8 #2 5/77
Swamp Haunt (*Haunted Thrills* #5, Jan. 1953) W V1 #12 10/66
 As *Witches' Haunt* WT V1 #8 9/69

T

Taste of Blood, A (see Tiger-Tiger)
Tee Off a Tomb (*Strange Fantasy* #10, Feb. Mar. 1954)
 As *Cup of Death, The* HT V1 #8 8/69
Temple of the Beast (*Fantastic Fears* #5, Jan. 1954) W V2 #4
 10/67, TT V1 #9 7/69
Terror Below (*Haunted Thrills* #12, Nov. 1953) W V3 #1 1/68,
 TOV V3 #1 1/70, WT V3 #1 2/71
Terror in the Attic (*Strange Fantasy* #13, Aug. Sept. 1954) W
 V2 #4/67, TT V2 #2 3/70,TOV V4 #4 7/71
Terror of Akbar, The (*Strange Fantasy* #10, Feb. Mar. 1954) W
 V1 #10 1/66, TOV V2 #4 9/69
Terror Town (*Strange Fantasy* #12, June July 1954) W V3 #2
 5/69, HT V2 #5 9/70, W V6 #4 6/72
Terror Unlimited (see Horror Unlimited [sic])
They Couldn't Die (*Voodoo* #13, Jan. 1954) W V2 #1 12/66,
 TFTT V1 #7 11/69
Thief of Souls (*Voodoo* #4, Nov. 1952) TFTC V1 #10 7/68, WT
 V1 #9 12/69
 As *Bleeding Ruby, The* TOV V4 #3 5/71
Thirsty Blade, The (*Voodoo* #19, Jan. Feb. 1955)
 As *Bloody Ax, The* TOV V2 #3 7/69, WT V2 #6 12/71
This Head is Mine (see Vanishing Skull, The)
Three in a Grave (*Haunted Thrills* #8, Apr. 1953) W V2 #1 12/66
 As *Dig Me a Grave* TT V1 #10 11/69
 As *Ghoul, The* W V4 #6 12/70, TOV V4 #5 9/71
Three Times Dead (see Trail to a Tomb)
Tiger's Paw, The (*Fantastic* #11, Jan. Feb. 1955) HT V1 #7 6/69,
 WT V2 #4 8/70, TT V4 #4 6/72
Tiger-Tiger (*Haunted Thrills* #18, Nov. 1954) W V2 #1 12/66
 As *Taste of Blood, A* WT V1 #8 9/69
Torture Garden (*Voodoo* #13, Jan. 1954) W V2 #10 12/68, W V4
 #3 6/70, WT V3 #6 12/71
Torture Travelogue (*Voodoo* #9, May 1953) W V3 #2 5/69, HT
 V2 #5 9/70, HT V4 #3 4/72
Trail to a Tomb (*Haunted Thrills* #7, Mar. 1953)
 As *Three Times Dead* TFTT V1 #7 11/69
Trumpet of Doom (*Haunted Thrills* #14, Mar. Apr. 1954) W
 V1 #10 1/66
 As *Dead Went Marching By, The* TOV V2 #4 9/69
Two on the Aisle of Death (*Haunted Thrills* #7, Mar. 1953) TT
 V1 #7 3/69, TT V2 #3 5/70, TFTT V3 #2 4/71

U

Undertaker (see Ghoul for a Day)
Undying Fiend, The (*Strange Fantasy* #12, June July 1954) TT
 V1 #7 3/69, W V4 #5 10/70, WT V4 #3 5/72
Unknown, The (see Risky Report, A)
Unseen Terror, The (see Invisible Terror, The)
Until Dead, Rot! (see Caught in the Graft)

V

Vampires (see Scream No More My Lady)
Vanishing Cadavers (*Voodoo* #10, July 1953)
 As *Vanishing Dead, The* TOV V1 #11 2/69, HT V2 #4 7/70,
 TOV V4 #6 11/71
Vanishing Dead, The (see Vanishing Cadavers)
Vanishing Skull, The (*Haunted Thrills* #8, Apr. 1953)
 As *This Head is Mine*, HT V1 #8 8/69*
Voodoo Vengeance (*Haunted Thrills* #12, Nov. 1953)
 As *Zombie Vengeance* W V3 #2 6/69, W V2 #6 11/70, HT
 V4 #5 8/72
Voyager of Death (*Haunted Thrills* #2, Aug. 1952)
 As *Death to a Traitor* WT V1 #8 9/69

* "This Head is Mine" is really a combination of the pre-code
"Vanishing Skull" and its 1958 reworking "Long Live Good
King Charles" from Dark Shadows #2. Burgos and Jackson
did their best to revert it back to the horror of the original.

W

Wall of Blood (see Speedy the Sport)
Web of the Widow (*Haunted Thrills* #16, July Aug. 1954) W V1
 #11 4/66, TT V1 #10 11/69, HT V2 #6 11/70, WT V4 #4 7/72
Weird Dead, The (*Voodoo* #6, Feb. 1953) W V2 #9 10/68, TT V2
 #1 1/70, TOV V2 #3 7/71, W V6 #6 10/72
Werewolf (see Hawk's Folly)
Werewolf (see Little Red Riding Hood and the Werewolf)
Werewolf Castle (*Voodoo* #18, Nov. Dec. 1954) W V2 #8 7/68,
 WT V2 #2 4/70, TFTT V3 #3 6/71
When the Sea Goes Dry (*Strange Journey* #1, Sept. 1957) W V2
 #3 6/67, TOV V2 #4 9/69
Who Knows? (*Midnight* #4, Nov. 1957) HT V1 #8 8/69
Witches' Haunt (see Swamp Haunt)
Witch or Widow (*Voodoo* #14, Mar. Apr. 1954) W V3 #2 5/69,
 TOV V3 #5 9/70, W V6 #2 3/72
Witch's Brand (*Strange Fantasy* #5, Apr. 1953) TOV V2 #2
 5/69, HT V2 #4 7/70,TOV V4 #6 11/71
Witch's Curse (*Haunted Thrills* #1, June 1952) TOV V2 #3 7/69,
 HT V2 #6 11/70, WT V4 #4 7/72
Witch's Horror (*Haunted Thrills* #10, July 1953) W V3 #1 1/68,
 TOV V3 #1 1/70
 As *Witch's Revenge* WT V3 #1 2/71
Witch's Revenge (see Witch's Horror)

Y

Your Coffin is Waiting, Sir (*Fantastic Fears* #6, Apr. May 1954)
 TOV V1 #11 11/68, HT V2 #3 5/70, TOV V4 #6 11/71

Z

Zombie Bride (*Voodoo* #2, July 1952) W V2 #3 6/67
Zombie Vengeance (see Voodoo Vengeance)
Zombi's Bride, The (*Fantastic Fears* #3, Sept. 1953) W V3 #1
 2/69, TFTT V2 #3 6/70, TT V3 #3 5/71, W V7 #1 2/73

New Art Master List

 This list represents the stories that were drawn expressly for the Eerie Publications horror magazines. The majority of these stories were selected from pre-code horror comics, with new artwork illustrating the borrowed scripts. There are some strange idiosyncrasies present with the Pubs' story selection process.

 For instance, from Ace Magazines, the Pubs chose only stories from the title *Web of Mystery*, ignoring the company's other horror titles. Ace, like many other precode companies, were no strangers to reprinting their own material, so some of the stories from *Web* had seen print earlier in different titles. Still, despite a few stories that were previously printed in *The Beyond* and *Challenge of the Unknown*, Eerie Pubs were definitely only dealing with *Web of Mystery* and that is what is referenced here.

 Comic Media, who published two horror titles in the '50s, had their stories from *Weird Terror* appropriated by the Pubs, but not from its sister title *Horrific*. Of course, there are a few instances of stories being reprinted between the two titles, but in most cases (not all), Comic Media re-titled them and made minute changes in text before reuse, thus making it clear that *Weird Terror* was favored by Burgos.

 The trend continued with most publishers: Fawcett's *Beware Terror Tales*, Story's *Mysterious Adventures*, Standard's *Out of the Shadows* and St. John's *Weird Horrors*. These publishers all had other fine horror comics published back in the day, but Eerie Publications stuck to their chosen titles.

 While Gillmor had stories from both *Weird Tales of the Future* and *Weird Mysteries* redrawn, their flagship horror title *Mister Mystery* was not used. The whole of *Weird Mysteries* #2 (Dec. 1952) was later reprinted in *Mister Mystery* #18 (Aug. 1954), but this list refers to the tales' original appearance only.

 Harvey Comics was a completely different story. All four of their horror titles were hit, and hit hard. Nearly 200 of the redrawn Eerie Publications stories came from Harvey's quartet of *Black Cat Mystery*, *Chamber of Chills*, *Tomb of Terror* and *Witches Tales*. That is a benefit for Pubs fans because Harvey, while prolific, always kept the quality high.

 There are some stories here that I am positive are redraws but I have not been able to track down their pre-code counterparts. I leave these blank and hope that further research uncovers their origins.

KEY

Angry Vampire, The (Fraga; redraw "Blood Thirsty"—Mysterious Adventures #21, Aug. 1954, Story) W V4 #6 (12/70), W V5 #5 (10/71), TT V5 #6 (12/73)

Title, Artist, Original story and the comic from which it came, Eerie Pubs appearances

HT—HORROR TALES
SG—STRANGE GALAXY
TFTT—TALES FROM THE TOMB
TOV—TALES OF VOODOO
TT—TERROR TALES
TOD—TERRORS OF DRACULA
W—WEIRD
WVT—WEIRD VAMPIRE TALES
WW—WEIRD WORLDS
WT—WITCHES' TALES

A

Angry Vampire, The (Fraga; redraw "Blood Thirsty"—
 Mysterious Adventures #21, Aug. 1954, Story) W V4 #6
 (12/70), W V5 #5 (10/71), TT V5 #6 (12/73)
Assassin and the Monster, The (Torre Repiso; redraw "The
 Specter's Face"—*Web of Evil* #6, Sept. 1953, Quality) TOV
 V5 #1 (1/72), TFTT V5 #5 (9/73)
Atomic Monsters, The (Fraga; redraw "Day of Doom"—*Weird
 Terror* #11, May 1954, Comic Media) WW V1 #10 (12/70),
 HT V4 #6 (10/72)

B

Bagpipes from Hell (Marchionne; redraw "The Merry Ghosts
 of Campbell Castle"—*Black Magic* #27, Nov. Dec. 1954,
 Prize) WT V6 #5 (9/74), W V10 #2 (6/77), W V13 #3 (6/80)
Banshee Hex (Muñoz; redraw "The Brannock Curse"—*Out of
 the Shadows* #14, Aug. 1954, Standard) TT V5 #6 (12/73)
Bats, The (see The Vampires- Fraga)
Beast from Below, The, (Ayers; redraw "The Monster from
 the Deep"—*Web of Evil* #20, Nov. 1954, Quality) W V5 #3
 (6/71), TOV V5 #7 (12/72), WT V6 #6 (11/74)
Beast in the Cellar, The (see The Thing in the Cellar)
Beast, The, (Casadei; redraw "The Mad Beast of Monaco"—
 Web of Mystery #6, Dec. 1951, Ace) W V6 #4 (6/72), W
 V8 #3 (6/74)
Beast, The, (Muñoz; redraw "The Beast of Skeleton Island"—
 Web of Mystery #13, Sept. 1952, Ace) W V5 #4 (8/71),
 TT V5 #5 (10/73)
Better Off Dead (Woromay; redraw "Bum Ticker"—*Weird
 Mysteries* #8, Jan. 1954, Gillmor) HT V2 #1 (1/70), W V5
 #1 (2/71), WT V5 #4 (7/73), HT V9 #3 (8/78)
Beyond Evil (Oswal; redraw "Return of the Dead"—*Beware!
 Terror Tales* #5, Jan. 1953, Fawcett) W V6 #1 (2/72), TOV
 V6 #6 (11/73), W V13 #3 (9/80)
Beyond the Grave (Barnes; redraw "Vengeance of the
 Undead"—*Web of Evil* #4, Aug. 1951, Ace) TT V7 #1
 (2/76), W V11 #4 (12/78)
Black Death (Reynoso; redraw "Choker"—*Weird Mysteries*
 #4, Apr. 1953, Gillmor) WT V2 #6 (12/70), W V7 #6
 (10/73)
Black Light Monsters (Castellon; redraw "Out of Blackness
 They Come"—*Web of Mystery* #18, May 1953, Ace) TOV
 V4 #2 (3/71), WT V4 #5 (9/72), TT V7 #3 (7/76) As "Black
 Light Terror" WT V6 #4 (7/74), HT V9 #2 (5/78), TOD
 V3 #1 (5/81)
Black Light Terror (see Black Light Monsters)
Black Magic (Muñoz; redraw "The Unholy Quest"—
 Mysterious Adventures #2, June 1951, Story) W V4 #6
 (12/70), TOV V4 #5 (9/71)
Blackness of Evil, The (Woromay; redraw "Walpurgis"—
 Witches Tales #18, Apr. 1953, Harvey) W V3 #5 (12/69),
 TFTT V2 #4 (8/70), HT V4 #4 (6/72), TOV V3 #3 (5/74),
 HT V7 #4 (11/76), W V12 #2 (6/79), WVT V4 #4 (4/80)
Blind Monsters (Torre Repiso; redraw "The Eyeless Ones"—
 Tomb of Terror #7, Jan. 1953, Harvey) W V9 #1 (2/75),
 TT V8 #1 (4/77), W V11 #1 (3/78), TOD V1 #5 (11/79), W
 V14 #3 (11/81)
Blind Terror, The (Casadei; redraw "The Eyeless Ones"—
 Tomb of Terror #7, Jan. 1953, Harvey) W V5 #5 (8/73),
 W V11 #2 (6/78)
Blob, The (Jackson; redraw "Mind over Matter"—*Weird
 Mysteries* #5, June 1953, Gillmor) W V4 #1 (2/70)
Blood Bath (Macagno) (see Satan's Blood Bath)
Blood Bath (Stone) W V3 #5 (12/69), TFTT V4 #8 (8/70),
 HT V4 #2, W V8 #4 (10/74), TT V7 #3 (7/76), TOD
 V1 #4 (8/79)
Blood Cult, The (Cristóbal; redraw "Cult of Evil"—*Tomb of
 Terror* #2, July 1952, Harvey) TFTT V5 #4 (7/73), W V10
 #3 (12/77), WVT V3 #1 (4/79)
Blood Dripping Head, The (Fraga; redraw "River of Blood"—
 Black Cat Mystery #48, Feb. 1954, Harvey) TOV V5 #6
 (10/72), W V9 #1 (1/75), W V9 #3 (9/76)
Blood Goddess, The (Woromay; redraw "Goddess of
 Murder"—*Web of Evil* #3, Mar. 1953, Quality) TFTT V3
 #5 (10/71), WT V5 #5 (9/73), HT V9 #3 (8/78), TOD V2
 #2 (5/80)
Blood Monster, The (Reynoso; redraw "The Last Man on
 Earth"—*Black Cat Mystery* #35, May 1952, Harvey) TOV
 V4 #6 (11/71), TOV V6 #5 (9/73)
Blood Slave, The (Casadei; redraw "Down to Death"—
 Chamber of Chills #14, Nov. 1952, Harvey) TOV V7
 #1 (1/74)
Blood-Dripping Scarecrow, The (Marchionne; redraw
 "Scarecrow's Revenge"—*Witches Tales* #14, Sept. 1952,
 Harvey) TOV V6 #1 (1/73), TT V7 #3 (7/76), TOD V2
 #1 (2/80)

Blood-Mad Monster, The (Stepancich; redraw "Monster of the Mist"—*Web of Evil* #4, May 1953, Quality) *WT V4 #2 (3/72)*

Blood-sucker, The (Muñoz; redraw "It!"—*Witches Tales* #10, May 1952, Harvey) *TT V2 #3 (3/73), WVT V3 #4 (1/80)*

Bloodsucker (see Vampire—Ayers)

Bloody Ax, The (Muñoz; redraw "Paralyzed"—*Mysterious Adventures* #17, Dec. 1953, Story) *TT V2 #6 (11/70), W V6 #3 (4/72), W V8 #2 (4/74)*

Bloody Blob, The (Oswal; redraw "The Crawling Horror"—*Beware! Terror Tales* #4, Nov. 1952, Fawcett) *WT V3 #4 (8/71), TFTT V5 #3 (5/73)*

Bloody Corpse, The (A. Fernandez; redraw "Pandora's Bucks"—*Mysterious Adventures* #23, Dec. 1954, Story) *HT V4 #3 (4/72)*

Bloody Corpse, The (Mandrafina; redraw "Vengeful Corpse"—*Chamber of Chills* #15, Jan. 1953, Harvey) *W V6 #5 (8/72), WT V6 #6 (11/74)*

Bloody Creature, The (Cerchiara; redraw "The Beast from Beyond"—*Web of Evil* #3, Mar. 1953, Quality) *TOV V5 #1 (1/72), TT V5 #4 (8/73)*

Bloody Demon, The (Castellon; redraw "The Vengeful Curse"—*Web of Evil* #5, July 1953, Quality) *HT V3 #6 (11/71), HT V5 #4 (8/73), HT V7 #3 (8/76)*

Bloody Guillotine, The (Stepancich; redraw "The Phantom Guillotine"—*Weird Horrors* #6, Feb. 1953, St. John) *WT V2 #2 (4/70), WT V5 #1 (1/73), HT V6 #3 (6/74)*

Bloody Hands, The (Macagno; redraw "The Strangling Hands"—*Web of Evil* #7, Oct. 1953, Quality) *TOV V5 #2 (3/72), HT V6 #1 (1/74), HT V7 #3 (8/76)*

Bloody Head (Stepancich; redraw "Decapitation"—*Weird Terror* #6, July 1953, Comic Media) *TOV V3 #5 (9/70), WT V4 #2 (3/72)*

Bloody Head, The (Casadei; redraw "Syr-Darya's Death Song"—*Web of Mystery* #13, Sept. 1952, Ace) *TOV V5 #3 (4/72), TOV V7 #2 (3/74), W V13 #3 (9/80)*

Bloody Horror, The (Casadei; redraw "Terror Vision"—*Chamber of Chills* #19, Sept. 1953, Harvey) *TOV V5 #6 (12/72)*

Bloody House, The (Torre Repiso; redraw "She Shrieked with Horror"—*Web of Mystery* #24, May 1954, Ace) *W V5 #5 (10/71), HT V5 #3 (5/73)*

Bloody Knife, The (Casadei; redraw "Doomed"—*Voodoo* #15, May June 1954, Ajax) *HT V6 #1 (2/74)*

Bloody Mary (Stepancich; redraw "Bloody Mary"—*Strange Fantasy* #10, Feb. Mar. 1954, Ajax) *HT V6 #3 (6/74)*

Bloody Monster, The (Fraga; redraw "The Nameless Horror"—*Beware! Terror Tales* #1, May 1952, Fawcett) *TT V3 #1 (1/71), WT V5 #4 (7/73), HT V8 #1 (4/77), W V10 #3 (12/77)*

Bloody Nightmare, The (Muñoz; redraw "The House"—*Chamber of Chills* #18, July 1953, Harvey) *HT V4 #6 (10/72)*

Bloody Razor, The (Muñoz; redraw "Haircut"—*Chamber of Chills* #18, July 1953, Harvey) *HT V5 #5 (6/73)*

Bloody Statues, The (Torre Repiso; redraw "The Death Statue"—*Mysterious Adventures* #16, Oct. 1953, Story) *TT V4 #1 (1/72), TOV V6 #5 (9/73)*

Bloody Talus (Torre Repiso; redraw "The Man Who Owned the Earth"—*Strange Worlds* #6, Feb. 1952, Avon) *WT V3 #5 (10/71), W V7 #1 (2/73), W V11 #2 (6/78)*

Bloody Ten Fingers (Stepancich; redraw "Crimson Hands against Him"—*Web of Mystery* #20, Sept. 1953, Ace) *WT V4 #6 (11/72), TOV V7 #5 (9/74), TT V8 #3 (10/77), W V12 #3 (9/79)*

Bloody Thing, The (Burgos; redraw "The Thing That Grew"—*Witches Tales* #6, Nov. 1952, Harvey) *TFTT V2 #1 (1/70), HT V3 #1 (1/71), TT V5 #3 (6/73)*

Bloody Thing, The (Mandrafina; redraw "Portrait in Blood"—*Black Cat Mystery* #39, Sept. 1952, Harvey) *TFTT V5 #3 (5/73), W V13 #2 (3/80), W V14 #2 (7/81)*

Bloody Thing, The (Stepancich; redraw "The Running Ghost"—*Mysterious Adventures* #12, Feb. 1953, Story) *HT V3 #5 (5/71) As "The Gory Thing" TT V4 #1 (1/72), TOV V6 #5 (9/73)*

Bloody Totem, The (Casadei; redraw "Wrath of the Totem"—*Strange Worlds* #6, Feb. 1952, Avon) *TFTT V3 #1 (2/71)*

Bloody Vampire, The- (Romero; redraw "The Undying Fiend"—*Strange Fantasy* #12, June July 1954, Ajax) *TFTT V6 #2 (3/74), WVT V3 #2 (7/79)*

Bloody Wolfman, The (Muñoz; redraw "Hungry as a Wolf"—*Black Magic* #31, July Aug. 1954, Prize) *HT V5 #2 (4/73)*

Body Snatcher (Stepancich; redraw "The Cabinet of the Living Death"—*Mysterious Adventures* #2, June 1951, Story) *HT V3 #2 (3/71), W V6 #5 (8/72), TT V6 #6 (12/74)*

Broomstick Witch, The (Romero; redraw "Madame Cyanide and Mister Tricks"—*Black Magic* #29, Mar. Apr. 1954, Prize) *HT V6 #4 (8/74)*

Buried (Casadei; redraw "Flight to the Future"—*Weird Tales of the Future* #2, June 1952, Gillmor) *TT V6 #2 (4/74)*

Burn, Miser, Burn (Fraga; redraw "Money Hungry"—*Mysterious Adventures* #14, June 1953, Story) *TT V3 #2 (3/71), WT V4 #6 (11/72), TOV V7 #5 (9/74)*

Burn, Witch, Burn (Casadei; redraw "Revenge of a Witch"—*Witches Tales* #16, Dec. 1952, Harvey) *TOV V3 #4 (7/70), TFTT V4 #1 (2/72), HT V5 #6 (12/73)*

Burn, Witch, Burn (Romero; redraw "The Witch's Curse"—*Haunted Thrills* #1, June 1952, Ajax) *TFTT V6 #3 (5/74)*

Burning Corpse, The (Gallo; redraw "Devil's Disciple"—*Weird Mysteries* #4, Apr. 1953, Gillmor) *TOV V5 #3 (4/72), W V8 #1 (2/74)*

Burning Creature, The (Ayers) *WW V2 #1 (2/71)*

C

Call of the Monsters (Casadei; redraw "Gateway to Death"—*Witches Tales* #16, Dec. 1952, Harvey) *TFTT V2 #5 (10/70), TFTT V4 #2 (3/72), WT V6 #4 (7/74)*

Castle of the Dead (Novelle; redraw "The Castle Sinister"—*Web of Mystery* #17, Feb. 1953, Ace) *WT V3 #3 (6/71), TFTT V5 #1 (1/73)*

Cat of Horror (Reynoso; redraw "My Husband, the Cat"—*Black Cat Mystery* #43, Apr. 1953, Harvey) *TOV V5 #6 (10/72), TOV V7 #6 (11/74)*

Cats of Doom (Kato; redraw "Lynx Man's Nine Lives"—*Web of Mystery* #9, May 1952, Ace) *HT V7 #2 (5/76), TOD V1 #3 (5/79), WVT V3 #3 (10/79), WVT V5 #2 (8/81)*

Cave Monsters, The (Marchionne; redraw "The Little People"—*Black Magic* #32, Sept. Oct. 1954, Prize) *WT V5 #3 (5/73), TT V9 #4 (10/78)*

Cave of Vampires (Reynoso; redraw "Legion of the Doomed"—*Web of Mystery* #22, Jan. 1954, Ace) *TOV V5 #4 (6/72), W V10 #3 (12/77) As "Like Blood, the River is Red" WVT V3 #1 (4/79)*

Chain Reaction (Stepancich; redraw "Radium Monsters"—*Strange Worlds* #9, Nov. 1952, Avon) *WW V2 #3 (6/71)*

Chamber of Horrors (Casadei; redraw "The Museum"—*Chamber of Chills* #23, May 1954, Harvey) *TT V4 #6 (10/72)*

Chop Their Heads Off (Macagno; redraw "Murder at Moro Castle"—*Chamber of Chills* #12, Sept. 1952, Harvey) *TFTT V6 #1 (1/74), TT V8 #1 (4/77), W V13 #2 (3/80)*

Circle of Fear (Zoppi; redraw "The Man with Two Faces"—*Witches Tales* #8, Mar. 1951, Harvey) *TOV V6 #3 (5/73)*

Circle of Terror (Sesagero; redraw "Pit of the Damned"—*Chamber of Chills* #7, Apr. 1952, Harvey) *HT V5 #6 (12/73), TT V8 #2 (7/77)*

Claw, The (Jackson; redraw "Hand of Fate"—*Weird Mysteries* #3, Feb. 1953, Gillmor) *TT V2 #1 (1/70)*

Claws of Horror, The (Casadei) (see Old Hag's Claws of Horror)

Claws of Horror (Mandrafina; redraw "The Tiger's Paw"—*Fantastic* #11, Jan. Feb. 1955, Ajax) *WT V6 #1 (1/74), TT V9 #4 (10/78), TOD V2 #3 (8/80)*

Claws of Horror (Muñoz; redraw "The Bride of the Crab"—*Chamber of Chills* #12, Sept. 1952, Harvey) *TOV V6 #6 (11/73), W V13 #3 (9/80)*

Claws of the Cat (Casadei; redraw "Spawn of the Cat"—*Weird Mysteries* #7, Oct. Nov. 1953, Gillmor) *TOV V3 #4 (7/70), TFTT V4 #1 (2/72), TT V6 #3 (6/73)*

Coffin for Two, A (Casadei; redraw "Share My Coffin"—*Witches Tales* #5, Sept. 1951, Harvey) *TFTT V5 #1 (1/73)*

Coffin, The (?- redraw "I, the Coffin"—*Fantastic Fears* #7, May June 1954, Ajax) *TFTT V6 #4 (7/74), W V10 #2 (6/77)*

Coffin, The (Casadei; redraw "Cavern of the Doomed"—*Tomb of Terror* #3, Aug. 1952, Harvey) *WVT V6 #6 (11/74)*

Coils of Terror (Cristóbal; redraw "The Big Snake"—*Tales of Horror* #3, Nov. 1952 and again in #8, Dec. 1953, TOBY) *W V9 #1 (1/75), W V11 #1 (3/78)*

Conjurer, The (Fraga; redraw "The Medium of Murder"—*Web of Evil* #16, July 1954, Quality) *WT V3 #6 (12/71), WT V5 #3 (5/73), W V13 #2 (3/80)*

Corpse for the Coffin, A (Ayers; redraw "The Coffin"—*Mysterious Adventures* #19, Apr. 1954, Story) *WT V2 #4 (8/70), TOV V5 #4 (6/72), HT V7 #3 (8/76), TT V9 #1 (1/78), WVT V3 #3 (10/79)*

Corpse Macabre, The (Stone; redraw "Shadows on the Tomb"—*Black Cat Mystery* #34, Apr. 1952, Harvey) *TFTT V2 #1 (1/70), HT V3 #1 (1/71), TOV V6 #4 (7/73), HT V8 #2 (5/77), HT V9 #2 (5/78)*

Corpse That Lives, The (Stepancich; redraw "Double Murder"—*Weird Terror* #13, Sept. 1954, Comic Media) *HT V4 #7 (12/72), HT V6 #4 (8/74)*

Corpse They Couldn't Bury, The (Muñoz; redraw "Death Song"—*Weird Terror* #2, Nov. 1952, Comic Media) *TT V3 #2 (3/71), WT V4 #6 (11/72), TOV V7 #6 (11/74)*

Corpse, The (Ayers; redraw "The Terror of the Lively Corpse"—*Mysterious Adventures* #9, Aug. 1952, Story) *WW V1 #10 (12/70), WT V4 #4 (7/72)*

Corpse, The (Casadei; redraw "Halfway to Eternity"—*Web of Mystery* #21, Jan. 1954, Ace) *TFTT V4 #3 (7/72)*

Corpse, The (Casadei; redraw "Return from the Grave"—*Tomb of Terror* #6, Nov. 1952, Harvey) *WT V5 #4 (7/73)*

Corpse, The (Macagno; redraw "The Corpse That Wouldn't Hide"—*Web of Evil* #5, July 1953, Quality) *W V5 #6 (12/71), TT V5 #1 (1/73), HT V5 #2 (5/77), WVT V4 #3 (7/80)*

Corpse, The (Reynoso) (see Satan's Corpse)

Creature of Evil (Woromay; redraw "The Moon Was Red"—*Web of Mystery* #18, May 1953, Ace) *TT V3 #2 (3/71), TOV V5 #6 (10/72), TFTT V6 #6 (11/74), WVT V4 #2 (4/80)*

Creature, The (Fraga; redraw "The Lost Kingdom of Althala"—*Strange Worlds* #4, Sept. 1951, Avon) *WW V1 #10 (12/70), TT V4 #5 (8/72)*

Creature's Crypt (Reynoso; redraw "Crypt of Tomorrow"—*Tomb of Terror* #8, Aug. 1952, Harvey) *HT V7 #1 (2/75), TT V10 #1 (1/79)*

Creatures of Evil (Romero; redraw "Black Knights of Evil"—*Chamber of Chills* #6, Mar. 1952, Harvey) *TT V6 #5 (10/74)*

Creatures of Stonehenge (Castellon; redraw "The Druid Dirge"—*Web of Mystery* #11, July 1952, Ace) *TOV V4 #6 (11/71), TFTT V5 #5 (11/73)*

Creatures, The (?- redraw "The Little People "- *Black Magic* #32, Sept. Oct. 1954, Prize) *TFTT V7 #2 (2/75), HT V8 #4 (8/77), W V12 #2 (6/79), WVT V3 #4 (1/80)*

Creatures, The (Casadei; redraw "Big Screen"—*Weird Terror* #5, May 1953, Comic Media) *TFTT V2 #5 (10/70), TOV V5 #2 (3/72), HT V6 #1 (2/74), W V11 #2 (6/78), WVT V5 #3 (3/82)*

Creatures, The (Reynoso; redraw "Ten Thousand Years Old"—*Weird Tales of the Future* #1, Mar. 1952, Gillmor) *WT V6 #2 (3/72), TT V9 #3 (7/78), TOD V3 #2 (9/81)*

Crusher, The (Macagno; redraw "The Man Germ"—*Chamber of Chills* #13, Oct. 1952, Harvey) *W V7 #6 (10/73)*

Cup of Death, A (Casadei; redraw "Happy Anniversary"—*Chamber of Chills* #19, Sept. 1953, Harvey) *TFTT V4 #5 (11/72)*

Curious Coffin, The (Macagno; redraw "Dying is so Contagious"—*Haunted Thrills* #14, Mar. Apr. 1954, Ajax) *TFTT V6 #3 (5/74)*

Curse of the Dead, The (see The Curse of the Dead Witch)

Curse of the Dead Witch, The (Marchionne; redraw "The Invisible Curse"—*Weird Terror* #1, Sept. 1952, Comic Media) *HT V5 #6 (9/71) As "The Curse of the Dead" W V7 #5 (8/73), HT V9 #2 (5/78)*

Curse of the Mummies (Reynoso; redraw "The Evil Eye"—*Witches Tales* #2, Mar. 1951, Harvey) *TT V5 #2 (4/73) As "The Mummies" TFTT V7 #1 (2/75), HT V8 #4 (8/77), HT V9 #1 (2/78)*

Curse of the Vampire (Ayers; redraw "Bride's Dowry of Doom"—*Web of Mystery* #11, July 1952, Ace) *HT V3 #4 (7/71), TT V5 #2 (4/73), TFTT V7 #1 (2/75), HT V8 #2 (5/77), HT V8 #4 (8/77), WVT V3 #2 (7/79)*

D

Day Man Died, The (Marchionne; redraw "Serve and Obey"—*Weird Tales of the Future* #7, May June 1953, Gillmor) *HT V3 #6 (11/71), TT V5 #4 (8/73)*

Dead Can't Sleep, The (Cristóbal; redraw "The Dead Sleep Lightly"—*Chamber of Chills* #10, July 1952, Harvey) *TFTT V5 #6 (11/73)*

Dead Demons, The (Ayers; redraw "Ferry of the Dead"—*Chamber of Chills* #22 [#2], Aug. 1951, Harvey) *TT V2 #2 (3/70), HT V3 #6 (6/71), WT V5 #1 (1/73), TOV V7 #3 (5/74), HT V7 #4 (11/76), W V11 #3 (9/78), TOD V1 #3 (5/79), W V12 #3 (9/79), TOD V3 #2 (9/81)*

Dead Dummies (Fraga; redraw "Mannequin of Murder"—Witches tales #17, Feb 1953, Harvey) *W V5 #2 (12/69), TFTT V2 #4 (8/70), TOV V5 #4 (6/72), TT V9 #1 (1/78)*

Dead Live, The (Casadei; redraw "The Half Men"—*Black Magic* #31, July Aug. 1954, Prize) *TT V5 #3 (6/73)*

Dead Live, The (Muñoz; redraw "Buried Alive"—*Black Magic* #28, Jan. Feb. 1954, Prize) *W V8 #4 (8/74), TT V8 #3 (10/77), W V14 #3 (11/81)*

Dead Live, The (Torre Repiso; redraw "The Man Who Died Twice"—*Web of Evil* #5, July 1953, Quality) *W V6 #7 (12/72), TOV V7 #6 (11/74)*

Dead Man's Train (Casadei; redraw "Midnight Limited"—*Witches Tales* #16, Dec. 1952, Harvey) *W V4 #5 (10/70), TT V4 #3 (4/72), TFTT V4 #3 (7/72)*

Dead Monsters, The (Fraga; redraw "The Black Candle of Life"—*Beware! Terror Tales* #4, Nov. 1952, Fawcett) *WT V2 #4 (8/70), TT V4 #4 (6/72), WT V6 #2 (3/74), TT V9 #3 (7/78)*

Dead Thing Among Us (Barnes; redraw "Ghost in the House"—*Black Magic* #30, May June 1954, Prize) *TFTT V6 #6 (11/74), HT V7 #3 (8/76), WVT V5 #2 (8/81)*

Dead Witch (Ayers; redraw "Witch Girl"—*Weird Terror* #10, Mar. 1954, Comic Media) *TFTT V2 #4 (8/70), HT V4 #4 (6/72), WT V6 #3 (5/74), HT V7 #4 (11/76), W V11 #1 (3/78), W V12 #2 (6/79), WVT V3 #4 (1/80)*

Deadly Corpse, The (Fraga; redraw "The Corpse that Wouldn't Die"—*Web of Evil* #2, Jan. 1953, Quality) *TOV V5 #2 (3/72), HT V6 #2 (4/74), W V9 #3 (9/76), TT V9 #2 (4/78), TOD V1 #5 (11/79), W V12 #4 (12/79)*

Deadly Demon, The (Cerchiara; redraw "Terrible Encounter"—*Ghostly Weird Stories* #121, Dec. 1953, Star) *TFTT V3 #2 (4/71), WT V5 #2 (4/73), TT V4 #6 (10/72)*

Deadly Fangs (Gallo; redraw "Mirror Image"—*Weird Terror* #8, Nov. 1953, Comic Media) *WW V1 #10 (12/70), HT V4 #5 (8/72), TT V6 #4 (8/74)*

Deadman (Reynoso; redraw "The Man from the Moon"—*Weird Tales of the Future* #5, Jan. 1953, Gillmor) *WT V3 #6 (12/71), TFTT V5 #3 (5/73)*

Deadman's Dance (Reynoso; redraw "Dance of Death"—*Web of Evil* #4, May 1953, Quality) *TOV V4 #6 (9/71), TFTT V5 #2 (3/73), HT V8 #5 (11/77), WVT V3 #1 (4/79)*

Deadman's Dream (Olivera; redraw "Two on the Aisle of Death"—*Haunted Thrills* #7, Mar. 1953, Ajax) *W V8 #2 (4/74), HT V9 #2 (5/78)*

Deadman's Duel (Stepancich; redraw "The Duel"—*Witches Tales* #16, Dec. 1952, Harvey) *TOV V4 #1 (1/71) As "The Duel" TFTT V5 #4 (7/73), HT V8 #4 (8/77)*

Deadman's Ghost (Ayers; redraw "Terror of the Lion's Revenge"—*Mysterious Adventures* #9, Aug. 1952, Story) *HT V2 #6 (11/70), TFTT V4 #3 (7/72)*

Deadman's Hand (Macagno; redraw "When Death Takes a Hand"—*Out of the Shadows* #14, Aug. 1954, Standard) *HT V4 #2 (3/72), W V9 #4 (12/76), W V12 #1 (2/79)*

Deadman's Hand, The (Reynoso; redraw "Death's Revenge"—*Mysterious Adventures* #16, Oct. 1953, Story) *W V5 #4 (2/71), TFTT V5 #4 (7/73), HT V8 #5 (11/77), W V13 #2 (3/80)*

Deadman's Ring (Stepancich; redraw "Better Off Dead"—Witchcraft #3, July Aug. 1952, Avon) *W V7 #3 (4/73)*

Deadman's Rope (Mandrafina; redraw "The Captain's Return"—*Chamber of Chills* #9, June 1952, Harvey) *W V6 #6 (10/72), TFTT V6 #5 (9/74),*

Deadman's Ship, The (Cristóbal; redraw "The Flying Dutchman"—*Black Magic* #29, Mar. Apr. 1954, Prize) *W V8 #4 (8/74), TT V7 #1 (4/76)*

Deadman's Tomb (Casadei; redraw "It!"—*Chamber of Chills* #14, Nov. 1952, Harvey) *HT V5 #6 (12/73), HT V9 #2 (5/78)*

Deadman's Tree (Fraga; redraw "The Fruit of Death"—*Chamber of Chills* #12, Sept. 1952, Harvey) *WT V5 #6 (11/73), TT V9 #3 (7/78), TOD V2 #2 (5/80)*

Deadman's Well (Torre Repiso; redraw "The Deep River"—*Weird Terror* #10, Mar. 1954, Comic Media) *TT V4 #5 (8/72), HT V8 #2 (5/77)*

Death Demon (Stepancich; redraw "The Prophecy"—*Out of the Shadows* #11, Jan. 1954, Standard) *W V6 #1 (2/72), HT V5 #6 (12/73)*

Death is an Artist (Casadei; redraw "Art for Death's Sake"—*Witches Tales* #15, Oct. 1952, Harvey) *W V4 #4 (8/70), HT V4 #2 (3/72)*

Death to the Witch (Reynoso; redraw "Terror of the Burning Witch"—*Mysterious Adventures* #6, Feb. 1952, Story) *HT V3 #1 (1/71), W V7 #4 (9/73)*

Death Trap (Fraga; redraw "The Man Who Bribed Death"—Witchcraft #4, Sept. Oct. 1952, Avon) *W V4 #1 (2/70), TFTT V3 #2 (4/71), W V9 #3 (9/76), W V11 #3 (9/78)*

Death's Path (Kato; redraw "Death's Highway"—*Web of Evil* #10, Jan. 1954, Quality) *TT V7 #4 (4/76), W V11 #4 (12/78)*

Demon (Reynoso; redraw "The Witch Wore White"—*Witches Tales* #8, Mar. 1952, Harvey) *W V4 #1 (2/70), WT V3 #2 (4/71), TFTT V4 #4 (9/72)*

Demon from Beyond, The (Ayers; redraw "The Man Who Had No Body"—*Witches Tales* #8, Mar. 1952, Harvey) *WT V2 #1 (2/70), HT V3 #2 (3/71), TOV V5 #6 (10/72), TFTT V6 #6 (11/74)*

Demon Ghost, The (Muñoz; redraw "Demon in the Dungeon"—*Strange Fantasy* #4, Feb. 1953, Ajax) *TT V6 #1 (2/74)*

Demon Goddess (Novelle; redraw "Blood Potion of the Black Cult"—*Web of Mystery* #17, Feb. 1953, Ace) *W V6 #2 (3/72), HT V6 #2 (4/74)*

Demon is a Hag, The (Jackson; redraw "The Witch Killer"—*Black Cat Mystery* #39, Sept. 1952, Harvey) *WT V5 #3 (5/73), W V10 #2 (6/77), TOD V1 #4 (8/79)*

Demon is a Hangman, The (Reynoso; redraw "No Noose is Good Noose"—*Mysterious Adventures* #20, June 1954, Story) *TOV V4 #6 (11/70), HT V5 #9 (9/71), TOV V6 #3 (5/73)*

Demon Star, The (Ayers; redraw "Death Ship"—*Ghostly Weird Stories* #122, Mar. 1954, Star) *WW V2 #2 (4/71), TOV V6 #1 (1/73)*

Demon Strikes, The (Fraga; redraw "The Skeptic"—*Chamber of Chills* #2, Mar. 1954, Harvey) *TFTT V4 #5 (11/72), TT V7 #4 (10/76)*

Demon, The (Macagno; redraw "Demon Fiddler"—*Fantastic Fears* #7, May June 1954, Ajax) *TFTT V6 #4 (7/74), W V10 #2 (6/77)*

Demon, The (Reynoso; redraw "The Ice Horror"—*Chamber of Chills* #9, June 1952, Harvey) *HT V4 #5 (8/72), TFTT V6 #5 (9/74), HT V9 #1 (2/78), WVT V3 #4 (1/80)*

Demons and Skeletons (Romero; redraw "Skeletons Have Secrets"—*Haunted Thrills* #1, June 1952, Ajax) *HT V6 #2 (4/74), WT V10 #1 (3/77), TOD V2 #1 (2/80)*

Demons and Vampires (Woromay; redraw "Portrait of Death"—*Weird Terror* #1, Sept. 1952, Comic Media) *TOV V3 #5 (5/70), WW V2 #2 (4/71), TT V4 #6 (10/72)*

Demons Night, The (Fraga; redraw "The Fearful Night"—*Out of the Shadows* #13, May 1954, Standard) *TT V4 #1 (1/72), TOV V6 #5 (9/73), HT V7 #3 (8/76), WVT V5 #2 (4/81)*

Devil Ghouls (Fraga; redraw "Premonition"—*Weird Mysteries* #8, Jan. 1954, Gillmor) *W* V4 #1 (2/70), *WT* V3 #2 (4/71), *W* V6 #5 (8/72), *WT* V6 #6 (11/74)

Devil Power (Fraga; redraw "Satan's Love Call"—*Weird Terror* #11, May 1954, Comic Media) *TOV* V5 #3 (4/72), *TT* V6 #1 (2/74)

Devil Statues, The (Fraga; redraw "The Night the Statues Walked"—*Web of Mystery* #19, July 1953, Ace) *W* V5 #2 (4/71), *TOV* V5 #6 (10/72), *WT* V6 #1 (2/75)

Devil You Say?!, The (Cristóbal; redraw "The Seal of Satan"—*Chamber of Chills* #7, Apr. 1952, Harvey) *HT* V5 #6 (12/73)

Devil's Fiddle, The (Casadei; redraw "The Violin of Death"—*Weird Horrors* #2, Aug. 1952, St. John) *WT* V2 #1 (2/70), *WW* V2 #4 (4/71), *TFTT* V5 #1 (1/73)

Devil's Girl, The (see The Devil's Witch)

Devil's Looking Glass, The (Woromay; redraw "Mirror of Mephisto"—*Web of Mystery* #15, Nov. 1952, Ace) *TFTT* V3 #4 (8/71), *WT* V3 #3 (5/73), *W* V11 #3 (9/78), *HT* V10 #1 (2/79), *W* V13 #2 (8/80)

Devil's Machine, The (Casadei; redraw "The Jonah"—*Weird Tales of the Future* #6, Mar. Apr. 1953, Gillmor) *TOV* V4 #5 (9/71), *TFTT* V5 #2 (3/73), *TT* V9 #1 (1/78)

Devil's Monster, The (Woromay; redraw "Monster of Sarno Gulch"—*Witchcraft* #6, Mar. 1953) *WT* V1 #9 (12/69), *HT* V2 #5 (9/70), *TOV* V7 #1 (1/74), *TT* V8 #3 (10/77), *WVT* V3 #4 (1/80)

Devil's Plague (Fraga; redraw "Black Death"—*Beware* #7, Jan. 1954, Trojan) *TFTT* V2 #3 (6/70), *HT* V3 #3 (5/71), *TOV* V5 #1 (1/72), *WT* V5 #3 (9/73), *TT* V8 #1 (4/77), *W* V11 #3 (9/78), *W* V14 #3 (11/81)

Devil's Sword, The (Novelle; redraw "Satan and the Devil Bull"—*Web of Mystery* #11, July 1952, Ace) *W* V3 #4 (8/71), *TT* V5 #2 (4/73)

Devil's Vampire, The (Fernand; redraw "Devil's Bride"—*Haunted Thrills* #16, July Aug. 1954, Ajax) *TOV* V7 #4 (7/74), *WT* V3 #3 (10/79)

Devil's Witch, The (Mandrafina; redraw "The Devil's Own"—*Witches Tales* #14, Sept. 1952, Harvey) *HT* V4 #7 (12/72) As "The Devil's Girl" *HT* V6 #4 (8/74), *W* V9 #2 (6/76)

Devil's Zombie, The (Ayers; redraw "The Wage Earners"—*Weird Terror* #1, Sept. 1952, Comic Media) *TOV* V3 #3 (5/70), *WT* V3 #2 (4/71), *TFTT* V4 #4 (9/72), *TT* V6 #5 (10/74), *HT* V3 #8 (8/76), *TOD* V3 #1 (5/81)

Dimension Horror (Burgos; redraw "Dimension IV"—*Witches Tales* #17, Feb 1953, Harvey) *W* V3 #5 (12/69), *HT* V2 #5 (9/70), *W* V6 #3 (4/72), *W* V8 #1 (2/74), *W* V11 #2 (6/78)

Doll Witch, The (Barnes; redraw "This Time You'll Die"—*Black Magic* #33, Nov. Dec. 1954, Prize) *W* V7 #6 (9/74)

Doom Creatures (Fraga; redraw "Creatures of the Bomb"—*Witches Tales* #17, Feb 1953, Harvey) *WT* V1 #9 (12/69), *TT* V2 #6 (9/70), *SG* V1 #11 (8/71), *TT* V5 #4 (8/73)

Doom Witch, The (Stepancich; redraw "Heads of the Dead"—Beware #7, Jan. 1954, Trojan) *HT* V2 #4 (7/70), *TT* V3 #6 (11/71), *TFTT* V5 #5 (9/73)

Drowned in Sand (Fraga; redraw "The Search"—*Tomb of Terror* #4, Mar. 1953, Harvey) *W* V7 #6 (10/73), *W* V9 #3 (9/76), *WVT* V5 #1 (1/81)

Duel, The (see Deadman's Duel)

E

Eat the Flesh! Drink the Blood! (Marchionne) *WT* V5 #6 (11/73), *TT* V9 #3 (7/78), *TOD* V2 #2 (5/80)

Escape to Nowhere (Reynoso; redraw "Escape to Death"—*Weird Tales of the Future* #2, June 1952, Gillmor) *TT* V6 #2 (4/74), *WVT* V3 #4 (1/80)

Evil Black Cats, The (Reynoso; redraw "Black Fury"—*Web of Mystery* #19, July 1953, Ace) *WT* V3 #2 (4/71), *W* V6 #5 (8/72), *W* V8 #4 (10/74), *HT* V9 #3 (11/78), *TOD* V1 #5 (11/79)

Evil Cat (Castellon; redraw "Day of Reckoning"—*Out of the Shadows* #14, Aug. 1954, Standard) *W* V5 #6 (12/71), *W* V7 #1 (2/73), *W* V9 #4 (12/76), *W* V10 #3 (12/77), *WVT* V3 #1 (4/79)

Evil Cat, The (Reynoso; redraw "Curse of the Black Panther"—*Chamber of Chills* #16, Mar. 1953, Harvey) *TT* V4 #5 (8/72)

Evil Idol, The (Zoppi; redraw "The Eight Hands of Ranu"—*Chamber of Chills* #18, June 1952, Harvey) *W* V6 #7 (12/72), *HT* V6 #5 (10/74), *HT* V7 #3 (8/76), *HT* V9 #2 (5/78), *HT* V9 #2 (7/79), *TOD* V3 #1 (5/81)

Evil is the Witch (Fraga; redraw "Search for Evil"—*Black Cat Mystery* #44, June 1953, Harvey) *WT* V4 #5 (9/72) As "Experiment in Terror" *HT* V6 #4 (8/74)

Evil Monsters (Woromay; redraw "Evil Ones"—*Weird Terror* #2, Nov. 1952, Comic Media) *TT* V2 #4 (7/70), *WT* V3 #5 (9/71) As "Tunnel Crawlers" *TOV* V6 #2 (3/73), *TT* V8 #3 (10/77), *W* V14 #3 (11/81)

Evil One, The (Marchionne; redraw "Wizard of Evil"—*Adventures into the Unknown* # 26, Dec. 1951, ACG) *HT* V5 #4 (8/73), *HT* V7 #4 (8/76), *W* V12 #4 (12/79)

Evil Ones, The (Muñoz; redraw "The Keeper of the Flames"—*Web of Mystery* #25, July 1954, Ace) *W* V5 #3 (6/71),

TOV V5 #7 (12/72), *TFTT* V6 #6 (11/74)

Evil Ones, The (Oswal; redraw "Waterfront"—*Weird Terror* #6, July 1953, Comic Media) *WT* V3 #3 (5/71), *TFTT* V5 #1 (1/73)

Evil Trip, The (Reynoso; redraw "Nightmare World"—*Weird Tales of the Future* #3, Sept. 1952, Gillmor) *WW* V2 #3 (6/71), *WT* V5 #3 (9/73), *HT* V9 #2 (5/78), *TOD* V2 #3 (8/80), *WVT* V5 #2 (4/81)

Evil Zombie, The (Reynoso; redraw "Long Arm of the Undead"—*Web of Mystery* #23, Mar. 1954, Ace) *TT* V3 #5 (9/71), *TOV* V6 #3 (5/73)

Experiment in Terror (see Evil is the Witch)

Eye of Evil (Reynoso; redraw "A Hole in the Sky"—*Strange Journey* #2, Nov. 1957- Ajax) *W* V8 #2 (4/74), *HT* V9 #3 (11/78)

F

Fanged Freak, The (Barnes; redraw "The Greatest Horror of them All"—*Black Magic* #29, Mar. Apr. 1954, Prize) *TFTT* V7 #1 (2/75), *HT* V8 #2 (5/77), *HT* V8 #4 (8/77), *WVT* V4 #1 (1/80)

Fanged Monster, The (Cristóbal; redraw "Fanged Terror"—*Haunted Thrills* #18, Nov. 1954, Ajax) *W* V8 #3 (6/74)

Fangs of Horror (Olivera; redraw "Werewolf Castle"—*Voodoo* #18, Nov. Dec. 1954, Ajax) *WT* V6 #2 (3/74), *TT* V9 #2 (4/78), *TOD* V2 #1 (2/80), *WVT* V5 #2 (4/81)

Fangs of Revenge (Reynoso; redraw "Trail to a Tomb"—*Haunted Thrills* #7, Mar. 1953, Ajax) *HT* V6 #2 (4/74), *WVT* V3 #4 (1/80)

Fangs of Terror (Macagno; redraw "Fangs of Fear"—*Strange Fantasy* #12, June July 1954, Ajax) *TT* V6 #2 (4/74), *W* V9 #3 (9/76), *W* V12 #1 (2/79), *TOD* V1 #5 (11/79), *WVT* V5 #1 (1/81)

Feast for Rats (Stepancich; redraw "Return from the Dead"—*Mysterious Adventures* #3, Aug. 1951, Story) *W* V5 #1 (2/71), *TOV* V6 #4 (7/73)

Feast for Rats, A (Reynoso; redraw "Cycle of Horror"—*Chamber of Chills* #16, Mar. 1953, Harvey) *TT* V4 #5 (8/72)

Feast for Vampires (Woromay; redraw "One Man's Poison"—*Mysterious Adventures* #17, Dec. 1953, Story) *W* V4 #5 (10/70), *HT* V4 #3 (4/72)

Fiend from the Outside, The (Cristóbal; redraw "The Haunted Ghost"—*Adventures into the Unknown* #26, Dec. 1951, ACG) *WT* V4 #4 (7/73), *HT* V6 #4 (8/74)

Fighting Vampire, The (Cerchiara; redraw "Blood of the Bat"—*Weird Terror* #8, Nov. 1953, Comic Media) *HT* V6 #3 (6/74), *WVT* V3 #3 (10/79)

Fingers of Doom (Cristóbal; redraw "Revolt of the Fingers"—*Beware! Terror Tales* #4, Nov. 1952, Fawcett) *TFTT* V5 #5 (9/73), *HT* V4 #1 (11/76)

Fire Beast, The (Casadei; redraw "Phantom in the Flames"—*Witches Tales* #2, Mar. 1951, Harvey) *TFTT* V6 #2 (3/74)

Fire Monster (Casadei; redraw "The Ghost of Fire" Beware #9, May 1954, Trojan) *TFTT* V2 #3 (6/70), *WT* V3 #3 (5/71), *HT* V5 #1 (2/73)

Flaming Ghost (Torre Repiso; redraw "Flame Thrower"—*Mysterious Adventures* #14, June 1953, Story) *SG* V1 #8 (2/71), *TOV* V5 #5 (8/72)

Flesh Eaters, The (Marchionne; redraw "Nightmare of Doom"—*Chamber of Chills* #15, Jan. 1953, Harvey) *TOV* V5 #5 (8/72), *TT* V7 #1 (4/76), *W* V11 #4 (12/78), *TOD* V2 #1 (2/80), *WVT* V5 #2 (4/81)

Flesh-Eaters, The (Reynoso; redraw "The Web of the Spider"—*Witches Tales* #12, July 1952, Harvey) *WT* V5 #2 (7/73)

Fleshless Corpse, The (Macagno; redraw "Dirt of Death"—*Tomb of Terror* #4, Sept. 1952, Harvey) *TFTT* V5 #5 (9/73), *W* V9 #2 (6/76)

Fleshripper, The (Barnes; redraw "A Beast is in the Streets"—*Black Magic* #25, June July 1953, Prize) *TT* V6 #6 (12/74), *HT* V7 #2 (5/76), *TOD* V1 #3 (5/79)

Fleshrippers, The (Muñoz; redraw "The Spider Man"—*Chamber of Chills* #14, Nov. 1952, Harvey) *W* V7 #6 (10/73), *WVT* V5 #1 (1/81)

Floating Dead, The (Fraga; redraw "The Ship of Lost Souls"—*Web of Evil* #7, Oct. 1953, Quality) *TT* V4 #2 (3/72), *WT* V6 #3 (5/74), *TT* V8 #2 (7/77)

Food for Ghouls (Stepancich; redraw "Chef's Delight"—*Mysterious Adventures* #20, June 1954, Story) *TFTT* V2 #6 (12/70), *TT* V5 #3 (6/73)

Force of Horror (Casadei; redraw "The Flash of Doom"—*Witches Tales* #10, May 1952, Harvey) *TOV* V6 #2 (3/73)

Frankenstein (Burgos) *W* V1 #10 (1/66), *TFTT* V2 #1 (1/70)

From Out of the Coffin (Fraga; redraw "His Brother's Keeper"—*Tomb of Terror* #4, Sept. 1952, Harvey) *TOV* V6 #4 (7/73)

From the Grave Below (Fraga; redraw "Cloth of Terror"—*Witches Tales* #10, May 1952, Harvey) *W* V7 #1 (2/73), *HT* V7 #3 (8/76), *HT* V4 #1 (11/76), *TOD* V3 #1 (5/81)

From the Grave Below (Mandrafina; redraw "Wake up the Dead"—*Black Magic* #33, Nov. Dec. 1954, Prize) *TT* V5 #3 (6/73)

Frozen Colossus, The (Mandrafina; redraw "Cave of Doom"—*Chamber of Chills* #10, July 1952, Harvey) *TOV* V6 #6 (11/73), *HT* V7 #2 (5/76), *W* V11 #4 (12/78)

G

Garden of Corpses (Reynoso; redraw "Garden of Horror"—*Chamber of Chills* #7, Apr. 1952, Harvey) *TOV* V6 #6 (11/73), *W* V8 #3 (6/74)

Geek, The (Casadei; redraw "Next Attraction: Death"—*Black Cat Mystery* #42, Feb. 1953, Harvey) *W* V7 #3 (4/73)

Ghoul Without Pockets (Woromay; redraw "No Pockets on the Dead"—Beware #9, May 1954, Trojan) *HT* V2 #2 (3/70), *WT* V3 #6 (6/71), *W* V6 #7 (12/72), *HT* V6 #5 (10/74)

Ghoul, The (Sesagero; redraw "Gravestone for Gratis"—*Fantastic* #11, Jan. Feb. 1955, Ajax) *TFTT* V6 #1 (1/74), *W* V13 #2 (3/80), *W* V14 #2 (7/81)

Ghoul, The (Casadei; redraw "Heartline"—*Chamber of Chills* #23, May 1954, Harvey) *HT* V4 #6 (10/72)

Ghoul, The (Torre Repiso; redraw "Custodian of the Dead"—*Web of Evil* #1, Nov. 1952, Quality) *TFTT* V4 #1 (2/72), *TT* V5 #6 (12/73), *TT* V8 #4 (4/77), *W* V11 #1 (3/78), *HT* V10 #1 (2/79), *W* V14 #1 (5/81)

Ghoul's Mansion (Jackson; redraw "The King is Dead"—*Black Cat Mystery* #50, June 1954, Harvey) *HT* V5 #2 (4/73), *W* V9 #4 (12/76), *TT* V8 #2 (7/77), *W* V12 #1 (2/79)

Ghoulish Feast (Reynoso; redraw "Killing Spree"—*Weird Terror* #13, Sept. 1954, Comic Media) *TT* V2 #5 (9/70), *HT* V3 #6 (11/71), *TT* V5 #4 (8/73)

Ghouls Graveyard (Reynoso; redraw "Custodian of the Dead"—*Beware! Terror Tales* #1, May 1952, Fawcett) *TFTT* V2 #2 (4/70), *W* V5 #4 (8/71), *TFTT* V5 #6 (11/73)

Ghouls, The (Torre Repiso; redraw "Ghoul Crazy"—*Mysterious Adventures* #15, Aug. 1953, Story) *WT* V4 #3 (5/72)

Ghouls, The (Woromay; redraw "The Ghouls Who Ruled the World"—*Weird Tales of the Future* #1, Mar. 1952, Gillmor) *TFTT* V3 #6 (12/71), *TFTT* V5 #3 (9/73)

Gift of Horror, A (Fraga; redraw "Rift of the Maggis"—*Tomb of Terror* #11, Sept. 1953, Harvey) *HT* V4 #1 (2/75)

Give Me Back My Brain (Olivera; redraw "Skulls of Doom"—*Voodoo* #12, Nov. 1953, Ajax) *TT* V4 #4 (8/74), *HT* V7 #2 (5/76), *TT* V9 #2 (4/78), *W* V11 #4 (12/78), *WVT* V5 #2 (8/81)

Glass Corpse, The (Oswal; redraw "China Doll"—*Weird Terror* #12, July 1954, Comic Media) *TT* V2 #6 (11/70) As "The Glass Morgue" *TOV* V5 #3 (4/72), *TT* V6 #1 (2/74), *HT* V7 #3 (8/76), *WVT* V3 #3 (10/79)

Glass Morgue, The (see The Glass Corpse)

Gory Thing, The (see The Bloody Thing)

Graveyard (Zoppi; redraw "Amnesia"—*Chamber of Chills* #17, May 1953, Harvey) *TT* V4 #5 (8/72), *W* V9 #2 (6/76), *W* V12 #4 (12/79)

Graveyard, The (Fraga; redraw "Cemetery"—*Weird Terror* #6, July 1953, Comic Media) *WT* V4 #4 (7/72)

Green Horror, The (Casadei; redraw "The Planet Eaters"—*Weird Mysteries* #1, Oct. 1952, Gillmor) *WW* V1 #10 (12/70), *TT* V4 #6 (10/72)

Grotesque (Fraga; redraw "The Wax Man"—*Chamber of Chills* #16, Mar. 1953, Harvey) *HT* V4 #5 (8/72), *W* V8 #4 (8/74), *HT* V7 #2 (5/76)

Grotesque Checkmate, The (Reynoso; redraw "The Game Called Dying"—*Voodoo* #3, Sept. 1952, Ajax) *HT* V6 #1 (2/74), *TT* V9 #2 (4/78)

Gruesome Cannibal, The (Stepancich; redraw "The Cannibal"—*Out of the Shadows* #13, May 1954, Standard) *TFTT* V3 #6 (12/71), *TOV* V6 #3 (5/73), *HT* V10 #1 (2/79)

Gruesome Creatures, The (Macagno; redraw "The Visitor"—*Black Cat Mystery* #42, Feb. 1953, Harvey) *TT* V4 #6 (10/72)

Gruesome Nightmare (Kato; redraw "The Curse of King Kala"—*Tales of Horror* #4, Jan. 1953, TOBY) *WT* V7 #1 (2/75)

Gruesome Shock (Woromay; redraw "Dead End"—*Witches Tales* #21, Oct. 1953, Harvey) *TFTT* V2 #1 (1/70), *HT* V3 #1 (1/71), *TT* V5 #3 (6/73)

Gruesome Shock, A (Muñoz; redraw "What d'you Know Joe"—*Tomb of Terror* #13, Jan. 1954, Harvey) *W* V9 #1 (1/75), *HT* V9 #3 (11/78)

Gutless One, The (Casadei; redraw "The Coward"—*Mysterious Adventures* #21, Aug. 1954, Story) *TOV* V3 #6 (11/70), *HT* V3 #5 (9/71), *TOV* V6 #3 (5/73)

H

Hairy Beast, The (Marchionne; redraw "Katumba- The Man Made Monster"—*Web of Evil* #20, Nov. 1954, Quality) *HT* V4 #2 (3/72), *W* V10 #1 (3/77), *W* V13 #3 (6/80)

Hands of the Dead (Fraga; redraw "Hands of Terror"—*Haunted Thrills* #5, Jan. 1953, Ajax) *W* V8 #1 (2/74)

Hanged, The (Macagno; redraw "The Choker"—*Mysterious Adventures* #21, Aug. 1954, Story) *TFTT* V6 #2 (3/74), *W* V10 #1 (3/77)

Haunt (Fraga; redraw "Bridge"—*Chamber of Chills* #17, May 1953, Harvey) *WT* V4 #4 (11/72), *TFTT* V6 #6 (11/74), *W* V10 #1 (3/77)

Haunts, The (Fraga; redraw "Eternity"—*Black Cat Mystery* #43, Apr. 1953, Harvey) *TOV* V5 #7 (12/72), *HT* V7 #4 (11/76)

He Rose from the Grave (Muñoz; redraw "The Coin of Evil"—*Out of the Shadows* #11, Jan. 1954, Standard) *TFTT* V4 #2 (3/72), *W* V8 #3 (6/74), *HT* V9 #3 (11/78)

He Walked away from the Grave (Fraga; redraw "Screams in the Night"—*Haunted Thrills* #7, Mar. 1953, Ajax) *TOV* V7 #4 (7/74)

Head Chopper, The (Casadei; redraw "Night of Terror"—*Voodoo* #16, July Aug. 1954, Ajax) *HT* V6 #3 (6/74)

Head Chopper, The (Fraga; redraw The Shrunken Skull- *Chamber of Chills* #5, Feb. 1952, Harvey) *TFTT* V7 #1 (2/75), *HT* V8 #4 (8/77) As "The Head from Hell" *HT* V9 #1 (2/78)

Head from Hell, The (see The Head Chopper- Fraga)

Head Full of Snakes, A (Macagno; redraw "Head of Medusa"—*Tomb of Terror* #5, Oct. 1952, Harvey) *W* V7 #5 (8/73), *TT* V7 #3 (8/76), *HT* V9 #2 (5/78), *TOD* V1 #4 (8/79), *TOD* V3 #1 (5/81), *WVT* V3 #2 (3/82)

Head of Horror (Fraga; redraw "The Face of Horror"—*Chamber of Chills* #10, July 1952, Harvey) *TT* V5 #5 (10/73), *W* V10 #1 (3/77)

Head Shrinkers, The (Reynoso; redraw "Devil Drums"—*Black Cat Mystery* #43, Apr. 1953, Harvey) *TFTT* V4 #5 (11/72), *TT* V6 #6 (12/74), *TT* V8 #3 (10/77), *WVT* V4 #2 (4/80)

Headless Ones, The (Cristóbal; redraw "Man in the Hood"—*Chamber of Chills* #13, Oct. 1952, Harvey) *WT* V6 #1 (1/74), *TT* V9 #4 (10/78)

Heads of Horror (Romero; redraw "Heads of Horror"—*Voodoo* #14, Mar. Apr. 1954, Ajax) *TFTT* V6 #4 (7/74), *HT* V8 #5 (5/77), *W* V8 #5 (11/77)

Heads of Terror, The (Woromay; redraw "The Dancing Lights of Kula"—*Weird Horrors* #2, Aug. 1952, St. John) *TT* V2 #1 (1/70), *HT* V3 #2 (3/71), *WT* V4 #5 (9/72), *TOV* V7 #4 (7/74), *HT* V7 #2 (5/76), *TT* V9 #4 (10/78) *TT* V10 #1 (1/79), *W* V14 #2 (7/81)

Hidden Horror (Reynoso; redraw "Corpses from the Sea"—*Black Cat Mystery* #33, Feb. 1952, Harvey) *TT* V5 #3 (6/73), *HT* V7 #4 (11/76), *TOD* V2 #3 (8/80)

Horrible Thing, The (Woromay; redraw "They Never Return"—*Mysterious Adventures* #23, Dec. 1954, Story) *TOV* V3 #5 (9/70), *TT* V4 #2 (3/72), *TT* V6 #2 (4/74)

Horror Bell, The (Macagno; redraw "The Lamenting Voice of the Bell"—*Web of Mystery* #1, Feb. 1951, Ace) *TOV* V5 #5 (8/72), *HT* V2 #5 (5/76), *TT* V10 #1 (1/79)

Horror Bugs, The (Reynoso; redraw "Slaughter House"—*Black Magic* #31, July Aug. 1954, Prize) *TT* V5 #6 (12/73)

Horror Club (Fraga; redraw "Kiss and Kill"—*Witches Tales* #20, Aug. 1953, Harvey) *HT* V2 #1 (1/70), *TOV* V4 #1 (1/71), *W* V7 #4 (6/73)

Horror Doll, The (Barnes; redraw "The Devil Doll"—*Black Magic* #32, Sept. Oct. 1954, Prize) *TFTT* V6 #5 (9/74), *HT* V8 #2 (5/77), *TT* V9 #1 (1/78), *WVT* V3 #2 (7/79)

Horror Dolls, The (?- redraw "Horror of the Voodoo Dolls"—*Mysterious Adventures* #9, Aug. 1952, Story) *WT* V3 #4 (7/71), *W* V7 #3 (4/73)

Horror Face (Mandrafina; redraw "The Man with the Iron Face"—*Witches Tales* #12, July 1952, Harvey) *TOV* V6 #1 (1/73)

Horror in Jade (Muñoz; redraw "Death Pact"—*Tomb of Terror* #3, Aug. 1952, Harvey) *TOV* V7 #5 (9/74)

Horror in Slime (Fernand; redraw "Horror Harbor"—*Haunted Thrills* #8, Apr. 1953, Ajax) *TOV* V7 #3 (5/74)

Horror in Wood (Reynoso; redraw "The Last Word"—*Tomb of Terror* #2, July 1952, Harvey) *WT* V5 #5 (9/73), *W* V13 #2 (3/80)

Horror Island (Novelle; redraw "The Coward"—*Ghostly Weird Stories* #124, Sept. 1954, Star) *TT* V3 #4 (7/71), *WT* V5 #3 (5/73)

Horror on Radar, The (Casadei; redraw "The Worm Turns"—*Weird Tales of the Future* #5, Jan. Feb. 1953, Gillmor) *WW* V2 #4 (8/71), *W* V7 #6 (10/73), *W* V11 #2 (6/78)

Horror on the Moor (Cristóbal; redraw "Murder on the Moor"—*Haunted Thrills* #10, July 1953, Ajax) *TOV* V7 #4 (7/74), *HT* V7 #4 (11/76), *W* V12 #3 (9/79)

Horror Tree (Fernand; redraw "Green Killer"—*Chamber of Chills* #8, May 1952, Harvey) *TOV* V7 #2 (3/74), *TT* V7 #1 (4/76), *W* V12 #3 (9/79)

Horror with 4 Legs (Marchionne; redraw "Nightmare Island"—*Voodoo* #15, May June 1954, Ajax) *TOV* V7 #2 (3/74), *TT* V7 #1 (4/76), *W* V12 #3 (9/79)

Horror with Fangs (Fernand; redraw "Special on Beet Soup"—*Tales of Horror* #6, 1953, TOBY) *TOV* V7 #6 (11/74), *HT* V7 #2 (5/76), *TT* V10 #1 (1/79), *TOD* V1 #3 (5/79), *W* V14 #2 (7/81)

Horror without a Head (Olivera; redraw "Headless Horror"—*Chamber of Chills* #8, May 1952, Harvey) *WT* V6 #5 (9/74), *W* V10 #2 (6/77), *TOD* V1 #4 (8/79), *W* V13 #3 (6/80), *TOD* V3 #2 (9/81)

House of Blood (Mandrafina; redraw "Night of Terror"—*Voodoo* #16, July Aug. 1954, Ajax) *TT* V4 #4 (8/74), *HT* V7 #4 (11/76), *W* V12 #2 (6/79) As "The House that Dripped Blood" *TT* V8 #3 (10/77), *W* V14 #2 (7/81)

House of Blood (Marchionne; redraw "Junk Man's Treasure"—*Out of the Shadows* #14, Aug. 1954, Standard) *HT* V4 #1 (1/72), *WT* V5 #6 (11/73), *TT* V8 #1 (4/77), *TT* V9 #3 (7/78), *W* V14 #3 (11/81)

House of Monsters (Ayers; redraw "The Castle of Fear" - *Weird Mysteries* #3, Feb. 1953, Gillmor) *HT* V2 #1 (1/70), *TOV* V4 #1 (1/71), *TFTT* V5 #4 (7/73), *W* V9 #3 (9/76), *W* V10 #3 (12/77)

House of Shock (Burgos; redraw "Murder Mansion"—*Witches Tales* #6, Nov. 1952, Harvey) *TOV* V3 #1 (1/70)

House of the Vampire (Stepancich; redraw "Death Never Takes a Furlough"—*Web of Mystery* #15, Nov. 1953, Ace) *WT* V4 #1 (2/72), *WT* V5 #6 (11/73), *HT* V9 #2 (5/78), *TOD* V3 #1 (5/81)

House of Vampires (Reynoso; redraw "Vampire's Roost"—*Beware* #9, May 1954, Trojan) *WT* V2 #3 (6/70), *TOV* V4 #5 (9/71), *TOV* V6 #2 (3/73)

House that Dripped Blood, The (see House of Blood-Mandrafina)

Human Monster, The *SG* V1 #9 (4/71), *W* V6 #1 (2/72)

Hungry Brain, The (Reynoso; redraw "World of the Monster Brain"—*Strange Worlds* #9, Nov. 1952, Avon) *WW* V2 #1 (2/71)

Hungry Corpsemakers, The (Fraga; redraw "The Things"—*Chamber of Chills* #13, Oct. 1952, Harvey) *TT* V5 #6 (12/73)

Hungry Ghoul, The (Ayers; redraw "The Ghoul at Eldritch Manor"—*Beware! Terror Tales* #5, Jan. 1953, Fawcett) *TOV* V3 #4 (7/70), *WT* V4 #1 (2/72), *W* V7 #6 (10/73), *W* V9 #3 (9/76), *TOD* V1 #5 (11/79)

Hungry Monster, The (?- redraw "Monster in the Mist"—*Haunted Thrills* #17, Sept. Oct. 1954, Ajax) *TOV* V7 #3 (5/74)

Hungry Slime, The (Marchionne; redraw "The Living Slime"—*Tomb of Terror* #5, Oct. 1952, Harvey) *TT* V5 #5 (10/73), *TT* V7 #3 (7/76)

Hungry Vampire, The (Reynoso; redraw "Vengeance Weaves a Tapestry"—*Web of Mystery* #5, Oct. 1951, Ace) *W* V6 #3 (4/72), *TFTT* V6 #1 (1/74), *TOD* V1 #5 (11/79), *WVT* V5 #1 (1/81)

Hungry Vampire, The (Stepancich; redraw "Two for the Money"—*Mysterious Adventures* #22, Oct. 1954, Story) *WT* V2 #6 (12/70), *HT* V5 #5 (6/73)

I

I Chopped Her Head Off (Ayers; redraw "I Killed Mary"—*Weird Mysteries* #8, Jan. 1954, Gillmor) *TT* V2 #1 (1/70), *TOV* V4 #2 (3/71), *WT* V4 #5 (9/72), *TFTT* V6 #4 (7/74), *W* V9 #2 (6/76), *HT* V9 #1 (2/78)

Ice Monsters, The (Muñoz; redraw "Glacier Beast"—*Tomb of Terror* #4, Sept. 1952, Harvey) *TOV* V6 #4 (7/73)

In the Slime Below (Macagno; redraw "Les Miserables"—*Black Cat Mystery* #48, Feb. 1954, Harvey) *HT* V4 #5 (8/72), *TFTT* V6 #4 (7/74), *W* V9 #2 (6/76), *HT* V8 #5 (11/77), *W* V14 #2 (7/81)

Invaders, The (Reynoso; redraw "The Mind Movers"—*Weird Tales of the Future* #7, May June 1953, Gillmor) *WW* V2 #4 (8/71), *W* V8 #1 (2/74), *W* V11 #2 (6/78), *W* V13 #3 (9/80), *WVT* V5 #1 (1/81)

Invitation from a Vampire (Muñoz; redraw "Life's Blood"—*Mysterious Adventures* #13, Apr. 1953, Story) *TT* V4 #3 (4/72), *TFTT* V6 #3 (5/74), *TT* V8 #2 (7/77), *WVT* V3 #4 (1/80)

Isle of Demons (Ayers; redraw "Isle of Doom"—*Weird Terror* #2, Nov. 1952, Comic Media) *TT* V2 #4 (7/70), *SG* V1 #9 (4/71), *HT* V4 #1 (1/72), *TOV* V6 #4 (7/73), *TT* V7 #3 (7/76)

It Came from the Grave (see The Thing from the Grave)

It Cried for Blood (see The Vampire—Torre Repiso)

J

Jaws of Terror (Cristóbal; redraw "Pest Control"—*Black Cat Mystery* #48, Feb. 1954, Harvey) *W* V7 #4 (6/73)

Jeb's Bloody Ghost (Marchionne; redraw "Hangman's Horror"—*Web of Evil* #2, Jan. 1953, Quality) *WT* V3 #6 (12/71), *WT* V5 #3 (5/73), *W* V10 #2 (6/77), *TOD* V3 #2 (9/81)

Jungle Ghost, The (Woromay; redraw "The Manhunting Lion"—*Mysterious Adventures* #22, Oct. 1954, Story) *TT* V3 #1 (1/71), *WVT* V4 #3 (6/73)

Jury of Skeletons, A (Cristóbal; redraw "Corpses of the Jury"—*Voodoo* #5, Jan. 1953, Ajax) *TT* V6 #1 (2/74), *TOD* V2 #1 (2/80)

K

Killer Creatures, The (Ayers; redraw "Homecoming"—*Ghostly Weird Stories* #124, Sept. 1954, Star) *TFTT* V2 #6 (12/70), *HT* V5 #5 (6/73)

L

Lighthouse of Horror (Mandrafina; redraw "Beam of Terror"—*Tomb of Terror* #7, Jan. 1953, Harvey) *TT* V5 #5 (10/73), *W* V9 #4 (12/76), *W* V12 #1 (2/79)

Lighthouse Terror (Cristóbal; redraw "Beam of Terror"—*Tomb of Terror* #7, Jan. 1953, Harvey) *TOV* V7 #6 (11/74)

Like Blood, the River is Red (see Cave of Vampires)

Living Corpse (Macagno; redraw "Alive after Five Thousand Years"—*Black Magic* #28, Jan. Feb. 1954, Prize) *TFTT* V6 #5 (9/74), *TT* V9 #1 (1/78)

Living Dead, The (Casadei; redraw "The Lost Souls"—*Chamber of Chills* #24 [#4], Dec. 1951, Harvey) *W* V4 #3 (6/70), *WT* V3 #4 (8/71), *WT* V5 #5 (9/73), *HT* V9 #2 (5/78)

Living Dead, The (Cerchiara; redraw "The Man Who Cheated Death"—*Web of Evil* #7, Oct. 1953, Quality) *W* V6 #2 (3/72), *TFTT* V6 #1 (1/74)

Living Dead, The (Macagno; redraw "The Zombi's Bride"—*Fantastic Fears* #3, Sept. 1953, Ajax) *HT* V6 #3 (6/74), *W* V9 #2 (6/76)

Living Horoscope (Fraga; redraw "Zodiac"—*Witches Tales* #18, Apr. 1953, Harvey) *TFTT* V2 #1 (1/70), *HT* V3 #1 (1/71), *W* V7 #4 (6/73)

Lottery of Horror (Reynoso; redraw "Lottery"—*Chamber of Chills* #22, Mar. 1954, Harvey) *HT* V5 #5 (6/73), *W* V12 #4 (12/79)

M

Mad Bowler, The (Casadei; redraw "Final Warning"—*Weird Terror* #13, Sept. 1954, Comic Media) *HT* V4 #6 (10/72)

Mad Ones, The (Cerchiara; redraw "Insane"—*Mysterious Adventures* #22 Oct. 1954, Story) *HT* V4 #5 (8/72), *TT* V8 #2 (7/77)

Mad Witch, The (Casadei; redraw "Return from Bedlam"—*Chamber of Chills* #11, Aug. 1952, Harvey) *HT* V5 #5 (10/73), *HT* V8 #2 (7/77)

Madman's Knife (Muñoz; redraw "The Curse of Morgan Kilgane"—*Chamber of Chills* #11, Aug. 1952, Harvey) *TT* V5 #6 (12/73)

Man Beast, The (Reynoso; redraw "The Survivors"—*Tomb of Terror* #6, Nov. 1952, Harvey) *HT* V5 #4 (8/73)

Man from Hell, The (Muñoz; redraw "The Son of Satan"—*Tales of Horror* #9, Feb 1954, TOBY) *HT* V6 #6 (11/74)

Man in the Heavy Metal Suit, The (see The Metal Horror)

Man of Evil (Torre Repiso; redraw "The Vultures of Doom"—*Mysterious Adventures* #12, Feb. 1953, Story) *W* V5 #1 (2/71), *WT* V5 #4 (7/73)

Man Who Didn't Believe, The (Casadei; redraw "The Disbeliever"—*Weird Mysteries* #3, Feb. 1953, Gillmor) *TT* V2 #1 (1/70), *WW* V2 #2 (4/71), *TOV* V5 #6 (10/72), *TOV* V7 #4 (11/74), *W* V10 #3 (12/77)

Man-Rat (Reynoso; redraw "The Rat Man"—*Tomb of Terror* #5, Oct. 1952, Harvey) *TOV* V6 #5 (9/73)

Mask of Horror (Ayers; redraw "Realm of Lost Faces"—*Web of Mystery* #24, May 1954, Ace) *WT* V3 #3 (6/71), *TFTT* V5 #1 (1/73)

Mask of Horror (Marchionne; redraw "Mask of the Murderer"—*Black Cat Mystery* #42, Feb. 1953, Harvey) *W* V6 #6 (10/72), *TFTT* V6 #5 (9/74), *W* V9 #3 (9/76), *TT* V9 #1 (1/78), *WVT* V4 #2 (4/80)

Mask of Horror (Woromay; redraw "Mask of Medusa"—*Weird Terror* #3, Jan 1953, Comic Media) *WT* V2 #4 (8/70), *TT* V4 #4 (6/72), *HT* V6 #1 (2/74)

Mechanical Monster (Woromay; redraw "Death Kiss"—*Weird Terror* #10, Mar. 1954, Comic Media) *TFTT* V2 #4 (8/70), *TOV* V5 #4 (6/72)

Metal Horror, The (Muñoz; redraw "Vision in Bronze"—*Tomb of Terror* #8, Mar. 1953, Harvey) *W* V7 #1 (2/75) As "The Man in the Heavy Metal Suit" *W* V11 #2 (6/78), *WVT* V4 #1 (7/80)

Metal Replacements, The (Oswal; redraw "We Shall Rise Again"—*Planet Comics* #72, Fall 1953, Fiction House) *WW* V2 #3 (6/71), *W* V8 #4 (10/74), *HT* V9 #3 (11/78)

Metal Terror (Gallo; redraw "The Metal Murderer"—*Strange Worlds* #8, Aug. 1952, Avon) *SG* V1 #10 (6/71), *WT* V5 #6 (11/73)

Midnight Hag, The (Muñoz; redraw "The Horror from the Shade"—*Chamber of Chills* #11, Aug. 1952, Harvey) *TOV* V7 #1 (1/74), *HT* V5 #5 (6/73)

Monster (Casadei redraw "Mark of the Brute"—*Weird Terror* #11, May 1954, Comic Media) *TT* V2 #5 (9/70), *W* V5 #6 (12/70), *W* V6 #1 (1/71)

Monster (Cristóbal; redraw "The Man Who Imagined a Monster"—*Tales of Horror* #4, Jan. 1953, TOBY) *TFTT* V6 #4 (7/74), *WVT* V4 #2 (4/80)

Monster (Marchionne; redraw "Lone Shark"—*Black Magic* #33, Nov. Dec. 1954, Prize) *TFTT* V5 #4 (7/73), *W* V9 #2 (6/76), *W* V13 #2 (3/80), *W* V14 #2 (7/81)

Monster (Muñoz; redraw "The Ape Man"—*Black Cat Mystery*

#39, Sept. 1952, Harvey) *TFTT* V5 #3 (5/73), *TT* V8 #3 (10/77), *WVT* V3 #4 (1/80), *W* V14 #3 (11/81)

Monster Cloud, The (Marchionne; redraw "The Shower of Death"—*Witches Tales* #12, July 1952, Harvey) *TOV* V6 #2 (3/73)

Monster Freakout (Reynoso; redraw "Revenge"—*Mysterious Adventures* #15, Aug. 1953, Story) *W* V6 #2 (3/72), *HT* V6 #2 (4/74)

Monster from Dimension X (Ayers with probably Adkins inks: redraw "The Fiend from Outer Space"—*Web of Evil* #19, Oct. 1954, Quality) *SG* V1 #9 (4/71), *TFTT* V4 #5 (11/72), *W* V8 #4 (10/74), *HT* V9 #3 (11/78)

Monster in Cloth (Marchionne; redraw "The Crypt of Death"—*Tomb of Terror* #2, July 1952, Harvey) *HT* V5 #5 (10/73), *W* V9 #4 (12/76), *TT* V9 #4 (10/78), *W* V12 #4 (12/79)

Monster in White (Fraga; redraw "Operation Monster"—*Chamber of Chills* #5, Feb. 1952, Harvey) *WT* V2 #2 (4/70), *TFTT* V3 #4 (8/71), *TOV* V6 #1 (1/73)

Monster is Hungry, The (Macagno; redraw "Found: Lair of the Snow Monster"—*Tomb of Terror* #6, Nov. 1952, Harvey) *TFTT* V5 #6 (11/73)

Monster Maker (Fernand; redraw "Formula for Death"—*Chamber of Chills* #8, May 1952, Harvey) *W* V8 #4 (8/74), *W* V10 #2 (6/77), *HT* V9 #3 (11/78), *W* V13 #3 (6/80)

Monster of Darkness (Reynoso; redraw "The Clinging Phantom"—*Witches Tales* #5, Sept. 1951, Harvey) *TFTT* V5 #1 (1/73)

Monster of Evil (Muñoz; redraw "Orgy of Death"—*Web of Evil* #4, Sept. 1953, Quality) *TFTT* V4 #2 (3/72), *WT* V6 #4 (7/74), *HT* V9 #3 (8/78)

Monster that Burns, The (Fraga; redraw "The Flaming Horror"—*Witches Tales* #10, May 1952, Harvey) *WT* V1 #3 (1/73), *HT* V6 #3 (6/74), *HT* V7 #4 (11/76)

Monster Town (Marchionne; redraw "The Hamlet of Horror"—*Web of Evil* #16, July 1954, Quality) *TFTT* V3 #4 (8/71), *TFTT* V5 #3 (5/73), *HT* V7 #3 (8/76), *W* V11 #1 (3/78), *HT* V10 #1 (2/79)

Monster, The (Casadei; redraw "Excursion"—*Black Cat Mystery* #44, June 1953, Harvey) *WT* V5 #2 (4/73) As "The Thing" *W* V10 #3 (12/77)

Monster, The (Fraga; redraw "The Man-Ape"—*Weird Terror* #10, Mar. 1954, Comic Media) *HT* V3 #6 (11/71), *HT* V5 #4 (8/73), *W* V12 #4 (12/79)

Monster, The (Fraga; redraw "The Menace That Stalked Brooding Cunliffe"—*Web of Mystery* #5, Oct. 1951, Ace) *W* V6 #6 (10/72), *TFTT* V6 #6 (9/74), *HT* V9 #2 (5/78)

Monster, The (Marchionne; redraw "Transformation"—*Witches Tales* #14, Sept. 1952, Harvey) *TFTT* V4 #7 (12/72), *TFTT* V6 #4 (7/74), *TT* V7 #4 (10/76), *HT* V8 #5 (11/77), *WVT* V3 #1 (4/79)

Monster, The (Muñoz; redraw "The Killer from Saturn"—*Web of Evil* #3, Mar. 1953, Quality) *HT* V4 #1 (1/72), *W* V7 #3 (6/73), *W* V11 #2 (6/78), *WVT* V4 #3 (7/80), *WVT* V5 #3 (3/82)

Monster's Nightmare (Ayers; redraw "Creatures of the Swamp"—*Chamber of Chills* #22 [#2], Aug. 1951, Harvey) *HT* V2 #3 (5/70), *W* V5 #5 (10/71), *HT* V5 #5 (10/73)

Monsters of Evil (Reynoso; redraw "Demons of the Night"—*Chamber of Chills* #9, June 1952, Harvey) *HT* V4 #4 (7/72)

Monsters, The (Kato; redraw "Dungeon of Doom"—*Chamber of Chills* #6, Mar. 1952, Harvey) *TOV* V6 #6 (11/74), *HT* V7 #2 (5/76), *HT* V9 #2 (5/78), *W* V12 #3 (9/79)

Moon is Red, The (Oswal; redraw "A Nation is Born"—*Strange Worlds* #4, Sept. 1951, Avon) *SG* V1 #8 (2/71), *TT* V5 #2 (4/73)

Morgan's Ghost (Castellon; redraw "Bridge of Death"—*Witches Tales* #17, Feb 1953, Harvey) *WT* V3 #2 (4/71), *W* V6 #5 (8/72), *HT* V7 #1 (2/75), *W* V10 #1 (3/77), *TT* V10 #1 (1/79)

Mud Creatures, The (Fraga; redraw "The Quagmire Beast"—*Tomb of Terror* #2, July 1952, Harvey) *WT* V5 #4 (7/73), *W* V13 #2 (3/80)

Mummies, The (Casadei; redraw "Marriage of the Monsters"—*Tomb of Terror* #5, Oct. 1952, Harvey) *HT* V5 #4 (8/73)

Mummies, The (Fraga; redraw "The Living Mummies"—*Chamber of Chills* #15, Jan. 1953, Harvey) *W* V6 #5 (8/72), *TT* V6 #6 (12/74), *HT* V7 #2 (5/76), *TT* V9 #2 (4/78), *TT* V10 #1 (1/79), *TOD* V1 #3 (5/79), *W* V14 #2 (7/81)

Mummies, The (Macagno; redraw "The Arm of Tatra Magis"—*Web of Mystery* #12, Aug. 1952, Ace) *W* V5 #4 (8/71), *TT* V5 #5 (10/73)

Mummies, The (Reynoso) (see Curse of the Mummies)

Mummies, The (Stepancich) *WT* V2 #1 (2/70), *TT* V3 #2 (3/71), *W* V4 #6 (11/72)

Mummy, The Ayers; Casadei; redraw "Death from the Tomb"—*Web of Evil* #20, Nov. 1954, Quality) *HT* V3 #1 (1/71), *HT* V5 #5 (6/73)

Mummy's Evil Eyes, The (Cristóbal; redraw "The Terror of Akbar"—*Strange Fantasy* #10, Feb. Mar. 1954, Ajax) *TFTT* V6 #1 (1/74), *HT* V8 #2 (5/77), *TOD* V2 #3 (8/80)

Mummy's Revenge, The (Fraga; redraw "The Case of the

Beckoning Mummy"—*Web of Mystery* #1, Feb. 1951, Ace) *W* V6 #3 (4/72), *W* V8 #2 (4/74), *TT* V7 #4 (10/76)

N

Naked Horror (Fraga; redraw "The Ugly Duckling"—*Chamber of Chills* #22, Mar. 1954, Harvey) *TFTT* V4 #4 (9/72)

Never Curse a Corpse (Muñoz; redraw "Cadaver's Revenge"—*Strange Fantasy* #5, APR. 1953, Ajax) *WT* V6 #3 (5/74), *W* V11 #1 (3/78)

Never Kill a Corpse (Macagno; redraw "Don't Call on the Dead"—*Black Magic* #27, Nov. Dec. 1954, Prize) *TT* V6 #6 (12/74), *HT* V7 #2 (5/76), *W* V11 #4 (12/78), *TOD* V1 #3 (5/79), *TOD* V3 #2 (9/81)

Night Monsters- (Romero; redraw "Blood Money"—*Tomb of Terror* #11, Sept. 1953, Harvey) *WT* V7 #1 (2/75)

Night of Terror (Casadei; redraw "Shock"—*Witches Tales* #20, Aug. 1953, Harvey) *TT* V2 #2 (3/70), *W* V5 #3 (6/71), *W* V6 #7 (12/72), *TT* V6 #6 (12/74)

Nightmare (Casadei; redraw "The Last Man Alive"—*Ghostly Weird Stories* #121, Dec. 1953, Star) *TOV* V7 #2 (3/74)

Nightmare (Fraga; redraw "Bird of Prey"—*Witches Tales* #18, Apr. 1953, Harvey) *WT* V1 #9 (12/69), *WT* V2 #5 (9/70), *WT* V4 #2 (3/72)

Nightmare (Reynoso; redraw "Rehearsal for Death"—*Web of Evil* #1, Nov. 1952, Quality) *TT* V3 #6 (11/71), *HT* V5 #6 (12/73), *TT* V7 #4 (10/76)

Nightmare for a Hero (Woromay; redraw "The Hunter and the Hunted"—*Mysterious Adventures* #15, Aug. 1953, Story) *TOV* V5 #2 (3/72), *W* V9 #4 (12/76)

Nightmare in Blood (Reynoso; redraw "Dream of Horror"—*Strange Fantasy* #9, Dec. 1953, Ajax) *WT* V4 #4 (7/74), *HT* V8 #2 (5/77), *HT* V9 #3 (8/78)

O

Ogre from Space, The (Muñoz; redraw "What Was It?"—*Web of Mystery* #20, Sept. 1953, Ace) *WW* V2 #2 (4/71), *W* V6 #6 (10/72), *W* V8 #4 (10/74) As "Who Are You?" *W* V11 #2 (6/78)

Ogres, The (Reynoso; redraw "The Lost Race"—*Chamber of Chills* #13, Oct. 1952, Harvey) *HT* V5 #5 (10/73), *W* V12 #4 (12/79)

Old Crones' Voodoo, The (Fraga; redraw "When Witches Summon"—*Beware* #8, Mar. 1954, Trojan) *TOV* V3 #2 (3/70), *WW* V2 #3 (6/71), *WT* V5 #1 (1/73), *TT* V6 #3 (6/74)

Old Ghoul, The (Casadei; redraw "Cadaver"—*Weird Terror* #5, May 1953, Comic Media) *TFTT* V2 #4 (8/70), *W* V6 #4 (6/72), *W* V9 #1 (1/75)

Old Hag's Claws of Horror, The (Casadei; redraw "Darker than Death"—*Chamber of Chills* #21 [#1], June 1951, Harvey) *WT* V2 #2 (4/70), *TFTT* V4 #4 (9/72), *HT* V4 #7 (12/72) As "Claws of Horror" *HT* V6 #4 (8/74)

One Step Beyond (Cristóbal; redraw "Tale of Cain"—*Tomb of Terror* #12, Sept. 1953, Harvey) *WT* V7 #1 (2/75)

One Step Beyond (Reynoso) *WT* V5 #3 (10/71)

Open Grave, The (Mandrafina; redraw "The Waiting Grave"—*Witches Tales* #9, Apr. 1952,Harvey) *TFTT* V5 #2 (3/73), *W* V9 #2 (6/76), *W* V10 #2 (12/77), *WVT* V4 #2 (7/80)

Over Her Dead Body (Woromay; redraw "While the Iron Was Hot"—*Weird Mysteries* #3, Feb. 1953, Gillmor) *WT* V1 #9 (12/69), *TT* V2 #6 (11/70), *W* V6 #3 (4/72), *TOV* V7 #1 (1/74)

P

Pit of Evil (see Satan's Pit of Evil)

Pit of Horror, The (Reynoso; redraw "Volcano of Doom"—*Tomb of Terror* #6, Nov. 1952, Harvey) *TOV* V6 #4 (7/73)

Pit of Monsters (5) (art: Casadei) redraw "Mind over Matter"—*Chamber of Chills* #15, Jan. 1953, Harvey) *TOV* V5 #5 (8/72), *HT* V9 #1 (2/78)

Planet of Horror (Oswal; redraw "The Last Expedition"—Planet Comics #72, Fall 1953, Fiction House) *SG* V1 #8 (2/71), *HT* V5 #2 (4/73)

Planetoid Monsters (Stepancich; redraw "The Space Gods of Planetoid 50"—*Strange Worlds* #7, May 1952, Avon) *SG* V1 #10 (6/71), *HT* V6 #6 (10/73)

Poison of Evil, The (Fraga; redraw "Grave on the Green"—*Black Cat Mystery* #33, Feb. 1952, Harvey) *W* V7 #3 (4/73)

Pool of Evil (Muñoz; redraw "The Girl of the Moonpool"—*Chamber of Chills* #11, Aug. 1952, Harvey) *TOV* V7 #1 (1/74), *HT* V8 #2 (5/77), *W* V12 #3 (9/79)

Pool of Horror (Mandrafina; redraw "Colony of Horror"—*Tomb of Terror* #7, Jan. 1953, Harvey) *TT* V5 #4 (8/73), *HT* V7 #4 (11/76), *TOD* V1 #3 (5/79), *WVT* V4 #3 (7/80), *WVT* V5 #2 (8/81)

Priestess of Death (Barnes; redraw "Pathway to the Great Abyss"—*Web of Mystery* #9, May 1952, Ace) *HT* V7 #2 (5/76), *TT* V10 #1 (1/79)

R

Rack, The (Muñoz; redraw "Torture"—*Weird Tales of the Future* #5, Jan. Feb. 1953, Gillmor) *W* V6 #2 (3/72), *WT* V6 #1 (1/74), *TT* V8 #3 (10/77), *WVT* V4 #2 (4/80), *W* V14 #2 (7/81)

Rat Feast, The (Zoppi; redraw "Fear Has a Name"—*Voodoo* #12, Nov. 1953, Ajax) *TT* V6 #3 (6/74), *HT* V8 #4 (8/77)

Rats are Coming, The (Cristóbal; redraw "Who Shall Inherit the Earth?"—*Tales of Horror* #4, Jan. 1953, TOBY) *TOV* V7 #5 (9/74), *WVT* V4 #2 (4/80)

Reincarnation (Fraga; redraw "A Stone's Throw from Eternity"—*Weird Mysteries* #1, Oct. 1952, Gillmor) *TT* V2 #1 (1/70), *W* V5 #2 (4/71), *WT* V4 #5 (9/72), *W* V8 #4 (10/74), *TT* V9 #4 (10/78)

Restrained (Fraga; redraw "Under Her Thumb"—*Weird Tales of the Future* #5, Jan. Feb. 1953, Gillmor) *W* V6 #4 (6/72), *HT* V6 #5 (10/74), *TT* V9 #4 (10/78)

Rhyme of Shock (Muñoz; redraw "Old Mother Lubbard"—*Mysterious Adventures* #23, Dec. 1954, Story) *HT* V4 #4 (6/72), *TT* V6 #2 (4/74)

Ring of Corpses, A (Macagno; redraw "Trumpet of Doom"—*Haunted Thrills* #14, Mar. Apr. 1954, Ajax) *TT* V6 #1 (2/74), *TT* V8 #2 (7/77), *TOD* V2 #2 (5/80)

River of Blood (Macagno; redraw "Massacre of the Ghost"—*Witches Tales* #2, Mar. 1951, Harvey) *WT* V5 #3 (5/73), *TT* V9 #4 (10/78)

Rotting Coffin, The (Muñoz; redraw "If I Should Die"—*Haunted Thrills* #18, Nov. 1954, Ajax) *W* V8 #2 (4/74)

Rotting Ghouls, The (Muñoz; redraw "Graveyard Monsters"—*Tomb of Terror* #4, Sept. 1952, Harvey) *W* V7 #4 (6/73)

S

Satan, the Demon (Ayers; redraw "The Man Who Beat the Devil"—*Mysterious Adventures* #23, Dec. 1954, Story) *HT* V3 #1 (1/71), *W* V4 #4 (6/73)

Satan's Blood Bath (Macagno; redraw "Wrath of Satan"—*Weird Terror* #2, Nov. 1952, Comic Media) *TFTT* V4 #1 (2/72), *HT* V10 #1 (2/79) As "Blood Bath" *W* V7 #7 (12/73)

Satan's Bloody Pearls (Marchionne; redraw "The Devil's Necklace"—*Chamber of Chills* #14, Nov. 1952, Harvey) *TOV* V6 #6 (11/73), *TT* V7 #4 (9/76), *W* V13 #3 (9/80)

Satan's Cat (Fraga; redraw "First Come, First Served"—*Weird Mysteries* #2, Dec. 1952, Gillmor) *HT* V2 #2 (3/70), *W* V5 #3 (6/71), *TT* V4 #7 (12/72), *TFTT* V6 #4 (7/74), *HT* V8 #5 (11/77), *TOD* V1 #5 (11/79), *TOD* V3 #1 (5/81)

Satan's Corpse (Reynoso; redraw "Make up for Death"—*Web of Evil* #2, Jan. 1953, Quality) *HT* V4 #1 (1/72) As "The Corpse" *TOV* V7 #1 (1/74), *TT* V8 #3 (10/77), *W* V12 #3 (9/79), *W* V14 #2 (7/81), *W* V14 #3 (11/81)

Satan's Curse (Mandrafina; redraw "Devil's Hex"—*Weird Terror* #5, May 1953, Comic Media) *TFTT* V5 #6 (11/73), *W* V9 #4 (12/74), *TT* V9 #4 (10/78)

Satan's Dead Demons (Macagno; redraw "Tank of Corpses"—*Witches Tales* #9, Apr. 1952, Harvey) *TOV* V5 #7 (12/72), *W* V9 #1 (1/75), *HT* V7 #3 (8/76), *W* V11 #1 (3/78), *HT* V9 #3 (11/78)

Satan's Demon (Cristóbal; redraw "King of Hades"—*Voodoo* #11, Sept. 1953, Ajax) *TOV* V7 #2 (3/74), *HT* V7 #4 (11/76), *TOD* V2 #3 (8/80)

Satan's Demon (Saborido- redraw "The Black Heart"—*Weird Terror* #12, July 1954, Comic Media) *HT* V2 #5 (9/70), *TFTT* V4 #2 (3/72), *W* V8 #3 (6/74), *TT* V9 #1 (1/78)

Satan's Demons (Romero; redraw "The Cry of Satan"—*Tomb of Terror* #3, Aug. 1952, Harvey) *WT* V6 #4 (11/74), *TT* V8 #2 (7/77), *TOD* V2 #2 (5/80)

Satan's Horror (Fraga; redraw "Trick the Devil"—*Black Cat Mystery* #35, May 1952, Harvey) *TOV* V4 #4 (11/71), *TOV* V6 #4 (7/73), *TT* V8 #1 (4/77)

Satan's Mad Dog (Casadei; redraw "Devil's Due"—*Chamber of Chills* #10, July 1952, Harvey) *W* V7 #7 (12/73)

Satan's Man (Macagno; redraw "Satan's Spectacles"—*Web of Evil* #4, May 1953, Quality) *TT* V4 #3 (4/72), *TFTT* V6 #3 (5/74), *TT* V7 #4 (10/76)

Satan's Pit of Evil (Fraga; redraw "League of the Damned"—*Witches Tales* #7, Jan. 1952, Harvey) *WT* V5 #1 (1/73), *HT* V9 #3 (8/78) As "Pit of Evil" *TOV* V7 #2 (3/74), *W* V9 #3 (9/76), *W* V13 #3 (9/80)

Satan's Revenge (Zoppi; redraw "The Devil Collects"—*Haunted Thrills* #15, May June 1954, Ajax) *TT* V6 #4 (8/74), *HT* V7 #2 (5/76)

Satan's Stone (Macagno; redraw "Devil's Diamond"—*Witches Tales* #14, Sept. 1952, Harvey) *TFTT* V5 #2 (3/73), *W* V9 #3 (9/76), *W* V10 #3 (12/77), *W* V12 #1 (2/79)

Satan's Toys (Muñoz; redraw "Satan's Playthings"—*Voodoo* #8, Apr. 1953, Ajax) *HT* V6 #2 (4/74)

Satan's Warlock (Marchionne; redraw "The Slaying of Joshua Sprague"—*Beware! Terror Tales* #2, July 1952, Fawcett) *W* V5 #5 (10/71), *HT* V5 #3 (10/73), *TT* V7 #3 (7/76), *TOD* V1 #4 (8/79), *WVT* V5 #2 (8/81)

Sawdust Banshee (Fraga; redraw "The Thirteenth Clown"—*Witchcraft* #3, July Aug. 1952, Avon) *HT* V3 #2 (3/71), *W* V6 #6 (10/72), *TT* V6 #5 (10/74)

Scream in Terror (Cristóbal; redraw "Crawling Death"—*Haunted Thrills* #6, Feb. 1953, Ajax) *W* V8 #2 (4/74)

Scream of Horror, A (Casadei; redraw "Reincarnation"—*Chamber of Chills* #22, Mar. 1954, Harvey) *WT* V5 #1 (1/73), *TOV* V7 #3 (5/74)

Screaming Hell (Muñoz; redraw "Colony of Horror"—*Tomb of Terror* #7, Jan. 1953, Harvey) *HT* V7 #1 (2/75), *TT* V10 #1 (1/79)

Screaming Things, The (Casadei; redraw "The Gruesome Garden"—*Haunted Thrills* #13, Jan. 1954, Ajax) *WT* V6 #2 (3/74)

Sea Ghost (Fraga; redraw "Haunt of the Iskander Fjord"—*Web of Mystery* #14, Oct. 1952, Ace) *WT* V3 #4 (8/71), *TFTT* V5 #3 (5/73)

Sea Monsters, The (Muñoz; redraw "The Half Creatures of the Sargasso Sea"—*Web of Evil* #19, Oct. 1954, Quality) *TFTT* V3 #4 (8/71), *W* V7 #3 (4/73), *HT* V10 #1 (2/79)

Seat of Doom (Mandrafina; redraw "Man Made Monster"—*Black Cat Mystery* #33, Feb. 1952, Harvey) *TFTT* V5 #3 (5/73), *W* V9 #2 (6/76), *W* V12 #4 (12/79), *W* V13 #2 (3/80)

Seven Skulls, The (Fraga; redraw "The Seven Skulls of Magondi"—*Chamber of Chills* #6, Mar. 1952, Harvey) *TT* V6 #5 (10/74), *TT* V9 #2 (4/78)

Sewer Werewolves, The (Ayers; redraw "Terror in the Streets-Beware #8, Mar. 1954, Trojan) *W* V4 #1 (2/70), *TFTT* V3 #2 (4/71), *WT* V5 #2 (3/73), *W* V11 #3 (9/78)

Shadow of Evil (Marchionne; redraw "My Sinister Double"—*Web of Mystery* #24, May 1954, Ace) *W* V8 #1 (2/74), *TT* V8 #1 (4/77)

Shadow of Horror (Fraga; redraw "Invasion"—*Chamber of Chills* #23, May 1954, Harvey) *TOV* V6 #3 (5/73)

Shape of Evil, A (Muñoz; redraw "Invitation to Doom"—*Witches Tales* #7, Jan. 1952, Harvey) *TT* V5 #3 (5/73)

Shock (Fraga; redraw "White Heat"—*Black Cat Mystery* #50, June 1954, Harvey) *W* V8 #3 (6/74)

Shock of Horror, A (Casadei; redraw "Black Passion"—*Chamber of Chills* #19, Sept. 1953, Harvey) *TFTT* V5 #4 (7/73), *HT* V9 #1 (2/78)

Shock of Horror, A (Reynoso; redraw "Reincarnation"—*Witches Tales* #12, July 1952, Harvey) *HT* V5 #1 (1/73)

Shrunken Monster, The (Woromay; redraw "The Shrunken Skull"—*Chamber of Chills* #5, Feb. 1952, Harvey) *W* V4 #3 (6/70), *WT* V3 #5 (10/71), *TOV* V6 #1 (1/73)

Signed in Blood (Reynoso; redraw "The Man Who Tricked the Devil"—*Tales of Horror* #7, Oct. 1953, TOBY) *HT* V7 #1 (2/75), *TT* V8 #1 (4/77), *W* V14 #3 (11/81)

Signed in Blood (Woromay; redraw "The Pact"—*Witches Tales* #19, June 1953, Harvey) *TOV* V3 #1 (1/70), *TFTT* V3 #1 (2/71), *HT* V7 #3 (8/76), *WVT* V5 #2 (4/81)

Silent Horror (Stepancich; redraw "Aria in Blood"—*Out of the Shadows* #11, Jan. 1954, Standard) *TFTT* V4 #1 (2/72), *W* V7 #7 (12/73), *HT* V10 #1 (2/79)

Silver Demon, The (Muñoz; redraw "The Silver Bell of Doom"—*Web of Mystery* #12, Aug. 1952, Ace) *WT* V3 #3 (6/71), *W* V6 #7 (12/72), *HT* V6 #5 (10/74)

Skeleton (Cristóbal; redraw "A Skeleton in the Closet"—*Strange Fantasy* #7, Aug. 1953, Ajax) *TOV* V7 #3 (5/74), *HT* V8 #2 (5/77), *WVT* V4 #3 (7/80)

Skeleton, The (Romero; redraw "Eerie Bones"—*Haunted Thrills* #4, Dec. 1952, Ajax) *TT* V6 #2 (4/74), *TT* V8 #2 (7/77)

Skeleton, The (Torre Repiso; redraw "I Died Laughing"—*Web of Mystery* #24, May 1954, Ace) *HT* V4 #4 (6/72), *HT* V6 #3 (6/74)

Skeleton, The (Woromay; redraw "My Brother's Keeper"—*Mysterious Adventures* #17, Dec. 1953, Story) *WT* V2 #5 (10/70), *W* V6 #2 (3/72), *WT* V6 #4 (11/74), *TT* V7 #4 (10/76)

Skeletons, The (Muñoz; redraw "Pool of the Skeletons"—*Tales of Horror* #8, Dec. 1953, TOBY) *TFTT* V7 #1 (2/75), *HT* V8 #4 (8/77)

Skin Crawlers, The (Muñoz; redraw "Curse of the Caterpillar"—*Witches Tales* #5, Sept. 1951, Harvey) *W* V6 #7 (12/72), *HT* V6 #5 (10/74), *HT* V9 #2 (5/78), *WVT* V3 #2 (7/79), *TOD* V3 #1 (5/81)

Skin Rippers (Olivera; redraw "Terror Below"—*Haunted Thrills* #12, Nov. 1953, Ajax) *W* V7 #7 (12/73), *TT* V7 #3 (7/76), *TOD* V1 #4 (8/79), *WVT* V5 #3 (8/82)

Skin Rippers, The (Barnes; redraw "Black Death"—*Fantastic Fears* #4, Nov. 1953, Ajax) *TFTT* V6 #4 (7/74), *HT* V8 #5 (11/77), *WVT* V3 #1 (4/79)

Skull in a Box (Muñoz; redraw "Dive to Death"—*Weird Terror* #13, Sept. 1954, Comic Media) *TT* V2 #5 (9/70), *HT* V3 #6 (11/71), *HT* V5 #4 (8/73)

Skull, The (Fraga; redraw "A Hole in his Head"—*Black Magic* #27, Nov. Dec. 1954, Prize) *TOV* V6 #5 (9/74), *HT* V9 #1 (2/78), *WVT* V3 #4 (1/80)

Slimy Corpse, The (Muñoz; redraw "Partners in Death"—*Mysterious Adventures* #20, June 1954, Story) *TFTT* V2 #5 (10/70), *W* V6 #2 (3/72), *TFTT* V6 #1 (1/74)

Slimy Gargoyle, The (Casadei; redraw "The Chase"—*Witches Tales* #21, Oct. 1953, Harvey) *HT* V2 #2 (3/70), *WW* V2 #3 (6/71), *TOV* V6 #1 (1/73)

Slimy Haunt, The (Cristóbal; redraw "Death from the Sea"—*Tales of Horror* #4, Jan. 1953, TOBY) *WT* V7 #1 (2/75)

Slimy Mummy, The (Stone; redraw "Servant of the Tomb"—*Witches Tales* #6, Nov. 1952, Harvey) *W* V3 #5 (12/69), *TT* V2 #5 (9/70), *TFTT* V3 #5 (10/71), *WT* V5 #5 (9/73), *W* V11 #3 (9/78)

Slimy Snakeman, The (Woromay; redraw "The Snake Man"—*Chamber of Chills* #22 [#2], Aug. 1951, Harvey) *TOV* V3 #2 (3/70), *W* V5 #3 (6/71), *TOV* V5 #7 (12/72), *HT* V7 #1 (2/75)

Slimy Thing, The (Reynoso; redraw "The Creeping Death"—*Chamber of Chills* #16, Mar. 1953, Harvey) *WT* V4 #5 (9/72), *HT* V6 #5 (10/74), *WVT* V3 #2 (7/79)

Snakepit (Sesagero; redraw "Hissing Horror"—*Fantastic Fears* #4, Nov. 1953, Ajax) *W* V7 #7 (12/73), *WVT* V5 #1 (1/81)

Sorcerer, The (Cerchiara; redraw "The Man Who Died Tomorrow"—*Web of Mystery* #25, July 1954, Ace) *W* V5 #3 (6/71), *TOV* V5 #7 (12/72), *WT* V6 #6 (11/74)

Sorceress, The (Reynoso; redraw "The Spell of the Black Gloves"—*Witches Tales* #5, Sept. 1951, Harvey) *W* V7 #1 (2/75)

Space Demon (Castellon; redraw "The Monster on Mars"—*Weird Tales of the Future* #3, Sept. 1952, Gillmor) *SG* V1 #10 (6/71), *TT* V5 #6 (12/73)

Space Monsters (Fraga; redraw "The Monster Men of Space"—*Strange Worlds* #6, Feb. 1952, Avon) *SG* V1 #8 (2/71), *HT* V5 #1 (2/73),

Space Spirits (Casadei; redraw "The Spirits from Outer Space"—*Weird Mysteries* #1, Oct. 1952, Gillmor) *WW* V2 #1 (2/71)

Space Vampires (Muñoz; redraw "The Vampires of the Void"—*Strange Worlds* #4, Sept. 1951, Avon) *WW* V1 #10 (12/70), *TT* V5 #1 (2/73)

Spider (Cristóbal; redraw "Jelly Death"—*Chamber of Chills* #6, Mar. 1952, Harvey) *TT* V6 #5 (10/74), *HT* V7 #3 (8/76), *TT* V9 #2 (4/78)

Spider, The (Ayers; redraw "Lair of the Silken Doom"—*Web of Mystery* #25, July 1954, Ace) *TOV* V4 #1 (1/71), *TT* V5 #3 (6/73)

Spider, The (Fraga; redraw "Web of the Widow"—*Haunted Thrills* #16, July Aug. 1954, Ajax) *TFTT* V6 #1 (1/74), *TOD* V1 #5 (11/79)

Spirit of Evil, The (Cristóbal; redraw "The Devil You Say?"—*Black Magic* #30, May June 1954, Prize) *HT* V6 #4 (8/74), *W* V9 #4 (12/76)

Spirits of Doom (Casadei; redraw "Fountain of Fear"—*Out of the Shadows* #11, Jan. 1954, Standard) *WT* V4 #1 (2/72), *W* V5 #6 (11/73)

Spirits of the Witch (Fraga; redraw "Two Ways to Die"—*Chamber of Chills* #24 [#4], Dec. 1951, Harvey) *WT* V2 #3 (6/70), *TT* V3 #5 (9/71), *TOV* V6 #2 (3/73), *HT* V8 #2 (5/77), *WVT* V3 #2 (7/79), *TOD* V2 #3 (8/80)

Spirits, The (Casadei; redraw "The Place on the Hill"—*Weird Horrors* #6, Feb. 1953, St. John) *HT* V2 #1 (1/70), *TOV* V4 #1 (1/71)

Spooks, The (Fraga; redraw "Coward's Curse"—*Haunted Thrills* #8, Apr. 1953, Ajax) *HT* V6 #1 (2/74), *HT* V8 #2 (5/77), *W* V12 #4 (12/79)

Stage of Horror (Marchionne; redraw "Designer of Doom"—*Witches Tales* #9, Apr. 1952, Harvey) *TT* V5 #1 (2/73), *HT* V7 #4 (11/76), *W* V12 #2 (6/79), *WVT* V3 #4 (7/80)

Stay out of My Grave (Reynoso; redraw "Dust Onto Dust"—*Chamber of Chills* #23, May 1954, Harvey) *WT* V4 #4 (11/72), *TOV* V7 #5 (9/74), *HT* V7 #2 (5/76), *W* V11 #3 (9/78)

Stone Monsters, The (Fraga; redraw "Gargoyle's Revenge"—*Web of Mystery* #6, Dec. 1951, Ace) *W* V6 #4 (6/72), *WT* V6 #5 (9/74), *W* V9 #4 (12/76), *TT* V9 #4 (10/78)

Storm of Blood, A (Reynoso; redraw "Blood in the Sky"—*Haunted Thrills* #11, Sept. 1953, Ajax) *W* V8 #1 (2/74)

Strange Corpse, The (Ayers with probably Adkins inks: redraw "The Corpse who Prowled by Night"—*Web of Evil* #15, June 1954, Quality) *WT* V4 #3 (10/71)

Strange Escape, The (Muñoz; redraw "Destiny"—*Black Cat Mystery* #44, June 1953, Harvey) *TT* V4 #6 (10/72)

Strange Friend, The (Clemen; redraw "The Lonely"—*Black Cat Mystery* #48, Feb. 1954, Harvey) *TFTT* V4 #9 (4/72), *TOV* V7 #5 (9/74), *TT* V10 #1 (1/79)

Strange Ghosts (see Witches Ghosts)

Strange Spaceship, The (Casadei; redraw "The Thing in the Iceberg"—*Planet Comics* #72, Fall 1953, Fiction House) *WW* V2 #4 (8/71), *TFTT* V5 #3 (5/73)

Strange Vampire, The (Marchionne; redraw "The Vampire's Weird Duel"—*Web of Mystery* #6, Dec. 1951, Ace) *HT* V4 #4 (6/72), *TT* V6 #4 (2/74), *TT* V7 #3 (7/76), *TOD* V1 #4 (8/79), *WVT* V5 #1 (1/81), *TOD* V3 #2 (8/80)

Supernatural, The (Reynoso; redraw The Holland Haunt"—*Adventures into the Unknown* #26, Dec. 1951, ACG) *W* V8 #3 (6/74), *HT* V7 #4 (11/76), *HT* V8 #5 (11/77), *W* V12 #2 (6/79)

Swamp Creature (Mandrafina; redraw "The Swamp Monster—*Chamber of Chills* #12, Sept. 1952, Harvey) *W* V7 #7 (12/73), *W* V9 #4 (12/76), *W* V12 #3 (9/79)

Swamp Devils, The (Macagno; redraw "Ghosts of Doom"—*Web of Evil* #1, Nov. 1952, Quality) *TT* V4 #1 (1/72), *TT* V5 #4 (8/73)

Swamp Monster, The (Muñoz; redraw "The Phantom of the Lonesome Swamp"—*Mysterious Adventures* #6, Feb. 1952, Story) *W* V5 #1 (2/71), *WT* V5 #4 (7/73), *HT* V9 #3 (8/78)

Swamp Monsters (Ayers; redraw "The Life of Riley"—*Beware* #7, Jan. 1954, Trojan) *TFTT* V2 #2 (4/70), *TOV* V4 #4 (7/71), *W* V10 #1 (3/77), *TOD* V1 #5 (11/79), *W* V13 #3 (6/80)

Swamp Terror (Reynoso; redraw "Lover, Come Back to Me"—*Black Magic* #30, May June 1954, Prize) *TOV* V6 #5 (9/74)

Swamp Witch, The (Muñoz; redraw "Swamp Haunt"—*Haunted Thrills* #5, Jan. 1953, Ajax) *WT* V6 #4 (7/74), *W* V11 #3 (9/78)

T

Tear 'em Apart (Marchionne; redraw "The Monsters!"—*Black Magic* #32, Sept. Oct. 1954, Prize) *TFTT* V6 #5 (9/74), *HT* V9 #1 (2/78), *WVT* V4 #2 (4/80)

Tear Him Apart (Macagno; redraw "Hive"—*Tomb of Terror* #8, Mar. 1953, Harvey) *TOV* V6 #5 (9/73), *HT* V7 #2 (5/76), *W* V11 #4 (12/78), *W* V12 #2 (6/79)

Terror Asteroid (Reynoso; redraw "Mystery of Asteroid 9"—*Strange Worlds* #9, Nov. 1952, Avon) *SG* V1 #11 (8/71), *WVT* #7 (12/73), *W* V11 #2 (6/78), *W* V13 #3 (9/80), *WVT* V3 #3 (3/82)

Terror Below (Casadei; redraw "Screaming City"—*Witches Tales* #7, Jan. 1952, Harvey) *HT* V5 #1 (2/73)

Terror Fables (Casadei; redraw "Cinderella"—*Mysterious Adventures* #22, Oct. 1954, Story) *HT* V5 #2 (3/73)

Terror from the Sky (Reynoso; redraw "In the Beginning"—*Weird Tales of the Future* #7, May June 1953, Gillmor) *WT* V3 #5 (10/71), *HT* V5 #2 (4/73)

Terror in Black (Reynoso; redraw "The Closet"—*Tomb of Terror* #11, Sept. 1953, Harvey) *TFTT* V6 #6 (11/74)

Terror in Stone (Macagno; redraw "Curse of the Statue"—*Witches Tales* #7, Jan. 1952, Harvey) *TOV* V6 #1 (1/73), *TT* V7 #3 (7/76)

Terror of the Dead (Muñoz; redraw "Beware the Phantom Spear"—*Web of Mystery* #19, July 1953, Ace) *TOV* V4 #2 (3/71), *TT* V4 #6 (10/72)

Terror of the Dead (Torre Repiso; redraw "Death Comes in Small Pieces"—*Mysterious Adventures* #13, Apr. 1953, Story) *SG* V1 #11 (8/71), *TOV* V5 #5 (8/72)

Terror on Station One (Muñoz; redraw "Sabotage on Space Station 1"—*Strange Worlds* #7, May 1952, Avon) *WW* V1 #10 (12/70), *TFTT* V5 #2 (3/73)

Terror Tunnel (Mandrafina; redraw "Horror in the Mine"—*Haunted Thrills* #2, Aug. 1952, Ajax) *WT* V6 #2 (3/74)

There's a Blood-Sucker Among Us" (Casadei; redraw "Out of the Black Night"—*Web of Mystery* #20, Sept. 1953, Ace) *TOV* V4 #3 (5/71), *TFTT* V4 #5 (11/72), *HT* V7 #2 (2/75), *TT* V10 #1 (1/79), *WVT* V3 #3 (10/79)

Thing from the Grave, The (Woromay; redraw "The Pale Light of Death"—*Chamber of Chills* #24 [#4], Dec. 1951, Harvey) *TFTT* V2 #3 (6/70), *HT* V3 #3 (5/71) As "It Came from the Grave" *W* V6 #1 (2/72), *TFTT* V5 #6 (11/73)

Thing in a Box, The (Reynoso; redraw "Death on the Earth-Mars Run"—*Strange Worlds* #8, Aug. 1952, Avon) *W* V6 #1 (2/72), *TFTT* V5 #6 (11/73)

Thing in the Cellar, The (Stone) *HT* V1 #9 (11/69), *WT* V2 #4 (8/70). *HT* V4 #6 (6/72), *TOV* V7 #3 (5/74) As "The Beast in the Cellar" *W* V12 #3 (9/79)

Thing in the Parlor, The (Woromay; redraw "Step into My Parlour"—*Weird Terror* #8, Nov. 1953, Comic Media) *TOV* V4 #1 (1/71), *TT* V5 #3 (6/73)

Thing in the Ring, The (Muñoz; redraw "The Corpse in the Ring"—*Beware* #9, May 1954, Trojan) *HT* V4 #7 (12/72), *W* V8 #4 (8/74)

Thing of Evil, A (Cristóbal; redraw "The Body Maker"—*Black Cat Mystery* #39, Sept. 1952, Harvey) *WT* V5 #2 (3/73)

Thing of Flesh and Wire, A (Reynoso; redraw "Jazz"—*Witches Tales* #20, Aug. 1953, Harvey) *TFTT* V5 #6 (11/73)

Thing of Horror, A (Casadei; redraw "Don't Look Behind"—*Out of the Shadows* #13, May 1954, Standard) *TT* V4 #7 (12/72), *TT* V6 #4 (8/74)

Thing of Horror, A (Castellon; redraw "The Carpenter's Cursed Creature"—*Web of Mystery* #12, Aug. 1952, Ace) *TOV* V4 #4 (7/71), *HT* V8 #3 (8/76)

Thing of Horror, A (Novelle; redraw "The Oozing Horror"—*Web of Mystery* #23, Mar. 1954, Ace) *TT* V3 #5 (9/71) As "A Thing of Terror" *TOV* V6 #2 (3/73)

Thing of Terror, A (see A Thing of Horror)

Thing Out There, The (Olivera; redraw "From Outer Space"—*Weird Horrors* #6, Feb. 1953, St. John) *TOV* V7 #4 (7/74), *W* V12 #3 (9/79)

Thing that Screamed, The (Macagno; redraw "Screaming Doll"—*Black Magic* #28, Jan. Feb. 1954, Prize) *WT* V6 #6 (11/74), *W* V10 #2 (6/77)

309

Thing with Fangs, A (Romero; redraw "Dinky"—*Tales of Horror* #7, Oct. 1953, TOBY) *W* V9 #1 (1/75)

Thing with the Empty Skull, The (Muñoz; redraw "Skulls of Doom"—*Voodoo* #12, Nov. 1953, Ajax) *W* V8 #1 (2/74)

Thing, The (see Monster—Casadei)

Thing, The (Fraga; redraw "The Thing on the Broken Balcony"—*Strange Worlds* #8, Aug. 1952, Avon) *TT* V2 #6 (11/70), *W* V6 #3 (4/72), *TOV* V7 #1 (1/74), *HT* V7 #4 (11/76), *W* V12 #4 (6/79)

Thing, The (Reynoso; redraw "Spirit in the Stone"—*Chamber of Chills* #5, Feb. 1952, Harvey) *HT* V2 #5 (9/70), *TOV* V5 #3 (4/72), *TFTT* V6 #2 (3/74)

Things of Evil (Cristóbal; redraw "The Evil Ones"—*Weird Terror* #2, Nov. 1952, Comic Media) *HT* V5 #6 (12/73), *TT* V9 #2 (4/78)

Things of Horror (Reynoso; redraw "Tribe of the Terrible Trees"—*Web of Mystery* #6, Dec. 1951, Ace) *TT* V4 #4 (6/72), *WT* V6 #2 (3/74), *TT* V9 #3 (7/78), *TOD* V3 #2 (9/81)

This Cat is Evil (Mandrafina; redraw "She Stalks at Sundown"—*Web of Mystery* #22, Jan. 1954, Ace) *TFTT* V4 #3 (7/72), *W* V11 #3 (3/78)

This House is Haunted (Miranda; redraw "The Romantic Souls"—*Black Magic* #25, June July 1953, Prize) *TT* V6 #6 (12/74)

Tick Tock Horror (Cristóbal; redraw "Death Strikes Four"—*Strange Fantasy* #8, Oct. 1953, Ajax) *WT* V6 #3 (5/74), *TT* V9 #3 (7/78)

Tomb of Hate, The (Muñoz; redraw "Madness of Terror"—*Haunted Thrills* #9, May 1953, Ajax) *HT* V6 #1 (2/74), *W* V12 #4 (12/79)

Tomb of Horror (Reynoso; redraw "The House Where Horror Lived"—*Web of Evil* #6, Sept. 1953, Quality) *TFTT* V3 #5 (10/71), *TFTT* V5 #5 (9/73)

Tomb of Horror, A (Macagno; redraw "A Safari of Death"—*Chamber of Chills* #8, May 1952, Harvey) *W* V8 #4 (8/74), *TT* V7 #1 (4/76), *HT* V7 #3 (11/78)

Tomb of Ice, A (Muñoz; redraw "Else You'll Be Dead"—*Weird Tales of the Future* #5, Jan. Feb. 1953, Gillmor) *WT* V5 #6 (11/73)

Tomb of Ice, A (Olivera;Saborido redraw "Death on Ice"—*Strange Fantasy* #6, June 1953, Ajax) *TFTT* V6 #3 (5/74), *HT* V7 #4 (11/76), *W* V12 #2 (6/79), *TOD* V2 #3 (8/80)

Tomb of Ogres (Macagno; redraw "The Monsters"—*Black Magic* #32, Sept. Oct. 1954, Prize) *TOV* V6 #3 (5/73), *HT* V7 #2 (5/76), *W* V12 #2 (6/79)

Tomb of Terror, The (Reynoso; redraw "The Weird Dead"—*Voodoo* #6, Feb. 1953, Ajax) *TT* V6 #3 (6/74), *W* V10 #1 (3/77), *TT* V9 #2 (4/78), *W* V13 #3 (6/80)

Tomb, The (Ayers; redraw "The Sign of Doom"—*Web of Mystery* #14, Oct. 1952, Ace) *TT* V3 #4 (7/71), *W* V7 #3 (4/73)

Tombstone for a Ghoul (Reynoso; redraw "Guest of the Ghouls"—*Beware* #7, Jan. 1954, Trojan) *HT* V3 #2 (5/70), *TFTT* V3 #4 (8/71), *TT* V5 #4 (6/73), *W* V10 #3 (12/77), *HT* V10 #1 (2/79), *WVT* V3 #1 (4/79), *TOD* V2 #2 (5/80)

Toreador and the Demons, The (Reynoso; redraw "How Manuelo Died"—*Web of Mystery* #23, Mar. 1954, Ace) *WT* V4 #1 (2/72), *WT* V6 #1 (11/73), *TT* V9 #3 (7/78)

Torture (Reynoso; redraw "Atom"—*Chamber of Chills* #18, July 1953, Harvey) *HT* V7 #1 (2/73)

Torture Castle (Torre Repiso; redraw "You Dare Not Speak About It"—*Web of Mystery* #14, Oct. 1952, Ace) *TFTT* V3 #3 (6/71), *HT* V4 #7 (12/72)

Torture Chamber (Stepancich; redraw "Mine Own Executioner"—*Web of Mystery* #25, July 1954, Ace) *WW* V2 #3 (6/71), *TT* V4 #7 (12/72), *TOV* V7 #4 (7/74)

Transparent Ones, The (Reynoso; redraw "Ghost Ship of the Caribbean"—*Web of Mystery* #1, Feb. 1951, Ace) *TOV* V5 #4 (6/72), *TT* V9 #1 (1/78)

Tunnel Crawlers (see The Evil Monsters)

Twice Dead (Macagno; redraw "Dollars and Doom"—*Voodoo* #8, Apr. 1953, Ajax) *WT* V6 #3 (5/74), *W* V10 #2 (6/77), *TT* V9 #3 (7/78), *W* V12 #1 (2/79), *W* V13 #3 (6/80)

Twisted Brain, The (Woromay; redraw "Death's Vengeance"—*Web of Evil* #16, July 1954, Quality) *TOV* V4 #3 (5/71), *WT* V1 (1/73), *TT* V6 #3 (6/74), *W* V11 #3 (9/78)

U

Undead, The (Reynoso; redraw "Ghoul's Bride"—*Voodoo* #6, Feb. 1953, Ajax) *TT* V6 #1 (2/74)

Unknown, The (Fraga; redraw "The Demon Coat"—*Web of Evil* #15, June 1954, Quality) *TT* V3 #4 (7/71), *W* V7 #3 (4/73)

Unknown, The (Reynoso; redraw "Plaything"—*Weird Tales of the Future* #6, Mar. Apr. 1953, Gillmor) *TOV* V6 #2 (3/73)

Unknown, The (Reynoso) *SG* V1 #8 (2/71)

Until Death Do Us Part (Fraga; redraw "Robot Woman"—

Weird Mysteries #2, Dec. 1952, Gillmor) *WT* V1 #9 (12/69), *TFTT* V2 #5 (10/70), *TOV* V5 #2 (3/72), *WT* V6 #1 (1/74)

V

Valley of Hell (Barnes; redraw "Valley of Horror"—*Web of Evil* #8, Nov. 1953, Quality) *TT* V7 #1 (4/76)

Vampire (Ayers; redraw "Mark of the Tomb"—*Mysterious Adventures* #2, June 1951, Story) *WT* V2 #5 (10/70), *TT* V4 #2 (3/72), *TT* V7 #4 (10/76), *TOD* V1 #4 (8/79), *WT* V5 #2 (8/81) As "Bloodsucker" *TFTT* V6 #2 (3/74), *HT* V9 #1 (2/78)

Vampire (Fraga; redraw "Shadow of Death"—*Tomb of Terror* #7, Jan. 1953, Harvey) *TOV* V7 #6 (11/74), *HT* V7 #2 (5/76), *W* V11 #4 (12/78), *TOD* V1 #3 (5/79), *TOD* V3 #2 (9/81)

Vampire (Fraga; redraw "The Footlight Furies"—*Web of Mystery* #12, Aug. 1952, Ace) *TFTT* V3 #3 (6/71), *HT* V4 #7 (12/72), *TT* V6 #4 (8/74), *TT* V8 #3 (10/77), *WVT* V3 #1 (4/79)

Vampire (Fraga; redraw "Woman of a Thousand Faces"—*Web of Mystery* #23, Mar. 1954, Ace) *TFTT* V3 #2 (4/71), *WT* V5 #2 (3/73)

Vampire (Macagno; redraw "Deadly Pickup"—*Voodoo* #16, July Aug. 1954, Ajax) *TOV* V7 #2 (3/74), *HT* V8 #2 (5/77), *HT* V9 #1 (2/78), *WVT* V3 #2 (7/79), *TOD* V2 #3 (8/80), *WVT* V5 #2 (4/81)

Vampire Caper, The (Casadei; redraw "Bank Night"—*Mysterious Adventures* #19, Apr. 1954, Story) *TOV* V3 #6 (11/70), *SG* V1 #11 (8/71), *TOV* V6 #3 (5/73)

Vampire Flies (Woromay; redraw "Demon Flies"—*Witches Tales* #8, Mar. 1952, Harvey) *TT* V2 #1 (1/70), *WT* V3 #1 (2/71)

Vampire Flies, The (Fraga; redraw "The Improved Kiss"—*Weird Terror* #8, Nov. 1953, Comic Media) *W* V5 #4 (8/71), *TT* V5 #5 (10/73), *HT* V7 #4 (11/76), *TOD* V1 #3 (5/79), *WVT* V4 #3 (7/80), *WVT* V5 #2 (4/81)

Vampire Flower (Fraga; redraw "The Blood Blossom"—*Fantastic Fears* #7 [#1], May 1953, Ajax) *WT* V6 #4 (7/74), *W* V11 #3 (9/78), *HT* V7 #3 (11/78)

Vampire Ghouls, The (Casadei; redraw "The Fiend of the Nether World"—*Witches Tales* #15, Oct. 1952, Harvey) *W* V4 #4 (8/70), *HT* V4 #2 (3/72)

Vampire Lives, The (Fraga; redraw "Villa of the Vampire"—*Web of Mystery* #19, July 1953, Ace) *HT* V3 #5 (9/71), *W* V7 #5 (8/73), *W* V9 #4 (12/76), *TT* V8 #1 (4/77), *W* V12 #1 (2/79), *WVT* V3 #3 (10/79), *WVT* V5 #2 (4/81)

Vampire Monster Trap, The (Fraga; redraw "Ordeal by Wax"—*Weird Mysteries* #2, Dec. 1952, Gillmor) *TT* V2 #2 (3/70), *WT* V3 #3 (6/71), *W* V6 #7 (12/72), *HT* V6 #5 (10/74), *WVT* V2 #2 (7/79)

Vampire Witch, The (Fraga; redraw "The Witches Curse"—*Weird Mysteries* #8, Jan. 1954, Gillmor) *W* V4 #1 (2/70), *HT* V3 #2 (3/71), *TT* V4 #6 (10/72)

Vampire, The (Fraga; redraw "Shadow of Death"—*Tomb of Terror* #7, Jan. 1953, Harvey) *WT* V5 #3 (9/73), *HT* V9 #3 (8/78), *TOD* V2 #2 (5/80)

Vampire, The (Torre Repiso; redraw "Name from the Underworld"—*Web of Mystery* #17, Feb. 1953, Ace) *W* V5 #6 (12/71), *W* V7 #1 (2/73), *HT* V8 #3 (11/77), *TOD* V1 (5/81) As "It Cried for Blood" *WVT* V3 #1 (4/79)

Vampire's Plague (Cristóbal; redraw "Legacy of the Accursed"—*Web of Mystery* #2, Apr. 1951, Ace) *TT* V7 #1 (4/76), *W* V11 #4 (12/78), *TOD* V2 #1 (2/80), *WVT* V5 #2 (4/81)

Vampire-Ghouls (Woromay; redraw "Ghoulash"—*Mysterious Adventures* #20, June 1954, Story) *HT* V5 #4 (9/70), *TFTT* V4 #2 (3/72), *TT* V6 #5 (10/74), *TOD* V2 #1 (2/80)

Vampires Bride (Fernand; redraw "Vampire Bride"—*Web of Mystery* #9, May 1952, Ace) *HT* V7 #2 (5/76), *TOD* V1 #3 (5/79), *WVT* V5 #2 (8/81)

Vampires From Beyond (Reynoso; redraw "The Horrors of the 13th Stroke"—*Beware! Terror Tales* #5, Jan. 1953, Fawcett) *HT* V2 #4 (7/70) As "Vampires from Dimension X" *SG* V1 #11 (8/71), *HT* V5 #4 (8/73)

Vampires from Dimension X (see Vampires From Beyond)

Vampires, The (Fraga; redraw "Venom of the Vampires"—*Web of Mystery* #1, Feb. 1951, Ace) *TT* V4 #4 (6/72) As "The Bats" *TOV* V7 #2 (3/74), *WVT* V3 #3 (10/79), *WVT* V5 #3 (8/82)

Vampires, The (Muñoz; redraw "Wake up the Dead"—*Black Magic* #33, Nov. Dec. 1954, Prize) *HT* V6 #4 (8/74), *WVT* V3 #2 (7/79)

Vengeance (Casadei; redraw "Revenge"—*Witches Tales* #21, Oct. 1953, Harvey) *HT* V3 #2 (3/71), *TFTT* V4 #4 (9/72), *TOV* V7 #5 (9/74), *HT* V8 #4 (8/77)

Voodoo Doll (Novelle; redraw "The Human Clay"—*Mysterious Adventures* #14, June 1953, Story) *SG* V1 #8 (2/71), *HT* V5 #1 (2/73)

Voodoo Doll (Reynoso; redraw "Anger of the Devil"—*Mysterious Adventures* #3, Aug. 1951, Story) *TT* V4 #2 (3/72), *WT* V6 #3 (5/74)

Voodoo Horror (Casadei; redraw "A Stony Death"—*Mysterious Adventures* #12, Feb. 1953, Story) *WT* V3 #1 (2/71)

Voodoo Terror (Stone) *TOV* V3 #1 (1/70), *W* V5 #1 (2/71), *WT* V5 #4 (7/73), *TT* V7 #3 (7/76), *HT* V9 #3 (8/78), *TOD* V2 #2 (5/80)

Voodoo Witch, The (Casadei; redraw "Witches Never Die"—*Mysterious Adventures* #13, Apr. 1953, Story) *TOV* V4 #1 (1/71) As "The Witch" *WT* V5 #4 (7/73)

W

Walk the Edge of Darkness (Woromay; redraw "Die"—*Weird Terror* #6, July 1953, Comic Media) *HT* V2 #6 (11/70), *TFTT* V4 #3 (7/72)

Walking Dead, The (Casadei; redraw "The Ghost of the Rue Morte"—*Chamber of Chills* #21 [#1], June 1951, Harvey) *TOV* V3 #3 (5/70), *WW* V2 #2 (4/71), *TT* V4 #6 (10/72)

Walking Dead, The (Cristóbal; redraw "This Time You'll Die"—*Black Magic* #33, Nov. Dec. 1954, Prize) *HT* V5 #5 (6/73), *TT* V7 #4 (10/76)

Walls of Fear, The (Muñoz; redraw "The Dreaded Crypts of Horror"—*Web of Evil* #15, June 1954, Quality) *HT* V4 #2 (3/72)

Water Demon, The (Clemen; redraw "Kiss of Doom"—*Black Cat Mystery* #42, Feb. 1953, Harvey) *TT* V4 #7 (12/72), *W* V8 #4 (8/74)

Wax Witch, The (Cerchiara; redraw "From the Graves of the Unholy"—*Web of Mystery* #17, Feb. 1953, Ace) *W* V5 #2 (4/71), *HT* V4 #6 (10/72), *HT* V8 #2 (5/77), *WVT* V4 #3 (7/80)

Web of Horror (Fraga; redraw "Fatal Steps"—*Witches Tales* #9, Aug. 1952, Harvey) *WT* V5 #2 (3/73)

Web of Terror (Burgos; redraw "The Red Spider"—*Witchcraft* #3, July Aug. 1952, Avon) *TFTT* V2 #1 (1/70), *WT* V3 #1 (2/71)

Weird Corpse, The (Fernand; redraw "Test of Terror"—*Tales of Horror* #6, Aug. 1953, TOBY) *TOV* V7 #5 (9/74), *W* V12 #3 (9/79)

Weird Corpse, The (Reynoso; redraw "Black Knight"—*Black Cat Mystery* #43, Apr. 1953, Harvey) *TFTT* V4 #4 (9/72)

Weird House, The (Novelle; redraw "The Desert Castle"—*Weird Tales of the Future* #3, Sept. 1952, Gillmor) *TFTT* V3 #5 (10/71), *W* V7 #5 (8/73)

Weird Magic (see Zombie Magic)

Weird Old Man, The (Casadei; redraw "The Recluse"—*Out of the Shadows* #13, May 1954, Standard) *TT* V4 #3 (4/72), *WT* V6 #1 (1/74)

Weird Revenge (Casadei; redraw "Vengeance Trail"—*Weird Horrors* #6, Feb. 1953, St. John) *TT* V2 #3 (2/70), *W* V5 #6 (12/71), *HT* V5 #4 (8/73)

Weird Robots, The (Stepancich; redraw "Perils of Planetoid X"—*Planet Comics* #72, Fall 1953, Fiction House) *WW* V2 #1 (2/71)

Weird Safari (Muñoz; redraw "Mastodon Menace"—*Web of Mystery* #13, Sept. 1952, Ace) *HT* V4 #7 (12/72), *TFTT* V3 #3 (6/71), *HT* V6 #5 (10/74)

Weird Thing, The (Torre Repiso; redraw "The Wig"—*Out of the Shadows* #11, Jan. 1954, Standard) *TOV* V5 #6 (10/72), *TT* V6 #6 (12/74)

Weird Twist of Fate, A (Reynoso; redraw "Big Fight"—*Chamber of Chills* #17, May 1953, Harvey) *W* V7 #4 (6/73), *HT* V7 #3 (8/76)

Weird Vengeance (Woromay; redraw "Death Takes a Holiday"—*Weird Mysteries* #1, Oct. 1952, Gillmor) *WT* V2 #1 (2/70), *W* V5 #2 (4/71), *HT* V4 #6 (10/72)

Werewolf (Casadei; redraw "Dreaded Duo's Blood Banquet"—*Web of Mystery* #11, July 1952, Ace) *WT* V4 #2 (3/72)

Werewolf (Casadei; redraw "Werewolves"—*Mysterious Adventures* #19, Apr. 1954, Story) *TFTT* V3 #1 (2/71)

Werewolf (Reynoso; redraw "Full Moon"—*Weird Terror* #5, May 1953, Comic Media) *W* V4 #4 (8/70), *TFTT* V4 #1 (2/72), *TOV* V6 #6 (11/73), *W* V11 #1 (3/78), *WVT* V3 #3 (10/79), *W* V13 #3 (9/80), *WVT* V5 #1 (1/81), *WVT* V5 #3 (3/82)

Werewolf, The (Muñoz; redraw "Werewolf"—*Out of the Shadows* #14, Aug. 1954, Standard) *TT* V3 #6 (11/71), *HT* V5 #5 (10/73)

Werewolves, The (Cristóbal; redraw "The Werewolf Burial"—*Adventures into the Unknown* #26, Dec. 1951, ACG) *TT* V5 #4 (8/73)

(When They Meet the) Vampire (Macagno; redraw "Scream No More, My Lady"—*Fantastic* #10, Nov. Dec. 1954, Ajax) *WT* V6 #1 (1/74), *W* V10 #2 (6/77), *W* V12 #1 (2/79), *TOD* V1 #4 (8/79), *WVT* V4 #2 (4/80), *WVT* V5 #1 (1/81)

Where the Flesheaters Dwell (Muñoz; redraw "Fiends from the Crypt"—*Fantastic Fears* #8 [#2], July 1953, Ajax) *TFTT* V6 #2 (3/74), *TOD* V1 #5 (11/79)

Who Are You? (see The Ogre from Space)

Winged Monsters, The (Reynoso; redraw "Bug-a-Boo"—*Mysterious Adventures* #17, Dec. 1953, Story) *WT* V2 #6 (12/70), *HT* V5 #5 (6/73), *W* V12 #4 (12/79)

Witch and the Werewolf, The (Jackson; redraw/ reinterpretation "Sshhh"—*Weird Mysteries* #7, Oct. Nov. 1953, Gillmor) *HT* V2 #1 (1/70)

Witch Doctor, The (Stone; redraw "African Horror"—*Witchcraft* #6, Mar. 1953, Avon) *TFTT* V2 #1 (1/70), *TOV* V4 #1 (1/71), *W* V7 #4 (6/73), *W* V9 #3 (12/76), *W* V12 #1 (2/79)

Witch of Doom, The (Torre Repiso; redraw "The Dead Dance on Halloween"—*Web of Mystery* #14, Oct. 1952, Ace) *TOV* V4 #4 (7/71)

Witch, The (see The Voodoo Witch)

Witch's Claws, The (Reynoso; redraw "Claws of the Cat"—*Witchcraft* #4, Sept. Oct. 1952, Avon) *WT* V2 #1 (2/70), *TT* V3 #2 (3/71), *W* V6 #6 (10/72), *TT* V6 #5 (10/74), *HT* V9 #2 (5/78)

Witch's Horror, The (Stepancich; redraw "Spell of the Devil Dancers"—*Web of Mystery* #13, Sept. 1952, Ace) *WT* V3 #3 (5/72), *W* V7 #7 (12/73), *TT* V8 #2 (7/77)

Witch's House is Haunted, The (Ayers; redraw "The Haunter"—*Weird Horrors* #4, Nov. 1952, St. John) *W* V4 #1 (2/70), *TFTT* V3 #2 (4/71), *W* V5 #2 (3/73), *W* V10 #3 (6/77), *W* V13 #3 (6/80)

Witch's Pit, The (Muñoz; redraw "The Well of Mystery"—*Witches Tales* #15, Oct. 1952, Harvey) *TOV* V3 #5 (9/70), *WT* V4 #2 (3/72)

Witchcraft (Casadei; redraw "Book of Vengeance"—*Chamber of Chills* #24 [#4], Dec. 1951, Harvey) *W* V4 #3 (6/70), *WW* V2 #4 (8/71), *TFTT* V5 #6 (11/73)

Witches' Ghosts (Fraga; redraw "Lost Souls"—*Beware* #8, Mar. 1954, Trojan) *TT* V2 #5 (5/70), *TOV* V4 #3 (3/71) As "Strange Ghosts" *HT* V4 #6 (10/72)

Witches' Coven, The (Woromay; redraw "The Deadly Night"—*Web of Mystery* #15, Nov. 1952, Ace) *HT* V3 #4 (7/71), *TT* V5 #4 (4/73), *TT* V9 #1 (1/78)

Witches' Nightmare (Reynoso; redraw "The Witches' Tale"—*Weird Mysteries* #4, Apr. 1953, Gillmor) *HT* V2 #2 (3/70), *W* V5 #6 (3/71), *W* V4 #7 (12/72), *TOV* V6 #5 (9/74)

Witches' Revenge (Ayers; redraw "The Old Hag of the Hills"—*Chamber of Chills* #21 [#1], June 1951, Harvey) *W* V4 #2 (4/70), *WW* V2 #4 (8/71), *W* V7 #5 (8/73), *W* V9 #3 (9/76), *W* V12 #1 (2/79)

Wooden Menace, The (Casadei; redraw "The Phantom Puppet"—*Web of Mystery* #20, Sept. 1953, Ace) *TT* V3 #3 (5/71), *W* V6 #5 (8/72), *W* V8 #4 (10/74)

Y

Yeech! (Burgos; redraw "A Matter of Taste"—*Witches Tales* #19, June 1953, Harvey) *WT* V1 #9 (12/69), *TOV* V3 #5 (9/70), *TT* V4 #2 (3/72), *TT* V6 #1 (2/74), *HT* V8 #2 (5/77), *TOD* V2 #2 (5/80)

Z

Zombie (Reynoso; redraw "The Living Dead"—*Mysterious Adventures* #13, Apr. 1953, Story) *TFTT* V3 #1 (2/71)

Zombie Army, The (Fraga; redraw "A Rage to Kill"—*Witches Tales* #15, Oct. 1952, Harvey) *W* V4 #5 (10/70), *TT* V4 #3 (4/72), *TOV* V7 #1 (1/74)

Zombie for a Day (Woromay; redraw "Come Die with Me"—*Beware* #8, Mar. 1954, Trojan) *W* V4 #2 (4/70), *TOV* V4 #4 (7/71)

Zombie Magic (Woromay; redraw "Corpses on Cue"—*Web of Mystery* #18, May 1953, Ace) *HT* V3 #3 (5/71) As "Weird Magic" *TOV* V5 #1 (1/72), *TT* V5 #5 (10/73)

Zombie Manikins, The (Oswal; redraw "The Manikins of Death"—*Mysterious Adventures* #3, Aug. 1951, Story) *WT* V3 #1 (2/71)

Zombie-Maker, The (Marchionne; redraw "The Skid Row Monster"—*Web of Evil* #19, Oct. 1954, Quality) *TOV* V5 #1 (1/72), *WT* V5 #9 (9/73), *HT* V8 #3 (11/77), *TT* V9 #3 (7/78)

Zombies (Muñoz; redraw "The Chieftain of the Undead"—*Chamber of Chills* #21 [#1], June 1951, Harvey) *TFTT* V2 #4 (8/70), *TOV* V5 #4 (6/72)

Zombies' Cave, The (Muñoz; redraw "The Corpse Springs Alive"—*Mysterious Adventures* #6, Feb. 1952, Story) *TT* V3 #1 (1/71), *TOV* V6 #4 (7/73)

Zombies—Coast to Coast (Fraga; redraw "Corpses... Coast to Coast"—*Voodoo* #14, Mar. Apr. 1954, Ajax) *TT* V6 #3 (6/74)

Zombies' Vault, The (Reynoso; redraw "The Vault of Living Death"—*Chamber of Chills* #22 [#2], Aug. 1951, Harvey) *TT* V2 #3 (5/70), *HT* V3 #2 (3/71), *TOV* V5 #5 (8/72), *TT* V9 #1 (1/78)

Zombies, The (7) (Marchionne; redraw "Rendezvous with the Phantom Gypsies—*Web of Mystery* #5, Oct. 1951, Ace) *WT* V4 #4 (7/72)

Zombies, The (Fraga; redraw "Marching Zombies—*Black Cat Mystery* #35, May 1952, Harvey) *TFTT* V3 #6 (12/71), *HT* V5 #6 (12/73), *W* V9 #3 (6/76), *HT* V10 #1 (2/79)